Roman Architecture in Provence

This book provides a survey of the architecture and urbanism of Provence during the Roman era. Provence, or "Gallia Narbonensis" as the Romans called it, was one of the earliest Roman colonies in Western Europe. In this book, James C. Anderson, jr., examines the layout and planning of towns in the region, both those founded by the Romans and those redeveloped from native settlements. He provides an in-depth study of the chronology, dating, and remains of every type of Roman building for which there is evidence in Provence. The stamp of Roman civilization is apparent today in such cities as Orange, Nîmes, and Arles, where spectacular remains of bridges, theaters, fora, and temples attest to the sophisticated civilization that existed in this area during the imperial period and late antiquity. This book focuses on the remains of buildings that can still be seen, exploring decorative elements and their influence from Rome and local traditions, as well as their functions within the urban environment.

James C. Anderson, jr., is Josiah Meigs Distinguished Teaching Professor in the Department of Classics at the University of Georgia. He has published numerous articles in journals including *American Journal of Archaeology*, *Journal of the Society of Architectural Historians*, and *Bonner Jahrbücher*. He is the author of *Historical Topography of the Imperial Fora at Rome*, *Roman Brick Stamps: The Thomas Ashby Collection*, and *Roman Architecture and Society*.

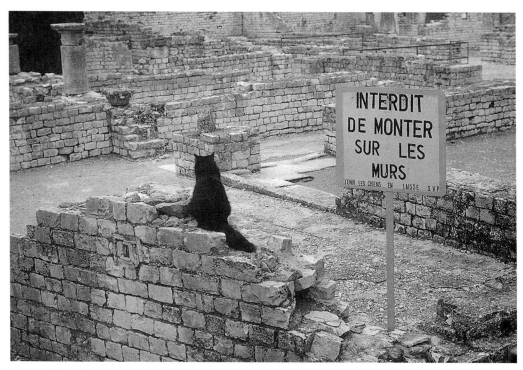

Walls of Roman houses at Vaison-la-Romaine (photo by the author).

ROMAN ARCHITECTURE IN PROVENCE

James C. Anderson, jr.

The University of Georgia

CAMBRIDGE
UNIVERSITY PRESS

CAMBRIDGE UNIVERSITY PRESS
Cambridge, New York, Melbourne, Madrid, Cape Town,
Singapore, São Paulo, Delhi, Mexico City

Cambridge University Press
32 Avenue of the Americas, New York, NY 10013-2473, USA

www.cambridge.org
Information on this title: www.cambridge.org/9780521825207

First published 2013

Published with the assistance of the Getty Foundation

Printed in the United States of America

A catalog record for this publication is available from the British Library.

Library of Congress Cataloging in Publication data
Anderson, James C.
Roman architecture in Provence/James C. Anderson, jr.
p. cm.
Includes bibliographical references and index.
ISBN 978-0-521-82520-7
1. Archiecture, Roman – France – Provence. 2. Cities and towns – Rome.
I. Title
NA335.P76A53 2012
722'.7093649–dc23 2012004192

ISBN 978-0-521-82520-7 Hardback

FAMILIAE OPTIMAE
– UXORI, LIBERIS PARENTIBUSQUE –
PIO MARITO, PATRE FILIOQUE

CONTENTS

List of Illustrations *page* viii

Acknowledgments xiii

I HISTORICAL OVERVIEW: ROMAN PROVENCE
 "PROVINCIA NOSTRA" 1

2 THE CITIES, SUBURBS, AND TOWNS OF ROMAN PROVENCE 18

3 ROMAN ARCHITECTURAL FORMS IN PROVENCE 61

4 A BRIEF CONCLUSION 234

Notes 237
Bibliography 259
Index 275

ILLUSTRATIONS

1 Map of Southern Gaul (France), *page* **2**
2 Map of Provence, **3**
3 Map of Greek colonization and native *oppida* in Provence, **20**
4 Surviving defense wall at Entremont, **22**
5 Plan of ancient Marseille (Massalia/Massilia), **24**
6 Plan of ancient Glanum (St.-Rémy-de-Provence), **29**
7 Detailed plan of central Glanum before 90 BCE, **31**
8 Plan of the forum area of Glanum, **34**
9 "Les Antiques": arch and cenotaph of the Iulii, at Glanum, **36**
10 Plan of ancient Aquae Sextiae (Aix-en-Provence), **38**
11 Plan of ancient Narbo Martius (Narbonne), **40**
12 Plan of ancient Arelate (Arles), **42**
13 Plan of ancient Forum Iulii (Fréjus), **46**
14 Plan of ancient Vienne (Vienna), **48**
15 Plan of ancient Nîmes (Nemausus), **51**
16 Roman aqueduct near Nîmes: the Pont du Gard, **53**
17 Plan of ancient Orange (Arausio), **55**
18 Plan of ancient Vaison-la-Romaine (Vasio), **59**
19 The "Tour magne" at Nîmes, **65**
20 The "Porte des Gaules" at Fréjus, **68**
21 The "Porte d'Auguste" at Nîmes, **69**
22 The "trophée des Alpes" at La Turbie, **71**
23 Model of the "trophée des Alpes" at La Turbie, **71**
24 Roman bridge with arches at St.-Chamas, **74**
25 Detail of arch at St.-Chamas, **74**
26 Arch at Glanum (St.-Rémy-de-Provence), **76**
27 Prisoners and trophy relief, arch at Glanum, **77**
28 Arch at Carpentras, **79**
29 Decorative carving, arch at Carpentras, **80**
30 Trophy relief, arch at Carpentras, **81**
31 Arch(es) at Cavaillon as reconstructed, **82**

32	Floral carving, Cavaillon,	**83**
33	Arch at Orange, south face,	**84**
34	Arch at Orange, south face, archivolt,	**84**
35	Arch at Orange, carved impost block,	**85**
36	Arch at Orange, west face, arcuated lintel,	**86**
37	Arch at Orange, carved shields with names,	**87**
38	Arch at Orange, architrave course with clamp holes,	**88**
39	Arch at Orange, north face with double attic,	**90**
40	Arch at Orange, battle reliefs in upper attic,	**91**
41	Glanum, plan of twin temples and porticus,	**95**
42	Glanum, twin temples as restored,	**95**
43	Glanum, view of twin temples from above,	**96**
44	Glanum, sanctuaries to Valetudo and Hercules,	**97**
45	Glanum, shrine to Valetudo as restored on site,	**98**
46	Roman temple at Chateau Bas near Vernégues,	**99**
47	Vernégues, Corinthian column and pilaster,	**100**
48	Vernégues, Chapelle de St. Césare,	**101**
49	Orange, Tuscan temple within hemicycle,	**102**
50	Orange, decorative elements of Tuscan temple in situ,	**103**
51	The "Maison Carrée" temple at Nîmes,	**104**
52	Façade and Corinthian order of the Maison Carrée at Nîmes,	**106**
53	Details of decorative carving on the Maison Carrée,	**107**
54	Ground plan with measurements of the Maison Carrée,	**108**
55	Entablature of the Maison Carrée with clamp holes,	**109**
56	The Roman temple at Vienne,	**112**
57	Flank and rear of the temple at Vienne,	**113**
58	Façade of the temple at Vienne,	**114**
59	Temple at Vienne, detail of entablature showing clamp holes,	**116**
60	Rectangular peristyle at Glanum,	**118**
61	So-called warrior portico at Entremont,	**119**
62	Roman forum and colonnades at Glanum,	**120**
63	Roman forum and colonnades at Aix-en-Provence,	**120**
64	Roman colonnades in Cour de l'Archévèché, Aix-en-Provence,	**121**
65	Architectural fragments in situ, Place du Forum, Arles,	**122**
66	Orange, plan of *porticus* at temple next to theater,	**123**
67	Vaison, plan of theater with colonnades above *cavea*,	**124**
68	Vaison, plan of Rue des Colonnes,	**125**
69	Vienne, plan showing porticoes at Place Camille-Jouffray,	**126**
70	Plan of forum, colonnades, and temple, Nîmes,	**127**
71	Elevation of forum and temple complex, Nîmes,	**128**
72	Basilica in forum at Glanum,	**131**
73	Basilica apse filled with rubble and cement, Glanum,	**132**
74	Arles, plan of forum, cryptoporticus colonnade, and apsidal *forum adiectum*,	**133**
75	Plan of Roman Vienne, indicating location of forum,	**136**
76	Hypothetical plan of forum, altar, and porticus, Vienne,	**137**
77	Rue des boutiques with porticoes, Vaison-la-romaine,	**140**
78	Vienne, St.-Romain-en-Gal, plan of artisanal insula and street,	**141**
79	Vienne, St.-Romain-en-Gal, plan of *horreum*/warehouse,	**142**
80	Narbonne, plan of cryptoporticus and *horreum*,	**145**
81	Fréjus (Forum Julii), remains of Roman docks at Butte St.-Antoine,	**147**
82	Fréjus, Roman lighthouse at port, called La Lanterne d'Auguste,	**148**

83 *Cavea*, orchestra, and scenae frons of Roman theater at Orange, **150**

84 *Aditus maximus*, connecting *cavea* and stage, theater at Orange, **151**

85 Plan of the Roman theater at Orange, **152**

86 View of *scenae frons*, as restored, theater at Orange, **153**

87 *Columnatio* as restored, theater at Orange, **154**

88 Statue of Augustus (?) in *scenae frons*, theater at Orange, **154**

89 Hypothetical plan of Roman Orange: St.-Eutrope hill, **155**

90 Roman theater at Arles, as retored, **157**

91 Orchestra and stage, theater at Arles, **157**

92 Vaison-la-Romaine, view of the Roman theater, **158**

93 *Cavea* and orchestra, theater at Vaison-la-Romaine, **158**

94 *Porticus in summa cavea*, theater at Vaison-la-Romaine, **159**

95 Location and fragments of scene building, theater at Vaison-la-Romaine, **159**

96 View of Roman theater at Vienne from the *summa cavea*, **161**

97 *Cavea* set into hillside, theater at Vienne, **161**

98 Plan of the Roman theater at Vienne, **162**

99 View of exterior, Roman amphitheater at Arles, **164**

100 View of exterior, Roman amphitheater at Nîmes, **164**

101 Detail of second-story decoration, amphitheater at Nîmes, **165**

102 Detail of exterior decoration, amphitheater at Arles, **166**

103 Carved bulls' head protomes, amphitheater at Nîmes, **167**

104 Interior *cavea* and arena as restored, amphitheater at Nîmes, **167**

105 View of *cavea* vaults, amphitheater at Fréjus, **169**

106 Arena as restored, amphitheater at Fréjus, **170**

107 Arles, circus *spina* in Place de la République, **171**

108 Vienne, circus obelisk ("L'aiguille" or "La Pyramide"), **172**

109 Plan of *bibliotheca* or library ("temple of Diana") at Nîmes, **173**

110 Nîmes, rear wall of library with niches and vaulted ceiling, **174**

111 Nîmes, niches lining side wall of library, **175**

112 Glanum, remains of Roman row-type baths, **177**

113 Remaining archway, La Porte Dorée Baths, Fréjus, **179**

114 Exterior view of apsed *caldarium*, Constantinian Baths, Arles, **181**

115 Interior of apsed cupola of *caldarium*, Constantinian Baths, Arles, **182**

116 *Suspensurae* of hypocaust, Constantinian Baths, Arles, **183**

117 Barrel vaulted water sanctuary, shrine to Glans, Glanum, **184**

118 Temple to Valetudo and shrine to Glans as reconstructed at Glanum, **185**

119 Circular fountain in front of twin temples, Roman forum at Glanum, **185**

120 Plan of *Augusteum* sanctuary, Nîmes, **187**

121 Floral decorative carving, Jardin de la fontaine, Nîmes, **188**

122 *Augusteum* sanctuary within overall plan of Roman Nîmes, **189**

123 Aqueduct arcade crossing modern road near Fréjus, **192**

124 Aqueduct piers near the Roman walls of Fréjus, **192**

125 Water distribution tank (*castellum divisorium*) at Nîmes, **193**

126 View of Pont du Gard aqueduct bridge over Gardon River near Nîmes, **194**

127 Pier of Pont du Gard showing protruding stone bosses, **195**

128 View of superimposed arches of the Pont du Gard, **196**

129 View of central section of Pont du Gard showing variant widths of openings, **197**

130 View of Roman mill race at Barbégal, from below, **199**

131 View of Roman mill race at Barbégal, from above, **200**

132 Ensérune, plans of adjacent houses, **202**

133 Plan of central residential quarter at Glanum, **204**

134 Glanum, House VI (House of the Anta Capitals), **205**
135 Glanum, Houses VII and VIII (House of Atys), **206**
136 Glanum, House XII (House of Sulla), **207**
137 Narbonne, plan of House at Clos de la Lombarde, **208**
138 Vaison, House of the Dauphin, phase 1 (Augustan period), **209**
139 Vaison, House of the Dauphin, phase 3 (second century CE), **210**
140 Vaison, view of House of the Dauphin, **210**
141 Vaison, plan of House of the Silver Bust, **211**
142 Vaison, House of the Silver Bust with palestra, **212**
143 Vaison, plan of House of the Messii, **213**
144 Vaison, eponymous mosaic from Villa of the Peacock, **214**
145 Vienne (St.-Romain-en-Gal), axonometric reconstruction, House of the Ocean Gods, **216**
146 Vienne (St.-Romain-en-Gal), plan of House of Sucellus, **217**
147 Vienne (St.-Romain-en-Gal), plan of House of the Columns, **217**
148 Vienne, plan of House of the Atrium, **218**
149 Orange, plans of houses A and B, **219**
150 Glanum (St.-Rémy-de-Provence), cenotaph of the Iulii, **225**
151 Glanum, inscription on cenotaph of the Iulii, **226**
152 Glanum, third level columned rotunda, cenotaph of the Iulii, **227**
153 Glanum, cenotaph of the Iulii, north frieze panel, **229**
154 Glanum, cenotaph of the Iulii, west frieze panel, **229**
155 Glanum, cenotaph of the Iulii, south frieze panel, **230**
156 Glanum, cenotaph of the Iulii, east frieze panel, **231**
157 Beaucaire, reconstruction of cenotaph/mausoleum, **232**

ACKNOWLEDGMENTS

I became fascinated by the Roman remains of Provence while still a graduate student enrolled in a seminar on Rome's Western Provinces (in 1977). I first visited and was bowled over by the ruins in February 1979, and I have returned regularly since. Although over the years I published two articles (Anderson 1987, 2001) that investigated individual Romano-Provençal monuments, the idea of undertaking a book-length study of this material was not my own; it was first suggested to me by Dr. Beatrice Rehl in 2001. When I agreed, devised a prospectus for such a book, and sent it to her, I had no idea that the actual research and writing would require another decade to complete, but such was the case (due largely to other professional commitments and demands), so it is with a sense of relief as well as accomplishment that I am able, at long last, to acknowledge at least some of the inestimable kindness and help I have received from many sources ever since the late 1970s.

My various journeys to and in Provence, and many other essential expenses involved with the field research for this project, were funded, at different times, by the National Endowment for the Humanities Summer Stipend Program and by several successive research funding programs at the University of Georgia including the Willson Center for Humanities and Arts, the University of Georgia Research Foundation Inc., the Office of the Vice-President for Research, and the Department of Classics, to all of whom I am deeply indebted. Access to often obscure archaeological journals and early publications not available on my home campus was graciously given me, at various times, by the Davis Library of the University of North Carolina at Chapel Hill, by the Blegen Library of the University of Cincinnati, and by the Library of the American Academy in Rome. It was at the American Academy in Rome that the bulk of the book was written during two periods as a Visiting Scholar: Spring semester of 2009 (thanks

to released time generously funded by the Franklin College of Arts & Sciences of the University of Georgia) and Summer 2010. Many other libraries and collections granted me access to materials they hold via Interlibrary Loan, and I have been treated with great generosity throughout the process of research and writing by all to whom I have appealed for assistance or access to materials. The photographs that illustrate the volume were all taken by me beginning in early 1979 and continuing through 2003; on every occasion when I requested permission to photograph, measure, or climb on (to get closer to) ancient remains, this was graciously permitted me by the authorities in charge of the various sites and monuments throughout southern France; indeed no scholar could have been treated more courteously at every place and time.

Individual scholars and colleagues have been notably generous in their assistance, advice, and direct support. I am deeply indebted to Prof. James F. D. Frakes for his generous permission to reproduce plans and drawings from his published work on portico colonnades in southern France, as well as from his most recent research. Over the decades, I have benefited from the thoughts and insights of many colleagues with whom I have discussed particular Romano-Provençal remains (and especially difficulties with them), and I fear this list will be woefully incomplete. My first study of the material was undertaken in the graduate seminar (mentioned above) taught by Emeline Hill Richardson, who first made me question the traditional dating of the arch at Orange. As I became more and more interested in Gallia Narbonensis and its remains, I was also extremely fortunate to have access (both while a graduate student and later in my career) to the knowledge and advice, always generously shared, of Gerhard M. Koeppel and George W. Houston (who had been my teachers and remain my friends and colleagues) and of my dissertation director, Lawrence Richardson, jr. All these mentors encouraged me to pursue these studies and to keep asking questions (even if they feared I was going in the wrong direction!). I must also mention important and insightful conversations and correspondence – over the last thirty years – with James E. Packer, Susann S. Lusnia, Greg Woolf, Ann Roth-Congès, Daniel Millette, C. Brian Rose, Robert I. Curtis, Mary T. Boatwright, Nicholas Purcell, A. Trevor Hodge, Nancy De Grummond, Lynne Lancaster, Frances Van Keuren, and Nigel Pollard, which helped me on both specific and more general scholarly questions that arose. I extend my apologies and my gratitude to any colleague whom I have inadvertently omitted. Comments and questions received from those who heard me lecture (all across the United States and Canada) on Roman Provence while I was Joukowsky Lecturer for the Archaeological Institute of America (2004–2006), and from University of Georgia students in several different iterations of my course on the Archaeology of Rome's Provinces over the years, have also repeatedly shaped and directed my focus, thinking, and analysis. When I had completed the first draft of the entire book, I was nervous about sending it to the Press, and at that point my good

friend Albert Lusnia offered to give the rough draft a detailed, thorough, and critical reading, which he proceeded to do. This was a tremendous gift: his questions and suggestions caused me to reorganize much of the manuscript and to revise an incalculable number of unclear passages; in short, he so improved my rough version that it was immediately acceptable to the Press. I am truly grateful to acknowledge the kindness of friends and colleagues I have mentioned in this paragraph, and I thank them (and anyone I have inadvertently omitted) from the bottom of my heart.

From the question that first made me think this might become a book-length project, through a decade of slow progress on my part, to the final procedures of refereeing, revising, and moving through the process of publication, no author could ever ask for a more helpful, encouraging, and patient editor than Dr. Beatrice Rehl of Cambridge University Press. She has kept me working when other duties almost overwhelmed my resolve, and I am very grateful to her. The entire staff at Cambridge and their associates have been extremely courteous, helpful, and professional throughout the process. I have also benefited from the great skill and careful reading of Hillary C. Ford, who served as copy editor for the manuscript and has saved me from many careless and technical errors, and from the editing (especially in the illustrations) of Stephanie Sakson, who has done the same. The actual publication through Cambridge University Press has been supported by the Getty Foundation, to whom I also extend my thanks.

My family has lived with this project for a very long time and has contributed so much to it that I can hardly provide a list. My wife Dana traveled with me, photographing and measuring, in Provence many times; our son Owen did the same in the summer of 1996, and our daughter Helena in the spring of 1999; Dana has continued to help in every way possible, even creating the index entries for the book. My late parents both knew of this project and hoped I would some day complete it; I hope they now know that I did. Hence it is to my beloved family – wife, children, and parents – that I gratefully dedicate this book.

ONE

HISTORICAL OVERVIEW

ROMAN PROVENCE / "PROVINCIA NOSTRA"

The modern name "Provence" derives from a popular Roman formula by which the territory of southeastern France was designated (Fig. 1). This nomenclature, "provincia nostra" (literally "our province") or simply "provincia" ("the province"), was in use at least as early as the governorship of Julius Caesar (58–49 BCE) and probably for some decades before. Caesar himself, when he describes the situation in 58 BCE that caused him to begin his Gallic campaigns, uses the term more than once, assuming that his audience at Rome would recognize the toponym (Caesar, *B Gall.* 1.7).

> Caesari cum id nuntiatum esset, eos per **provinciam nostram** iter facere conari, maturat ab urbe proficisci et cum maximis potest itineribus in Galliam ulteriorem contendit et ad Genuam pervenit. **Provinciae** toti quam maximum potest militum numerum imperat....
>
> When it had been announced to Caesar that they were attempting to follow a route through **our province**, he hurried to set out from the city and, by means of the best routes possible, marched to further Gaul and arrived at Geneva. From the entire **province**, he ordered a levy of the largest number of troops possible....

Not only is the area through which the Helvetians were attempting to pass referred to as "our" (*nostram*) without further detail, but Caesar treats it as the nearest and most obvious source of recruits for his army, with which he intends to oppose the proposed march of the Helvetii. From this remark alone, we must assume that – in Caesar's view at least – Provence was very much under Roman sway and apparently willing to be so (or at least to acquiesce in his massive draft of soldiers) by 58 BCE. Some confusion can arise from the fact that essentially this same territory had been referred to "officially" well before Caesar's time as

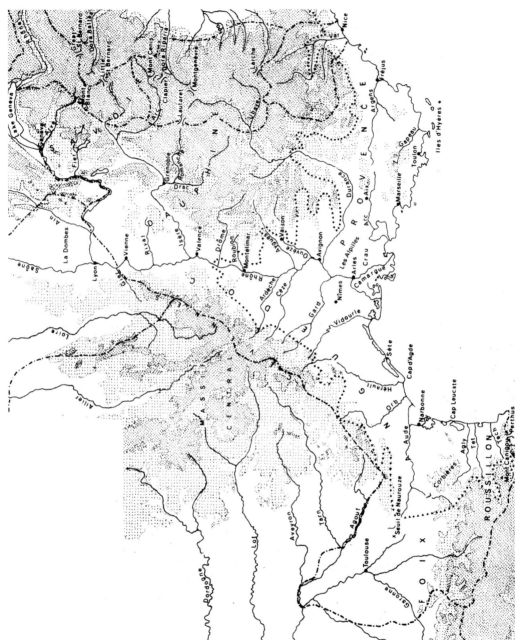

1 Map of Southern Gaul, including geography and major settlements (after Rivet 1988: fig. 2, p. 6).

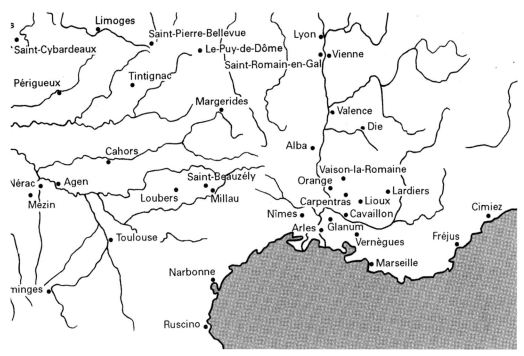

2 Map of Provence (after Gros 1996: 491 "Les Gaules et les Germanies").

"Gallia Transalpina," a name only gradually modified into "Gallia Narbonensis" in the course of the first century BCE (Fig. 2).

By the second half of the first century CE, written references to "provincia nostra" seem to have become routine, even though its official Imperial title "Gallia Narbonensis" was by that time well known. The Elder Pliny makes this apparent (*HN* 3.31.4):

> Narbonensis provincia appellatur pars Galliarum quae interno mari adluitur, Bracata antea dicta, amne Varo ab Italia discreta Alpiumque vel saluberrimis Romano imperio iugis, a reliqua vero Gallia latere septentrionali montibus Cebenna et Iuribus, agrorum cultu, virorum moruque dignatione, amplitudine opum nulli provinciarum postferenda breviterque Italia verius quam provincia.

> The part of the Gauls which is washed by the Mediterranean is labeled the Narbonese province, previously having been called Bracata. It is separated from Italy by the river Var and by the ranges of the Alps – very positively for the Roman Empire – and from the rest of Gaul on the north side by the Cevennes and Jura mountains. In agriculture, in worthiness of men and manners, in greatness of wealth (works), it should be placed second to none of the provinces; in short [it is] Italy more than a province.

This passage has long substantiated the assumption that Provence, by the second half of the first century CE, was thoroughly Romanized, far more so than

most other provinces at the same period; at least, that would appear to be what Pliny is implying. Writing (probably) at the very end of the first century CE, the historian Tacitus gives what seems a stark description of how this process of Romanization was inflicted upon a conquered territory – in this case, Britain – and its people (Tacitus, *Agr.* 21):

> Namque ut homines dispersi ac rudes eoque in bella faciles quieti et otio per voluptates adsuescerent, hortari privatim, adiuvare publice, ut templa fora domos extruerent, laudando promptos et castigando segnes: ita honor aemulatio pro necessitate erat. Iam vero principum filios liberalibus artibus erudire ... ut quo modo linguam Romanam abnuebant, eloquentiam concupiscerent. Inde etiam habitus nostri honor et frequens toga. Paulatim descensum ad delenimenta vitiorum, porticus et balinea et conviviorum elegantiam. Idque apud imperitos humanitas vocabatur, cum pars servitutis esset.

> And so that men scattered and rough and thus ready for war might be accustomed to peace and quiet by comforts, he would urge (them) privately, help (them) publicly, to build temples, forums, houses, by praising the quick and blaming the sluggards: and so there was rivalry for (his) praise rather than coercion. Indeed already the sons of chieftains were being educated in the liberal arts ... with the result that they (who) used to reject the Roman tongue were longing for eloquence. Then also our clothing [became] an honor and the toga [was] everywhere. Little by little [there was] a slide toward the pleasures of vices: colonnades and baths and the elegance of dinner parties. And amongst the conquered this was called "civilization" although it was a part of their slavery.

Allowing for the dramatic nature of Tacitus' rhetoric, these lines must be acknowledged to constitute the starkest of presentations of the Roman aristocrat's view of the process of Romanization, even if leading to a quotable epigram in the last line. The implication can certainly be drawn from these two first century CE remarks that the Romans themselves, at least those living and working in Rome, indeed saw Romanization as a process inflicted upon native populations. Once they had been subdued by force or treaty, they were influenced by persuasion, education, and money to adopt Roman living styles, architecture, dress, city plans, education, and the Latin language, as part of an intentional program carried out by the provincial governors and their administrations. It indeed seems plausible that the results of the process described by Tacitus could produce the result asserted by Pliny – the province becoming more Italy than province – especially in a territory as physically close to Italy as southeastern France, and which had been under Roman sway for a relatively long period of time.[1]

The archaeological record in Provence, as it has become clearer to us in the last fifty years or so, suggests that Pliny has, to some degree, overstated his case, that in fact Romanization did not work solely as a one-way process of

influence proceeding from Rome to province; nor could it be defined solely as the efforts of the local populace to accept and adopt the Roman way of life and culture, and how the central Roman administration made that happen. In studies focusing directly on Provence and its environs during Roman times, and indeed on Roman France more generally, it is becoming increasingly clear that Romanization – while unquestionably a general policy of Roman provincial administration – has to be assessed from a broader point of view. Archaeological evidence now permits us to see that Pliny's analysis of the "provincia" as more Italian than local is in part a literary *topos*, a conventional viewpoint with preconceived implications. An important insight has been gained with the realization that material culture suggests that the conquered locals of Provence, and undoubtedly of all other provinces as well, learned how to change and adjust in many areas of their lives, but maintained significant elements of their own background and civilization even as they accommodated Roman cultural priorities. To put it another way, the Provençal Romans always retained elements of their own culture in areas such as food production, farming, and animal raising (as has been shown by recent studies) and did the same in their adaptations and subtle variations on Roman forms of pottery, sculpture, and other artistic endeavors.[2] One focus of this book is to consider in what ways the architecture of Roman Provence may reflect this ongoing dialogue between Rome itself and the builders in one of its oldest and closest provinces, through the centuries.[3]

The geographical picture we receive from all sources is essentially the same. Caesar's term "provincia nostra" designates the geographical region which extended along the curve of the Mediterranean coastline from the river Var, which enters the sea on the eastern edge of France between Nice and Antibes, all the way west and southward to the slopes of the Pyrenees. The territory is divided by the Rhône River, which flows into the Mediterranean from a vast estuary between Arles and Marseille. The Alps provided the northeastern boundary, running from Geneva to the Var; in its western half the province spread north as far as the Cevennes Mountains, and west to Toulouse. Thus the province not only included modern-day Provence, but also incorporated Languedoc, Roussillon, and Foix to the west, as well as Savoie and Dauphiné on the north. This area is geographically distinct from the rest of France. For instance, both climate and vegetation change from continental to Mediterranean along the valley of the Rhône River between Lyon and Vienne, as they do around Toulouse in the west. Gallia Transalpina/Narbonensis, which opens onto the Mediterranean sea, has a climate, temperature, and rainfall much closer to that of Italy or Greece than that of central or northern France. The vegetation is mostly that of the so-called olive belt. As agriculture developed in Provence, its major produce was entirely Mediterranean in type: olives and olive oil, grapes and wine, and herbs of many varieties. Throughout antiquity the area was also an important supplier

of salt, gold, and tin; fish products were abundant and were frequently salted and exported. This area must always have seemed familiar, even home-like, to other Mediterranean peoples and hence incursions by first the Greeks, then the Romans offer no surprise. The native inhabitants were themselves acculturated to a Mediterranean geography and mode of life.[4]

To begin this inquiry, it is necessary to take a glance at the influences that created the culture of "provincia nostra" before the Roman military first entered the territory officially in 154 BCE (Polybius 33.8–10; Livy, *Per.* 47).[5] The (Celtic) tribes of the southern French littoral had established trading contact with both the Etruscans and the Carthaginians prior to the seventh century BCE. However, the establishment by the Phocaean Greeks in 600 BCE of Massalia was the most important development in the region prior to Roman entry in 154 BCE. While this Hellenic incursion was not the first contact the indigenous Celtic tribes of the southern French littoral had had with foreigners – local finds of pottery associated with both the Etruscans and the Carthaginians earlier in the seventh century suggest that trade with both those great sea powers was already well established – it was the most important prior to Romanization.[6]

Massalia was clearly intended to be a seaport, and seaborne trade became its principal source of wealth and power. We have little evidence of the Greek city itself. Caesar (*BC* 2.1) describes it as surrounded by water on three sides and thus difficult to besiege; the extent of its walls has been confirmed by excavations in the vicinity of the Bourse, which revealed the foundations of one of its gates, but otherwise the Greek city is known to us only in fragments of topography.[7] Its economic importance is attested in the literary and historical record (see for instance Diodorus' famous remark about the Massiliote wine trade, 5.26.3) and evidence for trade in olive oil, metalwork, pottery (both local and Greek import), tin, iron, grain, and slaves has been cited.[8] What is clear is that Massalia grew rapidly and became a major player in the trading economy of the Mediterranean. The city's growth led inevitably to contact with and expansion among the native peoples of the regions around her; by the fourth century BCE there is fair evidence for a distinctive amalgam of local Celtic-Ligurian and Massaliote Greek cultures in the territory surrounding the lower Rhône River, revealed in particular in remains such as the pre-Roman wall and towers at Nîmes, and by small finds both along the coastline running east from Marseille, and in the interior regions around L'Étang de Berre as well as at remarkable Hellenized Celtic hill forts at St.-Blaise, Entremont, and elsewhere.[9] Subsequent evidence for this interweaving of Hellenic traditions in architecture and urban planning with both native and then Roman elements is apparent in Provence at the city-sanctuary site of Glanum, although the amalgamation came about well after the fourth century BCE. Glanum had been a native shrine and town for centuries before it seems to have been overtaken by Massalia in the second

century BCE, yet it maintained a certain independence although many Hellenic elements were introduced into its architecture and urban form at that time. It was given an extensive Romanization beginning in the time of Augustus, and sorting out the various layers and periods remains a fascinating puzzle, to which we will return.[10]

By 154 BCE, the Massaliotes were unable to control their Ligurian neighbors, whose piratical raids had long made the entire coastline of southeastern France perilous. Massalia had been a constant ally of Rome throughout the Punic Wars, especially during the second when Massaliotes supplied both essential information about Hannibal's movements and naval assistance as needed, so its call for help brought a strong military response. Roman ships had been patrolling the region since 182 BCE (Livy 40.17.8 and 40.18.4–8), but now the Senate sent an army under the consul Q. Opimius that crushed the Ligurian tribes of the Oxii and Deciates, and turned over most of their territory to Massalia.[11] Peace held in the area from 153 to 125 BCE, until the Saluvii attacked Massalia. A consular army commanded by M. Fulvius Flaccus was sent to intervene. Although he would subsequently celebrate a triumph over the Saluvii (among others), Flaccus' victory did not pacify the territory and a second consular army, commanded by C. Sextius Calvinus, had to be sent in 124. Calvinus battled the Vocontii as well as the Saluvii, drove them from the coastline back into the interior, and established a large, permanent garrison at a location he named "Aquae Sextiae" later to be known as "Aquae Sextiae Salluviorum" (Aix-en-Provence). Initially, at least, Aquae Sextiae served to monitor and control developments and movements into and out of the substantial Celto-Ligurian hill fort at Entremont, just north of Aquae Sextiae. This fort (*oppidum*?), though it is not specifically named by any source, is assumed to have been the "city" of the Saluvii. The establishment of Aquae Sextiae gave the Romans their first permanent foothold inside the territory, making this one of the most important moments in the Roman conquest and domination of the *provincia*.[12]

Rome was now deeply involved in southeastern France. When the leaders of the defeated Saluvii fled north and joined the powerful tribe of the Allobroges, another army, commanded by Cn. Domitius Ahenobarbus (cos. 122 BCE), was sent, either in his consular year or the next.[13] The Romans inflicted a significant defeat on the Allobroges at Vindalium (near modern Avignon), but the war continued into the next year, with Q. Fabius Maximus sent from Rome to take over supreme command of the army, while Ahenobarbus stayed on in Provence as proconsul. A second major battle on 8 August 121 BCE (Pliny, *HN* 7.166) took place near the confluence of the Isère and the Rhône rivers (Strabo 4.2.3). Although outnumbered, the Romans were able to drive the Allobroges back across the river, during which one of the two bridges in use collapsed, drowning large numbers of the fugitives (Orosius 5.14), and leading directly to the capture of their chieftain, Bituitus, by Ahenobarbus who sent him to Rome as a traitor

(Valerius Maximus 8.6.3; Livy, *Per.* 61). At some point after the second battle, Ahenobarbus made a tour of (some at least) of Provence riding on an elephant, which caused a good deal of comment (Suetonius, *Nero* 2). Except for the continued garrisoning of Aquae Sextiae, the Romans seem to have turned direct control of the entire area east of the Rhône back over to Massalia. The territory west of the Rhône seems to have caused them far more concern, so much so that Ahenobarbus' next (and final) act in Provence was the construction of a new road: the Via Domitia. This was the first road the Romans built in Gaul; it provided a long route from the Rhône to the Pyrenees following more or less the route of the prehistoric Via Heraclea. Inscribed milestones found along the route show clearly that its real intent was to protect the passage between the Roman territories on the Rhône and Spain, thus making it a fortified boundary (*limes*). A number of towns seem to have begun as forts along this road. This list includes Ugernum (Beaucaire), Nemausus (Nîmes), Narbo Martius (Narbonne) and Tolosa (Toulouse). Narbo was a particularly significant foundation (118 BCE) as it was Rome's first overseas colony peopled by Roman citizens. The construction of roads and colonies marked an expansion and consolidation of Roman power in the region,[14] but total conquest was still years in the future.

Although sources are few and details obscure, sometime around 120 BCE a substantial southward migration of Germanic peoples, known as Cimbri and Teutones in the ancient sources, from northern Europe appears to have begun. By 113 they had reached Noricum, approximately the region of modern Austria and Slovenia, which was a Roman ally. To protect Noricum and to stave off any threat of an invasion of Italy, the Roman Senate sent a consular army under Cn. Papirius Carbo against them. The battle at Noreia in that year was a humiliating defeat for the Romans, who were only saved from annihilation by a thunderstorm (Strabo 5.1.8; Appian, *Celtica* 13; Livy, *Per.* 63). The defeat in 113 opened a period of revolt against Rome in Gaul on both sides of the Alps. By 107 BCE Tolosa fell to native rebels. The city was recaptured by Q. Servilius Caepio in 106, but the overall situation would continue to deteriorate. That same year, a new threat from the Cimbri materialized in eastern Provence. The consul Cn. Mallius Maximus and Q. Servilius Caepio moved to counter them, but when Caepio refused to join or cooperate with Mallius, the Cimbri took advantage of the Roman disarray and attacked the two armies near Arausio (Orange), inflicting the worst defeat a Roman army had sustained since Hannibal's victory at Cannae. The date of the disaster – 6 October – was listed as a *dies ater* (black day) in the Roman calendar ever afterward (Livy, *Per.* 67; Dio 27, fr. 91; Orosius 5.16.1–7; Plutarch, *Sertorius* 3).[15] Had the Germanic tribes chosen this moment to move into eastern Provence, and perhaps even into Italy, the Romans might have been hard-pressed indeed to stop their advance. But they chose instead to turn westward, toward modern Languedoc and southwestern France, seizing land as they went (Livy, *Per.* 67; Appian, *BC* 1.29). In the interim, the Romans

found a new general for Gaul – C. Marius – and gave him a free hand in rebuilding the army and his corps of officers. It was not until 102 BCE that Marius moved against the Germanic tribes. At this time they had moved eastward and threatened to invade Italy. Marius permitted them to march past his camp on the Rhône River, and then followed them to the vicinity of Aquae Sextiae (Aix). A skirmish rapidly escalated into a battle which the Romans won with wholesale slaughter of Germans (Livy, *Per.* 68; Plutarch, *Marius* 21.2; Frontinus, *Strat.* 2.4.6). The battle of Aquae Sextiae reestablished Roman military sway over southern France and confirmed that the territory was gradually becoming a provincial entity within the Roman Empire.[16]

When Gallia Transalpina was formally incorporated as a province is unclear. Names of various officials who might have been governors occur in our sources as early as the mid 90s BCE, but no absolute evidence that they were official governors of an incorporated province survives; they may simply have been in military control of parts of the territory with no civil responsibilities. By the late 70s BCE (most likely 74–72), M. Fonteius had been appointed as governor of "the province," so it is probable that an official and legal organization of the Roman territory had been established by then. Fonteius was accused of enriching himself through the brokering of road-building contracts and charging excess tax on wine imported into Provence from Italy; he was defended on these charges by no less an advocate than Cicero, and was acquitted despite strong evidence of misdoing.

In addition to the fragments of his defense of Fonteius, Cicero has left us some very interesting clues regarding the state of affairs in Provence. He creates an impression of tension between the steady progress of Romanization counterpoised with the need for troops to maintain order throughout the region (Cicero, *Font.* 11.13–14). Cicero's references to various locations (*Font.* 3 [4], 9 [19, 20], 12 [26, 27], 13 [29] 16 [36], 21 [46]) also correspond quite well to the topography of Roman Gallia Transalpina (or Narbonensis) as we know it from later sources.[17] During Fonteius' governorship, the province appears to have come under the influence and (to some extent) control of Gn. Pompeius (Pompey the Great) and his lieutenants, who were deeply involved in their own war against Sertorius in Spain and were demanding support of every kind from the nearest source possible: southern France. This Fonteius was obliged to provide until his departure from the province (probably in 72), which was followed in 71 by Pompey's completion of his Spanish campaigns and return to Rome. Whether Fonteius was a political ally of Pompey's or not, he had no choice but to do Pompey's bidding while he governed Provence.

Between the departures of Fonteius and Pompey and the first year of the governorship of Caesar (58), there is clear evidence of social and political unrest in the province, undoubtedly exacerbated by the political turmoil in Rome, and this is reflected in the convoluted connection between the Allobroges and

Lucius Sergius Catilina in the year of Cicero's consulship (63). Catiline, work-ing through intermediaries, tried to convince two envoys from the Allobroges whom he met in Rome to support him by helping raise a revolt in Gaul. The groundwork for this may have been laid by P. Clodius Pulcher, who had received money from Catiline and gone to Gaul to build support for the revolt. In the event, Catiline's ambassadors failed, and the Allobrogean envoys reported the attempt at subversion and were voted substantial rewards for their virtuous and patriotic behavior (Cicero, *Cat.* III.2 [4–6] and 9 [22]; *Cat.* IV.3 [5]).[18] Despite the positive reputation won by these Allobroges at Rome – indeed Cicero says of them that they were the one tribe in Gaul "*quae bellum populo Romano facere posse et non nolle videatur*" = "which might seem able to make war on the Roman people and does not want to" (*Cat.* III.9.22) – within two years, by 61 BCE, this same tribe had begun a major revolt in the province, the reasons for which are nowhere made clear. A consular army was commissioned by the Senate to suppress the Allobroges. The commanders very effectively devastated the terri-tory of the rebellious tribe and ended the revolt, but they failed to capture its leader, Catugnatus (Cicero, *De Prov. Cons.* 13 [32]; Livy, *Per.* 103; the most com-prehensive ancient account is that of Cassius Dio 37.47–8). This proved to be the last revolt against the Romans in the province prior to Julius Caesar's Gallic campaigns.

During the near-decade of Caesar's governorship of Gaul the people of *provincia nostra* offered apparently unwavering support to the Roman com-mander. Nothing more is heard of the rebel Catugnatus among the Allobroges, nor of any other kind of internal disturbance or resistance. Even in 53–52 BCE, when Caesar faced his most serious challenge from Vercingetorix's huge rebel-lion, the Gallic firebrand never succeeded in gaining support from any of the tribes in the province itself. Indeed he had to send some of his forces to attack the Allobroges, the Helvii, and the Volcae Arcomici, all of whom were actively fighting for Caesar (Caesar, *B Gall.* 7.7 and 64–5; *B Civ.* 3.59).

With the end of the Gallic campaigns, Caesar enjoyed solid support from all parts of "*provincia nostra.*" By the beginning of 49 BCE, as he was contemplat-ing a challenge to Rome itself, Caesar records that he had three legions, under the command of C. Fabius, who had spent their winter "*Narbone circumque ea loca* " = "in Narbo and those areas around" (Caesar, *BC* 1.37). To cover his western flank, and to allow quick access to Italy, Caesar shifted these legions to strategic points, all of which later became important Roman veteran colonies.[19] Although the entire province seems to have been on Caesar's side, his Senate-appointed successor as governor of Gaul, L. Domitius, tried to impede Caesar's invasion of Italy, then attempted to block his consolidation of power among the legions scattered around the Western provinces. Domitius was received by the city of Massalia, put in command of it, and had its gates closed to Caesar (*BC* 1.34–6; Velleius Paterculus 2.50; Cassius Dio 41.19). But the city was isolated,

surrounded on all sides by towns and tribes loyal to Caesar, and clearly Caesar did not think it posed too great a threat. He commissioned the rapid construction of twelve warships at Arelate (Arles) – the earliest appearance of that name for the city in our sources – but then turned the whole affair over to his legates and went to fight in Spain (Caesar, *BC* 1.36; Cassius Dio 41.19). After it fell to him Caesar did not destroy Massalia totally, but he left two legions as garrison, drastically reduced its influence and territory, and turned much of what it had controlled over to Arelate, which was formally founded in 46. With that foundation and the severe reduction of Massalia's power and importance, what would become the Imperial province of Gallia Narbonensis truly began to emerge.[20]

Although Caesar himself never returned to the province, he did control its organization. Ti. Claudius Nero – father of the emperor Tiberius – was dispatched there in 46 with, it would appear, the specific charge to found *coloniae*, or to refound those already in existence giving them new names and more Roman veterans as settlers. Suetonius (*Tiberius* 4.1) specifically cites the addition of army veterans to the Romans already residing at Narbo (Narbonne) and at Arelate (Arles); the result in both instances was a substantial increase in power and influence for those cities at the direct expense of Massalia. A number of other towns may well have become Roman *coloniae* at this time, but it is impossible to be certain, in many cases, whether they were established under Caesar, under the Second Triumvirate, or in the first years of Augustus' sole rule. What is clear is that all were in place by 28 BCE, and the process of organization and Romanization of Narbonensis was being capably and consistently pursued. In addition to Narbo and Arelate, the list of *coloniae* established in Provence almost certainly includes – as *Coloniae Romanae* in addition to Narbo and Arelate – Baeterra (Béziers), Forum Iulii (Fréjus), Arausio (Orange), and perhaps Valentia (Valence); those given the status of *Coloniae Latinae* include Aquae Sextiae (Aix), Apta Iulia (Apt), Avennio (Avignon), Cabellio (Cavaillon), Carcaso (Carcassonne), Carpentorate (Carpentras), Luteva (Lodève), Nemausus (Nîmes), Reiorum (Riez), Ruscino (Chateau Roussillon), Vienna (Vienne), and probably Tolosa (Toulouse).[21]

Augustus (still called Octavian at the time) visited the province briefly in 39 BCE shortly after putting M. Vipsanius Agrippa in control as proconsul of all Gaul (Appian, *BC* 5.75). Some of the new or refounded *coloniae* may well date from that year.[22] Octavian may have returned briefly to Gaul in 34, but there is no evidence that he did anything much in Provence (Cassius Dio 49.38). A far more important Imperial visit, his third, occurred in 27, when – now holding the title Augustus – the *princeps* assumed direct Imperial control of all Gaul, including Narbonensis. During his time there, he was certainly at Narbo and likely visited most of the major new cities in the area; he also reorganized the administration of the three other Gauls and took the first census of them. So well-pacified and Romanized was Provence, however, that in 22 its administration was officially

returned to the Senate (unlike the rest of Gaul, which remained under Augustus' direct control). Agrippa was again sent to Gaul in 20–19 BCE, and a variety of activities in Provence are attributed to him, but only the planning of a main road along the Rhône valley from Lugdunum (Lyon) to Arelate (Arles) can be documented.[23] Augustus came to Gaul for the fourth time between 16 and 13 BCE, when he paid for new walls and gates for both Nemausus (Nîmes) and Vienna (Vienne) and also authorized major road building projects.[24] The *princeps'* possible fifth and last visit to Gaul was in 10 BC, but seems to have had no effect on Narbonensis (Cassius Dio 54.36.3–4). The organization of *provincia nostra* was complete, and the Romacentric perception that it was "more Italy than province" was becoming a convention. The *tropaeum* at the terminus of the Via Julia Augusta seems to celebrate the pacification and Romanization of Provence. Located at the crossing between Italy and Gaul, the *trophée des Alpes* displays a lengthy list of Gallic peoples brought under Roman hegemony, a list organized geographically from east to west.[25] There is nothing subtle about its message, but that message was not yet entirely factual.

There are a few intimations in the ancient sources of disturbances either in Narbonensis itself, or in neighboring Gaul, that suggest some partisan unrest (or at least verbal resistance) from the province. Suetonius (*Tiberius* 13.1) says that the citizens of Nemausus threw down statues of Tiberius while he was in exile, and that at a party someone threatened to go to Rhodes and murder him, a remark made to young Gaius Caesar (who was touring the territory). In 2 CE, Gaius' younger brother Lucius died at Massilia (Cassius Dio 55.10a.9; *CIL* XI.1420), an event that some believe may have been recalled on the dedicatory inscription of the Maison Carrée at Nemausus (though the theory that both these sons of Agrippa were commemorated on the cenotaph at Glanum seems far-fetched).[26] No evidence supports the contention that the citizens of Narbonensis joined in the revolt attempted in 21 CE by Florus and Sacrovir (Tacitus, *Ann.* 3.40–7; Velleius Paterculus 2.129) although it was widespread in other parts of Gaul, nor is it likely that leading men of the province were among the *principes Galliarum* whose property was confiscated by Tiberius (Suetonius, *Tiberius* 49.2). In fact, throughout the Julio-Claudian era, Narbonensis seems to have been quietly prosperous and prosperously quiet, playing little role in Imperial history. The emperor Claudius must have passed through the province in 43 CE, on his way to Britain, since we are told that he set sail from Ostia but was obliged by gale-force winds to disembark at Massilia and take the road up the Rhône valley then on to the English Channel (Suetonius, *Claudius* 42.1–2; Cassius Dio (60.21.3); he was later honored with a statue in the theater at Vasio (Vaison) which has survived.[27]

In the civil war following Nero's suicide, Vienne sided with G. Iulius Vindex, who started a revolt in Gaul. As events developed, the same city recruited legionaries for Galba in support of his attempt to succeed to the purple (Tacitus,

Hist. 1.65); when Galba passed through the province, he was greeted with enthusiasm by some senators at Narbo (Plutarch, *Galba* 11.1). The implication may be that Gallia Narbonensis had suffered from Nero's excesses, presumably both financial and personal, in his later years, and was already in revolt against his principate at the time of his death, although that could be reading too much into the situation; the Narbonese may just have been attempting to avoid being plundered during a period of upheaval. After Galba's death at the beginning of 69 CE it appears that most of the province initially swore loyalty to Vitellius, rather than Otho. This led to armed combat when Fabius Valens, loyal to Otho, defeated Vitellian forces near Forum Iulii (Tacitus, *Hist.* 2.12–14). Later, Valens was captured by Vespasian's supporter Valerius Paulinus, who had also taken Forum Iulii for the Flavian cause (Tacitus, *Hist.* 3.42–4). This seems to have convinced the province to support Vespasian and then remain loyal to him, wisely choosing the winning side.[28]

The accession of Vespasian marks the beginning of a second lengthy period of peace and prosperity in Roman Provence. The first of the cadastral inscriptions (Cadaster A), detailing land boundaries and small holdings in and around Arausio, is securely dated to Vespasian's principate, and attests the strength of government organization and of agriculture there, as does the failure of Domitian's attempts to restrict the cultivation of vines in the province (Suetonius, *Domitian* 7.2, 14.2).[29] Despite Domitian's unpopularity in much of the rest of the Roman world, which is brutally attested by the *damnatio memoriae* inflicted on so many of his statues and inscriptions, a portrait statue of him that once stood in the theater at Vaison-la-Romaine was apparently intentionally buried there together with figures of Claudius, Hadrian, and Sabina, and survives today in the site museum.[30] Through the first century CE, we have the names of at least twelve Narbonese senators who rose to the consulate and whose origins can be traced to Vienna, Nemausus, Arelate, and Forum Iulii, the last of these being the renowned Gn. Julius Agricola, father-in-law of the historian Tacitus, the longest-serving governor (ca. 77–83 CE) of Roman Britannia, a significant figure in the Flavian civil administration and the Roman military. The prosperity of Gallia Narbonensis seems to have increased rapidly throughout the mid-first century CE and to have survived the damage suffered during 68–69 CE. Eight cities of the province were called "*urbes opulentissimae*" by Pomponius Mela (who wrote ca. 40 CE), a characterization supported after the civil strife by the elder Pliny's later remark (discussed above); Pliny also points especially to the province's wheat, several wines, wool, and fish, products also praised by other first century CE authors.[31]

In the second century CE, the connection between the aristocrats of Provence and the center of power in Rome became stronger as the wealth of the province burgeoned. Trajan himself seems to have had little enough concern with the area, though the creation of Cadaster B at Arausio attests to continuing careful

administration, as does the probable establishment of the aqueduct at Arelate and the first version of the immense water mill on its course at Barbégal; in addition, there is a possibility that he was responsible for the creation or reworking of the arch at Arausio. Far more important is the fact that Trajan, the first non-Italian-born Roman to become Emperor, was married to a daughter of the Narbonese provincial aristocracy: his wife, Plotina, appears to have come from Nemausus. After her death, Hadrian, Trajan's successor, erected a building in Nemausus in her memory and changed the official name of Avennio (Avignon) to *Colonia Iulia Hadriana*.[32] During an Imperial visit Hadrian also built a memorial to his horse, Borysthenes, when it died near Apta Julia (Apt). In addition to all the memorials, elegant statues of Hadrian (shown in heroic nudity) and his empress Sabina (fully clothed) were discovered buried in the theater at Vasio (Vaison-la-Romaine).[33] The apogee of this Provençal connection with Rome itself came with the accession (in 138 CE) of Antoninus Pius, who was the direct descendant of a family from Nemausus: his grandfather, T. Aurelius Fulvius, suffect consul in 70 CE and regular consul in 85, was born there. While Antoninus did not, insofar as we know, go to Provence himself during his principate, he made generous contributions to the Narbonese cities. He financed major restorations at Narbo after a devastating fire which very possibly resulted in the capital of the province being moved from there to Nemausus; apparently he also paid for substantial improvements to all the major roads in the province to expedite communication, as attested by a number of milestones.[34] Antoninus' successor, Marcus Aurelius, also appears to have been popular in the province, though the reasons for this are unclear.

Narbonensis barely avoided being swept up in the struggle among would-be emperors after the death of Commodus in 192 CE. The eventual victor, Septimius Severus, defeated the last of his rivals, Clodius Albinus, near Lugdunum (Lyon) – just beyond the northern border of the province – in 197 CE. Septimius' son and successor, Caracalla, cut a vengeful swath through the province at the beginning of his reign (late 211 or early 212 CE),[35] but was voted honors in both Narbo and Vienna. Caracalla's *constitutio Antoniniana* of 212 granted Roman citizenship to all free people of the Empire, including those in Gallia Narbonensis, thereby increasing their taxes, but what other effects it had are not clear.[36] After the end of the Severan dynasty in 235 CE, Provence must have suffered from the general instability of provincial and military administration that affected the entire Roman world: Aurelian may have tried to reinforce the territory's defenses since he is regularly called *Restitutor Galliarum* on milestones found in the province. The *Historia Augusta* biography of Probus claims, somewhat improbably, that he restored sixty notable cities in Gaul, including a number in Provence, after major barbarian incursions during the 270s CE. There is archaeological evidence of serious disturbances here at that time: the Maison des Dauphins at Vasio (Vaison) was burned during these decades and, even more startling, the

entire town of Glanum (St.-Rémy-de-Provence) was abandoned for no immediately obvious reason. But we receive frustratingly few details as the Western Empire reeled dangerously close to collapse in the third century CE.[37]

The near-collapse of Roman administrative and military authority was brought to an end when Diocletian became emperor in 284 CE. His division of Imperial power into realms of responsibility meant that one of the four Tetrarchs supervised all of Gaul, including Provence, as well as Germany, Britain, and Spain. The old large provinces were subdivided in *dioceses*; Narbonensis, together with Aquitania to the west and Alpes Maritimae to the east, was incorporated into the *diocesis Viennensis,* named for its capital city, Vienna (Vienne). The *diocesis Viennensis* was further subdivided, according to a list preserved under the title *Notitia Galliarum,* into seven smaller administrative "provinces" (*provinciae*); the cities and territory that had made up Gallia Narbonensis were administered as three separate units.[38] Supervisory authority resided at the Imperial city of Augusta Treverorum (Trier) in Germany. Military and civil administration for the *dioceses* was established at Vienne, which caused a substantial expansion and rebuilding of the city. By the early decades of the fourth century CE, however, Arelate (Arles) had become the most important city of the now Christianized territory with its own influential bishopric. Arles was the seat of the important ecclesiastical Council of 314 CE. Constantine also gave the city an impressive bathing complex. Later in the century the Imperial mint was transferred to Arles when Trier became too difficult and dangerous to maintain as Imperial capital, clearly making it the most important city of the former "provincia nostra" during later antiquity. This shift culminated ca. 395 CE with the movement of the entire military and administrative apparatus of the western Empire to Arles, making it in fact the capital. Another important ecclesiastical Council was held in the province, this time at Nîmes, in either 394 or 396, and much of the attention of the Church was focused on the province for a short while. But the external threat that had long hovered over the western Empire, and had mandated the abandonment of Trier as a capital, could not be withstood for long.[39]

The general Stilicho was campaigning with some success against both the Visigoths and the Ostrogoths in the east as the fifth century CE opened. Desperately in need of reinforcements, he withdrew troops from all over Gaul (as well as from Britain), leaving the garrisons of the entire western Empire all but empty. The result was predictable: on the last day of 406 CE, the river Rhine (which, according to legend, was frozen solid) was crossed by huge numbers of Alans, Suevians, and Vandals, who proceeded to ravage much of Gaul. How far they entered Narbonensis is unclear (their main targets seem to have been central and western France); but Tolosa (Toulouse) at least was attacked, and St. Jerome lists Narbonensis as one of the areas plundered, although the archaeological record does not seem to support this. Constantine III brought a few troops that had remained in Britain to the province and set himself up

at Arles as a self-appointed defender of the West. There was internal opposition, but the legions still in Gaul supported Constantine III, and the threat was a real one, since as early as 408 an army led by a Goth named Sarus tried (and failed) to dislodge him from Arles. As Constantine III and his son Constans gathered power and influence, they became increasingly worrisome to the Emperor Honorius (in Italy), and in 410 an army commanded by Constantius (successor to Stilicho) and Ulfila besieged Arles for three months. Constantine III was defeated and deported to Italy, where Honorius had him killed. From there, the situation in Provence only became more complicated. Athaulf, the new leader of the Visigoths, led them into southern Gaul in 412, bringing with him Gallia Placidia, the sister of Honorius, whom he kept as a hostage. Athaulf failed in an attack on Massalia, but captured both Narbo and Tolosa, and finally married Gallia Placidia at Narbo in 414, only to be killed in Spain the following year. In 418, Honorius decreed an annual meeting of provincial governors and leaders to take place every year at Arles, which further emphasized the importance of the city, but that very visibility also increased its risk: it was besieged by Theoderic and his Goths in 427 and again in 436. Constant instability throughout the western Empire was sapping its ability to survive, and Arles seems to have been a focal point of frequent attacks and upheavals. By 475 CE, the Visigothic king Euric held all of the province west of the Rhône as well as Marseille and Arles (and hence the coastline also). The Emperor at Constantinople, Zeno, acknowledged reality and ceded all of the remainder of the province to him. Roman Gallia Narbonensis – as an administrative, political, or military unit – ceased to exist.[40] Archaeological evidence indicates a decline in population, both urban and rural, in Provence throughout the fifth century CE, in contrast to its strength (relative to other provinces of the Empire) during the fourth. The post-Roman and post-classical period had begun, and Provence had entered a new era in its long and eventful history.

The remarkable history of Provence after the fourth century CE is not a direct concern of this investigation; indeed it need be mentioned only when it had a direct influence on the survival of sites and buildings from earlier times. In essence, for more than a millennium after the reign of Euric, Provence itself struggled to survive and its ancient monuments provided little more than a convenient source of pre-cut building stone and other materials. Curiosity about the Roman remains seems to begin only after the fifteenth century CE and even then the record of what happened to individual monuments is spotty at best, as Küpper-Böhm has so convincingly demonstrated for the free-standing Roman arches of the province.[41] Only in the 1700s do antiquarians begin investigating the possible meanings and attempting to reconstruct the texts of Latin inscriptions in the territory, and it is not until the nineteenth century that interventions on the more substantial ancient remains (e.g., the arch at Orange or the cenotaph of the Iulii at St. Rémy) are undertaken. Inevitably, then, much valuable

archaeological and stratigraphical information was irretrievably lost during that long period of neglect, and in some cases late interventions only made matters worse, although in many instances we undoubtedly owe the very survival of ancient Roman remains in Provence to those same early salvaging efforts. Substantial archaeological investigation of and the appearance of a scholarly bibliography on Roman Provence is a phenomenon of the twentieth century CE, especially the second half of it, and has produced an essential *corpus* of investigations, often under the sponsorship of the Centre National pour la Recherches Scientifiques, to which all who share an interest in these fascinating monuments are deeply indebted.

One premise of the scholarly approach to the Roman remains of Provence throughout the last century has been to assume, sometimes on grounds difficult to understand, that almost all remains of Roman architecture in Provence must date from the period of the foundation of the important Roman cities of the province, which can generally be placed in the second half of the first century BCE during the era of Julius and Augustus Caesar. While this assumption makes a certain logical sense, it has not been unarguably demonstrated to be true, and even more important, the possibility – indeed likelihood – of subsequent revision, reconstruction, and restoration of ancient buildings during antiquity has been all but totally ignored. A major thrust of this study is to suggest that a broader, more inclusive, view of the architectural history of Roman Provence is needed, and to point out where such a broader perspective on the architectural history of the Roman period will enrich and nuance our overall view.

It is also inevitable, given the nature of the material remaining, that this study must focus, in large part, on those monuments best known and best documented. Hence such items as the "Maison Carrée" temple at Nîmes, the free-standing arch at Orange, "Les Antiques" (free-standing arch and cenotaph) at St.-Rémy-de-Provence, the theaters at Orange and at Arles, and the amphitheaters of Arles and Nîmes will receive more attention than some less studied and hence less well-known Roman monuments in Provence. As archaeological investigation and architectural studies of other Romano-Provençal remains continue, it can only be hoped that an ever broader viewpoint may be adopted. This study attempts to do what it can at the present time, and with luck may suggest future directions for study and analysis of these fascinating remains.

@@ @@ @@ @@

TWO

THE CITIES, SUBURBS, AND
TOWNS OF ROMAN PROVENCE

URBANISM AND URBANIZATION

INTRODUCTION

The number of ancient Roman city and town street plans in Gallia Narbonensis
that can be partially or largely reconstructed (see Fig. 2) constitutes one of the most
important repositories of information on the nature of Roman urban planning and
how architecture was accommodated within the planned spaces of ancient Roman
urban environments. An overview of the best-known Roman cities and towns in
Provence will provide the urban context in which most civic and religious archi-
tecture was conceived, while a look at the peripheries of these same urban areas
may complement this survey of how Roman architecture created a truly Romano-
Provençal physical environment within which "provincia nostra" developed into
a distinctive region of the Empire. The attempt to understand Roman remains
within their urban context is a growing area of study in Roman architectural his-
tory and archaeology, one which promises new insights into how Roman builders
and planners employed space and how the needs of urban and suburban popu-
laces were accommodated in the ancient city's physical context.[1]

Our most important ancient guide to the planning and layout of Roman cit-
ies is Vitruvius. In the first book of his *de Architectura,* Vitruvius describes the
basic processes of site selection, zoning, and layout of orthogonal gridded street
plans. His theoretical information for the "correct" town plan is reflected in
the archaeological record all over the Roman world. He discusses the selection
of sites for towns on the bases of healthfulness, augural ritual, and possibility
of fortification (I.4), then proceeds directly to a description of how to lay out
and erect a town's walls in the best possible manner (I.5), then gives a lengthy
discussion of how the area and streets within the walls should be divided and
made most habitable (I.6). His treatment of the principles of town planning ends

with a description of how the sites for public buildings should be selected, and how certain areas should be reserved for the forum and for religious foundations – in short, the zoning of the urban area (I.7). From that point on, through much of the *de Architectura's* first five books (which are the half of the work concerned with towns and with urban buildings), Vitruvius describes, partially in theoretical terms and partially through examples, how a Roman urban environment was put together. His discussion shows us how a Roman architect and builder thought urban environments should be designed, and what human needs they had to fulfill. Hence Vitruvius is a uniquely valuable guide to show us the Roman vision of a city or town and its architecture, in Gallia Narbonensis or anywhere else the Romans created urban environments.

Vitruvius (I.7.1) makes clear the centrality of the open area that constituted the forum of any town laid out on the essentially orthogonal grid system of larger and smaller streets that the Romans employed over and over again when designing new cities:

> Divisis angiportis et plateis constitutis, arearum electio ad opportunitatem et usum communem civitatis est explicanda aedibus sacris, foro, reliquisque locis communibus.

> When smaller streets have been laid out and main streets settled, the selection of sites for the convenience and common usage of the citizenry must be made clear for sacred buildings, the forum, and other common places.

It is interesting that Vitruvius does not say that the forum has to be in the geometrical center of such a grid of streets. A survey of Roman towns underscores the system's flexibility, accommodating innumerable geographic and topographic variations. Gallia Narbonensis illustrates many of the problems encountered by Roman town builders and how they could be overcome through the methods summarized by Vitruvius: their grids were able to accommodate steep slopes and ridges rising from relatively flat plains (e.g., Nîmes, Orange); interruptions by the river Rhône (Arles, Vienne) and lesser streams; and the need for port facilities, either on the coast or on river banks (Fréjus, again Arles). They could also be fitted into areas surrounded on all sides by mountains (Aix-en-Provence, Vaison-la-Romaine). In short, almost every kind of terrain could be dealt with by the Roman system of town layout, insofar as the ancient street patterns known to us reveal them.[2]

As the cities and larger towns of Roman Provence grew, the rationality of their street plans within their walls or pomoeria appears to have led to, or at least permitted, the growth of peripheral "suburbs," often residential or industrial in nature, which served and communicated directly with the urban center. Such peri-urban quarters are particularly well attested and have been subjects of close study in recent years.[3] At Vienne in particular[4] and elsewhere, the ancient suburbs represent a successful development stemming from but expanding the application

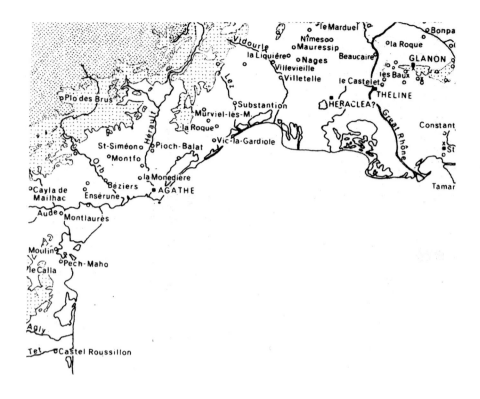

3 Map of Greek colonization and native settlements in ancient Provence (after Rivet 1988: fig. 3, p. 14).

of Roman planned layout beyond the urban centers of Gallia Narbonensis. The development of functional, convenient peri-urban quarters around the larger Roman cities attests that their orthogonal system was practical yet inventive, testimony to a conceptual and geometrical ability to cope with potential difficulties and allow for future development which reveals creative engineering in much the same manner that Roman architecture, especially after the introduction of concrete (probably in the second century BCE), demonstrates such creativity.[5] It is not a cliché to assert that one of the Romans' most innovative geniuses was for building, in the broadest sense, a sense which includes anticipatory planning. Evidence of this genius is apparent everywhere in Roman Provence.

THE EARLY URBANIZATION OF SOUTHERN GAUL: INDIGENOUS AND GREEK ANTECEDENTS

Celtic and Native Hill Forts (*Oppida*)

The transition from the Neolithic era to the Iron Age occurred in southern France during the seventh century BCE as elements of Hallstatt culture appeared in the

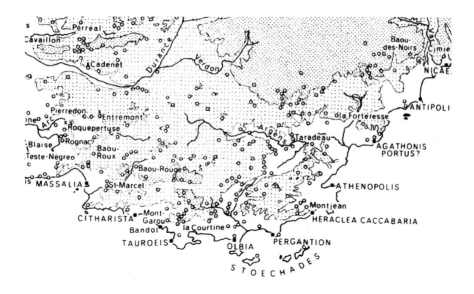

3 (Continued)

region. During the third century BCE, a culture sometimes described as "Celtic" and more precisely as "La Tène" seems to migrate into the area, bringing with them a more advanced material culture. One element of the Iron Age in southern France is the fortification of prominent hilltops, from which the surrounding territory could be controlled, and which could serve as places of refuge in times of crisis. Over time many of these strategic points seem to have developed into continuously inhabited fortified towns. The Latin term *oppidum* (plural, *oppida*) is used by Julius Caesar *(B Gall.* 5.21.3*)* to describe sites such as these, although the word originally meant only an urban nucleus as opposed to a village (*pagus*). In subsequent Roman times, the word referred to communities of Roman citizens living in the provinces, not to native hilltop settlements.[6] Hill-fort towns spread across southern France (see Fig. 3): the best-known include Entremont above Aix-en-Provence, Ensérune near Béziers, St.-Blaise above the Étang de Berre and the Crau plain, Constantine east of St. Chamas, Murcens east of Cahors in the Midi-Pyrénées, Nages-et-Solorgues west of Nîmes, and Taradeau in the Var.[7] Such hill-fort towns had become characteristic of the region by the time Roman contact became extensive in the second half of the second century BCE. The defensive and warlike appearance of these centers is apparent from archaeological plans and aerial photographs of them; especially striking is the manner

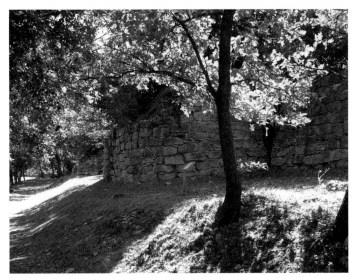

4 Section of the surviving defensive wall at Entremont, near Aix-en-Provence (photo by the author).

in which the defensive circuit of Entremont (Fig. 4) or of St.-Blaise reveals an absolute determination to take advantage of the natural escarpments and incorporate them into the walls, even when this must have made tremendous difficulties for those intending to build habitations within them. While what survives, especially at Entremont, is almost certainly from the second and early first centuries BCE – well after Roman contact – the indigenous nature of the layout and planning of the *oppidum* makes its attempt to include elements of an orthogonal or gridded pattern of streets and intersections look at times random and haphazard, as opposed to the clear dominance of the defensive circuit in every element of the architecture and planning of the town. This probably reflects the appeal of the orthogonal grid pattern for street layout, even when it was difficult to reconcile with the defensive foundations already in place in many Gallic *oppida*.

Massalia and Greek Colonial Foundations

There must have been a sharp visible distinction between native hill-forts and the Greek city and towns which otherwise dominated the human geography of southern France until the Roman conquest. Greek settlement was centered on the city and port of Massalia (Marseille) and its own colonial foundations along the coast at modern Agde, Antibes, Hyères (ancient Olbia), and Nice. While primarily cleaving to the coast, Greek settlement did extend inland at Theline (Arles). Glanum (St. Rémy-de-Provence) seems to have played a unique mediating role between the native peoples of the area and the Greek settlers. The site was a healing shrine or sanctuary that appears to have had direct connections with both the native and Greek populations throughout the pre-Roman era.[8] When Massalia was founded

ca. 600 BCE, it marked the arrival on a remote, but strategically important, stretch of the northern Mediterranean coast of an already established tradition of colonial foundation and town planning. Greek cities and towns had been establishing colonies since the archaic period: Smyrna, Phocaea, and Miletus were founded on the coast of Asia Minor as early as the seventh century BCE. In southern Italy, Greek colonies were established during the seventh and sixth centuries BCE at Tarentum (possibly seventh century BCE), Poseidonia/Paestum (late sixth century BCE), Croton (ca. 710 BCE), Locri (late seventh century BCE), and Metapontum (remarkably similar in layout to Paestum so probably contemporary). Perhaps equally or even more influential on Massalia and on southern France in general was the foundation of Greek colonies in Sicily: Syracuse and its nearby colonies Akrai and Heloros (possibly as early as the eighth century BCE), Megara Hyblaea (also possibly at the end of the eighth century), Selinus (from the seventh century until its destruction in 409 BCE), and finally Akragas (founded 580 BCE).[9]

Marseille's history of continuous occupation and its cycles of construction and growth, decline, decay, and reconstruction do not permit a comprehensive plan of the original city to emerge. The initial Phocaean colony appears to have stretched along the north side of the great protected inlet the Vieux Port, known to the Greeks as Lakydon. It probably featured docking facilities on the shore and rows of houses and other buildings running parallel to the beach. As the colony's importance within the trade routes of the western Mediterranean increased, the town grew to cover most, perhaps all, of the peninsula to the north of the harbor (Fig. 5), incorporating three high hills (les Buttes Saint-Laurent, des Moulins, and des Carmes) that run from west to east heading inland; it did not, however, extend as far eastward as the fourth and highest of these hills (la Butte St. Charles). The first defensive walls – presumably contemporary with the foundation of the colony – are conjectured to have run northward from the horn of the harbor, without actually including it within the city. It then seems to have curved westward to enclose the city's territory on the east and north all the way to the coast. Some scholars speculate that the hill of Les Carmes was outside the earliest wall circuit, but it appears to have been incorporated inside them by the fourth century BCE at the latest.[10] Terracing from the earliest centuries of settlement in Massalia has been found, along with retaining walls, on the Butte Saint-Laurent, which indicate early reworking of the physical topography of the site to accommodate some sort of regular street plan, but the evidence for this earliest period goes no further. A more extensive urban street pattern datable to the later fourth century BCE can be discerned to have spread eastward, leaving traces northwest of the Butte des Moulins. This development seems to have extended eastward until, by the middle of the second century BCE, the city covered the Butte des Carmes. Traces of both a main northeast–southwest thoroughfare, found beneath the modern Rue de La Caisserie and la Grand-Rue, and of a north–south intersecting avenue, found near the cathedral, have been

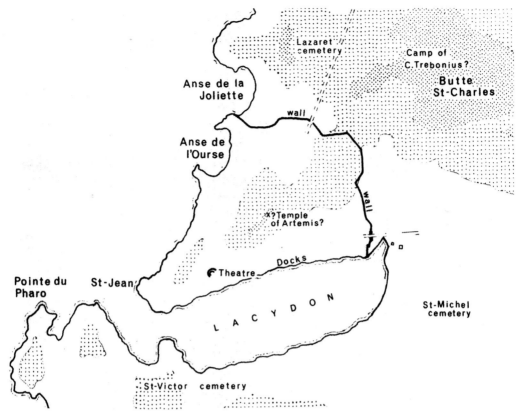

5 Hypothetical plan of ancient Marseille (Massalia/Massilia) (after Rivet 1988: fig. 28, p. 221).

located, as has the probable position of the Greek *agora,* near Place Lenche. Little is known of the architecture of Massalia: traces of a theater just east of la Butte St.-Laurent and of a possible *stadium* to the northwest of the agora have been reported, but the remains are extremely meager. La Butte des Moulins is often assumed to be the site of Massalia's acropolis, due to its height and prominence in the city's physical topography.[11]

Perhaps most interesting in the context of Greek colonization of the western Mediterranean, the subsequent Roman urbanization of ancient Provence and what, if any, influence the design of Greek Massalia may have exercised on it, is the increasingly common assumption that the first street plan of Massalia already employed a gridded pattern of streets intersecting at right angles, and possibly organized into zones or blocks: an orthogonal or "Hippodamian" town plan.[12] Whatever system or refinements Hippodamus created – possibly the division of the population into classes and the city into zones[13] – the basic concept of a gridded pattern of streets arranged in an orthogonal manner for convenience of access and communication between the parts of an inhabited area clearly existed and had been used in practice well before the middle of the fifth century

BCE. The essentials of it can be seen in a number of earlier Greek colonies: Tarentum, possibly; Megara Hyblaea, probably; Poseidonia/Paestum, probably; Metapontum, certainly. This points to the likely conclusion that application of the orthogonal system of street layout to the site of Massalia ca. 600 BCE is both reasonable and possible, which confirms the most recent conclusions drawn from the archaeological record of the early town.[14]

While the physical evidence for Massalia's orthogonal street plan is meager, what exists corroborates and explains some of the ancient literary testimonia. Strabo (*Geog.* 4.1.4) lists temples to Delphic Apollo and Ephesian Artemis on the Massalian acropolis, neither of which is surprising in choice of deity or aspect.[15] A potters' quarter in Massalia has been found on the Butte des Carmes dating back to the foundation of the city. These elements sound remarkably like the reserved areas, or zones, often thought to have been typical of Hippodamian planning. Vitruvius (2.1.5), who may have seen Massalia in 49 BCE while serving as a military engineer during Julius Caesar's siege of the city, mentions houses with thatched roofs spreading around the various heights of the city. This may imply that a regular street plan had been in place for many years.[16] Beyond these small indicators, we cannot securely restore the layout or architectural features of Greek Massalia inside its defensive walls. Those walls appear to have been in place early on and repaired or rebuilt in rose-colored granite in the course of the second century BCE, perhaps between 180 and 150. These were partially dismantled after Caesar's reduction of the city in 49, and restored in the reign of Nero.[17] The only more detailed chronology for Greek Massalia permitted by archaeological excavations must be drawn from the excavations carried out at the horn of the harbor, in the La Bourse site. The area formed a quay at the innermost point of the harbor and appears to have been in almost continuous use. The dating sequence recovered from these excavations can be added to the archaic history of the Greek city to provide the following overall acceptable chronology:[18]

1. 600–580 BCE: Foundation, settlement extends from St.-Laurent to Place Viaux. Axial orientation established, building in stone, wood, and mud-brick.
2. 580–540: Archaic city expands northwest to area of Cathedral de la Major.
3. 540–520: Street plan revised and realigned; beginning of Massaliot wine amphora manufacturing industry.
4. 520–480: Late archaic city expands to cover length of north coastline of harbor. First traces of construction on Bourse site.
5. 480–320: Classical city, as in most ancient literary descriptions.
6. 320–49: Hellenistic city and its development, especially ca. 175–140, the urban elaboration of the Butte des Carmes' western slope.
7. After 49: Severely damaged in Caesarean siege, then slow regrowth under the early Roman Empire.

The Roman centuries of Massilia (spelled Massilia, from the Latin *Civitas Massiliensium*) are also poorly attested. The walls were probably rebuilt under Nero, and the old theater was rebuilt in stone in the mid-first century CE, possibly under Claudius. The port facilities reveal extensive reconstruction and reworking throughout the Roman period, even though Massilia's importance to seaborne trade waned as Arles (Arelate), Narbonne (Narbo Martius), and Fréjus (Forum Iulii) increased in importance. Little else has been discovered.[19] By the late first century CE, the city seems to have gained a reputation as a sort of refined but secondary college town where noble young Romans might be sent to complete their educations, as was the case with Gn. Julius Agricola, later the Flavian governor of Aquitania and then Britannia, and father-in-law of the historian Tacitus (*Agr.* 4.2). It seems to have remained a cultured backwater throughout the rest of antiquity.

The names of Greek towns along the coast in the region of Massalia are known primarily from the Antonine Itinerary of 150 CE. These place names include Charsis (Cassis), Citharista (La Ciotat), Tauroentum, Portus Aemines, Alonis (modern locations disputed or unknown), Pergantion, Heraclea Caccabaria (also disputable), Athenopolis (St.-Tropez), Agde (Agay), Aigitna (possibly Cannes but very uncertain), Antipolis (Antibes), Nikaia (Nice), and maybe Heracleia Monoikeia (Monaco), from the aspect of Heracles "Monoikos" worshipped there. In every case these towns are little more than names to us with no archaeological or inscriptional evidence to reinforce identification or even their precise location. The only Massaliot colonial foundation along the Côte d'Azur of which physical traces survive is Olbia (Pomponiana?). The site is located between Toulon and Hyères (see Fig. 3) and was excavated in 1947–50 and 1956–73. Olbia is flat, and the overall layout of the town recalls that of Poseidonia/Paestum. It appears to have been founded ca. 350 BCE as an outpost for coastal control and shipping security. The presence of a rigorously "Hippodamian" orthogonal plan is not surprising, as it was founded well into the classical period. A Roman level is superimposed on the site, and is striking in its similarity to the Greek system underneath it; clearly the Roman system could adapt and adopt Greek orthogonal elements with very little difficulty. Little else can be deduced from the remains, although popular speculation would credit the Romanization of Olbia to the same period as that of Massalia, after 49 BCE.[20] What this meager evidence does imply is the effort that was put into colonization from Massalia and the extent to which Massalia dominated and controlled the coastline of Provence, both at sea and on land, at least until the later second century BCE. During the early part of the Roman era the Massaliote colonies of Antibes, Nice, and Olbia continued to serve as small ports, though for the most part they were rendered unimportant once Fréjus (Forum Iulii) was established as the main Roman port facility on the Côte d'Azur in the 40s BCE.[21]

Greek Influence in the Interior of Provence

Theline (Arelate/Arles) and Other Subsequently Roman Towns

Control of the interior of Provence seems to have been less important to the Massaliotes than control of the coast. However, Massaliote domination of the site of Theline (Arelate/Arles) as an emporium or trading center seems highly probable. Avienus (*Ora Maritima*, 689–91) a mid-fourth century CE writer who drew from sources that included the fifth century BCE explorer Pytheas of Massalia, says that Arles was first established and inhabited by Greeks, and called Theline. This has been confirmed by finds of Greek pottery, and by fragments of a pre-Roman building apparently in use from the sixth to the second centuries BCE. It is now generally assumed that Theline was founded by, or certainly dominated by, Massalia in its early centuries, but nothing further is known and our sources are silent until Caesar first mentions the town by its Roman name of Arelate (*B Civ.* 1.36.11.5).[22]

Beyond Theline, Greek Hellenistic remains have been identified in Provence at and below the hill-fort site of St. Blaise (possibly ancient Mastromela or Mastrabala), at Lattes (ancient Lattera) south of Montpellier, and at Agde. St.-Blaise was originally a native foundation, probably predating Massalia. The Greek materials, probably from Massalia, imply domination only at a later period, certainly after 520 BCE; the architectural fragments are two to three centuries later than that. Lattes appears to have been a trading outpost of Massalia from ca. 500 BCE. At Agde the excavated remains of circuit walls date from the second century BCE but are built upon foundations of fourth to third century construction. All three towns attest to the expansion of Massalia's power in the area from the late 500s BCE until the coming of the Romans. Late antique sources, such as Stephanos of Byzantium who apparently used earlier itineraries, ascribe Greek names to the Roman towns of Avennio (modern Avignon/Greek Aouenion) and Cabellio (modern Cavaillon/Greek Cavares), but there is no archaeological evidence of Greek settlement at either, so these Greek names may simply have been in addition to whatever local names the settlements possessed.[23]

Glanon (Pre-Roman Glanum/St.-Rémy-de-Provence)

In a gorge to the north of the jagged hills of Les Alpilles,1 kilometer south of St.-Rémy-de-Provence, lie the remains of Glanon.[24] (see Fig. 2). We know very little about its early history and development. The geographer Ptolemy identified it as a "Salyen" village, that is, a settlement of the Celto-Ligurians who inhabited what is now Provence during the late Iron Age and were responsible for founding many of the most important hill-fort towns including Entremont, which, according to Posidonius, served as their capital. Scattered finds indicate activity at the site as early as the seventh and sixth centuries BCE: this includes

remains of a few Iron Age huts, battered steps on the southwest side of the site leading to a cave sacred to the local god Glan, various finds of imported pottery from Etruria and Greece, and pottery and coins from Massalia, all from the sixth century. These fragments of evidence seem to indicate that the Celto-Ligurians would organize for mutual defense, but there is little to indicate any substantial amount of settlement or development before the second century, as the Romans took over the territory. What the pottery and coins do reasonably establish is that the indigenous settlers at Glanon were in contact with Etruscan traders, with Massalia, and with other Massaliote-founded towns, as well as with their own cultural colleagues throughout the area well before there is any convincing evidence for extensive urban development around the sanctuary site.[25] The lack of evidence at the sanctuary of Glan for urban development, for habitation, and for defense prior to the second century BCE may suggest that the true town site of Glanon remains to be uncovered. It could be located underneath modern St.-Rémy-de-Provence or in another more readily defensible location nearby, perhaps higher in Les Alpilles where it could have taken advantage of the terrain for defense, as did Entremont and other Celto-Ligurian *oppida*. The minimal remains of Celto-Greek Glanon do not support the current assumption that the early town was a commercial and agricultural center. The early phase of Glanon can best be understood as a minor dependency of an important religious site.[26]

The Roman presence in Provence begins in the last years of the third century BCE[27] and increases to the point of permanence after the Massaliote/Roman alliances in 154 and 125 BCE. At Glanon (or Glanum, as it will come to be known to its Latin-speaking residents) beginning in the second century BCE, Glan's sacred precinct, perhaps for the first time, is monumentalized, with a temple, a rectangular building of unknown purpose surrounded by a peristyle of columns, and a portico that covered a well (Fig. 6). Little remains of the temple: it was small, featured a square cella reached by two lateral staircases, and stood on a platform with six columns across the front. The remaining bases and entablature indicate the columns were Tuscan. The details of carving, especially on the cornice blocks, can be dated to the second century BCE and are similar to carvings on temples from central Italy, especially Molise. If the dating is correct, this temple would be the earliest example of specifically Roman architectural design and decorative principles at Glanum and, by extension, in ancient Provence.[28] The temple and the other buildings erected at Glanum in the first half of the second century BCE suffered extensive damage at some time later in the same century, the reason(s) for which have yet to be explained. During the last quarter of the second century BCE, fifty to seventy-five years after the buildings were destroyed, the center of Glanum was rebuilt.

This second period of construction – after the extensive destruction of the town, possibly due to hostile attack, in the middle of the second century BCE – included the reconstruction of the temple, the rectangular building, and the

6 Hypothetical plan of ancient Glanum (after Rivet 1988: fig. 24, p. 199).

portico at the shrine. A wall in ashlar masonry was constructed around it. Some identify this wall as the earliest evidence for the fortification of the site, but until further stretches of this early wall come to light, it hardly seems to be an adequate defensive response to the annihilation the town had suffered just before.[29] Further architectural development of the town center has left only meager traces, but appears to have included two small buildings that may have housed seated warrior sculptures and a portico with a basin, and a recess that contained a bench. During this period a hypaethral assembly hall, often identified as a *bouleuterion*, was built. Some of the seating arrangements around a central altar can still be seen. An adjacent building, contemporary with the "bouleuterion," is hypothetically identified as a treasury, although no direct evidence supports this identification. The rectangular courtyard structure of the earlier period was replaced by a larger trapezoidal open area that was surrounded on all four sides by porticoes: the overall effect was of something very like a Roman-style *porticus* (Fig. 7). The column capitals of this complex imply an intriguing syncretism of Greco-Roman deities (Dionysus), figures from myth (Cyclops), Celtic heroes (wearing torques), unknown female figures, and what might even be Roman-type allegorical figures (Africa). Whatever the nature of the cult or cults being commemorated, these capitals suggest strongly that the cult site at Glanum was being influenced by the gods and myths of the conquering Romans. Identification of this building has been much disputed, some calling it a *prytaneum*, but others questioning whether the fragmentary evidence is sufficient to assume a religious function. An attractive alternative identification proposes a dual function for the complex, both as a market building, almost a Roman-type *macellum*, and a sanctuary to the hero Heracles/Hercules. This identification does assume extensive Romanization of the cults and religious center of Glanum by the late second century BCE. The religious elements of its sculptural decoration seem suggestive of some sort of cultic function, if not definitive for a specific identification; the "Romanness" of the building is reinforced by the discovery of Latin letters and numbers engraved on some architectural elements of the building, fragments of a terracotta frieze, and a mosaic floor in *opus signinum*. Whatever its specific identification, the building's remains do suggest influence from Roman and Italic methods of construction and design, as well as elements of Roman cult influence.[30] "Greek Hellenistic"-style houses, best known from remains on the island of Delos, appear in the residential area of Glanum north of the center, and a number of inscriptions in Greek have come to light, suggesting a continuing Greek element in the population of the town, but all of these items are compatible with the possibility that a number of Romans had already come to live in Glanum and were responsible for at least some of its rebuilding, which helps to explain the apparent mixing of house styles and languages in the same place and time. Some fascinating evidence for Roman habitation at Glanum during this era and its cultural complexity is a votive altar

7 Plan of the second century BCE trapezoidal portico at Glanum (Frakes 2009: cat. #030, drawn by D. Skau; reproduced with permission of the author).

dedicated to local deities, upon which the typically Roman name "Cornelia" appears inscribed in the letters of the Greek alphabet. The dedication seems to have been made by a local woman who chose to have her very Latin name inscribed in Greek on her altar.[31] Evidence of pottery further reinforces the contention that, by the last quarter of the second century BCE, Glanum along with most of southern Gaul was already well on the way to extensive settlement by, and rebuilding to the taste and desire of, the Romans. At the very least, as Heyn suggests, there is good reason to assume a greatly increased Roman presence at that time among the native Salyens and the Massaliote Greeks both at Glanum and throughout Provence. Although this period of interaction among the Romans, the indigenous peoples, and the Greek inhabitants may not have lasted long, it does offer the best explanation for the early Roman influence observable in the architecture and design of Glanum.[32]

Prior to 90 BCE, Glanum was once again devastated; whether by invasion or natural disaster is not known. Shortly thereafter, houses were built on the area that had contained the monuments north of the sanctuary (see Fig. 6). One of those houses had an *opus signinum* mosaic floor inscribed with the name CO(RNELII) SULLAE. This suggests that residents of Glanum at least in the early first century BCE, and possibly fifty years earlier if we read the votive altar in Greek as similar evidence, were clients of the great Roman family of the Cornelii. Also recovered

from the "House of Sulla" were fragments of fresco similar to the so-called Pompeiian Second Style. Stylistic similarity would permit a possible dating of the fresco to the middle of the first century BCE, and it is tempting from such evidence to assume a stylistic chronology of fresco painting in southern Gaul congruent with that known or asserted for Roman Italy, in particular Campania, during the same era.[33] Such assumptions appear to be supported by Cicero's description of southern Gaul in the (fragmentary) *pro Fonteio*, section V.11, in the 70s BCE:

> Referta Gallia negotiatorum est, plena civium Romanorum. Nemo Gallorum sine cive Romano quicquam negotii gerit, nummus in Gallia nullus sine civium Romanorum tabulis commovetur.

> Gallia is stuffed with businessmen, full of Roman citizens. No Gaul conducts business without a Roman citizen. Not one small coin is used in commerce without the account books of the Roman citizens.

It is, however, important to note that the local population of Glanum retained some of its own habits and preferences, even while its town was being converted to a Roman architectural and religious character. The House of Sulla and several other buildings of this period in Glanum were not designed using any known Roman unit of measure; instead they used a local and undoubtedly traditional standard. The inhabitants, who were probably still mostly indigenous, though Romanized, people, were employing practices and techniques of local construction to design new houses and other buildings of the new Roman type. Thus a de facto element of compromise between indigenous and Roman can be observed here, just as it can at Entremont, the native *oppidum* that was completely reworked in the second century BCE to combine effectively Celto-Ligurian placement and design with both Greek elements and Roman methods of construction and design. It is much the same amalgamation of elements as found at first century Glanum.[34]

Glanum benefited from the stability that followed from the establishment of the Principate after 30 BCE. From that time into the first century CE, and possibly into the second, Glanum seems to have expanded and prospered, becoming more Roman and less native in the process. The sanctuary area was renovated and rebuilt, gaining a small temple dedicated to Valetudo (Good Health) with an inscription crediting it to Marcus Agrippa. Agrippa also provided a new façade and colonnade for the ancient sanctuary to Glan and the Matres Glanicae. The sacred spring was enclosed in a vaulted cistern-like room accessible by a stone staircase, changes which converted it into a Roman-style nymphaeum. Regardless of its newly Romanized aspect, the continuing importance of the sacred spring is well attested: inscribed altars dedicated to Hercules Victor, the Bona Dea, and other deities have been excavated. The Hercules altar probably identifies the location of a small temple to that most popular of mythical heroes, among Romans at least, which stood adjacent to the entrance to the Nymphaeum

and across from the temple to Valetudo.[35] The sanctuary precinct was separated from the rest of the town by a seemingly fortified gate of Greek type, which employed large masonry blocks and featured rounded merlons atop crenellations along the top, similar to one known at St.-Blaise.[36]

The center of the Roman town, often labeled the "monumental area," is immediately north of the sanctuary zone. On its east side was a portico of Doric columns which may have been associated with the indigenous cult of "severed heads," or may have been some kind of a hostel for pilgrims. Excavation suggests that this whole area was completely redesigned in the Roman period, possibly during the Augustan era (a date for which there is no specific evidence) or during the Flavian era (when other alterations to buildings at Glanum are attested). The lack of specific chronological evidence for this project is frustratingly typical not just of Glanum but of Roman Provence in general. The large-scale renovation and remodeling of the central public area of the town eliminated the Hellenistic Bouleuterion and the large lavishly decorated garden building adjacent to it as well as the original agora space. The result of all these changes was a Roman forum with adjacent basilica and a variety of surrounding buildings, including the so-called twin temples in their porticus (see Fig. 6). Two major phases of long-term construction are attested in the forum, the earlier usually assigned to the 20s BCE but probably continuing for well over a decade, while the later was much more sequential and complicated to document, possibly (but by no means certainly) beginning 10–20 CE, but continuing at least into the Flavian era (80s–90s CE) and perhaps longer. Precise datings within either construction period are frustratingly lacking. Structures still standing on the site from this long period of Romanization include the basilica on the north side of the forum, and a two-story apsed building, sometimes identified as the curia, which was constructed so as to share a wall with the basilica. At some later point, for an unknown reason, the apse was completely filled in with masonry, leaving it visible on the exterior, but otherwise rendering it (apparently) useless.

Two temples were built over part of what had been the earlier Bouleuterion. They are often called "gemini" or twin temples, but the label is inaccurate: excavation indicates that they were not built at the same time and they are of different dimensions (see Fig. 41). Another notable feature of these temples and their setting is the surrounding porticus which extends farther to the north than to the south. This asymmetry creates a sense that something is missing and seems to call for another small temple to the north of the larger one, which would balance that on the south. While a third temple seems to be a reasonable solution, there was insufficient space for it within the dimensions of the porticus. It would seem that the porticus, which is partly cut into the hill behind (to the west) of it, was intended to give the temples unity, but if so, its totally irregular proportions and placement failed to do so. The entire complex looks haphazard, or perhaps incomplete (Fig. 8). Gros suggests dating the smaller temple ca. 30

#031
Forum I

#027 Twin Temple
Portico

Trophy Platform

Theater

#028
Doric Portico

Rock
Sanctuary
Gate

0 30 m

N

8 Detailed plan of the area surrounding the twin temples at Glanum (Frakes 2009: fig. 5,
 p. 55, drawn by E. Lamy; reproduced with permission of the author).

BCE, and the larger about twenty years later (ca. 10), with the porticus added another ten years after that, but the evidence is slight, and there could well have been more than one subsequent renovation. The question of which deities were worshipped in this complex has received much speculation but the total absence of evidence trumps any theories. The Glanum temples, irregular as they are in overall plan and execution, would have provided a thoroughly Roman visual emphasis to the town's monumental center, and perhaps that was their main purpose all along. Restored in the 1990s in blindingly white – and totally incorrect – material (see Fig. 42 below), the twin temples constitute something of a puzzle for anyone studying the Roman architecture of Glanum.[37] What they did achieve, if not completely convincingly, was the placement of typical Roman temple buildings set in a porticus immediately adjacent to the town's forum, a space that from their height they would have dominated visually, although not on a strong axis.

Continuing to the north, the primary residential quarter of Glanum stretched out along the main street that ran northeast. A substantial public bath complex was built in this area prior to 25 BCE. The baths were reworked and modified during the mid-first century CE, and, despite the probable economic deterioration of Glanum, possibly more than once into later periods. The remains indicate the presence of an exercise yard (*palaestra*) and swimming pool, as well as the usual plumbing for the sequence of hot and cold rooms essential to *thermae*. At least one public fountain has been uncovered in the area. The remains of a *macellum* have been identified to the west of the baths. It must have been in use as a food market well before the Romanization of this part of the city. It fell out of use as a market since its ground space seems to have been incorporated into the yard of the House of the Antae Capitals and the House of Atys. This area of the Roman town probably extended farther north in the direction of modern St.-Rémy-de-Provence, but how far it spread or how densely it was built up at the height of Glanum's development has not been determined.

The northern edge of Glanum is defined by the platform called Les Antiques where the Mausoleum or Cenotaph of the Iulii and a badly deteriorated single fornix free-standing arch still stand (Fig. 9). The dating and other difficulties that surround both these heavily reworked monuments will be considered in more detail below. They might have marked the farthest northwestern extension of the city, especially since, by Roman custom, the Iulii monument, if it had any true funerary function (which is not known), would have had to stand outside the pomerium and the city's walls. The Glanum arch is most often assigned now to the second or third decades of the first century CE, but that cannot be proven. It is most commonly dated by comparison to the details of the triple fornix arch at Orange, a procedure that provides little likelihood of certainty given the severe chronological difficulties with the Orange arch, upon which discussion continues. If the arch at Glanum is regarded as contemporary in decoration

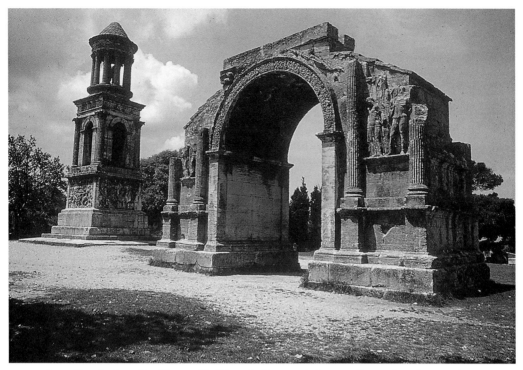

9 "Les Antiques" at Glanum (St.-Rémy-de-Provence), free-standing arch and cenotaph or mausoleum of the Iulii (photo by the author).

and detail to that at Orange, then it, too, should be able to be justified as a monument erected, or at least heavily reworked, as late as the late second or early third centuries CE. However, the assumption that the arch at Glanum must be dated by comparison to the arch at Orange is not an essential one. The similarities of order and architectural decoration may just as well testify to the innate conservatism of the Roman Corinthian order, and to local Romano-Provençal taste and practice in its execution, as to any essential chronological identification. In sum, the arch, while clearly of Roman design and type, provides no convincing evidence for dating the ongoing Romanization of Glanum, since it could perfectly well represent a late addition, or a late Imperial reworking of an earlier monument. Without epigraphic testimony, there is little more to be deduced from it. The arch is often mislabeled "triumphal" when it is much more likely to have been a commemorative dedication. Its location adjacent to the mausoleum/cenotaph suggests an intentional arrangement. It is likely that the area of Les Antiques stood at the point where the road coming to the area from Italy intersected the road leading into Glanum, so these monuments would have alerted travelers that the way into the sanctuary town turned off here. As such, they would have made an effective and impressive architectural introduction to Glanum, one whose *Romanitas* could neither be missed nor questioned.[38]

The Romanization of Glanum began in the second century BCE as increasing Roman military presence made itself felt in Provence. The amalgamation of decorative and architectural elements on the site suggests combining, compromising, and reworking of previous indigenous Salyan (Celto-Ligurian) and Greek influences into a Roman architectural and planning matrix. The progress was neither steady nor constant, since there are clear interruptions in the late second and early first centuries BCE. Major urban reworking began after 30 BCE with contributions, funds and, it should be assumed, encouragement and political pressure from the central Roman authority in Gallia Narbonensis, as implied by the presence of Agrippa on building inscriptions in Glanum. The traditional sanctuary area appears to have been extensively reworked, as was the city center, with the Greek-seeming bouleuterion and agora giving way to a formalized Roman style forum, basilica and (probably) curia plan, presided over by the "twin" temples of Italic type on their high podia. Similarly, the residential areas north of the sanctuary and the monumental zones were made more Roman in appearance, although Hellenistic house plans continued to be used along with more typically Roman ones, and Roman baths were added among the residences of the well-to-do. Finally, the arch and mausoleum/cenotaph, and perhaps other monuments long gone, where it met the main highway and probably marked the boundary of the sacred *pomoerium*, presented a Roman architectural introduction to the town and sanctuary. Once all these Romanizing elements had been achieved, Glanum had been converted from a native pilgrimage site into a solid yet attractive city of undeniable *Romanitas*. This seems to have happened, in the town center at least, by the late first century CE (the Flavian period), but the process in the residential and outlying sectors may have continued even longer.

CITIES AND TOWNS FOUNDED BY THE ROMANS

Aquae Sextiae (Aix-en-Provence)

According to Strabo (4.1.5), the first permanent Roman presence in Gaul was established by C. Sextius Calvinus in 122 BCE, following the defeat of the Saluvii. The location, known as Aquae Sextiae, was immediately adjacent to the hill fort of Entremont, which had been a stronghold and perhaps the capital of the Saluvii. In 102 BCE near Aquae Sextiae, G. Marius won a decisive victory over the Teutones (Plutarch, *Marius* 18 and 21.3).[39] Aquae Sextiae seems to have remained an essential military outpost, but does not seem to have received the status of a *colonia Latina* until shortly after the siege of Massalia in 49 BCE, when the territory of Massilia was divided by Caesar between Aquae Sextiae and Arelate. Due to its continuous habitation and continuing political, military, and cultural importance up to the present day, we have only limited knowledge of

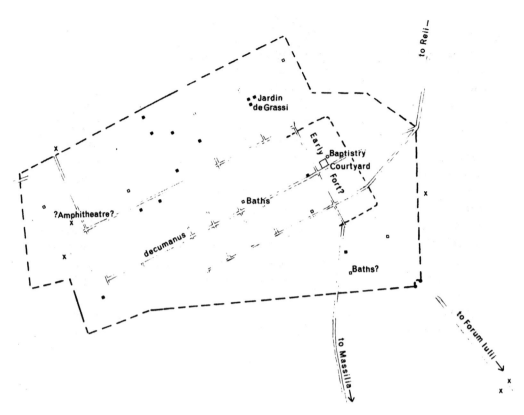

10 Hypothetical plan of ancient Aquae Sextiae (Aix-en-Provence) (after Rivet 1988: fig. 27, p. 214).

the Roman settlement and city, though recent discoveries have greatly increased our scope of understanding (Fig. 10). The original Roman fort, perhaps the one established in 122 BCE, probably stood on the site of the cathedral in Bourg St.-Saveur. This location is on the highest ground in the area and a number of Roman roads appear to have been aligned with it; however, there is little other archaeological evidence to support this deduction. The line of Aquae Sextiae's *decumanus maximus* seems to be confirmed by archaeological soundings, and constituted an extension of the street plan implied by the fort's layout.[40] Only the faintest foundation traces of the Roman town walls may be identified, but it seems unlikely that they can be identified with those of the medieval town. The outline of a gate identified under the Palais de Justice resembles the Augustan period gates at both Arles and Fréjus. Buildings within the Roman town walls continue to come to light, including the long-known baths underneath the modern "Thermes Sextius" and a second set of baths in Place des Herbes; a courtyard of Imperial date found beneath the cloister of the cathedral during excavations between 1976 and 1979[41]; the *cavea* (seating area) and other elements of a theater[42]; and remains of a number of houses in the Jardin de Grassi.[43] The cumulative effect of these clues to the structure and history of Aquae Sextiae is

of a town that expanded from an early *castra* (Roman military camp) plan, was organized and walled in the second half of the first century BCE, then developed around its hot springs (i.e., the baths) as it grew in importance into the fourth century CE. Further conclusions about the sequences of development will have to await further excavation.

Narbo Martius (Narbonne)

A town has existed on the site of Narbonne since the sixth century BCE. Originally the town was called "Naro" and it served as a locus of regional trade. In 118 BCE Rome established a *colonia* at Naro, calling it Narbo Martius. The *colonia* flourished, continuing the trading relations already in place. Narbo Martius also played a role in much of the military action in the final century BCE including Marius' campaigns against the invading Cimbri (102 BCE), Pompey's campaigns against Sertorius (80s BCE), Caesar's Gallic campaigns (58–52 BCE), and the subsequent civil wars. A second wave of Roman settlers was established there in 45 BCE when Caesar gave land nearby to many of his veterans and reestablished Narbo as a *colonia Latina*.[44] The town flourished during the principate until the middle of the second century CE (Fig. 11). Narbo became the administrative and military center of the developing province. Its importance was such that the province was even named for the city: Gallia "Narbonensis."[45] Augustus presided over a general assembly of all Gaul at Narbo in 27 BCE. Its very name in Augustan times – *Colonia Julia Paterna Narbo Martius* – reveals its connection to the Imperial family, and this was continued throughout the Julio-Claudian period; for instance, Claudius added the title *Claudia* to the city's official name. Narbo received gifts from Trajan, Hadrian, and Antoninus Pius in the first half of the second century. After the provincial capital was shifted to Nemausus (Nîmes) a slow decline appears to have begun. A severe fire ravaged the city in 145 CE, greatly exacerbating the city's deterioration. The silting of its port compounded the gradual erosion of Narbo's economic position and seems to have shadowed its declining political position.[46]

Although the history of Narbo is well documented, its archaeology is practically nonexistent. Very few monuments mentioned in inscriptions or texts remain in any condition, so even its general topography has to be assumed by reference to the known plan of medieval Narbonne. The Roman town seems to have been bisected by the great Via Domitia which served as its *cardo maximus*. The battered fragments of its capitol have been found just north of the likely location of the forum, on a low hill called Les Moulinassès. The remains appear to be from a second century CE rebuilding, once presumed to have occurred after the fire of 145, though Gayraud has argued strongly for a Hadrianic date for these remains.[47] Other religious monuments of importance are recorded in literary texts, but nothing is known of their architecture or even their locations.

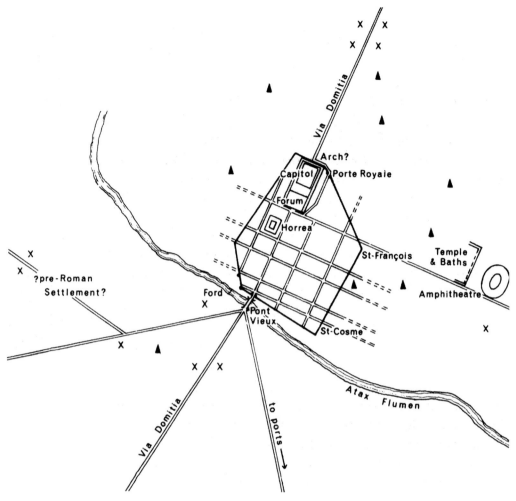

11 Hypothetical plan of ancient Narbo Martius (Narbonne) (after Rivet 1988: fig. 11, p. 132).

Massive warehouses once dominated the town, a number of which ran deep underground. The subterranean areas of some are still accessible.[48] There are reports of and fragmentary evidence for a number of private urban villas within the city, more than one bath complex, and an amphitheater. No trace of a theater has been found to date. Given its immense historical importance and very early expansion in the first century BCE, the lack of archaeological evidence and of architectural remains from Narbo is one of the greatest disappointments for the study of architecture and urbanism in Gallia Narbonensis. If more of Narbo had survived, and more could be convincingly dated, it might well have formed the lynchpin for the chronology of the entire Roman province. But to date that has not been possible since most of the evidence lies beneath the medieval city, if it is there at all.

Arelate (Arles)

The Greek settlement probably called Theline had been established early enough at the future site of the city of Arles to be destroyed by Ligurian raiders in 535 BCE. The town, again possibly called Theline, appears to have been revived in the fourth century. Rome's initial intervention came in 104 BCE when Marius constructed canals, called the *Fossae Marianae*, to link Theline with the sea and prompt what seems to have been a major phase of expansion. These canals were the likely reason that Julius Caesar chose Theline as the site at which to build the fleet he needed for the siege of Massalia (49 BCE). His gratitude to Theline was made known three years later, in 46 BCE, when the *Colonia Julia Paterna Arelate Sexternum* was founded on the site of or, as some assert, across the Rhône from, the older Theline.[49]

The most important extant Roman monuments at Arles (Fig. 12) are frequently attributed to two discrete eras: the Augustan and the Constantinian.[50] The early growth and importance of the city in the Augustan era and its rebirth in the time of Constantine are clearly established in the archaeological, epigraphical, and historical record, but continuing research in the history and archaeology of Arles suggests a more complex and nuanced chronology of development, setbacks, Imperial and aristocratic patronage, decline, renovation, and return. The earliest line of the city walls dates from the Augustan period, and the walls were renovated in the fourth century CE. The street plan inside these walls was laid out in a simple grid. The street pattern of modern Arles reflects the Roman grid, and the crossing of *cardo* and *decumanus* may still be clearly observed in the impressive remains of the forum, especially the huge *cryptoporticus* that stretched beneath three sides of it and which remains mostly intact. Construction of the *cryptoporticus* is dated mostly from items found in it, including a bust of Marcellus (earlier often thought to be the youthful Octavian himself), a marble copy of the golden shield dedicated in the Curia in Rome in 27 BCE, and some fragmentary inscriptions. The underground complex appears to have been restored a number of times over the centuries, and was still in use in the fourth century CE.[51] Two arches, of which only the slightest fragments remain (and not in situ*)*, may have marked the city's *pomoerium* to the northeast and southwest. The arches are traditionally labeled "Arcus Admirabilis" and "Arch of Constantine" and while they were both probably built when the street plan was laid out, the Arch of Constantine must have been refurbished in the fourth century CE; however, the paltry state of the evidence allows for the possibility that both arches were renovated at that time. Arles seems to have been well furnished with free-standing arches by the later Augustan period, including the so-called Arc du Rhône, all of the single fornix type and mostly attributable in origin to the first centuries BCE and CE. Nonetheless, there was clear continuance of the local habit of building free-standing arches, as Küpper-Böhm

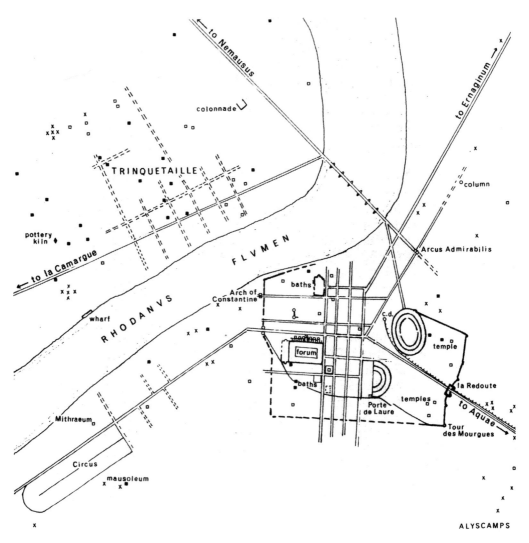

12 Hypothetical plan of ancient Arelate (Arles) (after Rivet 1988: fig. 22, p. 192).

has shown good evidence for such an arch being built in the mid-second cen-
tury CE (she calls it an "Antonine" arch), and hence reworking of an earlier arch
as late as the Constantinian revival of Arles (suggested by the name "Arch of
Constantine") is certainly plausible.[52]

To the west of this forum lie fragmentary and complicated remains of what
could have been a paved courtyard. The southern end seems to have been marked
by a large curved exedra with a gate or doorway, and perhaps colonnades that
ran to the north. This arrangement could suggest a symmetrical curved exedra
at the opposite end. The preserved material consists of one of the two hemi-
cycles or exedras which may still be seen at L'Hôtel de Laval, adjacent to the
ancient *cryptoporticus*. Grenier suggested that the structure was the peribolus of

a temple.[53] Elements of the remaining architectural sculpture suggest to a number of scholars a date for this addition to the forum in the first half of the second century CE, perhaps in the reigns of Trajan or Hadrian. These same remains have been reanalyzed by Gros as revealing, rather than the peribolus of the temple, a sort of *forum adiectum,* a long narrow colonnaded space placed next to the original forum of Arelate, which at the same time served as a forecourt to the temple beyond, and featured apsed hemicycles or exedras at either of its narrow ends.[54] Such a reconstruction recalls, or at least suggests, influence from the early Imperial fora at Rome, specifically that of Julius Caesar in the placement of the complex immediately adjacent to and accessible from the city's traditional forum, from that of Augustus in the use of the hemicycles opposite one another at the flanks of the open area, and from both in the possibility that a temple of the Tuscan order rose above and dominated the sight lines of the area. But there, however, the resemblances end, and a closer look at the reconstruction, while reinforcing the reasonable likelihood of Gros' proposition, must raise doubts about its chronology. First of all, the architectural sculpture that Gros would date to the early first century CE (specifically to the reign of Tiberius, associating it with the portrait of Tiberius found nearby in the *cryptoporticus*), is at least equally convincingly dated to the early second century CE by several other scholars (e.g., Verzar, Grenier, Amy), and the associations with the dedicatory inscription to L. Cassius Longinus (cos. 30 BCE) and the portrait of Tiberius – both found nearby but still beyond the architectural context of the *forum adiectum* – do not in and of themselves provide direct dating evidence for the complex. The placement of the long, narrow, apsidal building is far more reminiscent of, for instance, the placement of the Basilica Ulpia in Trajan's Forum in Rome than of any direct influence from the earlier Imperial fora, and hence the *forum adiectum* of Arles might well represent an addition to the original forum, based on what had become well-known architectural models at Rome which were spreading throughout the architecture of the Roman Empire in the first half of the second century CE. Hence, while the reconstruction of this *forum adiectum* seems likely, it becomes all the more probable if regarded as a second century CE addition, very possibly a gift to the city contemporary with the temple for which it provided the forecourt, and comfortably dated to the reigns of Trajan or Hadrian.[55]

The two best-preserved and best-known monuments of Roman Arles are the theater and the amphitheater. When considered within the urban context of the developing city these two monuments present an intriguing contrast. The theater, which is generally dated to the reign of Augustus based on the discovery of a statue of the *princeps* within it, was planned and built to fit into the original street grid. The *scaenae frons* aligns directly with the north/south streets of the grid. This alignment reinforces a construction date in the late first century BCE. The location of the theater as a unit within the grid plan of the city supports

the contention that it was built during the Augustan era. It also underscores the contrast with the amphitheater which defies the street grid. It appears to have been placed off-axis intentionally; it also covered over a number of original streets, thus interrupting the flow of traffic and communication in that area of Arelate. Built as an addition to, rather than a component of, the city's original plan, it should come as no surprise that the design and execution of the amphitheater reflects the engineering advances found in the Flavian amphitheater in Rome and, therefore, could not have been built prior to 80 CE. These two relatively well-preserved (but also extensively reconstructed) buildings attest to the progressive elaboration that important, and even secondary, cities and towns in Gallia Narbonensis enjoyed from the reign of Augustus well into the second century CE.[56] That Arles also received a major new aqueduct during the reign of Trajan reinforces this picture of an important Roman provincial city steadily gaining in architectural and engineering excellence and, presumably, in Imperial favor throughout the two centuries from 46 BCE to ca. 150 CE.[57]

Thus the architectural history of Arelate may be best understood as a progression leading to a high point in the early to mid-second century CE with the expansion and elaboration of the forum and the addition of a substantial temple adjacent to it. Evidence for building in Arelate, as in many Romano-Provençal urban areas, declines after the middle of the second century CE. No firm archaeological evidence for substantial building after the mid-second century CE has been identified in the city prior to the early fourth century CE when the emperor Constantine organized a major council there in the year 314. Constantine and his immediate successors, especially Constantius II, who was commemorated by inscription in the forum, appear to have rebuilt the city's defensive walls, reworked and redecorated at least some parts of the forum including the north gallery of the *cryptoporticus*, and given to the city a new and impressive bath complex. Other monuments still standing from the first and second centuries CE may have also been reworked or refurbished, but the overall street plan of the Roman city was little changed by these late antique additions, and indeed its appearance must have remained that of a prosperous Roman provincial city well after its Christianization. Extensive cemeteries along the roads outside the city walls remained in use and became mostly Christian, though still revealing an interesting mixture of Christian and pagan inscriptions throughout the fourth century CE. About 400 CE Arelate became the residence of the Prefect of all the Gauls, replacing Lugdunum (Lyon) as the first city of late antique Gaul; the city remained powerful until it was sacked by the Visigoths ca. 480 CE.[58] Its architectural continuity throughout antiquity was impressive and reflects the consistency of Roman architectural patronage and influence from the late first century BCE through at least the middle of the second century CE and perhaps further (we know nothing at all about the later Antonine and the Severan periods at Arles), and then the repairs and refurbishment needed to bring the city back to

some sort of architectural elegance as a major seat of power in the early fourth century CE. That story seems remarkably clear at Arles.

Forum Iulii (Fréjus)

Ancient Fréjus provides an excellent example of a purpose-built Roman town in Provence, which survived and flourished well into the high empire (Fig. 13). Forum Iulii was most likely founded by Julius Caesar around the time of the siege of Massalia in 49 BCE. The first notices of the town by name occur in Munatius Plancus' letter to Cicero written in 43 BCE (Cic. *Ad Fam.* 10.15.3, cf. 10.17.1), thus establishing the likely foundation date. The town was not directly on the seacoast, but was linked to it by a canal. The settlement was probably intended as a supply depot, but Tacitus (*Ann.* 4.5) tells us it continued to grow as the port facilities were developed during the Second Triumvirate and Forum Iulii's importance, both strategic and economic, was confirmed when Augustus designated it one of the bases for the Roman fleet (along with Misenum and Ravenna). As if to underscore the significance of the port within the empire, Marcus Agrippa appears to have been responsible for construction of the naval facilities and a detachment of veterans from the eighth legion was settled there permanently. The addition of Roman citizens to the new city added the title *Colonia Octavanorum* to the town's cumbersome official name: *Colonia Octavanorum Pacensis Classica Forum Iulii* (Pliny *HN* 2.35).[59] While the strategic importance of the Roman navy declined throughout the first and second centuries CE, Forum Iulii seems to have held onto its economic importance by developing its port facilities for marketing and trade. In the first century CE, the most renowned of all natives of Forum Iulii was Gn. Iulius Agricola – the Flavian governor of Britannia and father-in-law of the historian Tacitus – born here in 40 CE (Tac. *Agr.* 44.1).

The ancient port is now filled with silt, but wharfs and moles can still be seen in what was the dock area. At the entryway to the harbor stands the so-called lanterne d'Auguste. In spite of its name the hexagonal tower, probably the last of a series built on the same location, was a late addition to the facility. The rampart walls of the *colonia*, assumed to be contemporary with the port's Agrippan construction, can still be seen in several places around modern Fréjus. The *decumanus maximus* is marked on the east by the Porte de Rome and on the west by the Porte des Gaules. The Porte des Gaules, though much rebuilt in later times, is similar in plan to Roman gates preserved at both Aix and Arles with a semicircular wall flanked by two towers. Inside the walls traces of buildings have been found, including baths and a substantial residence sometimes assumed to have been that of the commander of the fleet. The area of the forum remains hidden beneath the later town but excavations in Place Magnin have revealed its outline and dimensions. Both a theater and an amphitheater have been excavated

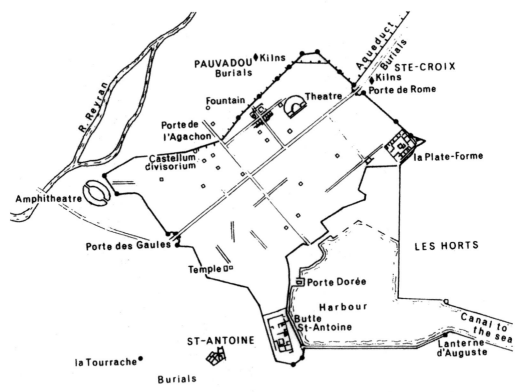

13 Hypothetical plan of ancient Forum Iulii (Fréjus) (after Rivet 1988: fig. 29, p. 227).

and restored; the theater has been so heavily reworked that it is undatable, but
the amphitheater is both visible and firmly dated to the early second century
CE, attesting to the continued vitality of Forum Iulii's economy during the high
empire.[60] The city's aqueduct is remarkably well-preserved throughout much of
its course and can be traced for around 40 kilometers from Mons all the way into
Fréjus, where it entered the city over the Porte de Rome.[61] We have little infor-
mation about the town in the third century other than a single inscription to
Caracalla (*CIL* XII.342) from the vicinity. This lack of evidence may suggest the
economic slowdown and the military and political uncertainty that seems often
to characterize the urban areas of Roman Provence in that century, but with
the coming of the fourth century CE clear indications of greater economic and
political stability, and a renewal of building activity, can be detected along with
the establishment of Christianity. The town and its neighbors are mentioned in
late geographical sources including the Antonine Itinerary and the Peutinger
Table, and the scattered stratigraphical evidence available also suggests con-
tinuity with little interruption from pagan into early Christian times.[62] Forum
Iulii's importance seems to have continued largely unabated into later antiquity
when it gained an impressive early Christian church whose surviving baptistery
dates back to the fifth century CE. Thus it provides something of a model for the

historical development of a Roman town and its architecture in Provence, notable not only for its establishment in the first century BCE and development in Augustan times, but also for its continued health and architectural elaboration well into the second century. While Forum Iulii did not have anything like the importance of Arelate in early Christian Provence, nonetheless it clearly profited from the short period of stability around and after the reign of Constantine. This would seem to be a state of affairs that can be observed in many, indeed most, of the Roman urban centers of Provence.

Vienna (Vienne)

Vienna (modern Vienne, south of Lyons), the northernmost of the major Roman cities of Narbonese Gaul (see Fig. 2) first functioned as an important stronghold of the Allobroges. Falling to Rome ca. 121 BCE, little is known of its earliest phases, either native or Roman. A destruction layer subsequent to the Roman conquest may record an attack by the Cimbri and Teutones ca. 105 BCE, and a second may indicate the brutal suppression of the Allobrogan revolt against Rome in 62–61. Julius Caesar passed through Vienne in 58 (Caesar, *BGal* 6. 11 and 28) and again in 52 (*BGal* 7.64–5). When exactly Vienne became a *colonia Latina* and when it was raised to the status of a full *colonia Romana* remains unclear. The most reasonable solution to this question proposed so far is Pelletier's suggested chronology: at the end of his Gallic campaigns, Caesar established the *colonia Latina* of Vienna; this status endured until the reign of Caligula when, probably in 40 CE, he granted to Vienna Latin status, giving the city the official name of *Colonia Iulia Augusta Florentia Vienna*. Certainly, this had to have occurred prior to Claudius' speech, delivered at Lugdunum in 48 CE, in which the emperor labeled Vienne *ornatissima ecce colonia valentissimaque Viennensium* ("the most ornate and most valiant colony of the Viennese").[63]

Augustus gave the city its first circuit of walls in 16–15 BCE (Fig. 14). At 7,250 meters in length and encircling an area of 200 hectares, the Viennese city wall was the longest in all of Roman Gaul. The impressive circuit of wall must have brought distinction to the town quite early on, and may in part explain the hyperbole in Claudius' speech. The area within the walls was never completely filled by the town, possibly because they enclosed a number of steep hills that were unsuitable for construction, even for the Romans. The chronology of the known monuments of Vienna, while not entirely clear in most cases, does again document a relatively rapid development of the town in the first century CE, and a continued economic vitality into at least the middle of the second. The foundation date and chronology of the so-called Temple of Augustus and Livia is at best obscure and fraught with difficulties. The original construction may have occurred during the reign of Augustus, although arguments for the reign of Claudius seem more plausible. Evidence exists for at least one major reworking

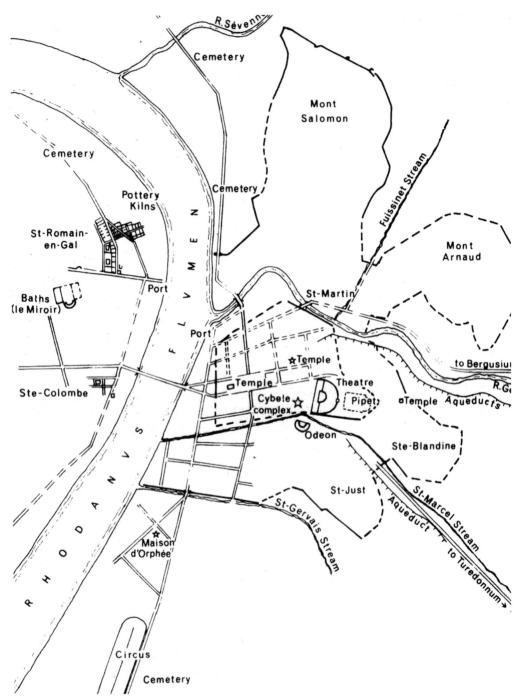

14 Hypothetical plan of ancient Vienna (Vienne) (after Rivet 1988: fig. 43, p. 308).

of the building and for its dedicatory inscription. Based on architectural, decorative, and stylistic similarities to the surviving version of the Maison Carrée, substantial building or restoration work during the reigns of Hadrian and/or Antoninus Pius seem likely.[64] The large theater of Vienna most likely originated sometime in the first century CE, although specific dating suggestions cover the full range from Augustus to Trajan; the *odeum* adjacent to it, however, appears to have been a gift from the patronage of Hadrian which may have replaced an earlier version from the time of Claudius.[65] Fragments of a third entertainment complex of unknown design have been identified. The building was embellished with mosaics and seems to have been dedicated to the cult of Cybele. It appears to be a gift to the city, most likely from the reign of Claudius, and was substantially enlarged in the second or even early third century CE. No amphitheater has ever been found at Vienna, but a large circus with an adjacent bath complex outside the walls to the south of the city may be dated to the second century CE. No archaeological evidence for a Capitolium temple has yet been identified, although the summit of Mont Pipet is usually mentioned as the most likely location for it. In sum, the city of Roman Vienna stretched along the left bank of the Rhône, never entirely filling the territory enclosed by its Augustan period defensive walls, but gaining a selection of elegant and impressive public monuments notably around the reign of Claudius (41–54 CE) and then again in the first half of the second century CE or a little longer, during the reigns of Hadrian (117–138 CE) and Antoninus Pius (138–161 CE).[66]

The city did expand outside the walls to the south toward the eventual location of the late first/early second-century CE circus and contemporary baths (commonly but erroneously called La Maison d'Orphée,) as well as across the Rhône where a substantial residential and commercial suburb – now called St.-Romain-en-Gal – grew and flourished well into late antiquity.[67] The quotidian life of Roman Vienna is also remarkably well documented from the excavations that have been carried out in this area since 1967. Here houses, some of impressive size and decoration, workshops and artisans' studios, warehouses and shipping offices, and other types of commercial buildings seem to have been grouped around three streets, presumably for convenience of access and delivery, and for communication with the port at the river docks. The street plan and the architecture are clearly designed for ease of passage and functionality. Twelve wealthy private villas have been uncovered in the suburb, suggesting that those who grew wealthy from the industry and commerce there also chose to stay and live there. The excavations reveal that St.-Romain-en-Gal was in existence, at least as a river port and warehouse district, by the mid-first century CE, and that it continued to expand throughout the second, as Vienna also flourished across the river. It seems to have contracted and possibly been abandoned in the third century CE (no coins later than the reign of Caracalla, 211–217 CE, have been found there). At the very least the suburban

development must have suffered a severe decline in the third century CE. This may reflect the deteriorating status of Vienna itself in that century; the city did not climb back to any real importance or influence in the new Christianized Roman Empire of the fourth century, when Arles surged back to such importance. Rather, Vienna provides us with an example of a Roman Imperial city of the first and second centuries CE, a model that appears applicable to most of the great Romano-Provençal urban areas.[68]

Nemausus (Nîmes)

The site of Roman *Nemausus*, or at least its highest hill Mont Cavalier, appears to have been inhabited from the Bronze Age (Fig. 15). It was the location of a spring sacred to Nemausus and was the capital of the *Volcae Arecomici* (Strabo 4.1.12; Pliny, *HN* 3.37). Roman control was established about 120 BCE with the construction of the Via Domitia and a camp or way station near the site of the Roman gate now known as the Porte d'Auguste. The chronology of the city's colonial status is unclear. Rivet has argued that the *ius Latii* may have been granted to Nemausus (and other places in the territory) by Julius Caesar in recognition of their loyalty during the revolt under Vercingetorix in 52 BCE. While inscriptions labeling it *Colonia Augusta Nemausus Voltinia tribu* would normally be assumed to date only to or after Octavian's assumption of the title Augustus in 27 BCE, pre-Augustan coin issues inscribed COL NEM must imply that the Latin right predated the title *Augusta*. The extra title *Augusta,* then, would have been added to its name after new settlers, probably veterans from the Roman army in Egypt, were settled there in or after 27 BCE. This event is commemorated on Nemausan coin issues that show heads of Augustus and Agrippa on one side and a crocodile chained to a palm on the other.[69] The extensive circuit of walls that surrounded Nemausus may be credited to Augustus from the inscription (*CIL* 12.3151) preserved on the Porte d'Auguste at the east end of the city's *decumanus maximus*. Like Vienna's, the walls enclosed an extensive territory. Included within the city walls were the native water sanctuary, the Tour Magne above it, and sufficient open space, at least initially, so that an amphitheater could be constructed inside their circuit.[70]

The city's forum was located at the intersection of the *cardo* and *decumanus*. The so-called Maison Carrée temple was located on the forum's south side, with an atypical orientation to the north. The temple was a pseudodipteral hexastyle temple of the Tuscan type and decorated in the Corinthian order. It was surrounded by a substantial colonnaded peribolus whose extent and decoration are only now coming to be fully appreciated. The initial construction of the temple was probably contemporary with or slightly subsequent to the general layout of the city's street grid, so almost certainly an Augustan dedication, possibly from 16–15 BCE or from 2–3 or 4–5 CE. Its entablature inscription (*CIL* 12.3156)

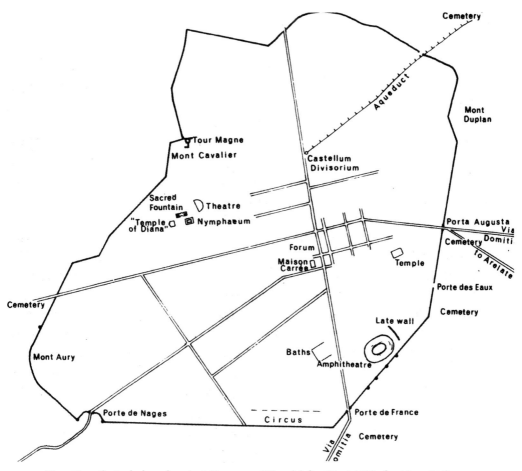

15 Hypothetical plan of ancient Nemausus (Nîmes) (after Rivet 1988: fig. 17, p. 164).

cannot be securely restored since it survives only as a series of clamp holes
across the frieze course and intrudes below upon the architrave, suggesting later
reworking, and hence also cannot be cited as evidence for dating. The temple
that survives appears to be a reconstruction of the original. The most common
explanation has been that the original temple of 16–15 BCE was both rebuilt and
rededicated a mere eighteen years later, but no evidence of unintended damage
such as fire has been found. Another possibility is that the building left today
was a faithful reconstruction (though using an unusual measurement unit) in
the time of Hadrian, during whose reign Nemausus is recorded as receiving
other forms of Imperial architectural patronage. Both temple and surrounding
porticus suggest design influence from the forum of Augustus and temple of
Mars Ultor in Rome, which remained the most influential models for all such
temple/sanctuary centers throughout the Roman Empire during and after the
reign of Augustus.[71] About 800 meters to the east, remains of a second substan-
tial building connected with the porticus beyond the Maison Carrée have been

located near the cathedral of Nîmes. These have been associated with either the supposed basilica built by Hadrian in memory of Plotina after her death in 122 CE (*HA Hadrian* 12.2 and Dio 69.10.3) or with a second temple in the area of the forum, whose dedication remains unknown.[72]

Northwest of the forum, the remains of an immense water sanctuary, frequently called an *Augusteum*, are preserved in the eighteenth century Jardin de la Fontaine. In the Roman phases of the sanctuary's existence, the Nemausus spring flowed into pools lined with sculpted marble basins and porticoes, as well as feeding into and supplying the adjacent *thermae*. The center of the pool area contained a quadrangular structure that is often dated, though not conclusively, to the reign of Augustus on the basis of foliated scrolls carved on its frieze. Pedimental fragments have been found nearby which are most readily dated to the second century CE; these were first attributed to a temple of Hadrianic date, but more recently it has been suggested that they belonged to a monumental gate, a sort of *propylaea*, that may have led into the complex.[73] To the west of the nymphaeum stands the rectangular barrel-vaulted chamber erroneously called the Temple of Diana. In architectural form and design this room most closely resembles a library, and may have served as such within the context of the bath complex connected with the sanctuary. Various hypotheses for dating have been advanced for this complex of contructions, ranging from an Augustan origin for the decorative capitals to the possibility of a third century CE date for, at least, the *thermae* as they are left to us. The mixture of styles and techniques could very likely indicate a reconstruction of an earlier bathing complex; perhaps the best solution is to view the *Augusteum* as a Roman preservation and monumentalization of the native water sanctuary, begun during Augustus' Romanization of the city, expanded, added to, and much redecorated in the second century and then again reworked in the early third. Even in its battered and much restored condition, the spring and sanctuary sacred to Nemausus remain both impressive and beautiful.[74]

Also preserved within the walls of Roman Nîmes is an amphitheater which is still in regular use today. Its location within the walls of the city suggests that here, as at Vienne and probably also at Arles, the Augustan circuit wall was designed to incorporate the largest amount of space possible within which the city might grow. The amphitheater itself is convincingly dated to the reign of Domitian or slightly later, indicating the continuing surge of construction, and hence of economic growth, that seems to have characterized Nemausus from Augustan times well into the second century CE.[75]

Beyond the city's walls, the most impressive ancient remain must be the aqueduct bridge over the Gardon River. While it is popular to attribute the inception of this bridge, and the aqueduct as a whole, to Marcus Agrippa, the best archaeological dating for, at least, the Pont du Gard (Fig. 16), if not the entire aqueduct, is at or just after the early years of the second century CE, in the

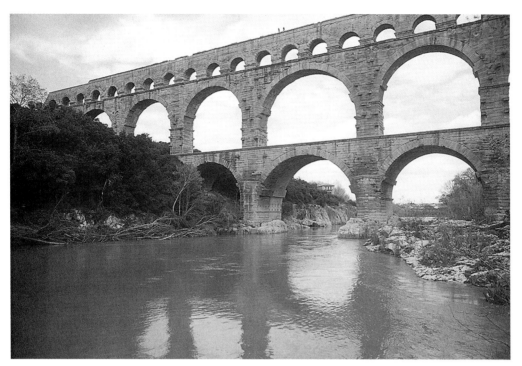

16 The Pont du Gard aqueduct bridge over the Gardon River, near Nîmes (photo by the author).

time of Trajan or possibly Hadrian.[76] In addition to these still extant structures, mention is made in various sources of a circus, a temple to Augustus and the Hadrianic basilica (or some other building) erected in memory of Plotina. Furthermore, there are numerous indications that Nemausus succeeded Narbo Martius as administrative capital of Gallia Narbonensis at some point during the second century CE, possibly only after Narbo was devastated by fire in 145 CE, but perhaps before that. As a central point of communication, transportation, and trade along the Via Domitia, Nemausus had already surpassed its western neighbor due to natural strategic advantages, economic viability, and ambitious populace by the end of the first century CE, so the official transfer of the seat of power may have come as no surprise. By the mid-second century CE, Roman Nemausus was at its apogee of influence and of architectural grandeur. This status was bolstered, at least in part, by the city's role as ancestral home to some elements of the Antonine dynasty. The empress Plotina, herself the wife of the first emperor born in the provinces, was from a Nemausan family, and may have been born there. This connection undoubtedly explains her commemoration there by Hadrian after her death in 122 CE. The longest-ruling emperor of the entire Imperial period, Antoninus Pius, was also descended from a family based in Nîmes (although Antoninus himself was born at Rome).[77] Given this remarkably strong connection to the ruling dynasty during the second century CE, it

would be hardly surprising if Nîmes received extensive architectural patronage as well as many other kinds of favor and support from the Imperial government. Nor should it occasion any surprise that there is so much evidence for reworking and reconstruction of earlier, especially Augustan, elements within the city during this period. Nemausus, clearly, was being transformed into the most important Imperial city of a prosperous province which was now even supplying successful candidates for the Imperial purple.[78] Roman Nîmes appears to have retained its vitality to the end of the second and into the early decades of the third centuries CE, but by the middle of the fourth century, much of the urban area within the walls appears to have been abandoned, although a synod is reported as meeting there in either 394 or 396 CE; the first mention of a bishop of Nîmes, named Sedatus, comes only in 506.[79] In late antique and early Christian Provence, then, Nîmes was completely superseded by Arles, and its magnificent Imperial monuments began a long process of deterioration and decay. But in its heyday, it was possibly the greatest Roman city of Gallia Narbonensis.

Arausio (Orange)

The name "Arausio" first appears in Livy's account of the defeat of the Roman generals Cn. Mallius and Q. Servilius Caepio there at the hands of the Cimbri and Teutones in 105 BCE (Livy, *Per.* 67). One of the Romans' *castra* was built on a ridge, now called St.-Eutrope hill, and although this did not win them the battle, it did indicate the location's strategic value. St.-Eutrope was probably subsequently fortified by the Cavares tribe who controlled the area in the last century BCE. The site of Arausio commanded both the Rhône River and the surrounding plain (Fig. 17). Established on and around the high hill, the site rose almost 100 meters above the river and the plain and was the logical location from which to monitor and control both river and road traffic between Massalia and the cities to the north, in particular Lugdunum (Lyon). When the Roman *colonia* was founded, most likely ca. 35 BCE under Octavian as a settlement for veterans of the *Legio II Gallica* after the defeat of Sextus Pompey the year before (Dio 49.34.4), the epithet *firma* was added to its official name to indicate its function as monitor of the river and road: *Colonia Firma Iulia Arausio Secundanorum*. The name "Arausio" itself may derive, as did "Nemausus," from that of a native water divinity.[80]

Dating the remains of Arausio has long been a complicated and contentious matter. The city's walls can be traced in various sections around the city center, and a few stretches are still visible, but some doubt must remain about the commonly accepted hexagonal plan, and about their date. The usual assumption is that the walls would be contemporary with or built only shortly after the date of the Roman foundation, hence either Octavianic or Augustan. But comparison with the walls of Baeterrae (Béziers), the other military *colonia* founded in

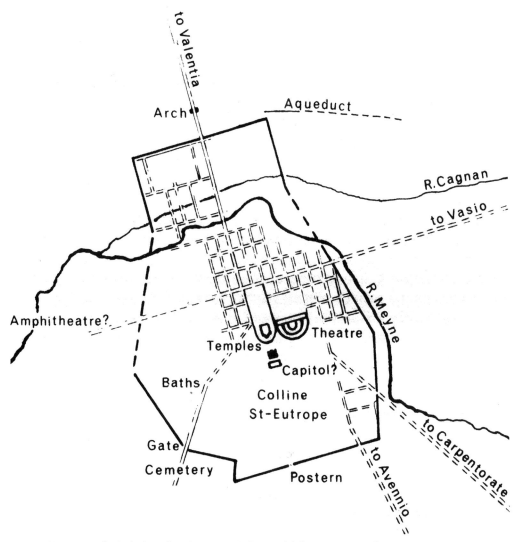

17 Hypothetical plan of ancient Arausio (Orange) (after Rivet 1988: fig. 37, p. 274).

Provence at the same time, does not confirm contemporary construction. Even more worrisome in considering the walls of Arausio is the presence of two small streams, the Meyne and the Cagnan, which flowed through the lower northern sector of the city. It is at least possible that the area north of the Meyne, which is restored as enclosed in a rectangle of the city walls, was either the original fortified *castra* of Arausio, or a later addition to a circuit of wall that had always enclosed the St.-Eutrope hill to the south but had to be extended to include the two streams. In either reading of the evidence, no unified single date for the city walls can be assumed. The street system of the center of Imperial Arausio has been established, but only one ancient cemetery has been located, to the south-west of the town center. While the date of its foundation seems well attested by

historical evidence, the archaeological record does not clearly confirm the phys-
ical fact of the town's development in the Octavianic, or even the subsequent
Augustan, period.[81]

Orange contains two substantial Roman monuments, a theater and an arch,
which are in a remarkable state of preservation or restoration; however, they
do very little to establish a datable history for the architecture and develop-
ment of the city, since the chronologies of both are disputed. The theater, at
least in its original plan and decoration, is usually assumed to be Augustan,
perhaps from late in his long reign, but a substantial reconstruction during the
reign of Hadrian is now generally accepted. The remains immediately to the
west of the theater are now convincingly restored as a temple complex, also
of Hadrianic date. On the hill above the temple complex, adjacent to the the-
ater, stand two axially aligned religious monuments that probably constituted a
Capitolium. The arrangement of a theater and temple complex beneath a higher
temple, which would have dominated the surrounding landscape must have cre-
ated a striking impression, recalling either Greek and Italian Hellenistic-period
hill sanctuaries or the sort of monumental layout and planning associated with
larger and grander Imperial cities of the second century CE.[82] Dating the extant
free-standing, triple fornix arch at Orange is far more difficult, as will be dis-
cussed in detail below; the majority of the evidence for dating is contradictory
and ambiguous; dates in the second and even the early third century CE are in
every way as acceptable and as justifiable, if not more so, than the once-common
assignment of it to the reign of Tiberius.[83] A first phase not earlier than the reign
of Trajan, and a substantial reworking in the time of Septimius Severus, makes
sense of its form and its architectonic decoration; that its original dedication
was hurriedly removed does not affect the possible dating, but can perhaps be
explained more readily by reference to events in the early third century.[84]

The sequential development of the city from the later first well into the
second century CE is also attested by the remarkable set of cadastral inscrip-
tions that were discovered beginning in the nineteenth century, and then
much expanded by the fragments recovered in excavations in the Place de la
République, north of the Roman theater, beginning in 1949. The concentra-
tion of inscriptions recovered in this small area probably indicates that it was
the location of the ancient city's record office, the *tabularium publicum*. Carved
cadasters indicating the centuriation of territory surrounding Arausio seem to
have been first erected in 77 CE. As the heading of Cadaster A clearly states, this
was done on the orders of the Emperor Vespasian. Cadaster B, the most complete
of the three discovered, is convincingly dated to the reign of Trajan (98–117 CE),
and Cadaster C, while not specifically datable, must have been commissioned
somewhat later than B. The centuriation indicated by these cadasters is exten-
sive, covering virtually all the territory originally held by the federation of the
Cavares and some beyond it. To the north the centuriation of Arausio appears

to have overlapped the centuriation previously established for the *colonia* of Valentia (Valence) and to the east that of Carpentorate Meminorum (Carpentras), indications perhaps of the growing dominance Arausio was exercising over its area of Gallia Narbonensis, as well as of efforts made to ensure from the start that veteran colonists, and indeed the *colonia* itself as a city, could annex profitable land at will, not just territory that lay within a limited area. Continued study of the cadastral inscriptions from Orange, and the possibility of discovery of more fragments, can only increase our knowledge of the Roman city as well as of the extent to which, and the system by which, it dominated its region of the province.[85]

It is both attractive and probably correct to conceive of Roman Orange as a developed and rather grand town dominating the great road along the Rhône River between the Durance and the Isère, growing more influential and gaining increased quantities of Imperial patronage throughout the second and into the third centuries CE, having sprung from Octavian's veteran colony of 35 BCE and grown steadily ever since. What happened at Orange beyond the first half of the third century CE is not nearly as clear as are events at Arles or Nîmes, though there is a relatively late inscription that records a *taurobolium* (*CIL* 12.1222), and a Christian priest from Orange named Faustinus, although not yet a bishop, attended the Council at Arles in 314 CE. The sparseness of late antique evidence from Orange can only suggest, though admittedly *ex silentio*, that a slow deterioration from its apogee in the late second and early third centuries CE had begun, much as it seems to have done at Nîmes, with the result that, by the early fourth century, Orange too fell very much into the shadow of the renaissance enjoyed by Arles.[86]

Vasio (Vaison-la-Romaine)

Vasio was the primary city of the Vocontii, who obtained this privileged status most likely in the late 60s BCE. Vasio itself never became a *colonia;* it is first mentioned by name only in the middle of the first century CE, when Pomponius Mela (2.5.75) called it one of the *"urbes opulentissimae"* of Narbonese Gaul, a somewhat surprising superlative given the sparse archaeological evidence for the town at that period. Although Vasio apparently remained a secondary locale within Roman Provence, it did at an undetermined time acquire the title *Vasio Iulia Vocontiorum,* and produced a large number of distinguished Romans, including S. Afranius Burrus (the tutor of the emperor Nero), L. Duvius Avitus (suffect consul of 56 CE and legate of the province of Aquitania), C. Sappius Flavius (a military tribune), Cn. Pompeius Trogus (the first century CE historian whose grandfather had received citizenship from Gnaeus Pompey), and, possibly, the great historian of the early Empire, Cornelius Tacitus.[87] Sadly, insufficient stratigraphical recording during early excavations on the site have

rendered it practically impossible to establish a chronology for the development of the town. The best available stratigraphical evidence comes from the Maison au Dauphin, where an early level can be dated to 40–30 BCE lying beneath floors that are certainly from the Flavian period (70s to 90s CE). Otherwise, the earliest datable remains at Vasio appear to be the shops found just north of the Villa du Paon, which appear to have been in use by the second half of the first century CE. Roman masonry techniques appear at Vasio only in the first century CE, probably the second half of it, when *opus vittatum* (a rubble fill faced with small stones) makes its appearance. Ch. Goudineau has suggested that the lack of traditional Roman construction techniques here during and shortly after the Augustan period probably helps to explain many of the unusual features of the site, such as the total lack of evidence for a defensive wall, which would not be needed since the town was not a colony and so was intentionally left open; the lack of any orthogonal gridded street pattern at the earliest levels; the lack, so far, of an identifiable *cardo*; the paucity of parallel or perpendicular streets; and the obvious differences in axial orientation between public buildings and private houses. Only at the end of the first century CE, it seems, was some attempt at city planning made, but that reworking never completely disguised the irregularities of the original layout. Lacking the normal indicators provided by a true Roman street plan, it has proven impossible to identify the location of the forum, and since the site can only be excavated in random sectors due to modern overlay, there is no reliable way to predict where it might have been.[88]

The bridge over the Ouvèze River is usually designated the earliest surviving Roman monument at Vasio, though there is no absolute evidence for this, and no Roman remains are yet known on the left bank of the river. Within the modern town two areas have been excavated (Fig. 18): Le Puymin to the northeast and La Villasse to the southwest. Reliable chronological data is also lacking for Vasio's theater, the city's largest Roman monument. Stratigraphical information was never collected at the site before it was heavily restored in 1932–4. Well-known, heroizing statues of Claudius (sometimes identified as Tiberius for no good reason), Domitian. and Hadrian (the latter together with an elegant statue of Sabina) were recovered from a pit in front of the stage of the theater during excavation. If these are all, as they appear to be, contemporary pieces intended for the decoration of the theater's *scenae frons,* then the presence of Hadrian and Sabina might provide a *terminus post quem* at least for a redecoration of the theater,[89] but that cannot be used as evidence for its original construction. An origin in the second half of the first century CE is usually asserted, but without certain evidence. Evidence of repairs and reworking in both the second and the third centuries is also found within the fabric of the building. The rest of the Le Puymin quarter contains a major public porticus (sometimes called the Porticus of Pompey, after Pompeius Trogus of Vasio) and a number of large houses, all of which can be dated readily to the second century CE.[90] To the

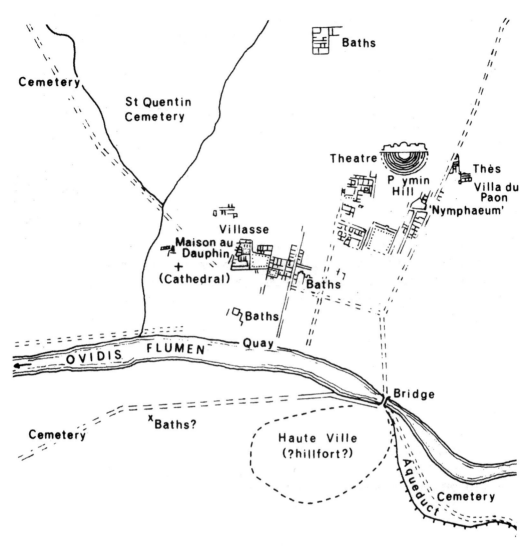

18 Hypothetical plan of ancient Vasio (Vaison-la-Romaine) (after Rivet 1988: fig. 40, p. 290).

southwest the nearby La Villasse quarter contains the well-known "Rue des boutiques," a colonnaded street lined with shops on its east side, and a so-called commercial basilica (heavily restored after excavation) on the west, which was elaborately decorated and could date back into the late first century CE. Beyond the line of *tabernae* on the east side of the street were a number of mansions of, presumably, the wealthy elite of Roman Vasio. These include the House of the Atrium, the House of the Dauphin, and the huge House of the Silver Bust, which expanded over the generations and ultimately seems to have included three peristyle courtyards within one structure. Beyond the La Villasse quarter, remains of *thermae* have been reported under Place de la Poste, in the Rousillon

district and in the La Tour district of the modern town. Large architectural fragments including column drums and capitals remain underneath the floor of the town's cathedral, but nothing further is known about them.[91]

A purported destruction of Vasio sometime in the second half of the third century CE is often cited in historical summaries, but there is no real archaeological evidence for such an event, though it remains a possibility. If it did occur, then Vasio managed to recover since a Bishop of Vasio named Dafenus (or possibly Daphnus), along with an exorcist named Victor, was present at the Council of Arles in 314 CE, and another Bishop of Vasio is recorded at the Council of Riez in 439; indeed, a regional religious council appears to have been convened in Vasio in 442, and yet another Bishop of the town is listed in 475.[92]

Despite the very real difficulties with the excavation and chronology of the site, what we can see and assess at Vaison-la-Romaine provides scattered but convincing evidence for a wealthy hill town, dominated by opulent mansions, that developed from a minor town founded under Octavian, regularized and probably extensively reworked in the Flavian period at the end of the first century CE, and which reached its height of elegance and prosperity – as did many other Narbonese cities and towns – during the second and (perhaps) early third centuries CE. The reason for such an increase in the prosperity of a town as out of the way as Vasio is difficult to understand; one possibility is that wealthy residents of nearby Arausio (the towns are only 20 kilometers apart) built their country villas here, but there is no absolute evidence to support such a hypothesis. Pomponius Mela's inclusion of Vasio among the *urbes opulentissimae* of Narbonese Gaul fits the second century CE town revealed by archaeology very well, but Mela was writing around 40 CE, when there is no such indication of wealth or elaboration provided by the remains; hence his remark remains puzzling. The conclusion that must be drawn from the archaeological evidence, scattered and incomplete as that is for this site, however, is that given above, which brings its rise to prosperity into remarkable agreement with the evidence that abounds in the other major cities and towns of Narbonese Gaul: a foundation early in the establishment of the Roman Empire under Augustus, a rise to remarkable prosperity and the enjoyment of extensive Imperial patronage beginning in the late first century CE and extending into and through the second century, probably even into the first half of the third, followed by a sharp decline in the second half of the third century. The pattern, by now, is readily recognized and would appear to be true.

THREE

ROMAN ARCHITECTURAL FORMS
IN PROVENCE

CONSTRUCTION, DECORATION, AND THE CORINTHIAN ORDER

"Provincia nostra" was brought under Roman military control relatively early, as already described (see Chapter 1). Therefore, we might expect to see Roman building types, design, and decoration – especially a widespread adoption of the Corinthian order of decoration so beloved by the Romans – appear there well before the expansion of the Empire and the establishment of Romanization as a deliberate policy throughout the Empire in the reign of Augustus. However, little hard evidence supports this hypothesis. In part this is due to the overall conservative nature of Roman policy in architectural design, particularly in buildings that employed the Corinthian order. It is now generally agreed that the canonical nature of this particular order was established by its use in the Temple of Mars Ultor in the Forum of Augustus during the final decades of the first century BCE,[1] in precisely the period in which extensive construction of Roman buildings began in the cities and towns of Provence. The conservatism exercised in the use of the Corinthian order can render dating Roman buildings of the Imperial era by stylistic and decorative details difficult. Without epigraphical, textual, or some other independent evidence, physical comparisons and contrasts drawn between elements of the Corinthian order do not provide enough information. Although a great deal of effort has been devoted to establishing patterns of development in the carving of column capitals and other elements of architectural decoration, it is extremely difficult to show that those elements changed in any uniform manner or on any predictable schedule anywhere in the Roman world at any period. Much can be hypothesized, and many detailed studies have focused on the chronological problem, with results that do permit some convincing sequences to be hypothesized for, for example,

the development of carving acanthus leaves on Corinthian capitals in Romano-Provençal monuments, but no absolute "litmus test" can guarantee an absolute date for the construction of a Roman building without independent evidence (from epigraphy, historical texts, etc.) for dating.[2] It is essential to keep this caveat in mind when studying the remaining examples of Roman architecture in Provence.

Construction in Narbonese Gaul made use of all the techniques that were in the repertory of Roman builders. Because Provence is a Mediterranean land, it could provide, if not the exact materials already known to Roman building practice in Italy, in just about every situation an acceptable simulacrum or substitute. Roman construction is an architecture based on the use of wood and timber, earth and its derivatives created by man (particularly brick, both sun-dried and baked, and mortar and cement), and quarried stone of various kinds, colors, strengths, and prices. Because all these items were available (in some sort) in Provence, there is relatively little evidence for the large-scale importation of building materials to the province that is attested for other parts of the Empire, where essential items were lacking (e.g., timber and bricks to North Africa). Provence in Roman times was sufficiently forested to provide the needed timber; bricks and mortar (*opus latericium; opus testaceum*) and cement (*opus caementicium*) could be made with local clays and sands,[3] and the region provided a variety of acceptable building stones so that the import of precious but costly marbles from elsewhere in the Empire is relatively uncommon here, tending to be limited only to decorative elements of presumably official foundations, or those in which ostentatious display was deemed desirable. Roman quarries can still be seen here and there around Provence, and the stone they contributed to local construction is still in evidence at many Roman sites. Thus we are dealing, in Provence, with widespread and well-known forms of Roman architecture executed, for the most part, in local materials.[4] That alone would set the appearance of Romano-Provençal buildings at least slightly apart from that in Roman Italy, but not so much as to produce startlingly different visual effects.

Use of, and variation within, the Corinthian order, and indeed in other elements of the decorative repertory of Roman architecture in Provence, demonstrates clearly, as Pierre Gros has observed, that Transalpine (or Narbonese) Gaul shared with Roman Sicily and Spain a Greek Hellenistic tradition of architectural design and decoration which was already in place when Roman architecture was introduced. This prior tradition may help to explain the relatively wide range of variation that was acceptable within the Corinthian order in Provence, for example, the carving of vegetal decoration on monuments which, in Italy, we would expect to conform far more closely to the norm established by the Temple of Mars Ultor. For instance, the mausoleum (or cenotaph) of the Iulii at Glanum reveals a geometric application of vegetal decoration in its capitals and other stylistic elements, and similar fascinating variations from any sort of

rigid Italo-Corinthian canon may be seen throughout not only the monuments of Glanum (for instance, in the twin temples and the temple to Valetudo), but also in Corinthian order buildings, including the earlier parts of the temple at Vienne, the temple at Vernègues, and a number of monuments known to us only by scattered fragments.[5] In a rare example of the importation of marble for a major monument (probably a gift to the city from the Emperor), the Corinthian capitals of the *scenae frons* in the theater at Arles were carved in Italian marble from Carrara, but the less visible capitals of, for example, the *parascaenium* are of local stone. The contrast is subtle but clear: the Carrara marble capitals conform for the most part to Augustan Corinthian practice, while the local stone examples are much closer to practice elsewhere in Provence, that is, much more like those of the "Rhône arch" or the forum temple in Arles than like their physical neighbors in the theater. Whether or not strict chronologies for the development of these unusual local variations on Corinthian decoration should be assumed, as they frequently are, what seems apparent is that the Corinthian vegetal decoration as executed in local stones and (probably) by local artisans in Provence did not conform to any preconceived or mandated rules being observed in Rome. What is important is to realize that the Corinthian order as carved in Narbonese Gaul provides an appearance – to the buildings it decorated – that was subtly but clearly specific to the areas where they were being used, in the eye of the beholder.[6] Such local versions of standard Roman Corinthian must have made a clear, if subtle, visual statement to informed observers that they were now in the province, not in Italy.

On buildings and monuments that may have had a more "official" character, the local divergences are fewer. This suggests that the Imperially "approved" version of Corinthian was applied more strictly to some types of construction – or perhaps in some cities, or in situations in which stylistic elements could be dictated from Rome, or needed to conform to specifically Italic models – than to others. However, this closer adherence to the Italo-Roman "model" also, by definition, cannot imply strict parallels in dating, since the order itself had become relatively standardized when forced to conform to the Imperial stereotype and so extremely similar decoration and carving might occur in different Roman places spread over more than a century in time. Thus it should occasion no particular surprise that the Corinthian capitals of the Porte d'Auguste or the Maison Carrée at Nîmes, the later elements of the temple at Vienne, or those of the fragmentary so-called Arc admirable at Arles or of the triple fornix arch at Orange conform rather closely to what was standard in Rome.[7] Indeed, it would probably be far more surprising if they did not, particularly given that many of these monuments clearly underwent revision, restoration, and reworking in the course of antiquity. But that closeness in form does not provide evidence for dating in and of itself. What is clear is that, on more "official" types of monuments, the conservatism of the Roman Corinthian order was still influential throughout

the centuries that followed its establishment under Augustus.[8] If there are local variants on such monuments, they are more understated than those revealed, especially, at Glanum and in the contrasting capitals of the theater at Arles. Nonetheless it is fair to state that, even early in its development, Roman architecture in Provence was subtly distinguishable from Roman architecture in Italy, or at least could be distinctive in this manner, depending on the circumstances in which the individual monument was created.

MONUMENTS OF ROMAN POWER, PROPAGANDA, AND HONOR

City Walls, Towers, and Gates

Pre-Roman Wall Circuits

Building a wall around a town or city, or even building a wall around an area with the goal of establishing a city, seems to have been not just the normal practice in order to protect citizens and property in ancient times, but from quite early on an essential element that an organized urban area needed in order to define itself to the world outside that wall. In the area that would become Gallia Narbonensis, defensive walls are attested long before the Roman period. Native walled towns and hill forts as well as Greek-founded Massalia itself and towns that appear to have come under Massiliote influence all built walls.

Iron Age hill forts, or as the Romans referred to them, *oppida*, have been excavated throughout Provence, and many reveal clear evidence of fortification walls complete with ramparts and towers, as early as the sixth and fifth centuries BCE. An example is the oppidum at Ensérune, near Béziers in the western part of the territory (see Fig. 3). This hill fort was surrounded by a defensive wall with stone masonry by at least the later part of the fifth century BCE. The walls at Ensérune stood anywhere from 4 to 6 meters high, had a pathway around the top protected by a parapet, and were reinforced by quadrangular towers spaced along its course. Here chronology becomes somewhat confused, since at Ensérune, as at almost all other hill forts in Provence, there is clear evidence of trade with the Greeks, from whom the local Celts might have been expected to adopt methods of defensive construction, but the basic system, method, and design of walling and wall construction appear to be entirely local and native.[9] The most impressive set of native walls, and the most closely studied, are the fragmentary Iron Age walls at Nîmes (see Fig. 15). The surviving tower of that early circuit, called the Tour Magne, dates from a Roman reworking probably at the end of the first century BCE, and incorporates still visible remnants of a huge pre-Roman wall tower (Fig. 19). The structure would have dominated the Iron Age oppidum itself and would have made an impressive show over all the surrounding territory. The Iron Age circuit walls of Nîmes must have been

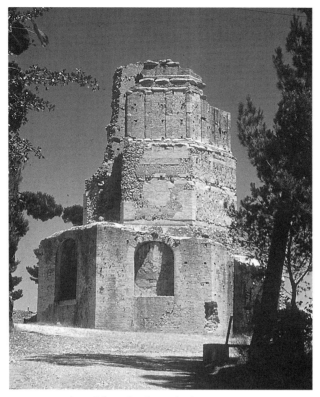

19 The Tour magne at Nîmes (photo by the author).

conceived, at least in part, with the intention to dominate a substantial territory, perhaps even as a visible indication of hegemony over the region. Their reconstruction under the Romans seems to have perpetuated this architectural statement intended to express power and might.[10]

Elements that reveal clear influence from Massalia and the Greeks begin to appear at the same time (in the fifth century BCE and thereafter) and include the introduction of Doric and Ionic elements into column capitals used to decorate early houses at Ensérune, the use of Greek elements in the town plan of the oppidum at Entremont, and the appearance of bastions on hill fort walls at Entremont, Nages, and Constantine. The evidence may best be interpreted as indicating near-contemporary advances in native wall construction and other architectural elements among the hill forts just as the first influences of Greek planning and architecture were being demonstrated and exerted on the locals by the foundation and expansion of Massalia. Indeed the Gallic writer Pompeius Trogus, a member of the tribe of the Vocontii who wrote in the first century CE, implies as much when he states that "Gallia in Graeciam translata" = "Gaul had been reworked into Greece" (or, figuratively, had been "translated into Greek").[11] With the foundation of Massalia ca. 600 BCE, we must consider

the question of when and how far Hellenic influence spread among the native inhabitants of the region.

The earliest walls of Massalia (see Fig. 5) are no longer extant, but a stretch that can be dated to the second century BCE has been uncovered on the north side of the Palais de la Bourse. The stonework of these walls is typically Hellenic, using a facing of regular quadratic masonry without binding mortar. The plan as reconstructed from archaeological remains had to accommodate abrupt changes of direction and angles, and connected directly into the port facilities, which these walls protected. Similarly constructed walls exist at Olbia, a city founded by Massalia about 60 kilometers to the east, at Agde (though only traces remain), at St.-Blaise, and at Glanum, although the date at which either of the last two places came under the influence or direct control of Massalia (if they did so at all) is not clear. Nonetheless, the construction of substantial city walls in both the Hellenic and the native manner – and with some intermixing of those techniques, as at Entremont – was obviously well established and indeed quite sophisticated before the Roman entry. By the second century BCE, just before the Roman military intervention in Gallia Transalpina (as it was then called), native Celtic and Ligurian traditions of wall building had become inextricably entwined with Greek practices. This is well exemplified at Jastres, where square bastions derived from Greek fortification architecture may still be seen in the oppidum's walls, at St.-Blaise, and especially at Entremont. Indeed the destruction of these native oppida during the second century BCE is both puzzling and intriguing. Although clearly in trading contact with and otherwise culturally influenced by Massalia, the native *oppida* seem to have been politically and militarily hostile to the Greek colony despite strong commercial ties. Most interesting of all in this regard is Entremont, the hill fort of the Saluvii, which overlooks Aix-en-Provence (the Roman city of Aquae Sextiae). The site features remarkable defensive walls (see Fig. 4) that meld the best of native and Greek techniques in military architecture and a street plan that suggests – and may well have employed – the planning practices of the Hellenistic era elsewhere in the Mediterranean. Entremont was besieged by the Roman army under G. Sextius in 124–123 BCE, its citizens forcibly evacuated, and its outstanding natural site abandoned. Although the remains suggest that the Saluvii had adopted a good deal of architectural practice from the nearby Greek population, they preserved an implacable resentment toward Massalia, which led the Massalians to call for Roman armed intervention and thus straight to the destruction of the town. What sites such as Entremont do reveal is the extent to which the native, and already Mediterranean-oriented, culture of southeastern France had absorbed the architectural, artistic, and economic influence that came out of the Greek colony at Massalia. To put it another way, in construction of city walls alone, it is apparent that the territory and the towns into which a Roman consular army marched in 154 BCE must have looked quite familiar to the Romans.[12]

Roman Wall Circuits

The Roman cities of Gallia Narbonensis (see Figs. 1 and 2) were all encircled in defensive walls, but the remains of those circuits reveal little information. Textual evidence exists for wall circuits presented to Aix-en-Provence (Aquae Sextiae) and to Narbonne (Narbo Martius), but almost nothing of those walls remains, nor is their exact chronology clear. Construction of circuit walls throughout Roman Provence is quite uniform: gates and passageways, where some sort of impressive architectural effect might be needed, were done in large-scale ashlar masonry, usually of cut blocks in *opus quadratum*, while the long stretches of protective walling were made of *opus caementicium* with facings of small rectangular cut stones and no use of brick. A walkway along the top of the wall was protected by square or rectangular ramparts. Towers were constructed along the length of the circuit, projecting outward from the exterior face of the wall. [13] The lines of the Roman walls of Arles, Fréjus, Orange, and Vienne can be traced and some remains of towers and foundations of each can be seen. The entire circuit of the walls of Vienne can be reasonably estimated at approximately 7.2 kilometers. However, in all cases these walls were extensively reworked, and sometimes removed, in the Middle Ages and afterward, towers were rebuilt or eliminated, and they remain extremely difficult to reconstruct.[14]

The Walls of Fréjus

At Fréjus (Forum Iulii) on the coast (see Fig. 13) several impressive stretches of wall are preserved at different points around the city. These appear to be of early date (certainly not later than the time of Augustus) and thus enclosed a good deal of territory not yet developed. These walls, although not primarily defensive, were provided with parapet and towers. The locations of three of the four main gates are known (north, east, and west) and these effectively define the routes of the main cross-streets – the *decumanus* (east–west) and the *cardo* (north–south) – of the town. The north gate has never been excavated. The plan of the east gate (called locally La Porte de Rome) is known from excavation and a single battered column remains in situ. The west gate (La Porte des Gaules near the modern Place Agricole) has been uncovered (Fig. 20), although the inner side has been hidden by infilling of earth in modern times. The gate had a double entranceway which was flanked by semicircular curves in the wall each terminating in a circular tower, a system also known from the Augustan walls at Arles. The base of one of the towers appears incomplete, suggesting that the course of the wall may have been changed in this area, but that is only conjecture. The extent and technique of the walls, as well as the design of the west gate, strongly suggest an Augustan date, with evidence of periodic patching and reinforcement in later centuries; however, the southern section of the

20 The Porte des Gaules at Fréjus (photo by the author).

wall circuit, as far as la Plate-Forme, has been dated by excavations (in 1991) to between 70 and 100 CE, attesting to alterations in the Flavian period.[15]

The Walls of Nîmes

By far the best known and best preserved of the Roman wall circuits of Provence is that of Nîmes (see Fig. 15). They are also those most carefully explored and published. The Nemausan circuit bears an inscription at the Porte d'Auguste (*CIL* XII. 3151) that reads:

> Augustus portas murosque col(oniae) dat trib(unicia) pot(estate) VIII
>
> Augustus gives gates and walls to the colony in his 8th year of tribunician power (= 16–15 BCE)

At first glance this would seem straightforward, that the gates and walls were a gift to the city from the Emperor Augustus in (or at least announced in) 16–15 BCE. However, both technical studies of the construction technique and reconsideration of what is not, as well as what is, said in the inscription has led some to assert that that date represents solely the time of the approval of funding for the project, and that the archaeological record would more likely date their

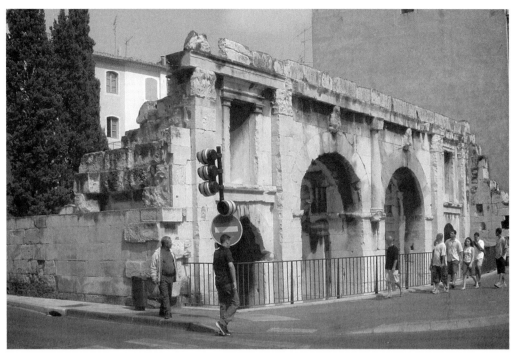

21 Porte d'Auguste at Nîmes (photo by the author).

creation to the first or second decades of the first century CE. This seems a rea-
sonable hypothesis, but no more than that. The remains of the Porte d'Auguste
are substantial, with four separate passageways that led into the city from the
east (Fig. 21). A second known gate, called the Porte de France, lies south of the
amphitheater but is far less well preserved, and was smaller.[16] The ca. 6-kilome-
ter circuit of the walls enclosed some 220 hectares of land. For the great majority
of its circuit, the wall is 2.10 meters thick (almost exactly 7 Roman feet). The
towers along the exterior face of the circuit were placed most often ca. 71 meters
from each other, though that distance could be increased to as much as 96.45
meters when the wall passed over hilly topography, or decreased to as little as
52 meters when it crossed a flat stretch. Tower plans vary considerably: circular
and semicircular are common, some are rectangular projections with walls curv-
ing further when outside the main wall face. The reason for such a diversity of
tower designs is unclear: questions of purpose, elevation, and structural neces-
sity must have played a significant role in the planning and construction of the
structures, but the extent of the diversity is quite unusual, and no single con-
vincing explanation has been offered. The famous Tour Magne (whose predeces-
sor was discussed above) has nothing to do with any of the other towers of the
Roman wall. The Roman reworking of the structure almost doubled its height,
probably intentionally since the Tour Magne stands at the very highest position
in the entire circuit of Nîmes' walls. By far the best explanation would also seem

the most obvious: it was not meant to play a strategic role in the city's defenses, but a propagandistic one. Its plan is that of a hexagonal cone which would have recalled the famous *pharos* (lighthouse) of Alexandria in Egypt. It towered over the plain around the city, with the presumed intent of making Roman power visible from all sides, from both without and within.[17]

As with the walls of all Roman colonies, the walls, gates, and towers of Nîmes served both defensive and propagandistic goals. They offered real physical protection to the cities, but at the same time stated with silent clarity where that protection came from, and kept Roman might an ever present symbol.

Tropaeum Alpium at La Turbie (Le Trophée des Alpes)

Other monuments celebrating the might of Rome were no more subtle than the Tour Magne at Nîmes. Beginning in 12 BCE travelers entered "provincia nostra" along the via Iulia Augusta, a road opened by Augustus after the assumed final pacification of Gaul. Along this new route at modern La Turbie, above Monaco, travelers were greeted with the sight of a massive *tropaeum* rising on the highest point above the road (Fig. 22). *Tropaea* were monuments set up throughout the Roman Empire, often on borders or former battlefields, to commemorate Roman victories at crucial or meaningful sites. They were meant to be noticed. This was not the first *tropaeum* the Romans erected in Narbonese Gaul: apparently Fabius Maximus and Domitius Ahenobarbus raised one at the confluence of the Rhône and the Isère in 121 BCE, and Pompey did the same at a high point in the Pyrenees sometime after his campaigns in Spain (77–73 BCE). Both have disappeared, but they undoubtedly provided the models and the inspiration for the monument at La Turbie. Such *tropaea* were erected on other Roman battlefields and boundaries throughout the Imperial centuries; the *tropaeum* that commemorated Trajan's victories early in the second century CE in Dacia (modern Rumania) still stands at Adamklissi.[18]

The La Turbie *tropaeum* rises 49.67 meters from its base, thus soaring above the height on which it stands, and measures 33.11 meters in circumference; its elevation is divided into three sections: an immense square platform, faced in ashlar masonry, which served as an imposing support for the structure and provided sufficient space to carry a lengthy triumphal inscription flanked by trophies in relief on either side; a circular colonnade in the Tuscan order which surrounded an interior circular cella, all of which stood on a tripartite stepped plinth, with a triglyph and metope frieze running above the column capitals; and above the colonnade soared a round pyramid surmounted (it is assumed) by a statue of Augustus (Fig. 23). What survives today is largely reconstruction carried out between 1905 and 1933, but it stands on the foundations of the original *tropaeum,* and provides an impressive sense of what it may have been like, although only the two lower elements have been restored. The restoration employs, insofar as is possible, the original stones

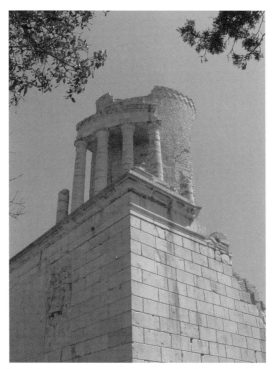

22 Tropaeum Alpium (Trophée des Alpes) at La Turbie (photo by the author).

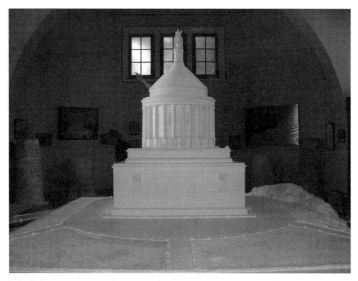

23 Model of the Tropaeum Alpium in the site museum at La Turbie (photo by the author).

used in the monument: local stone from ancient quarries at Mont des Justices near La Turbie, and from a second quarry further to the north, provided the overwhelming majority of the masonry; where marble was employed, it was brought in by boat from the quarries at Carrara in Italy.[19] It is typical

of Romano-Provençal architecture that the local stone was not only used but made visible and apparent.

The message of the *Tropaeum Alpium* (also sometimes called *Tropaeum Augusti*) was driven home by the gigantic inscription placed on its base (*CIL* V. 7817). Only fragments of the original remain, but the full text was recorded by the elder Pliny (*HN* 3.136–7). The first section dates to 7–6 BCE and makes a triumphant Imperial statement, followed by the names of forty-five Gallic tribes who had been subdued:

> Imperatori Caesari divi filio Augusto Pont Max Imp XIIII Trib Pot XVII Senatus Populusque Romanus quod eius ductu auspiciisque gentes alpines omnes quae a mari supero ad inferum pertinebant sub imperium P R sunt redactae gentes....

> To the Emperor Caesar Augustus, son of the deified (Caesar), Pontifex Maximus, in the 14th year of (his) Imperial command (and) the seventeenth of (his) tribunician power, the Roman Senate and People (dedicates this) because under his leadership and auspices all the Alpine tribes who lived from the upper to the lower sea [i.e., from the Adriatic to the Tyrrhenian] have been subdued to the authority of the Roman people, the tribes....

The tribes listed are those who occupied the territory that would later become the province called Alpes Maritimae. In 7–6 BCE that province had not yet been organized, and the territory inhabited by these tribes was apparently thought of as part of the older Gallia Transalpina, which had only recently been reorganized as Gallia Narbonensis. The territory therefore seems to have been connected with "provincia nostra," just as today the greater part of it is in France, not Italy. Writing in the early third century CE, Cassius Dio (54.24) calls the native people of the area Ligurian "Comati," which would suggest that the Romans connected them with the Gallic Ligurians, and considered the territory from La Turbie westward to the river Var, including modern Nice and Cimiez (Cemenelum), as well as a number of other towns around the area, as part of, or associated with, Narbonese Gaul immediately adjacent to it.[20] This would explain the location of the *tropaeum* at the gateway to the region whose conquest it served to commemorate.

At La Turbie, Roman architecture was consciously employed to assert and celebrate Roman conquest and Rome's continuing power. The *Tropaeum Alpium* also affirmed the policy and process of Romanization, in which Rome as the victor bestowed the benefits of its civilization upon the conquered native population, a concept readily embraced by the Romans and one easily used for political messages. The form of the monument recalled the older tradition, of mausolea, massive tomb monuments that propagated a political or dynastic message at the same time that they served as tombs of the once rich or powerful: the mausoleum of Halicarnassus in Asia Minor, that of L. Munatius Plancus at Gaeta in Campania, and that of Caecilia Metella on the Via Appia were all examples of

this architectural tradition which not only held the remains but also served as cenotaphs to recall the distinguished dead buried in them and what they had accomplished by their deeds, in particular military victories. A *tropaeum* was not, and did not claim to be, a dynastic tomb; it was a monument to commemorate victory whose form was modeled on that of the mausoleum and promoted a somewhat similar message of Roman solidarity and tradition.

Free-Standing Arches: Honorific and Triumphal

Provence contains a remarkable series of free-standing arches – more than in any other single province of the Roman Empire – six, seven, or eight of which (depending on how one counts the examples at St.-Chamas and Cavaillon)[21] are still standing: single fornix examples survive at the St.-Chamas bridge, Glanum (St.-Rémy-de-Provence), Carpentorate (Carpentras), Cabellio (Cavaillon), and Aquae (Aix-les-Bains), and a triple fornix at Arausio (Orange). We also have evidence from architectural and sculptural fragments, from fragmentary inscriptions, or from literary references for as many as four arches at Arelate (Arles): the arc du Rhône, arcus admirabilis, and arcus municipalis (or arc de la porte d l'Aure), as well as an arch that dates perhaps to the Antonine age or possibly later.[22] Fragments of others have been found or recorded at Avennio (Avignon), Narbo (Narbonne), Baeterrae (Béziers), Apta Iulia (Apt), Tolosa (Toulouse), and Dea Augusta (Die). Each of the surviving examples presents questions and contradictions that call for further study, especially when attempting to establish their dates. The fragmentary arches will be cited only for comparison, contrast, and chronology where appropriate; in a number of cases their dating, too, remains uncertain.[23]

The Bridge Arches at St.-Chamas

Two arches, similar in design, execution, and inscription, stand at either end of a Roman bridge that crossed the small river Touloubre on the Roman road that ran between Arles and Marseille (Fig. 24). No Latin toponym for the bridge or the spot survives. Although extensively restored some time around 1763, again around 1820, and after the Second World War,[24] the arches almost certainly look as they did in antiquity. Each arch stands 3.80 meters high, and features a fluted Corinthian pilaster on each side. The pilasters carry the flat entablature above the inscription and support the architrave and frieze course which bears the inscription. Above the inscription is a cornice line. Finally, lions crouch at each end of the arches' flat tops (Fig. 25). The arcuated lintels (ca. 2.90 meters high) are contained within the space defined by the fluted pilasters; the arches themselves spring from poorly preserved pilasters at the top of which a cornice marks the start of the arch's curve. Overall, the form, size, proportions, and decoration of the St.-Chamas arches recall those of Augustan single fornix arches in Rome (the so-called Arch of Gallienus) and Italy (e.g., the arches Aosta, Pola, and Sergi).

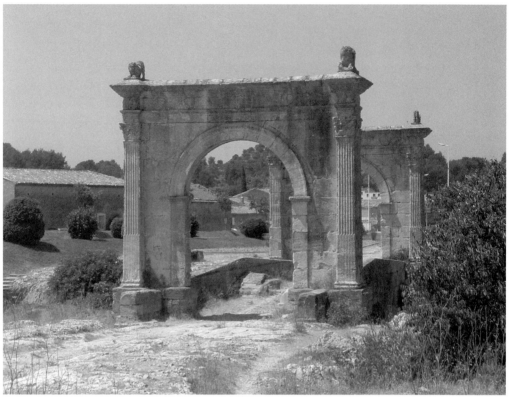

24 Arches at either end of the Roman bridge at St.-Chamas (photo by the author).

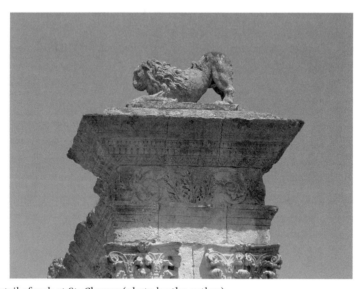

25 Detail of arch at St.-Chamas (photo by the author).

Based on these similarities the arches and the bridge are often dated to the reign of Augustus, sometimes in the middle period of his reign (i.e., before 2 BCE) and sometimes at the end (first or second decades CE).[25] However, a date in the second century CE has also been proposed with some justification through provincial comparanda.[26] As we will see, major discrepancies in the dates assigned to the arches of Roman Provence are the rule, rather than the exception. While a number of Roman bridges featuring a single arch at mid-span survive in various parts of the Empire (e.g., the Trajanic bridge at Alcantarà in Spain), no others survive with arches at either end, though the arrangement is attested on coins. The identical inscription (*CIL* XII.647) that appears on the frieze courses of each arch records their dedication according to instructions given in the will of one Lucius Donnius Flavos, son of Gaius, a flamen of the cult of Rome and Augustus. Donnius Flavos himself is otherwise unknown to us, as are the two executors of his will who are also named in the inscription (Gaius Donnius Vena and Gaius Attius Rufus). The inscription also does not indicate in which city Lucius held his flaminate, although the location of the bridge would make either Arles or Aix-en-Provence reasonable possibilities. The donor's cognomen – Flavos – has provided the (occasionally misleading) common name "Pont Flavien" to the bridge;[27] even more misleading is the periodic labeling of these arches as "triumphal" when they are clearly honorific, more specifically commemorative. Hence, the bridge arches of St.-Chamas were meant to perpetuate the memory of their locally distinguished donor, not to propound a specific message, except in the mildest of ways by recording that he was a priest in the cult of Rome and Augustus, that is, the Imperial cult.[28] No absolute dating can be convincingly established.

The Arch at Glanum

Although most of its superstructure has long disappeared, the arch at Glanum (Fig. 26) still preserves enough of its architectural decoration to suggest both its original elegance and its message; moreover, partial reconstruction is far easier than with the more fragmentary examples at Carpentras and Cavaillon. The archivolt at Glanum is about 6.85 meters high; the arch springs from plain pilasters in *opus quadratum* crowned by a cornice where the curve begins. The curved section of the archivolt is deeply carved with what seems to be a single massive swag made up of leaves, fruit, and pine cones, contained inside a delicate framing molding. The interior of the vault is decorated with finely carved hexagons, the center of each featuring a rosette. The vegetal motifs applied to the arch, as well as the carving, are highly reminiscent of that found on religious buildings in the town. Flanking the archivolt on either side are attached columns: the capitals are missing, but their bases, proportions, and fluting clearly indicate the Corinthian order. The columns frame reliefs of male and female captives chained or otherwise bound. In the south panel on the west side of the arch, the columns frame a relief carving of a trophy (*tropaeum*) with

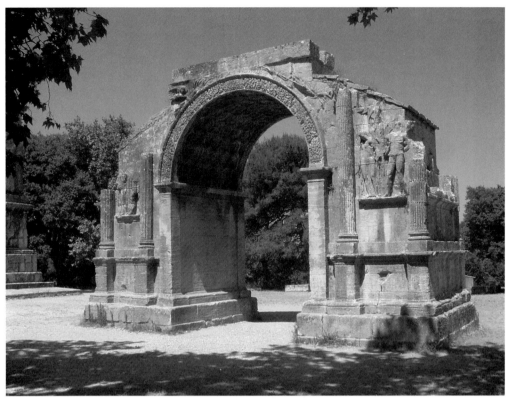

26 Arch at Glanum (St.-Rémy-de-Provence), south face (photo by the author).

a female figure turning to her left and a male figure with arms bound, turned away from her (Fig. 27). In each of the surviving reliefs, the figures stand on what seems to be a platform or altar of ashlar masonry, so that their feet are placed about a third of the way up the height of the attached columns' shafts, clearly suggesting these were spoils of conquest being displayed by the victorious Romans. Winged Victory figures originally flew in the spandrels of the archivolt, but they survive only in part. Henri Rolland has proposed parallels in design with ostensibly Augustan arches such as the one at Pola,[29] not to mention the clear repetitions of the same spandrel décor in the Narbonese arches at Cavaillon and Orange. Victory figures located in the spandrels became standard on free-standing arches by the later first century CE (e.g., the arch of Titus in Rome). Nothing remains of the superstructure of the arch, nor is there any trace of an inscription.[30]

The arch stands on or near the *pomoerium* (sacred boundary) of ancient Glanum, next to a cenotaph (sometimes often misidentified as a mausoleum) which commemorated the family of the Iulii (see Fig. 9). Their proximity has caused the arch and the cenotaph to be connected for stylistic and dating analysis, but no clear connection exists; they are better approached as entirely

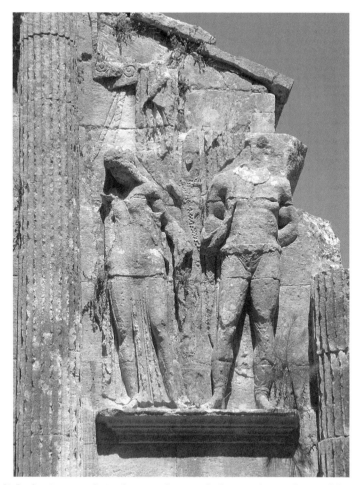

27 Relief of prisoners chained to trophy, south face, arch at Glanum (photo by the author).

separate monuments. Their connection is reinforced by the tradition of lumping them both under the popular label of "Les Antiques." Discussion of dating for the arch at Glanum continues, tied as it is to the dating of other arches in Provence; the most widely accepted dating would place it in the second decade of the first century CE (10–20 CE), primarily on the hypothesis that its decoration – especially the prisoner panels – would have been particularly appropriate to its location, not far from the important Via Domitia, and during the nervous years of the transition from the long reign of Augustus (who died 14 CE) to that of Tiberius. While such an emotional analysis may seem slightly stretched, it is now widely accepted, and in turn has influenced stylistic studies of the architectural decoration on this arch, as well as proposed chronologies for the group of Romano-Provençal arches.[31] However, this date is by no means certain, as it depends heavily on comparison with the other Roman arches of Provence, whose chronology is unsure.

The Arch at Carpentras

Even less of the arch at Carpentras survives (Fig. 28) than of that at Glanum. At first, the two appear to be much alike, but the similarity is illusory and fades with closer observation. This arch was moved from its original position at the farthest extent of the *cardo* of Carpentras (Roman *Carpentorate*) and, presumably, at the point where that road crossed the town's *pomerium*, in which case its location relative to its town was much like that of the arch at Glanum. It now stands next to the Episcopal palace of Carpentras, recessed into a corner. Nothing remains of the arch above the archivolt; the decorative vegetal carving does recall that at Glanum (Fig. 29), but also that at Orange and Cavaillon. The most interesting remnant is the figure relief on its west face, which shows a trophy with captives chained one on either side of it (Fig. 30). This trophy relief is utterly dissimilar to the southwest one at Glanum (see Fig. 27). Here the huge frame of the trophy itself dominates the captives with heavy beams extended over the heads of each one, and weapons clearly hung on its central trunk. The captives are not generically "Celtic" or "Gallic" but rather are quite specifically connected with the eastern and western barbarians who threatened the *pax Romana*. A Parthian or Armenian stands to the left, identifiable by his Phrygian cap and his costume that includes pants and a fringed cloak; on the right is a powerfully muscled, bearded man dressed only in a heavy cloak of furred animal skin, all but a cliché of the Roman concept of a German barbarian. A similar, but much more battered, relief decorated the other (east) face, but not enough remains to show any compositional differences.

Dating the arch has long been a matter of disagreement; Courtet (in 1848) and Mingazzini (in 1957) argued on grounds of sculptural technique for assigning it to the late second century CE.[32] Gros initially assigned it to the first decade of the first century CE, but he has recently reconsidered and suggested that its symbolism would be more appropriate to the first years of the reign of Tiberius, in the late second or third decades. Discussion continues: the majority opinion would place it in the first half of the first century CE and connect it to the Emperor Tiberius; however, there is no proof, and a much later dating – to the Antonine or even Severan periods – remains a distinct possibility.[33] Disputes over dating aside, the message carried by the arch, as implied even in its fragmentary and battered condition, seems rather more specific than that on the arch at Glanum but it at the same time seems less specifically aimed at the people who would have seen it, the inhabitants of Carpentras in Roman times. If so, then its message would still have been obvious, but potentially less individually meaningful to its intended audience.[34]

The Arch(es) at Cavaillon

Possibly the most beautiful decorative carving on any Roman monument in Provence, certainly among the arches, remains visible today on the so-called

28 Remains of the arch at Carpentras (Carpentorate), in situ (photo by the author).

tetrapylon or *quadrifrons* (i.e., four-sided) arch at Cavaillon (Cabellio). But this arch, like the one at Carpentras, has been moved from its original location; and this one has been reconstructed to give the false appearance of a unified quadri-frontal arch (Fig. 31). In fact, the surviving archivolts – which were placed together on the same platform after being moved to their present location in 1880 – came from two separate arches. They were originally twin arches, each of which marked a monumental entranceway to the reserved sacred area or *tem-enos* of a temple. The floral and vegetal carving that survives is extraordinary and comprehensive (Fig. 32): even the pilaster bases are covered in low relief decoration, from the plinths to the torus and scotia moldings. The elegance of the carving is remarkable, and while it is most often compared to, and dated by analogy with, the architectural decoration of the arches at Glanum, Carpentras, and Orange, no independent evidence exists. The date most frequently sug-gested is the late Augustan period (first or second decade CE) but datings as late as the fourth century CE have also been proposed.[35] Walter suggests that bronze winged Victories may have been attached to the spandrels of the arch, and draws a comparison to the Trajanic arch at Ancona, which further suggests that a dating for the decoration of the original arches at Cabellio in the second century CE might make sense, a date which could further suggest a chronologi-cal relationship to the arch at Orange.[36]

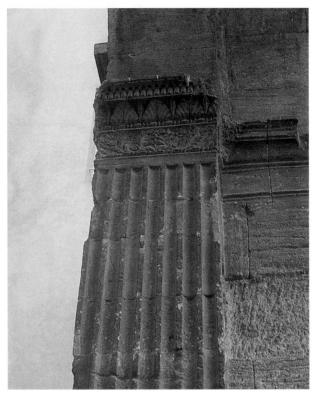

29 Decorative carving on the arch at Carpentras (photo by the author).

The Arch at Aix-les-Bains

At first glance, the single fornix arch at Aix-les-Bains (Roman Aquae) in the province of Alpes Maritimae (adjacent to Gallia Narbonensis on the east) comes as a shock. In total contrast to the arches in the Rhône valley and surroundings, this arch has little sculpted architectural decoration of any sort. Its decorative scheme comprised eight niches which were apparently intended to hold portrait busts of individuals connected to the family of its dedicator. The arch carries an inscription to Lucius Pompeius Campanus, who had also been responsible for a substantial bath building in front of which the arch was positioned. This arch is by tradition dated to the last quarter of the first century BCE, but for no apparent reason: the inscription does not provide a date, nor does the minimal architectural sculpture suggest one, unless it is assumed to be an arch that reproduces the decorative scheme of an Augustan *columbarium,* which seems unlikely at best. A different proposal would date the arch by its connection to the baths in front of which it stood, and based on the responsibility of the same benefactor for both structures. While not susceptible of absolute proof, this suggestion seems sensible. If accepted, then the dating of the arch at Aix-les-Bains should be placed in the second century CE, under one of the Antonine

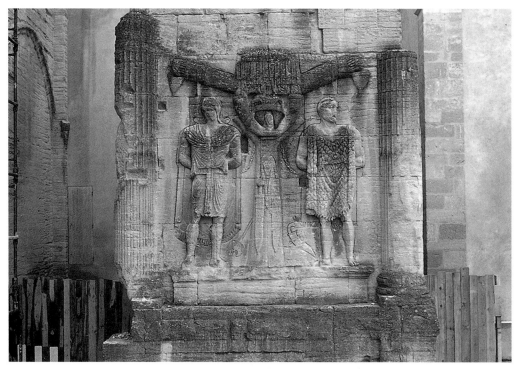

30 Trophy and prisoners relief on west face of arch at Carpentras (photo by the author).

emperors, and so it becomes a Romano-Provençal monument of the high Empire, not the early Empire. The hypothesis makes sense of the arch within its ancient topography, and thus is especially attractive.[37]

The Arch at Orange

Of all the Roman monuments in Provence, the triple fornix triumphal arch that stands at the north end of Orange is probably the most controversial; architecturally and sculpturally, it is also one of the most impressive. It stands 18.50 meters high; the central fornix is 8.87 meters high, and each of the side fornices 6.48 meters high. In antiquity it marked the point at which the main road from the north entered Arausio (see Fig. 17), and it must have served as a memorable landmark for *adventus* (arrival) or for *profectio* (departure). The architectural decoration on the arch is eclectic and shares a number of elements with the arch at Glanum. This similarity may be indicative of typical Romano-Provençal taste; but the arch at Orange also possesses much that is unique.

Similar to Glanum is the use of engaged columns to frame the three fornices (Fig. 33). The columns stand on individual pilasters that descend to the ground, where they end in true bases or plinths. This system of lower columnar articulation appears – outside Roman Provence – only on arches dated to the reign of Septimius Severus and later (i.e., not before the early third century CE). The

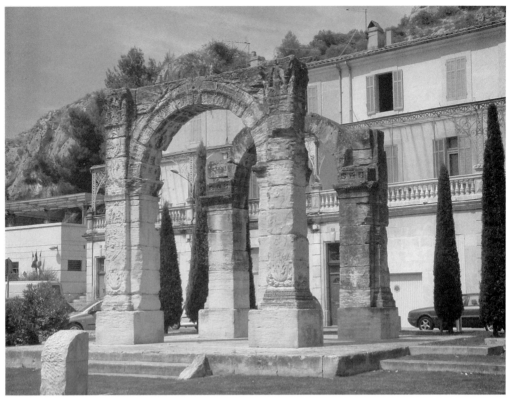

31 Arch(es) or Quadrifrons at Cavaillon (Cabellio) as reconstructed in situ (photo by the author).

arch at Orange also shares with the arch at Glanum molding profiles that are flatter than those common to arches in other parts of the Empire dated to the first century CE. However, this particular molding profile is common in arches of the high Empire. Another stylistic tendency common to both arches is the use of scrolled vegetation to decorate the surfaces of both pilasters and archivolts (Fig. 34). Again, this detail is uncommon in Augustan or Julio-Claudian architecture (early first century CE) other than in Provence; it came into general popularity only in the Flavian era (late first century CE) in Rome; thereafter it reappeared in both Hadrianic (second century CE) and Severan monuments in various parts of the Empire. Decorative elements unique to the arch at Orange (at least among the Provençal arches) include the springing of the archivolt from richly profiled impost blocks above cornices whose decoration continues into the cornices themselves (Fig. 35). This particular decorative detail appears in painted architecture as early as the Second Pompeiian style of fresco, but not in stone until much later. But most striking of all the unexpected elements is the arcuation that springs over the horizontal pediment carved on the narrow east and west faces of the arch, thus creating what looks like a niche above the central sculpted panel on each face (Fig. 36). This second anomaly in the

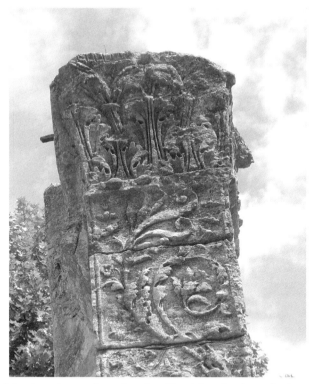

32 Detail of floral carving on the arch at Cavaillon (photo by the author).

architectural decoration is, again, seen in the fantasy architecture of Second Style Pompeiian fresco (e.g., Room 16 in the Villa of the Mysteries), but not in stone until the time of Hadrian (e.g., the colonnade that surrounds the Canopus at his villa near Tivoli). There appears to be space in the spandrels on either side of the central fornix, and the presence of attachment holes there supports the supposition that Victories – presumably of bronze, attached to the arch face and shown winged in the manner common to triumphal arches of the Imperial period – framed the central passageway, comparable to those assumed to have decorated the Trajanic arch at Ancona and probably one in second-century CE Rome attested on a coin.[38] In sum, in architectural decoration alone, the arch at Orange clearly shares some of the Romano-Provençal repertory with the arch at Glanum (and, in some elements, those at Carpentras and Cavaillon, as well as with a number of the decorated fragments known from arches that once stood at Arles), but seems to present no correspondence to the decorative tradition of arches outside Provence until one looks to the second century CE and later.[39]

Also open to question is the likelihood of a triple fornix arch being erected in Gallia Narbonensis as early as the first decades of the first century CE. Fragmentary evidence exists that can be interpreted to suggest the existence of three-bayed arches as early as the second century BCE. One example served as a

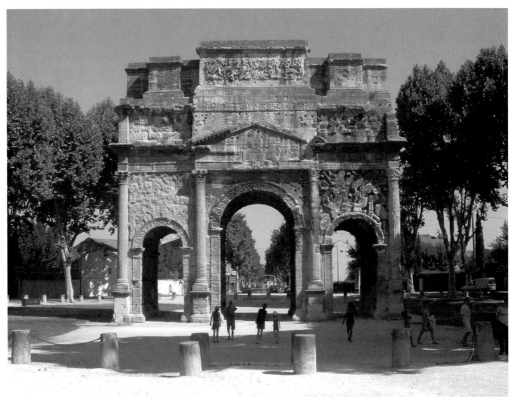

33 The Arch at Orange (Arausio), south face (photo by the author).

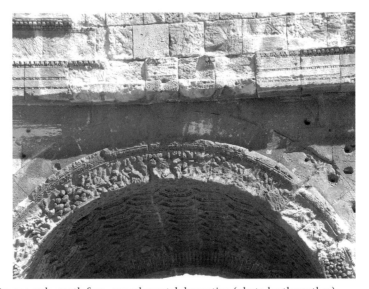

34 Orange arch, south face, carved vegetal decoration (photo by the author).

35 Orange arch, carved impost block (photo by the author).

gateway to the forum at Cosa; however, these remains are inconclusive and Gros, among others, dismisses that interpretation of them.[40] Any occurrence of a triple fornix arch, if indeed they occurred at all, before the second century CE, was rare. Other examples have been identified in Rome, Mainz, Arles, and at Medinaceli in Spain. The fragments of statuary from two arches of Germanicus – one in Rome, one at Mainz – suggest but do not prove conclusively that both might have been three-bayed, and datable to 19 CE. At Arles the battered fragments generally attributed to the otherwise vanished Arc admirable include scrolls and vault coffers of differing sizes, which could imply bays of different heights. Gros has suggested that the still extant three-bayed arch at Medinaceli in Spain might be of mid-Augustan date. His dating cannot be accepted, however, given that the supposed text of the Medinaceli arch's dedicatory inscription, upon which the dating is based, is every bit as much a fantasy as that proposed for the arch at Orange (see below). The Medinaceli arch has been more convincingly dated on stylistic grounds to the Severan period by Collins; as at Orange, there is nothing to render any date for it secure, so, as a comparandum, it is useless.[41] From the reign of Trajan onward, on the other hand, such triple fornix free-standing arches become an increasingly important feature of Roman Imperial architecture throughout the Empire; the arch at Orange would occasion no surprise if it were included within the sequence of such three-bayed monuments as the Trajanic arches at Leptis Magna in Libya and Timgad in Algeria, the arch of Hadrian at Gerasa in Jordan, and arches constructed in the reign of Septimius Severus both in the forum at Rome and at Palmyra in Syria. The weight of surviving architectural and sculptural evidence favors such an Imperial dating for the arch at Orange, and indeed after the arch was freed from the medieval walls

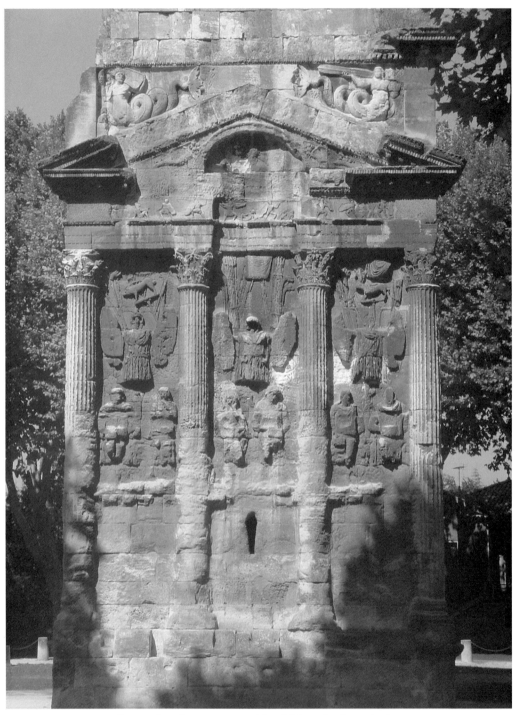

36 Orange arch, west face showing arcuated lintel (photo by the author).

37 Orange arch, south face, shields with names incised among piles of weapons (photo by
 the author).

of Orange (which had encompassed it) and restoration was completed in 1825,
that is exactly the period to which it was consistently assigned by antiquarians
and many scholars of the period before any attempt had been made to devise a
text for its nonextant inscription.[42]

In the mid-nineteenth century, Lenormant noted that there were what
appeared to be names incised into some of the shields that form parts of the reliefs
of *spolia* that decorate the arch above each of its side bays (Fig. 37). Two of these
names were also known from other sources: BODVACVS and SACROVIR (*CIL*
XII.1231). "Boduacus" occurs on two other inscriptions from Gaul; "Sacrovir"
is known from four; more importantly, however, an Aeduan chieftain who is
called Julius Sacrovir by Tacitus (*Ann*. 3.40) fought against Tiberius in Gaul in
21 CE (see Chapter 1). The occurrence of this name led Lenormant to propose
the reign of Tiberius as the date of foundation of the arch, although none of the

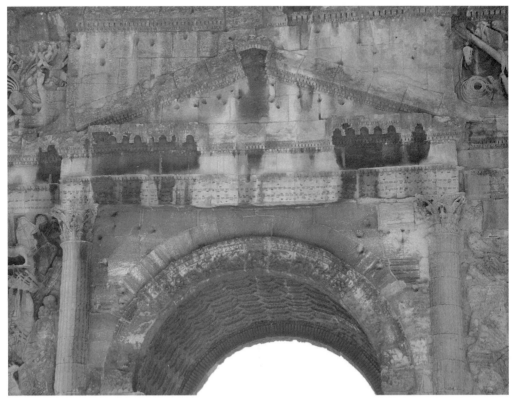

38 Orange arch, north face, detail of architrave course with clamp holes (photo by the author).

other names of Gauls on the shields could be dated so there is every possibility that some of them lived after Sacrovir, if this is indeed the Julius Sacrovir attested by Tacitus. The occurrence of the name does provide a possible *terminus post quem* for the construction of the arch, but nothing more.

The north-facing architrave course of the arch at Orange carries a series of clamp holes (Fig. 38). These have been postulated to have attached an inscription in bronze letters to the arch. Since the letters were not countersunk into the stone itself, no actual letters or words can be read. Nonetheless, in 1880 Bertrand proposed a text to fill the clamp hole patterns on the arch:

AVGVSTI F DIVI IVLI NEPOTI AVGVSTO
"To Augustus, Son of Deified Augustus, Grandson of Deified Julius"

and assigned the arch to Tiberius, in keeping with Lenormant's earlier hypothesis. This invisible text was accepted into the *Corpus Inscriptionum Latinarum* (XII.1230) and came to be taken as fact. However, neither that text nor any other can be convincingly restored to a mere series of clamp holes that form more-or-less square or rectangular patterns when it is remembered that the letters would all have been uppercase letters of the Latin alphabet, which are

overwhelmingly squared in outline and hence would all leave square or rectangular patterns of holes if clamped to a flat surface without being countersunk. In 1962, Amy and Piganiol proposed an expansion of the text of *CIL* XII.1230 which would fill every observable clamp hole on the north architrave. Rather than clarifying ambiguities, however, their proposal compounded the problem. In order to attach the letters for this lengthened text to the extant clamp holes, it is necessary to assume that the letters A and E were attached with six different patterns of clamps each; O with seven; V (as either vowel or consonant) and R with five; D, P, S, T, and X with four; and D and F with two. Since the letters required by this text could not be attached with consistent patterns, it should be apparent that the text hypothesized is most likely not the one that was attached to the series of holes that survives. Nor can any other text be devised that will necessarily surmount the difficulty, because the difficulty lies in the square profile that characterizes the capital letters of the Latin alphabet. In sum, there is no acceptable text for the dedicatory inscription that may have been added to the north face of the arch. Furthermore, it is also apparent on the arch itself that, if a text was clamped there at all, it was a replacement. The clamp holes run across the architrave course of the north face, where they would have covered the three fascias carved into it (as was canonical). The normal position for an inscription on a Corinthian entablature is on the frieze course above the architrave. But at Orange, Amy's measurements demonstrate clearly that the surface of the frieze course has been deeply cut back on the north face, as if something – whether an earlier inscription or a low relief carving – had been intentionally scraped away. This rendered the frieze course too deep to carry a new inscription since the cornice beneath it stuck out so far after the scraping back that the bottom halves of the letters would have been hidden from a viewer standing at ground level. This must have forced the replacement inscription to be clamped onto the architrave instead, so that it could be read at all. On this evidence, the hypothetical text of *CIL* XII.1230, as well as its expansion by Amy and Piganiol, must be doubted and, probably, rejected. And with it doubt must be cast upon any textual or inscriptional evidence that "requires" (or even suggests) assigning a date in the reign of Tiberius to the Orange arch.[43] Arguments continue to be advanced that attempt to dismiss the anomaly of the triple fornix design at a date as early as the reign of Tiberius, and to reassert that date based on the occurrence of the name "Sacrovir" on one carved shield, and from the appearance of other motifs of conquest typical of relief sculpture in Gaul, but – again – the "Sacrovir" inscription in fact provides nothing more than a *terminus post quem* for construction of the arch; the piles of military and naval *spolia* are standard motifs that could come from any time between the late Republic and the late Empire. In short, the popular assignment of the arch at Orange to the reign of Tiberius rests on hypotheses, assumptions, and comparanda that are doubtful at best.[44]

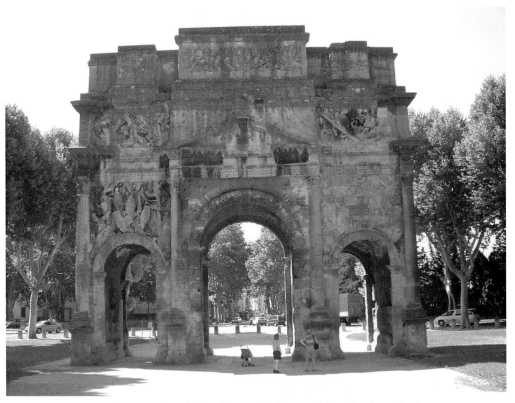

39 Orange arch, view of north face showing double attic (photo by the author).

One more anomaly on the arch at Orange is the fact that it carries a second attic story on top of the single attic normal to most arches (Fig. 39). The visual effect is to make the arch look excessively tall for the height of its fornices (at first glance) or to make it look top-heavy. Equally interesting are the battle scenes carved on both north and south faces of the second upper attic. These show a strong resemblance – in plan and layout, in position on the face of the attic, and in the carving of the individual figures – to the tradition of battle sarcophagi that became increasingly popular in the Roman Imperial period, but they show little connection to examples of Julio-Claudian relief (Fig. 40). So disturbing is the second attic and its battle reliefs that Küpper-Böhm, who otherwise favors a Tiberian date earlier than that assigned to the arch by any other scholar, asserts that this low second attic was added onto an early Tiberian arch (contemporary with the arch at Glanum) in 26–27 CE. This new arch was intended to carry the expanded text of *CIL* XII.1230 (!) as well as a triumphal statuary group on top.[45] She further hypothesizes that this second attic was altered again, the statuary removed, the upper attic now in place added with its battle reliefs, the Tiberian statues then replaced atop the now much higher attic, and the Tiberian dedicatory inscription copied onto the architrave (but still only on the north side of

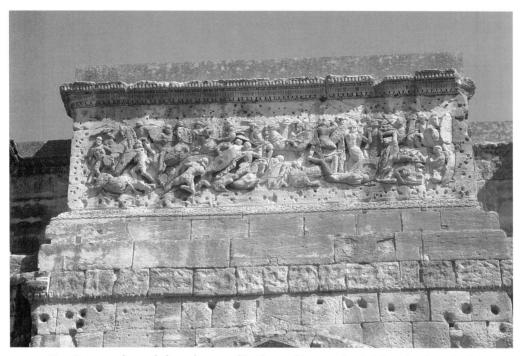

40 Orange arch, south face, close-up of battle panel in second attic (photo by the author).

the arch, which remains inexplicable). All of this was supposedly done in the time of Trajan, early in the second century CE. Küpper-Böhm's reading of the fragmentary evidence is ingenious, but renders the chronological difficulties of the arch at Orange even greater, for she offers no explanation whatsoever for why the old inscription would have needed to be erased in such a Trajanic reconstruction, nor any solid evidence for the earlier (late Tiberian) attic, but her hypothesis of a Trajanic restoration does, at least, permit the battle reliefs to be assigned a dating that places them at an acceptable, though the earliest possible, moment in the history of Roman relief sculpture. However, those battle panels can be even more convincingly dated by comparison to Antonine, Aurelianic, and Severan battle sarcophagi and relief, and probably should be so dated, as Mingazzini first argued.[46]

In recent decades, various dates in the second or early third centuries CE have been proposed for the arch. While debate continues, the possibility of a later Imperial dating has strong appeal. A major candidate must be the reign of Septimius Severus. Severus secured the Imperial throne only after his defeat of Clodius Albinus near Lyon in 197 CE. A triumphal arch whose sculptural program recalled the Romanization of Gaul by force of arms might have been considered a timely or at least appropriate warning to the local population, though Orange does not seem to have been directly involved in any of this. Later in his reign (207/208 CE), Severus passed through Arausio on his way to Britain,

and almost certainly used the city as a staging and recruitment area for that expedition. That would provide another possible point at which an honorific or triumphal arch might have been put up. Here further historical data can be brought to bear. After Severus' death at York in 211 CE, his campaign in Britain was abandoned by his elder son Caracalla, who wanted to bring the western Empire solidly under his control and, sometime in 212 CE, once he had killed his brother Geta and carried out a vengeful *damnatio memoriae* which largely obliterated the younger brother's memory in Italy, Caracalla set out for Gaul and there executed the *proconsul Narbonensis* whom he thought disloyal. If the arch at Orange bore an inscription that mentioned Geta, it would certainly have had to be removed, particularly given the threat that Caracalla might be coming to the province at any time. Such a hasty removal might explain the damage done to the frieze course of the arch, and the obviously hasty and cheap reinscribing by the simple expedient of clamping bronze letters, without bothering to countersink them (which would have taken far longer) onto the architrave, where an inscription did not belong, but where it could be attached swiftly. A Severan date for the arch, at least in its final form, removes a number of the problems and anomalies of its architecture and sculpture and may even offer a plausible explanation for the misplacement of its (still hypothetical) inscription.[47]

The greatest difficulty raised by assigning the arch at Orange to the second or early third century CE is probably the doubt that then must be admitted about the dates usually assigned to the other arches of Gallia Narbonensis, and – beyond the arches – to the dating of other surviving monuments by reference to the supposed chronology of those arches. If all the Roman arches of Provence are still assumed to date within a few decades of one another, as has been regularly hypothesized, and the only secure and independent dating is that assumed from the dubious text of the Orange inscription, then solid evidence for the chronology is sadly lacking. As we have seen, that inscription provides no acceptable evidence for dating.[48] Hence the question remains: are the similarities of decorative carving among the arches of Roman Provence sufficient to justify the hypothesis of contemporary creation, or might they instead constitute evidence for a distinctive taste in architectural sculpture – at least in the decoration of free-standing arches – in Narbonese Gaul? Is this a similarity in chronology at all, or evidence for the longevity of a provincial sculptural repertory? The jury must remain out on that question, at least for the present. It is a question that needs consideration also in relation to the architectural sculpture of other types of Romano-Provençal buildings (as will be suggested below). The shakiness of the epigraphical date so often assigned to the arch at Orange – placing it and its sculptural décor in the early Julio-Claudian period (specifically 20–26 CE) – allows, indeed demands, that questions be raised about all architectural and sculptural datings that have been assigned with reference to it for the Roman monuments of Gallia Narbonensis, and suggests that the architectural history

of the province, and the analysis of its surviving remains, may be rather more complex than has been previously supposed.

RELIGIOUS ARCHITECTURE: TEMPLES AND SANCTUARIES

Vitruvius, the Tuscan Temple, and the Etrusco-Italic Temple

Vitruvius provides the basic description of the temple design most favored by Romans, and calls it "Tuscan" (*De arch.* IV.7). What Vitruvius describes is, in fact, one specific kind of temple plan within a more general and more plastic "type" known as "Etrusco-Italic." The Etrusco-Italic temple and its subtype, the Tuscan temple, shared a number of basic characteristics that distinguished them as a particular and easily identifiable class of building. First, the ground plan of the temple itself is either square or rectangular (the Tuscan closer to a square shape, the Etrusco-Italic tending to have a longer central axis) but is never as elongated as a Greek temple. Second, the temple is raised above the ground on a podium (or socle), often quite high, which both gives it a visual dominance over its surroundings and also sets it apart from them. Third, Tuscan and Etrusco-Italic temples are determinedly frontal; there is never any doubt on which face they were to be entered, since that is indicated by a high axial staircase that ascends to the top of the podium. Fourth, such temples possess a *pronaos,* a porch or open (though often colonnaded) area at the front, from which a panoramic view could be obtained and from which the *auspices* might be taken. Fifth, behind the open porch, such temples had an enclosed area – usually divided into three rooms in the Tuscan type, much more varied (frequently a single room) in Etrusco-Italic examples – called the *cella* (or *cellae* when there was more than one room) and in which there would usually be placed the cult statue or statues, directly on the main axis of the building and facing the entrance. Clearly, these are not truly separate building types at all, but variations on a single basic plan.[49]

According to Vitruvius, Etrusco-Italic or Tuscan temples would typically employ a Tuscan columnar order, as is found at the Capitolium temple at Cosa in Etruria. However, in actual practice they could also be executed in the Doric (e.g., the temple at Cori in Latium), Ionic (e.g., the temple to Portunus in the Forum Boarium in Rome), and, of course, the much-loved Corinthian order (e.g., the Maison Carrée at Nîmes and innumerable others). Beginning in the fourth century BCE the application of Greek decorative orders to this Tuscan/Etrusco-Italic temple type was one of the first developments in a gradual evolution, mutation, and adaptation of the form to tolerate a variety of elements already used in Greek architecture which were probably brought to Rome by architects from the Hellenistic world. The process was completed by about 100 BCE. Vitruvius (*De arch.* IV.8.5) describes the synthesis of Etrusco-Italic plans with

Greek decoration as "*tuscanicorum et graecorum operum communis ratiocinatio*" (= "a common system of Tuscan and Greek practices"). The examples that still exist in Gallia Narbonensis show the success of this *communis ratiocinatio,* as do the better-known specimens from Rome and Italy. They also demonstrate how thoroughly the Tuscan/Etrusco-Italic temple plan was identified with the Romans. Use of this essential temple plan identified religious architecture as clearly Roman in appearance and (by implication) in practice. In *provincia nostra* as throughout the Roman world, temples continued to be built to the same essential plan for centuries.[50]

The Twin Temples, and the Temple to Valetudo, at Glanum

As an ancient town, Glanum had a long and complicated, if not thoroughly understood, development. Our earliest evidence for the site indicates both a religious sanctuary and a native settlement. By the third century BCE a strong Greek element is discernible. Finally, probably not before the Augustan period, Glanum was transformed into a Roman town. The manner in which the quintessential Roman temple plan was introduced into its civic architecture is interesting and illustrative. The process must have been complicated, since it involved clearing a large central space for a complex of thoroughly Roman buildings in the middle of a long-established town (this will be described in more detail below in sections describing Forums). When eventually completed, the area (see Fig. 8) incorporated a triangular space forming a cross-roads, over which two temples gazed from the west surrounded by a *porticus* of some kind, onto which a rectangular forum opened from the north. The two temples were of unequal size and they did not occupy the space inside the *porticus* in an axially symmetrical manner, as we might expect (Fig. 41). Both temples were, in Vitruvian terminology, "prostyle tetrastyle" – which means each had a front porch containing six columns, of which four were across the building's face. Both were decorated in the Corinthian order, with columns standing on Attic-style bases without plinths beneath them and marked by deeply cut scotias, relatively slender fluted columns (the proportion between the lower diameter and the total height of these columns including the capitals is a nearly canonical 1/8), and elaborate carving of the acanthus leaves on the capitals (Fig. 42). Vegetal motifs were used extensively on the undersides of the entablatures of both temples, a feature regularly seen in much of Roman Provence. While this is in no way inconsistent with the architectural decoration of Tuscan and Etrusco-Italic temples in general, the emphasis placed on it here at Glanum is distinctly regional. Individually, the temples are elegantly laid out and proportioned, and the order beautifully carved. Clearly, they were expensive dedications that graced and ennobled their sanctuary town.[51]

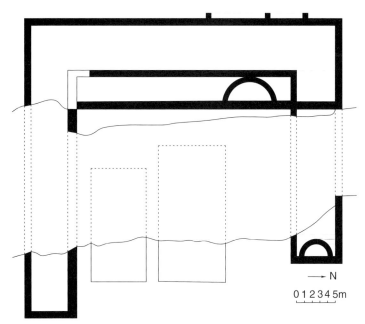

41 Glanum, plan of the twin temples and surrounding porticus (Frakes 2009: cat. #027, drawn by D. Skau; reproduced with permission of the author).

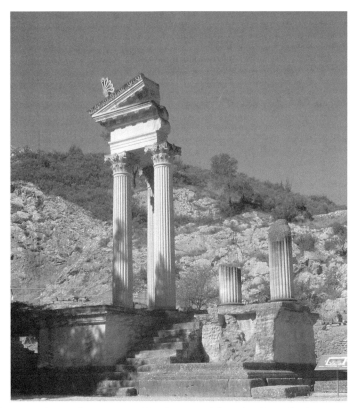

42 Glanum, twin temples as restored in the 1990s (photo by the author).

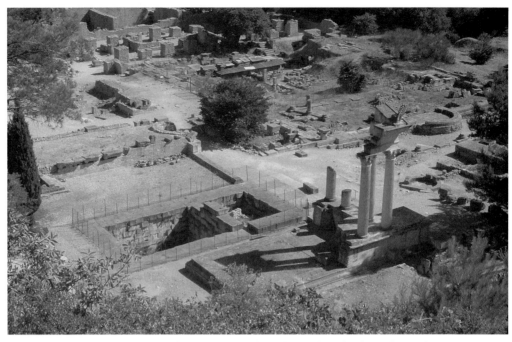

43 Glanum, the twin temples and porticus from above (photo by the author.JCA).

We have no information regarding the deities to whom these temples were dedicated. Of the inscription for the larger temple only the first letter – S – and the last – A – survive, but nothing much can be deduced from that. No obvious reason can be identified for the difference in their sizes. Nor is there any obvious reason for the peculiar arrangement of the temples: the larger temple stands on axis in the exact center of the *porticus,* while the smaller is shoe-horned into the space south of it, between its flank and the more southerly lateral extension of the *porticus,* while the corresponding open space to the north of the larger temple was unfilled (Fig. 43). The visual impression given is of a lacuna, an opening that cries out to be filled, but excavation and restoration on the site have shown conclusively that no third temple or other building of any sort was put there. The *porticus* itself is often restored as a roofed gallery, but there is no certainty that it was more than a three-sided colonnaded portico; although numerous fragments of its cornice are preserved, it is also impossible to tell how high the portico rose.[52] The two temples are usually dated stylistically, by the carving of their Roman Corinthian order, to the decade of the 30s BCE; the smaller temple is analyzed as the older (built at the beginning of that decade), and the larger constructed toward the end of the same decade. There is no other evidence upon which to assign them a date; it would be useful to know how long they survived and if subsequent restoration occurred during antiquity, but no such information has yet been published.[53]

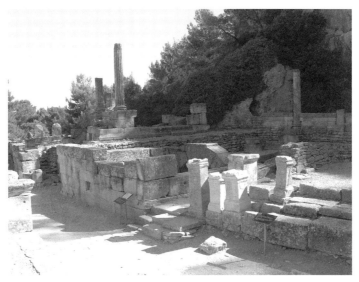

44 Glanum, Valetudo, and Hercules precinct (photo by the author).

Further south in the site of Glanum, as the main road began to climb toward the mountains now called "Les Alpilles," a cult site dedicated originally to a native deity called Glan, who must have given her name to the town, has been excavated. This was a natural spring, and must have been thought to have healing properties, since in the course of Romanization both a shrine or sanctuary to Hercules and a temple to *Valetudo* (Good Health) were erected, probably on either side of the older native shrine. Little survives beyond inscribed altars which assure us of the dedications (Fig. 44). The temple to Valetudo was dedicated by Marcus Agrippa, at the latest ca. 20 BCE and possibly a decade or more before, and a few Corinthian column shafts on the site, as well a surviving pilaster, may well come from it. If so, it was probably a relatively small temple (Fig. 45), but even its exact location is hypothetical; no actual platform has been found. Fragments of architectural decoration, whether from the temple or from the adjacent Hercules shrine, are surprisingly roughly carved, although revealing the same taste for heavy vegetal décor that is revealed on the twin temples (with which the Valetudo temple and Hercules shrine seem to be roughly contemporary) but with far less refined workmanship, sometimes attributed to local provincial artisans. The temple-shrine complex would have served as a Romanizing element for the much older shrine, but at the same time seems to have preserved the essential nature of the native cult place.[54]

The Temple(s) at Vernégues

Two, or perhaps three, Roman-style temples were built over time at a woodland water sanctuary (Fig. 46) in back of what is now the winery of Château-Bas,

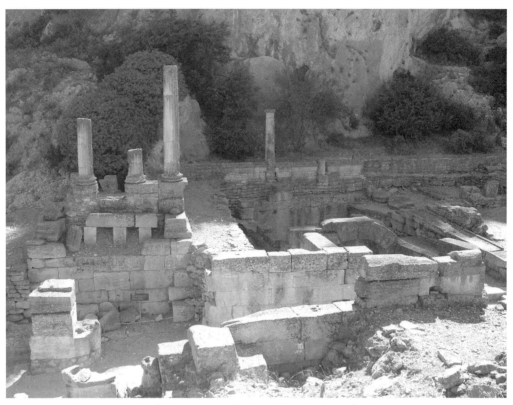

45 Glanum, Valetudo shrine as restored in situ (photo by the author).

near the village of Vernégues (which was destroyed by earthquake in 1909). At
some point in antiquity the temples were enclosed within a semicircular wall,
which implies they were all elements of the same shrine or sanctuary. One has
left behind both a Corinthian column (probably one that stood behind a corner
column of the porch) and a corresponding Corinthian pilaster in local stone. The
design of that temple can be reasonably reconstructed as a prostyle tetrastyle
building, much like the larger of the twin temples at Glanum. An inscription
(CIL XII.501) to *Jupiter Tonans* (Thundering) was discovered at the site, and
the possibility that this was a group of three temples has led some scholars to
speculate that it could have been a rustic shrine to the Capitoline Triad (Jupiter,
Juno, and Minerva). Only the barest foundation traces remain of the second
temple, and there is no actual evidence for the supposed third one within the
enclosure, so the triadic identification seems doubtful at best. The surviving
Corinthian column measures very close to 20 Roman feet in height (Fig. 47),
which would allow speculative reconstruction of the temple by comparison to
those at Glanum; a few remains of a monumental staircase (possibly containing
as many as twenty steps) can be seen in front of the temple platform. An altar
reported from the site had carvings of Jupiter and Minerva (but not Juno), but

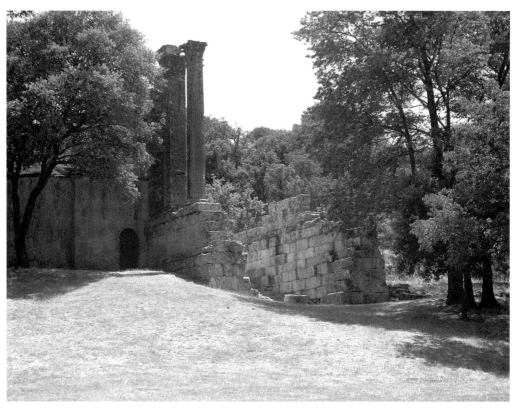

46 Vernégues, the Roman temple at Chateau Bas (photo by the author.JCA).

also Neptune and Mercury; a second inscription found here was a dedication
to Rome and Augustus, clearly of Imperial date (*CIL* XII.513). Traditionally, the
temple was thought to have been constructed in the early decades of the first
century BCE, but comparison with the twin temples at Glanum has caused that
date to be revised to no earlier than 20 BCE. Only recently has the overall nature
of the site – and probably of the temple(s) – become clear, after excavation of
a hydraulic pump, aqueduct, and basin nearby. These are tentatively dated to
between 150 and 50 BCE and may well have been the functioning elements
of an early water sanctuary, which was in turn developed and expanded in
the early Imperial period, on the model of other similar water sanctuaries at
Glanum and Nîmes. If this evidence is accepted, then the presence of a temple
to Jupiter Tonans and the carved altar would not be surprising elements of the
more highly developed sanctuary that was constructed, perhaps, in the late first
century BCE and probably reworked and modified into the first two or three
centuries CE. There can be no doubt that this woodland sanctuary enjoyed a
lengthy existence; burials in the area around it extend its use and existence at
least into the third century CE. Furthermore, the survival of vestiges of the tem-
ple at Vernégues is due to its conversion into a Christian chapel (Fig. 48) – the

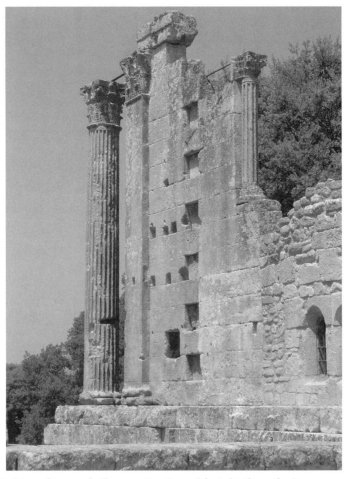

47 Corinthian column and pilaster at Vernégues (photo by the author).

aptly named "Chapelle de St.-Césaire" – parts of which also still stand, a conversion that appears to have taken place only after a period of abandonment of the pagan sanctuary.[55]

Detailed architectural study since 1999 has revealed much about the temple's architecture and reinforces comparison with water sanctuaries at Glanum and Nîmes, as well as suggesting a similarity in overall sanctuary plan to the temple and sanctuary adjacent to the theater at Orange, while proposed elevations of the small temple at Vernégues now suggest a close resemblance (at least in its initial phase) to the smaller of the twin temples at Glanum. The most recent hypothesis argues that the temple was the focal point of a water sanctuary and thus also reflective of the arrival and institutionalization of Imperial (or at least Augustan) cult in Gallia Narbonensis.[56] This theory is generally, but not specifically, supported by the fragmentary evidence of sculpture and inscriptions reported from the site, but it should be noted that the majority of the evidence

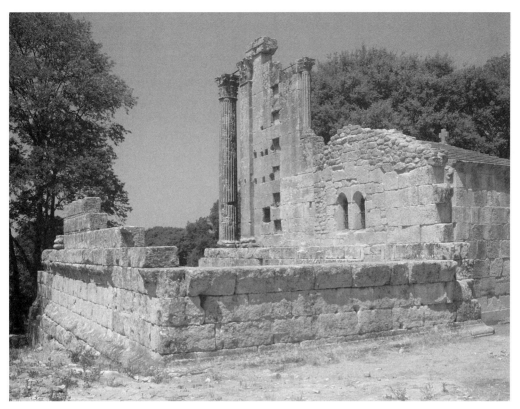

48 La chapelle de St. Césare on temple platform, Vernégues (photo by the author).

suggests development in the Julio-Claudian period at the earliest, if not later into Imperial times, rather than in the Augustan period. It is to be hoped that the recently renewed interest in the site at Vernégues will lead to publication of a full and detailed monograph on the remains of both temple and sanctuary, as well as provoke further excavation.[57]

The "Grand Temple" and the "Capitolium" at Orange

Two temples rose, one above the other, up the north face of the hill of St.-Eutrope at Orange, immediately adjacent to the immense Roman theater (see Fig. 17). Only substructures and occasional fragments of architectural decoration are preserved, but the minimal vestiges that survive suggest two huge sanctuaries that, when complete and able to be seen as the observer approached the escarpment, must have been impressive. Based on no particular evidence, the structure that crowned the St.-Eutrope hill has been called a "Capitolium" temple. This name would imply a tripartite dedication to Jupiter, Juno, and Minerva. The site was excavated between 1950 and 1953 by Amy. He deduced,

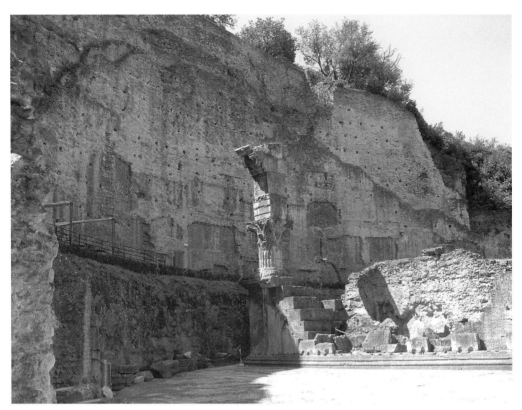

49 Orange, architectural members of the Tuscan temple within the hemicycle (photo by the author).

from the substructures that were about all that remained, evidence for a single cella temple surrounded by a three-sided porticus that stood on a high artificial platform. No further specific reconstruction has been possible. Epigraphical evidence indicates that Arausio did possess a *tabularium,* a records office and archive, a building type generally associated (at least in Rome) with Capitolia, but beyond what could simply be a structural and topographical similarity, no further evidence has been identified justifying the labeling of this structure as a Capitolium. Whatever the dedication of this temple, it must have been an overwhelming visual element of the town during Roman Orange's heyday.[58]

Below the Capitolium a gigantic hemicycle was excavated at an unknown date in antiquity out of the slope of the St.-Eutrope hill immediately to the west of the theater. The semicircular shape of the excavation gave rise to its identification as the rounded end of a circus, and this hypothesis persisted until modern excavations in the 1920s, then again in the 1950s. These excavations revealed that the platform rising on the axis of the hemicycle and just inside it, as well as the numerous fragments of columns and other architectural decoration, came from a substantial apsidal Tuscan-style temple that stood in the hemicycle (Fig. 49), which in turn provided an architectural frame for it. This so-called grand

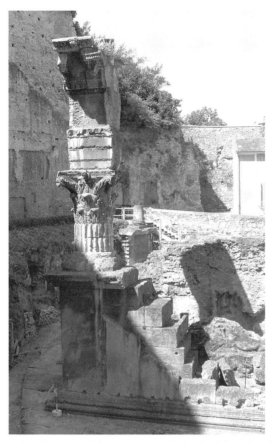

50 Orange, decorative elements of the Tuscan temple in situ (photo by the author).

temple was apparently intentionally placed directly on axis with the Capitolium temple that stood atop the hill behind it. The grand temple can be dated most convincingly to the second century CE or later (Fig. 50); what preceded it in the huge hemicycle area is uncertain, though a recent and logical suggestion would hypothesize an earlier, perhaps smaller, temple set into the curved space defined by the hemicycle similar to the system employed at the water sanctuary at Vernégues. Such an earlier temple would appear to have had a fountain running laterally along at least one side, although again the evidence is incomplete and open to interpretation, though the hypothesis seems consistent with the better preserved evidence from the better understood site at Vernégues and, possibly, from the earliest phase of the *Augusteum* at Nîmes. Further research and excavation might reinforce or alter this proposed reconstruction. What is certain is that, sometime in the high Imperial period, a truly immense temple was added to the already existing religious complex next to the theater and below the so-called Capitolium at Orange, strong evidence indeed for extensive Imperial interest and architectural contribution to the city.[59]

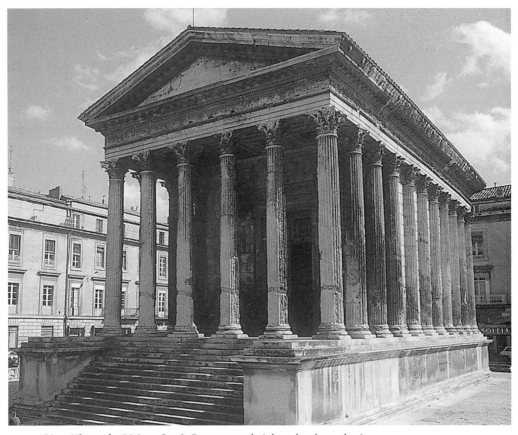

51 Nîmes, the Maison Carrée Roman temple (photo by the author).

The Maison Carrée Temple at Nîmes

The temple commonly called the "Maison Carrée" is arguably, along with the
Pont du Gard aqueduct bridge, the most widely known ancient monument in
Provence. It is also one of the best-preserved buildings from the Roman period
anywhere in the world (Fig. 51). That extraordinary state of preservation can
be attributed to its continuous use without significant alteration or despolia-
tion of the building materials. In addition to its centuries as a Roman temple,
it has served the city of Nîmes as town assembly hall, private home, Christian
church, granary, seat of the city prefecture, and stable for government-owned
horses. Louis XIV considered dismantling it and moving it to Versailles; Thomas
Jefferson, while minister to France in 1785, commissioned a stucco model of
it, which he used as his reference when designing the Virginia statehouse at
Richmond.[60] The temple is generally assumed to have been an Imperial gift to
Nemausus (Nîmes) from Augustus, since the city was refounded (or at least its
name was augmented by addition of the title *Augusta*) with the settling of a
number of the Emperor's veterans there during the 20s BCE; indeed Augustus

may have visited Nemausus during his time in Gaul (16–15 BCE), which might seem the appropriate occasion for such munificence on his part. However, no specific visit to the city is unequivocally attested in our sources.[61]

The remains of the temple are both elegant and impressive. Its design is pseudoperipteral, with six columns across the front and eleven along the flanks; only ten of the columns are free-standing (the six across the façade plus two on each flank immediately behind the corner columns); the rest are semicolumns attached to the exterior walls of the cella. The plan of the temple exemplifies the inherent geometry of design in temples of the Tuscan/Etrusco-Italic type: two squares may be superimposed on the façade: one inscribed horizontally along the top of the columns, descending on each side through the exact center of the corner columns to the horizontal provided by the bottom of the staircase (in technical terms "the interaxial width of the peristyle"), the other square drawn from the overall width of the façade minus the projections of the moldings, that is, a horizontal line drawn along the top of the flat cornice, dropped straight down on each flank along the outer edge of the projecting plinths on each side and then run once again along the bottom of the steps. This inherent squared design produces a remarkable impression of *symmetria*. Wilson Jones has wisely pointed out that the symmetry is not absolute nor rigidly maintained beyond the basic frontal squares: the length of the peristyle is more than twice the width, column spacing on the front is different from that on the sides, and the column bases do not come to quite half the column spacing. Wilson Jones reads this as likely evidence that the architect's original plan was simpler than what was finally built, requiring minor modifications throughout, so that the "ideal" plan in essence is revealed only on the front of the building.[62] The order of the temple is, naturally, Roman Corinthian (Fig. 52), and conforms moderately well to the standard set by the order of the Temple of Mars Ultor, although the depth of carving of the acanthus leaves and their outward projection may seem rather more naturalistic than the Roman model, and the egg-and-dart molding on the abacus is quite different, probably a specifically Provençal variant (Fig. 53). A running frieze of swirling acanthus garlands, on the other hand, strongly evokes Augustan acanthus carving, as seen most notably on the Ara Pacis Augustae in Rome, though a more exact comparison is to the decorative elements that survive from the Temple of Rome and Augustus at Pola.[63] In fact, the architectural decoration of the Maison Carrée, like its plan, seems to be something of a mixture in detail. Perhaps the carving as well as the ground plan underwent alterations during the course of construction or later during the Roman period (as noted above, the form of the building was not significantly altered after the end of antiquity). Although it is common in surveys of art and architecture to cite this temple as a quintessential example of the Augustan, and Vitruvian, ethos, a more detailed investigation suggests that this view is too simplistic.[64]

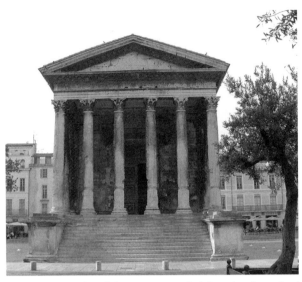

52 Façade and Corinthian order of the Maison Carrée (photo by the author).

In a preliminary summary of his ongoing study of the Maison Carrée, Harstone, basing his observation on measurements taken on the building itself and by making proportional comparisons, asserts that the temple as we see it today was designed using a square grid, that employed a basic modular unit of measurement of 835 millimeters, or just about 2.8 Roman feet. Harstone points out that such an unusual module is improbable if the designer was using the normal Roman foot. We know, however, that in Gaul more than one unit of measurement was used at different periods. For instance, according to Hyginus, during the reign of Trajan (98–117 CE) and well into the second century, a foot was used in Gaul called the *pes Drusianus* or "Drusian foot," equal to the normal Roman foot plus an inch and a half, or just about 333 millimeters. If that measurement is applied to the plan of the Maison Carrée, then the module used for the design of the building is revealed to be 2.5 times the Trajanic *pes Drusianus.*[65] Harstone's discovery raises important questions. Why would an "Augustan" temple be designed using a measurement module that is otherwise securely attested in Roman architecture only for the time of Trajan and later? The evidence of Hyginus, that it was in use among the Tungri (a Gallic tribe centered near modern Liège in Belgium) at the start of the second century CE, is supported minimally in the archaeological record but only for its use in Imperial military construction. A second important point raised by Harstone is amply demonstrated not only by his and by Wilson Jones' measured drawings but also by those published by Amy and Gros in their exhaustive monograph on the temple: the *pes Drusianus* was not used as the measurement module for the elevation of the Maison Carrée, but solely for its ground plan (Fig. 54). Columns, capitals, and upper entablature are all cut in multiples of the standard Roman

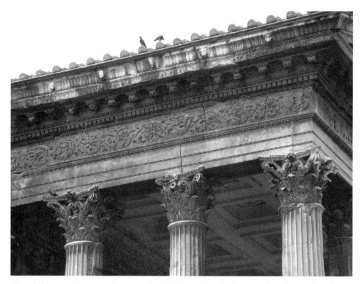

53 Details of decorative carving on the Maison Carrée (photo by the author).

foot. The most reasonable explanation for the use of differing standards of mea-
surement is that the individual stone elements for the building's elevation must
have been rough-cut at the ancient quarries near Lens, from which all the stone
used in the building came, transported to Nîmes already cut to size, and only
finished in detail and refinement on the building site. We know this system was
employed for long-distance, seaborne transportation of marble for buildings all
around the Mediterranean by the second century CE; it could well have been
adopted by local quarries for use in substantial projects anywhere in the Roman
world. While the process of rough-cutting column shafts to standard sizes can
be documented in quarries in Greece, Asia Minor, and Egypt by the middle of
the first century CE, there is no evidence that it was in place as early as the age
of Augustus. Thus the oddity of the occurrence of the *pes Drusianus* at Nîmes is
compounded by the fact that the building's elevation was measured in standard
Roman feet, unless the elements of that elevation were supplied premeasured
and precut. But the available evidence does not suggest that that quarrying sys-
tem would have been in use in the Lens or other local Provençal quarries as early
as the temple is traditionally dated. There is clearly a conundrum somewhere,
which threatens to become a contradiction.[66]

As on the arch at Orange, the entablature of the Maison Carrée reveals a
series of clamp holes running across the frieze course and, though in a shorter
stretch, the architrave below it (Fig. 55). Several texts have been proposed to fill
these holes, with the most popular being the one that also requires the smallest
number of variant clamping patterns for the same letters to be accepted, a text
which appears as *CIL* XII. 3156, and was reasserted by Amy and Gros in their
monograph. That hypothetical text would run as follows:

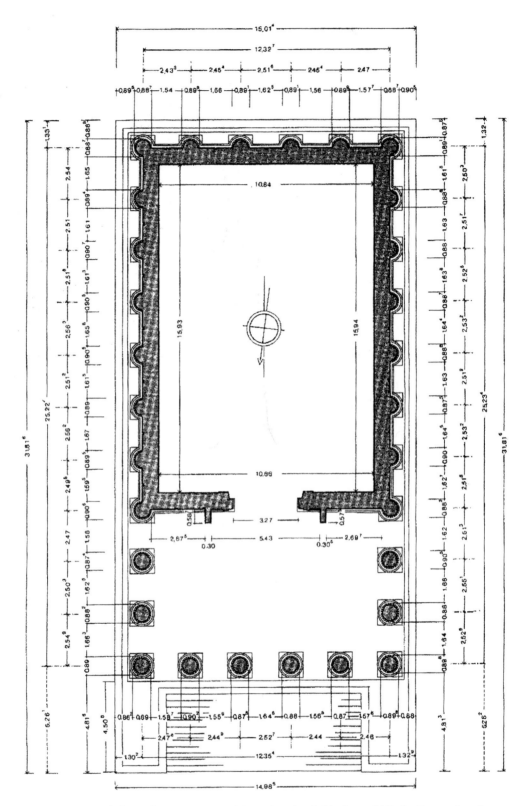

54 Ground plan with measurements of the Maison Carrée (Anderson 2001: fig. 7; reproduced
 with permission of the author).

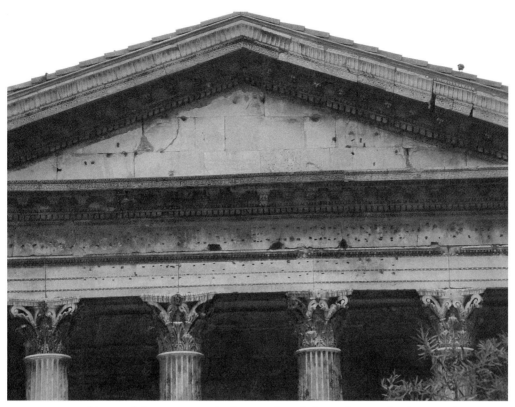

55 Entablature of the Maison Carrée showing clamp holes on frieze and architrave (photo
by the author).

C CAESARI AVGVSTI F COS L CAESARI AVGVSTI F COS DESIGNATO
[on the frieze]
PRINCIPIBVS IVVENTVTIS
[on the architrave]

To Gaius Caesar son of Augustus Consul [and] to Lucius Caesar son of
Augustus Consul Designate, to [them], First Citizens of the Young

As at Orange, we have to assume that – for some reason now forgotten – it
was required that the letters not be countersunk into the stone but merely cast
in bronze and clamped onto the exterior. This text would connect the dedica-
tion of the building to Augustus' grandsons Gaius and Lucius and indicate,
according to Amy, a dedication in 2 or 3 CE, with the addition of the architrave
text a year or two later, in 4 or 5, when Gaius and Lucius actually assumed that
title.[67] While this proposed text does not defy the "logic" of bronze clamping as
profoundly as does that proposed for the dedicatory text of the arch at Orange,
it still cannot be regarded as proven, nor should it be cited as evidence for dat-
ing the building. Espérandieu, hoping to tie the foundation of the temple to the
visit of Augustus and Agrippa to Gaul in 16–15 BCE, suggested a completely

different text – one that credited the original construction to Agrippa – and also pointed out that the variation in the sizes of the clamp holes on the frieze ought to suggest the presence of different inscriptions at different times. Despite Balty's acceptance, Espérandieu's theories have been put aside in favor of *CIL* XII.3156 for no clear reason. But if this building was one put up to honor young Gaius and Lucius, why would the inscription not have been properly counter-sunk into the fabric of the entablature? Such impermanence runs counter to Roman officialdom's epigraphic habit. Doubt must impinge.

Another point that needs to be remembered is that excavations both beneath and in the area around the Maison Carrée have demonstrated that the building in situ was not the first on the site. It stands atop an earlier building of which only foundation traces remain. That predecessor may have been rectangular in shape and was almost certainly oriented differently. Of greater importance is the evidence of a residential quarter in the same area dating back to the first half of the first century CE. In other words, the extant temple has two layers of construction beneath it, the lowest and earliest consisting of early first century houses, and the next a single building put there somewhat later. If the dating suggested by *CIL* XII.3156 is maintained, then we are forced to accept a con-structional history that seems excessively compressed: the removal of housing from the area sometime during the second half of the first century CE and the creation of the earlier rectangular building standing alone in its piazza, then the destruction or dismantling of that building and its replacement by the Maison Carrée we know only twenty or so years later (i.e., ca. 2–3 CE). The excavations revealed no evidence of a burn layer or other disaster that could account for the elimination of the first rectangular building. In short, the conundrum is increased by the lack of absolute epigraphic evidence, and compounded, not resolved, by the stratigraphy of the site.[68]

These problems of measurement and architecture, of dedication, and of stra-tigraphy can be ameliorated, if not resolved altogether, by reconsidering the chronology of the temple itself. There seems no reason at all to doubt that a temple was originally built here when the space was opened for it sometime during the reign of Augustus, whether after his putative visit to Nîmes in 16–15 BCE, or later with a dedication to his presumptive heirs Gaius and Lucius ca. 4–5 CE, we may never know for certain. But the building we have today reveals elements of measurement and design that would be commensurate with an extensive rebuilding or restoration during the second century CE, although – if they remained in good condition – there is no obvious reason why decorative elements from the earlier temple could not have been reused in a later version, and perhaps they were. Anomalies other than the unusual measurement unit employed for the ground plan are also made less difficult by hypothesizing such a reconstruction. It eliminates the need to assume the Augustan building was put up twice, and it may even allow a solution to the problems of the illegible

inscription. More to the point, it accords much better with the economic and political history of Roman Nemausus. The city grew in wealth and importance throughout the first century CE, and its prestige must have enjoyed a tremendous boost when Trajan became Emperor: in all likelihood, his wife Pompeia Plotina had been born there (Cassius Dio 69.10.3). Upon her husband's death in 117 CE, without a successor in place, Plotina put her considerable prestige behind Hadrian, thus guaranteeing him the succession, an act for which Hadrian clearly felt grateful. When Plotina herself died (about 122 CE), Hadrian is said to have erected a new basilica and/or some other major building at Nîmes in her memory (*HA Hadrian* 12.2). Apparently, Imperial benefactions to the city continued thereafter, nor should that be surprising to us, since Hadrian's successor Antoninus Pius (ruled 138–161 CE) was also descended from a Nemausan family; his grandfather was a native of the town. In addition to receiving munificence for building and rebuilding – a veritable architectural glorification of the city – it was during this same period that Nîmes succeeded Narbonne as the administrative capital of the province. The effects of the rise to power in Rome first of Plotina, then of Antoninus Pius are clearly shown in the expansion and elaboration that came to their familial city of origin throughout the first half or more of the second century CE. That the renovation and reconstruction of the elegant Augustan temple there, which was by then a century or more old, might have formed a part of this Imperial munificence would hardly seem surprising. If this happened under Hadrian – who in addition to commemorating Plotina there is reliably recorded as visiting the city in 122 CE – perhaps the oddity of the inscription can be explained, and even the text of *CIL* XII.3156 retained. If Hadrian followed his own precedent for such restorations (e.g., the Pantheon [*CIL* VI.896]), he might have restored the text of the Augustan dedication to the entablature of the mostly rebuilt temple as he had done elsewhere (*HA Hadrian* 19.9), although – for some unknown reason, and contrary to almost all official Imperial inscription carving – the letters were not countersunk into the building's entablature. Clearly, this can remain only hypothesis for now, but it is a hypothesis that resolves many problems that otherwise plague our knowledge of this splendid Roman temple.[69]

The Temple at Vienne

It is usual to draw both architectural and chronological parallels between the Maison Carrée and the extant Roman temple in modern Vienne (Fig. 56): both were in Gallia Narbonensis, both are usually attributed to the reign of Augustus and to his generosity. Such a parallel is attractive. However, the comparison is too facile and overlooks the distinctive characteristics of the temple at Vienne. The temple's very ground plan is different from that of the Maison Carrée: rather than pseudoperipteral, it is a *peripteros sine postico,* that is, a temple whose flank

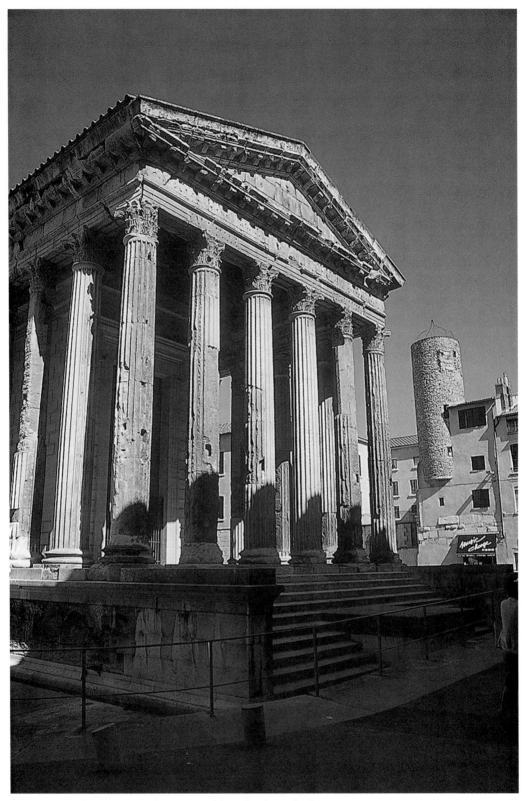

56 The Roman temple at Vienne (photo by the author).

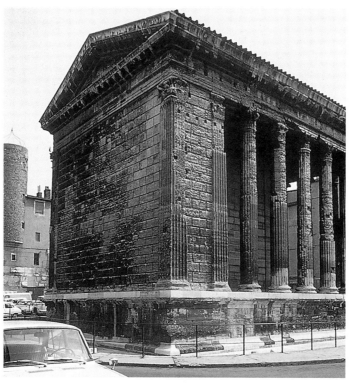

57 Flank and rear of the temple at Vienne, a *peripteros sine postico* (photo by the author).

columns are free-standing, except the final two which are engaged with the cella wall (Fig. 57). Rather than using engaged columns as at Nîmes, the architect at Vienne has chosen to substitute pilasters. The divergence makes no difference at all in the appearance of the façade of the temple, but the sides are distinct. This plan probably derived from the older tradition of designing temples with *alae* (wings). The Corinthian order of the temple at Vienne clearly reveals at least two separate periods of construction, or at least two phases of architectural decoration. The column capitals toward the rear of the building on both flanks share many characteristics of the carving of acanthus leaves with those of the twin temples at Glanum and the temple near Vernégues, which are at present usually thought to have been built in the 20s BCE, while the capitals of the columns closer to the front and all six along the façade look quite different (the acanthus is much smoother, and their volutes are at a totally different angle to the abacus) and should date later, at least toward the middle of the first century CE if not beyond (Fig. 58). The usual reconstruction of the temple's history would credit its first phase to the 50s or 40s BCE, presumably contemporary with whenever Vienne received colonial status but well before Augustus' period of high beneficence to the Romano-Provençal cities (which probably only began after 20 BCE), and its second phase to an extensive but not total restoration in the Julio-Claudian

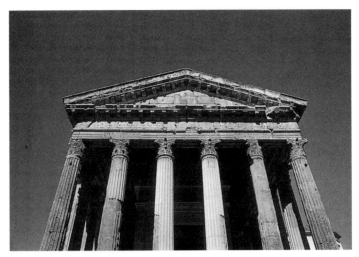

58 Façade of the temple at Vienne (photo by the author).

period, often connected with the Emperor Claudius' trip to Gaul in 48 CE, during which he heaped praise upon Vienna in a speech delivered at nearby Lyon (Lugdunum). But the earlier Corinthian capitals on the building seem unlikely to date as far back as the 50s or 40s BCE; they are consonant, however, with an initial building phase in the mid-Augustan period or with one under Claudius. Nothing specific in the architectural decoration supports assigning the second building phase to a specific reign. They could be Claudian; they could just as well be Hadrianic or Antonine. Both hypotheses would require inscriptional evidence to make them completely convincing, but attempts to restore a text (or texts) to the series of clamp holes on both frieze course and architrave of the temple (also visible on Fig. 58) continue to run into grave difficulties.[70]

The dedication of the temple is further complicated by two factors: the doubt indicated by Hirschfeld's refusal to publish any hypothetical text whatsoever as *CIL* XII.1845,[71] and new evidence published in *ILN* 5.1, no. 34. The prevalent scholarly wish at Vienne has been to assign the temple to the Imperial cult, first as some form of a dedication that would incorporate Augustus himself, at least after his death and deification, and then an alteration which would add his wife Livia, presumably after her death in 41–42 CE, in a rededication sponsored by the Emperor Claudius when he visited the area. To justify this reconstruction of events, there should have been two successive inscriptions on the entablature of the temple. The most common epigraphic reconstruction assigns the temple's origin to the same period as the Augustan walls of Vienne, ca. 16–15 BCE, and suggests that an inscription to Rome and Augustus first appeared there. Formigé supplied a text for this ghost inscription by analogy to inscriptions known from Augustan temples at Pola (*CIL* v.18) and Terracina (*CIL* x.6305) in Italy. Formigé himself altered the last word of his proposed text in the 1940s, from DIVI F to AVGVSTO. According

to Formigé these letters were replaced or reworked well after Augustus' death and deification – [DIVO AVGV]STO – when Livia's honorary title (as "Diva Augusta") was added on the architrave after her death. Unusual as that seems, even odder is the break in any of these texts required by the spacing of clamp holes on the architrave, which demands the assumption that the lines were separated left and right by some massive interruption that covered the center of the entire entablature (!). Such a presentation is utterly unlikely. This has not stopped epigraphical speculation: after Formigé, Pelletier has suggested adding either "APOLLO SANCTUS" or "HERCULES INVICTUS" to the later text, before the mention of Divus Augustus.

Without better evidence for either text, little of this random speculation makes much sense. However, the most recent study of the Vienne inscription (*ILN*, vol. 5.1, no. 34),[72] using high-definition black and white photography, does show faint traces of letter shapes on the frieze course at Vienne. The letters are in extremely low relief, little more than shadows on the face of the entablature, and correspond hardly at all to the placement of the clamp holes. While it is a bit difficult to believe that 250 years of scholars, archaeologists, and epigraphers, including Pelletier himself in his earlier studies, missed these traces utterly, that would seem to be the case if the new evidence is accepted. In spite of the illegibility of the letters on the right-hand side of the frieze, these shadow countersinkings lend some credence to the case for a first inscription that was subsequently scraped away and replaced by letters clamped on to the surface. The abbreviation AVG (for "Augusto") does seem to appear, but one must still take a leap of faith (with Pelletier) to restore ROMAE ET AUGUSTO with any conviction. At best, these traces justify restoration only of a few letters of a countersunk initial inscription. These countersunk letters must have been scraped off the frieze course so that they were illegible when another clamped inscription was placed there, on top of them, at a later date. The two short lines of clamp holes on the left and right of the architrave below (Fig. 59) reveal no countersinking at all, and their texts – if they ever were texts – cannot legitimately be reconstructed; hence any reference to "Divus Augustus" or "Diva Augusta" (i.e., Livia) remains purely speculative. What this new information does reinforce is that there was probably an initial dedicatory inscription on the frieze course of the temple. At some later time that inscription was removed and replaced by one clamped but not countersunk. However, no text for that second inscription can be convincingly restored, so no dating for the restoration of inscription or of temple can be assigned from it. Hirschfeld's doubts were justified all along. Interestingly, however, such a reconstruction of events in the history of the temple at Vienne agrees with what seems to have happened at the Maison Carrée at Nimes, and on the north face of the arch at Orange. While it is appealing to link the reworking and rededication of the temple at Vienne to Claudius and his veneration for the deified Livia, there is no absolute need to do so; indeed there is no absolute reason not to assign the initial construction of this temple to the time of Claudius, which

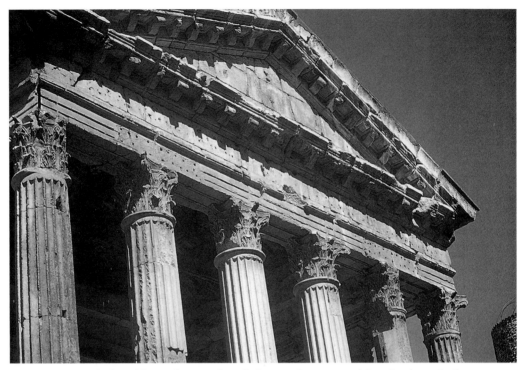

59 Detail of entablature showing clamp holes, temple at Vienne (photo by the author).

then allows many of the apparent conflicts and anachronisms to be resolved. It is important in this context to remember that Vienne's early rise to wealth and power in Narbonese Gaul simply continued in the second century CE. The architectural decoration of the second phase of the temple will permit the hypothesis of a somewhat later restoration, fitting easily into a second century CE context, and it might bring the temple's history into accord with that of Vienne's *odeum* (a Julio-Claudian building replaced in the second century CE) and the circus and adjacent baths (the so-called Maison d'Orphée, both of which are also second century CE), as well as helping to explain the many close correspondences between this temple and the Maison Carrée, if a second century CE restoration took place, which restored and preserved, while altering somewhat, a first century original whether Augustan or Claudian.[73]

CIVIC ARCHITECTURE

Colonnade and Porticus: Lining Streets and Framing Open Spaces the Roman Way

Tacitus (*Agr.* 21, quoted in Chapter 1) asserted that an essential element in Romanizing peoples who came under Roman sway was forcing them to live their

lives in a Roman, or an extensively Romanized, urban context. Beneath the rhetorical hyperbole he employs, Tacitus makes an important point. Gnaeus Julius Agricola, his father-in-law, was born at Forum Julii (Fréjus) in 40 CE, grew up in Roman Provence, and completed his education in Massilia. He spent much of his adult life and all of his career in the provinces. Agricola was a Gaul raised as a Roman in a province that received all the various influences Romans could and did bring to bear on their captives and converts. Thus Tacitus' remarks may well reflect an opinion he had actually heard from Agricola, the opinion of a Romanized scion of Gallia Narbonensis.[74] Certainly, the archaeology of the entire Roman Empire attests to how determinedly Roman conquerors and colonizers applied Roman practice in the layout of urban areas and the architectural forms used in them both to rebuild and newly establish cities and towns in the most far-flung areas imaginable. This process created what W. L. MacDonald called "urban armatures" in places where they would have exactly the effect implied by Tacitus: to surround those who were now to become Roman within the Roman urban scheme. MacDonald vividly describes these urban armatures:[75]

> Armatures consist of main streets, squares, and essential public buildings linked together across cities and towns from gate to gate, with junctions and entranceways prominently articulated. They are the setting for the familiar Roman civic building typology, the framework for the unmistakeable imagery of imperial urbanism.

It is particularly significant in this context that the first element of the Roman armatures Agricola identified and intended to introduce to the Britons as he Romanized their urban spaces was the *porticus* or colonnade. Clearly, he thought of the *porticus* as a quintessentially Roman feature of urban design, indeed apparently rather more than did Vitruvius in his manual of architecture. The Augustan architect deals with porticoes five times – thrice in Book 5 (chap. 1: colonnades around *fora*, chap. 9: colonnades behind theater stage buildings, and chap. 11: colonnades in exercise yards or *palaestrae)*, and twice more in Book 6 (chap. 3: domestic colonnades, and chap. 7: peristyle garden porticoes) – and although these *porticus* are clearly viewed as essential design elements, he does not go beyond that perception to discuss their importance in the overall visual and architectural integration of the Roman urban armature. Nonetheless, for Vitruvius the colonnade is clearly ubiquitous. When he treats temples and their architecture in his third and fourth books, he clearly conceives of the facades and flanks of those buildings as contributing what would look like colonnades to the city's streets and he notes that colonnades could and should surround the sacred enclosures that in turn encircled many temples and shrines. But whether Vitruvius would have agreed with Agricola in listing the *porticus* as the first and foremost element in architectural Romanization we will never know.[76] However, the archaeological evidence throughout the Roman world is

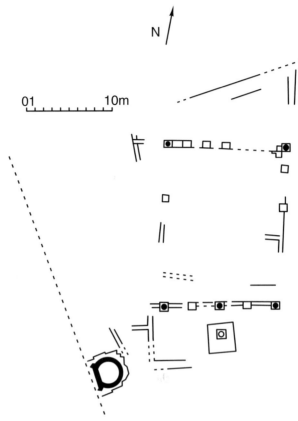

60 Plan of the rectangular peristyle of the forum at Glanum, ca. 200–125 BCE (Frakes 2009: cat. #029, drawn by D. Skau; reproduced by permission of the author).

clear and convincing: nowhere was there a Roman town or city, whether built from scratch or reworked from an earlier non-Roman existence, in which colonnades did not play a major role in defining the streets, the intersections, the approaches to and surroundings of major civic buildings and spaces, and the entrances to and exits from every sort of public (and much private) architecture. They formed a central concept in Roman city planning, which had been experimented with extensively in the Hellenic – and especially the Hellenistic – world, but which took on its definitive importance with the remarkable spread of Roman architecture.[77]

The Colonnaded Fora of Glanum (St.-Rémy), Aquae Sextiae (Aix), Arelate (Arles), and Narbo Martius (Narbonne)

The *porticus* came to urban areas in Narbonese Gaul as Roman architectural elements were introduced into native or Hellenized towns. Designs such as the so-called rectangular peristyle (ca. 200–125 BCE?; Fig. 60) and the trapezoidal portico (ca. 124–90 BCE?; see Fig. 7) at Glanum may have been established during

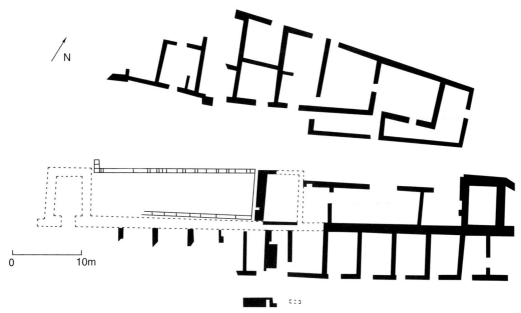

61 Plan of the so-called Warrior Portico at Entremont, ca. 150–125 BCE (Frakes 2009: cat.
 #026, drawn by D. Skau; reproduced by permission of the author).

the earliest era of Roman contact in the second century BCE; a similarly early
(ca. 150–125 BCE) portico, called the "warrior portico," is known at Entremont
(Fig. 61). The colonnades of Glanum's Roman forum (Fig. 62) were probably
laid out early in Augustan times (ca. 27–10 BCE) and may have been expanded
soon thereafter (i.e., soon after 10 BCE) although the date of this alteration to
the forum at Glanum can be disputed. Nonetheless, the overall picture of col-
onnades appearing as an early element in the Romanization of what had been
native and Hellenistic Glanum is convincing. The colonnades were expanded
and renovated again and again, well into the third century CE.[78]

Aquae Sextiae (Aix-en-Provence), the earliest Roman foundation in Provence
with no native or Hellenizing antecedents has revealed extremely fragmentary
remains of two colonnades: one (Fig. 63) beneath Place des Martyrs and the
cathedral of St.-Maximin, dated to early Flavian times (ca. 70 CE), and another
in the Cour de l'Archévèché that is associated with a raising and rebuilding of
the city streets after 166 CE (Fig. 64). Both could have been preceded by earlier
porticoes going back to the early years of the foundation, but no direct archaeo-
logical evidence for that survives. These examples demonstrate an important and
often overlooked fact: street- and forum-lining colonnades must have required
periodic reworking and replacement, if for no other reason than the accumu-
lation of wear and damage caused by the daily traffic, human and otherwise,
that must have passed through and around them every day. Hence, many of
the dates proposed by scholars and excavators probably represent the period of

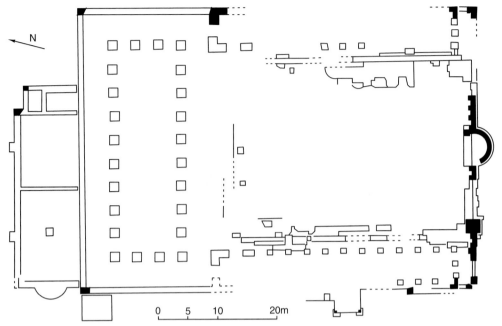

62 Plan of the Roman forum at Glanum and its colonnades (Frakes 2009: cat. #032, drawn
 by D. Skau; reproduced by permission of the author).

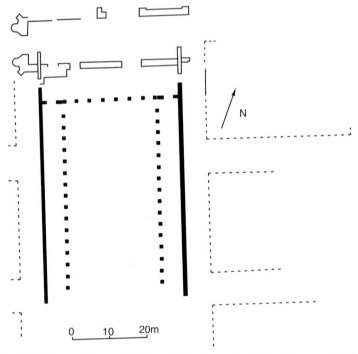

63 Plan of the forum of Aquae Sextiae and its colonnades, Aix-en-Provence (Frakes 2009:
 cat. #019, drawn by D. Skau; reproduced by permission of the author).

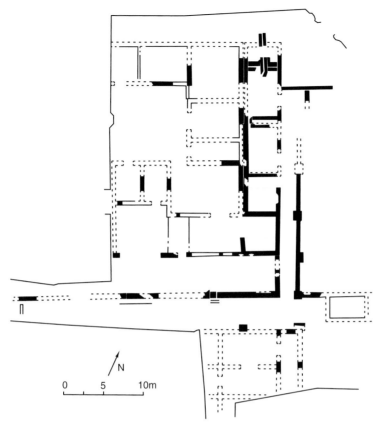

64 Plan of the colonnades in Cour de l'Archévèché, Aix-en-Provence (Frakes 2009: cat.
 #020, drawn by D. Skau; reproduced by permission of the author).

first foundation of these *porticus,* especially in heavily-populated urban centers such as Aquae Sextiae, Arelate, Nemausus, Arausio, and Narbo Martius, while remaining fragments may actually be from subsequent repairs, renovations, or expansions. Keeping this succession of replacement colonnades in mind will help reinforce the dynamics of architectural development and architectural patronage throughout the Imperial period as they affected all the major urban centers of the province.[79]

Arelate (Arles) may have received the colonnades of its *cryptoporticus* as early as the Augustan period; however, the carving style of other elements therein is much more likely early second century CE, and with no absolute data upon which to base the assumed foundation before the reigns of Trajan or Hadrian, a more precise date for its construction cannot be proposed. The forum area received a major addition, the so-called temple-propylaion, in 337–340 CE, which is attested by a surviving inscription. Indeed, it is somewhat difficult to accept the oft-asserted notion that many of the open areas of Arles' Roman city center were established in the Augustan or Julio-Claudian periods. The columns

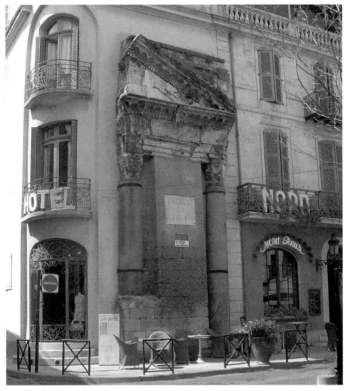

65 Architectural fragments from the Roman forum, Place du Forum, Arles (photo by the author).

and decorative material that have been excavated beneath the Place du Forum (Fig. 65) are more likely from the Trajanic-Hadrianic period, and the very layout of the so-called apsidal forum, really a quadriporticus with hemicyclic curves at its narrow ends, recalls no Roman building so much as the forum of Trajan and its Basilica Ulpia in Rome, rather than anything Tiberian (although that date is strongly argued on a speculative basis by Gros and is tentatively accepted by Frakes). Other colonnaded open areas in other parts of ancient Arles are equally difficult to date with any sort of conviction. However, there is nothing inherently unlikely in assuming that some of the original colonnades of the city were planned and executed in the Augustan period, but common sense insists that they had to be renewed or replaced over the centuries, and that newer extensions (such as the "apsidal forum") are at least as likely to be later additions to the town's armature as to have been accommodated in the original grid.[80]

The first administrative capital of Narbonese Gaul, Narbo Martius (Narbonne) was ravaged by fire in 145 CE, and hence the battered remains of both the colonnade of the Capitolium and that of the forum (see Fig. 11) appear to be Antonine or later in date. More recent discoveries in the so-called *horreum* plaza

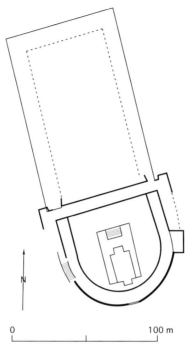

66 *Porticus* of temple precinct adjacent to the theater at Orange (Frakes 2009: cat. #063, drawn by E. Lamy; reproduced by permission of the author).

go back to ca. 30 BCE and strongly suggest a colonnade of that period; the remains beneath rue Clos de Lombarde appear to be first century CE, possibly Vespasianic. Despite the extensive destruction suffered by the city in the second century CE, there is no reason to suppose that colonnades were lacking in the pre-Antonine city.[81]

The Major Porticoes of Arausio (Orange), Vasio (Vaison), Vienna (Vienne), and Nemausus (Nîmes)

A fuller impression of Roman public and religious buildings, and more suggestions of their colonnades, can be developed from the remains at these four Romano-Provençal sites. All reinforce the importance of colonnades in the Roman urban environment. However, the assumption that all originate in the Augustan period remains just that: an assumption for which there is both logic and sentiment, but almost no archaeological evidence. The problem of dating the parallel porticoed squares (one behind the theater and another immediately adjacent to the west) at Orange (Fig. 66) provides an excellent example of the complications inherent in this question. The Augustan date for this porticus is based on excavation reports from 1835 to 1836, and on visual comparison to other known theaters. While that date is certainly possible, it is unprovable.

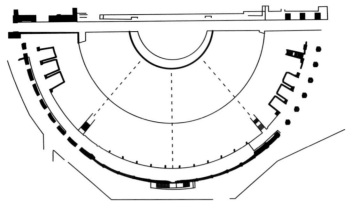

67 Plan of the theater at Vaison-la-Romaine, showing the colonnade at the top of the *cavea*
(Frakes 2009: cat. #065, drawn by E. Lamy; reproduced by permission of the author).

This situation holds true for most of the colonnade remains there, as Frakes
points out. The colonnaded square in which the Vespasianic cadaster fragments
(77 CE) were discovered was probably receiving architectural work at that date,
but that could have been reconstruction; again, excavation and data are sorely
lacking. In sum, unless and until an extensive archaeological survey or reex-
cavation is carried out in the entire center of ancient Orange, its architectural
history during the Roman era will remain entirely speculative.[82]

At Vasio (Vaison-la-Romaine), much evidence exists for colonnades, both
connected to major buildings and along the streets, but again secure dating
evidence is scarce. The theater's colonnade is dated by reference to the theater
itself (Fig. 67). Many think the theater was a Julio-Claudian construction since
a statue of Claudius, as well as a portrait head possibly of Tiberius, was discov-
ered there.[83] However, full-length portrait statues of Domitian, Hadrian, and
Sabina were also found at the same time and place, and match the Claudius in
proportion and workmanship remarkably closely,[84] so a dating for the theater's
decoration (at least) prior only to the last of those figures seems a more likely
proposition (see Figs. 3–5). Regardless, no certainty of date is currently pos-
sible. The best dating for any of the colonnades at Vasio comes from the Rue
des Colonnes itself, which retains its line of columns (Fig. 68). These can be
quite securely dated to the Flavian era (70–90 CE) on the basis of the stratigra-
phy established in excavation of the nearby Maison au Dauphin and its portico.
Hence, perhaps the best overall assignment of colonnade datings at Vasio would
be to the late first and early second centuries CE, which would take into account
all available evidence. Evidence for any earlier date among the extant remains of
colonnades and porticos is utterly lacking.[85]

Roman Vienna (Vienne) and its associated urban area across the Rhône River,
St.-Romain-en-Gal (see Fig. 14), were graced with a variety of colonnaded

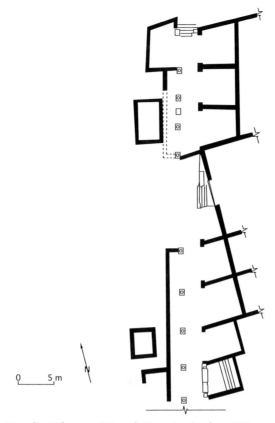

68 Plan of the Rue des Colonnes, Vaison-la-Romaine (Frakes 2009: cat. #068, drawn by
 E. Lamy; reproduced by permission of the author).

areas and streets. The earliest date for any of these is again speculative, based
on a theater *postscaenium* colonnade, which is labeled "Augustan" just like
every other example in Gaul. Little absolute evidence exists to support this
speculation, although the measurement system employed is congruent with
Augustan practice. For the Place Jouffray porticoes (Fig. 69), a dating around
100 CE is suggested by the excavators and is justified by the remains, as is the
same date for the portico of the artisanal *insula* (a city block characterized by
artisans' workshops) in St.-Romain-en-Gal. Most of the other porticoes there
can be comfortably dated to the second half of the first century CE as the com-
mercial and residential quarter expanded. Smaller porticoes are contemporary
with these (e.g., the commercial annex) or perhaps somewhat earlier (Rue du
Portique, ca. 20 CE) but overall at Vienna, the picture we take away is that
of the development of a substantial and greatly decorated Roman city whose
colonnaded armature was either established or completely rebuilt between
about 70 and 100 CE. The case for Augustan predecessors is speculative, not
archaeological.[86]

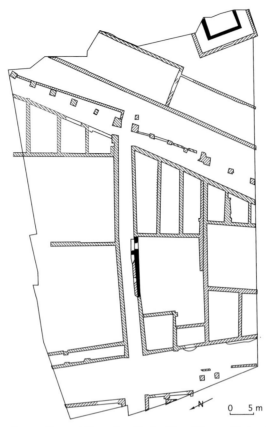

69 Plan showing the porticoes at Place Camille-Jouffray, Vienne (Frakes 2009: cat. #043–4, drawn by E. Lamy; reproduced by permission of the author).

Only at Nemausus (Nîmes) do we find sufficient evidence to attempt a substantial restoration of the appearance of a Roman city's forum with its surrounding *porticus*. This great plaza (Fig. 70) was rectangular (140 × 70 meters) and lined with double-aisled colonnades on east and west. The south side of the forum, which followed the line of the Via Domitia as it passed through the city center, was closed by a wall decorated with pilasters in the same Corinthian order as the forum's lateral porticoes and the façade of the Maison Carrée. The overall effect must have been of a closed *quadriporticus*, although the closure was in fact illusionary, and the southern side of the area with its raised temple must have dominated the whole, both architecturally and visually (Fig. 71). Extensive remains of multicolored marbles suggest elegant and elaborate wall revetment. The temple would most likely have been answered on the north side by another civic building of equally elegant architecture, perhaps a basilica, but nothing remains to support such an assumption. This great forum was probably planned and laid out in conjunction with the creation of the city's orthogonal street pattern, so probably ca. 20–19 BCE. However, much of what remains

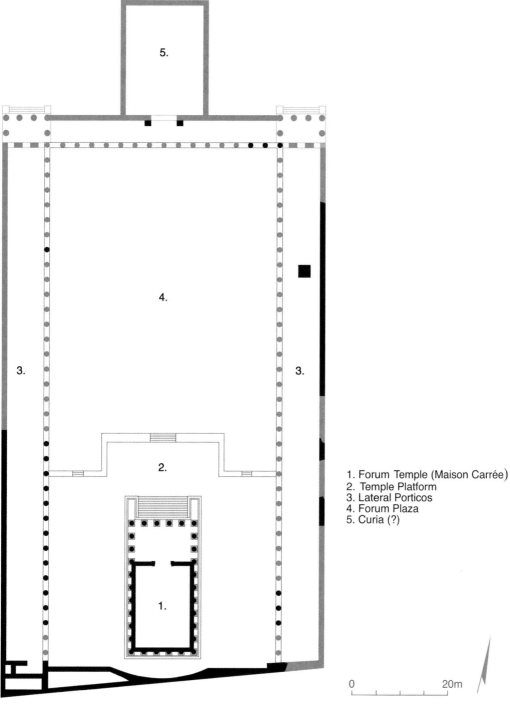

1. Forum Temple (Maison Carrée)
2. Temple Platform
3. Lateral Porticos
4. Forum Plaza
5. Curia (?)

0 20m

70 Plan of the forum colonnades and the Maison Carrée temple at Nîmes (Frakes forthcoming: fig. 2, drawn by A. Blackwell; reproduced by permission of the author).

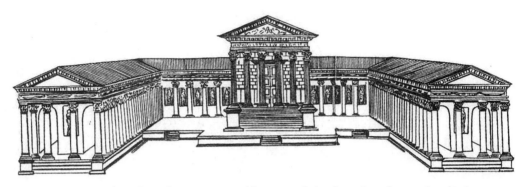

71 Nîmes, hypothetical reconstruction/elevation of the forum/temple complex (Frakes 2009: fig. 2, drawn by A. Leventis; reproduced with permission of the author).

could date from a later redevelopment under Hadrian or Antoninus Pius. To assume an Augustan date for this elegant city center is reasonable even if what we have is in part or *in toto* a second century CE reconstruction. Care should be exercised in drawing too many conclusions from the evidence that we do have, given the possibility of unknown and unattested subsequent redecoration and reconstruction.

Northwest of the center of Nemausus, another grand three-sided portico (*porticus triplex*) surrounded the sacred water source of the great nymphaeum and shrine called the Augusteum. While the shrine may, again, have been begun in the Augustan period, its various architectural elements appear to be a hodge-podge from several different eras and rebuildings. Fragments of its décor could indicate a Flavian or Hadrianic/Antonine intervention. Another part of this complex, the so-called Temple of Diana, more likely a library, is even more difficult to date, with suggestions ranging from Augustus to Septimius Severus. A precise sequence of construction and renovation is not currently possible, but the *porticus triplex* does seem to have been added to an already extant sanctuary to define and compliment the central cult area, at a time somewhat after the initial construction, but there is no certain dating evidence with which to pin it down. Further discussion of the dating issues surrounding the Maison Carrée may be found above, and those for the Augusteum below.[87]

The Forum and Its Component Buildings

Vitruvius contended and the archaeological record indicates that the essence of a Roman, and even more of a Romanized, city or town was its sacred buildings, its forum, and other spaces for common use (*De arch.* I.7.1). The forum was the focal point: administrative buildings such as the *curia* (senate house) and the *basilica* (which served both juridical and commercial purposes), as well as the *macellum* (central food market), if not located on the forum, tended to

be immediately adjacent to it. In addition, dedicatory inscriptions and statues were customarily displayed in the forum, giving it the character of a *monumentum,* a place of commemoration that could provide a sense of tradition and local pride to the citizens. In a typical Roman colonial city, at least by the age of Augustus when so many were established, the forum took the form of a large rectangle, surrounded on all sides by colonnades which provided architectural definition. The columned façades of buildings around a forum were integrated, insofar as possible, into the portico (surround of columns) that defined "the forum." Basilicas, curiae, temples in particular, and even macella could be given addorsed porticoes where they faced onto the open area. Other types of administrative buildings such as an archive and record office *(tabularium),* treasury *(aerarium),* and even jail *(carcer)* tended to be located on the periphery of the forum, too. This system, referred to often as either the "tripartite forum" or the "block forum," may seem rigid and axial at first glance, but in fact it permitted any number of variations depending on the individual topography of each city or town, as did that other fundamental characteristic of Roman urbanism: the orthogonal street grid. Unfortunately few examples of complete fora exist in Gallia Narbonensis for the simple reason that the centers of so many Roman towns remain the centers, or at least important parts, of the cities and towns of Provence to this day. What examples there are, however, demonstrate the importance and persistence of the forum in a Roman cityscape.

The Forum and Basilica at Glanum (Glanon)

Ongoing excavations at Glanum have revealed – at second century BCE stratigraphic levels – a forum, or at least the foundations of what appear to have been large public buildings surrounding an area that was intentionally left open. This area, onto which twin Roman temples would subsequently face, is now known as the "place triangulaire." Since the buildings so far discovered are often of Hellenic rather than Roman design, it is tempting to label the second century BCE urban center of Glanum an "agora." However, the excavations also indicate that Glanum suffered two waves of destruction, both of which should be connected to the Roman campaigns in Provence, the first in 125–124 BCE, and the second in 90 BCE. The repeated destruction of the city would imply that in spite of the general organization of the city's public area and the impression it gives of a Greek city, Glanum must have been primarily inhabited by the native Salyans. Evidence to support this contention is based on the proper names known from inscriptions. The presence of Hellenic architecture in a largely native city implies strong influence from Massalia. Perhaps the best explanation is to regard *Glanon* (as it was spelled then) in the second century BCE as a Hellenized Salyan sanctuary city, in cultural contact with Massalia.[88] The city center (see Fig. 8) formed a trapezoid, the perimeter of which was covered by a portico. Use of the term

"agora" can be justified, although it could simply have been an open market place or a location for religious functions that was open to the sky, or all of these. Outside this agora, beneath a Roman Doric colonnade, foundations remain of an oblong building which might suggest a stoa of Hellenistic type; beyond this to the north were a building divided into at least two rooms and a round foundation, perhaps a fountain. The best-preserved element of the Glanum agora is an assembly hall, in plan a rectangle with steps around three of its sides and an entrance at the east. The stepped sides turn the focus of those using the building toward its central lowest point, and anyone who stood there could, simply by turning, have seen and addressed everyone in the building. On the west side, the building had an annex with three interior supports that supported the roof. The form of the building is that of the Hellenistic period *bouleuterion*, or council hall, of which examples are known at a number of Greek cities, most famously Priene in Asia Minor. Discussion continues whether it should properly be labeled a *bouleuterion* (favored by Gros) or a *prytaneum* (asserted by Roth-Congès), but interpretation of its overall form and probable function are not significantly affected by this nomenclature. Despite the fragmentary nature of the remains at this stratigraphic level at Glanum, the evidence seems sufficient to call this the agora of the pre-Roman town.[89]

After the devastation suffered in 125–124 and in 90 BCE, stratigraphic evidence suggests that the rebuilding of the public area did not begin prior to 30 BCE. At that time the former agora was replaced by a colonnaded forum with three porticoes which faced south, the direction of the ancient water sanctuary. The colonnades to the east and west each consisted of eleven free-standing Corinthian columns and an engaged column at the north of each portico connecting it to the lateral colonnade across the north end, which was also the side of the first, relatively modest, basilica in the town. The flanking columns of the porticoes provided architectural definition to the open space and regularized its appearance. Since the earliest phase of a Roman-style forum at Glanum is contemporary with installation of the twin temples, it is usually associated with Augustus' and Agrippa's reorganization of the province and their provision of money for rebuilding (e.g., the temple of *Valetudo* here, whose dedication specifically credits Agrippa) during the last decades of the first century BCE. The forum itself seems to have remained a colonnaded open area through the Imperial period, with at least one major renovation and rebuilding, sometimes dated, based on little specific evidence, to the Flavian era (late first century CE). The forum was eventually enclosed to the south by a wall of ashlar masonry, in the middle of which, on the central north-south axis through the forum, was placed an apsidal vaulted structure which might have held a statue.

The original, presumably Augustan, basilica (Fig. 72) that served as the northern boundary of the forum was enlarged in Imperial times, though no precise date can be determined. It is a classic example of Roman basilica design:

72 Basilica and Curia in the Roman forum at Glanum (photo by the author).

its east–west transverse axis measured exactly twice its north–south axis. The substructural supports for the basilica's twenty-four columns indicate a concentric rectangle of columns inside the external walls of the building, thus forming a true three-aisled basilica. That system, common to most Roman basilicas of the Imperial period, allowed for the placement of a second set of columns above to rise atop the interior rectangle. A second story could permit windows for interior lighting and also in turn carry a roof raised significantly higher than that placed above the external colonnade, with windows let in at regular intervals to allow light to the interior, in fact a system of roofing and lighting subsequently called a "clerestory." Whether a clerestory roofing system was employed in this basilica remains unknown. A second, much smaller, rectangular structure was attached to the basilica on the north, its axis running parallel to the basilica's, with an apse in the building's west end. The apsidal building might have served as a tribunal, for holding court cases, or perhaps as a *curia* (senate-house), although it is in no way typical of other examples we know of the latter building type.[90] At some point probably late in its existence, the apse was completely filled with *opus caementicium* (Fig. 73). Except for the lack of a certainly identified curia, the history and monuments of the forum at Glanum

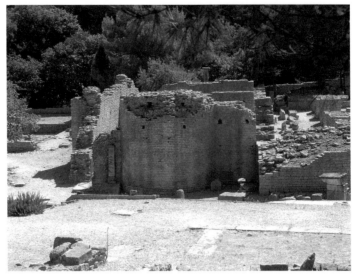

73 Apse of the Curia at Glanum, with rubble and cement fill (photo by the author).

clearly demonstrate the process of careful Romanization that was applied to the architecture of a city center when it was converted from a "native" into a Roman space. The break between the destruction of Glanon's agora and the creation of its first forum has been explained by assuming that the concentration of rebuilding through most of the first century BCE focused on restoration and elaboration of the sanctuary with civic architecture attended to only later. Given the apparent importance of the site as a sanctuary throughout all the centuries of Glanum's existence, this seems a reasonable explanation, but the archaeological evidence for reworking the sanctuary areas is ambiguous. Nonetheless, the forum, basilica, and central open areas of Glanum became a model of the smaller Roman provincial town once the second restoration had been completed.

The Fora of Arles, Nîmes, Fréjus, Narbonne, and Vienne

The remains of other fora in Gallia Narbonensis are fragmentary at best. Although it is not possible to reconstruct a clear chronology of their development, what is clear in each of these cases is the influence exerted on their design by the sequence of Imperial Fora created in Rome from the time of Julius Caesar through the reign of Trajan. The architectural influence of these remarkable complexes can be seen throughout the Empire, including Provence.[91]

The forum at Arles (*CIL* XII.5805) attributable, in conception if not creation, to the age of Augustus was built not at the geographic center of the city, but, due to topographical exigency, close to the western sector of the walls (see Fig. 12). The largest remaining element of the forum is an extensive *cryptoporticus*, which underlaid three sides of the early, Augustan, forum and supported its

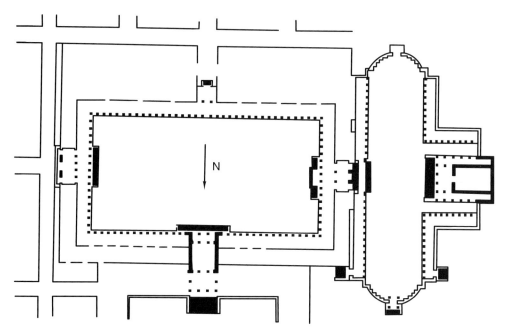

74 Arles, plan of forum, *cryptoporticus* and so-called apsidal *forum adiectum* (Frakes 2009: cat. # 021/023, drawn by D. Skau; reproduced by permission of the author).

colonnade. Although very little remains above ground, it is commonly assumed that the forum at Arles was directly influenced in design and in sculptural program by the forum of Augustus, dedicated and opened to the public in Rome in 2 BCE. The lateral porticoes may have possessed exedras for the display of statues labeled with *elogia* that celebrated the careers of the *summi viri* of the Roman world, suitably modified to emphasize provincial history, if the hypotheses of Gros are accepted. Others have argued for a different source of inspiration. The development of the forum at Arles seems to have begun in the early 30s BCE with the basic elements probably in place by ca. 10 BCE, well ahead of the completion of Augustus' forum in Rome. Some of the elements of the plan were perhaps more likely to have been inspired by the monumental complex, centered on the temple to Apollo, that Augustus constructed on the Palatine hill almost two decades earlier than his forum. This suggestion makes better chronological sense. At Arles, development, renovation, and refinement continued for centuries in the forum after its initial construction. A large paved open space to the west of the forum shows evidence of a wall with exedra to the south and a colonnade to the north, remains which Gros would reconstruct as a sort of *forum adiectum* added onto the original during the reign of Tiberius. This design (Fig. 74) is somewhat puzzling if a Tiberian date is accepted. It has otherwise been identified as the architectural surround *(peribolos)* of a temple of Trajanic or Hadrianic date. In the very late Empire, there is evidence also for additions to the *cryptoporticus,* and so one assumes to the forum area itself in the

reign of Constantine (306–337 CE); possibly the original forum was expanded, or another entirely new forum was built, due to Arles' increased importance in Provence during late antiquity.[92]

At Nîmes, the forum was more centrally located (see Fig. 15). The open space ran northward from the Maison Carrée temple, which marked the forum's southern extremity; however, little else of the forum has come to light. A basilica built by Hadrian at Nîmes to honor Plotina (who died in 122 CE) is mentioned in *HA Hadrian* 12.2, but no archaeological traces of it have been located. Excavation was carried out in the 1980s when a number of buildings around the Maison Carrée were removed; these are presumably vestiges of the normal appointments of a Roman forum. Unfortunately these remains are so battered that it is difficult to assign them to specific types of monuments, though it is now agreed that some sort of public building or buildings, probably colonnaded, stood immediately behind the site of the Maison Carrée temple. The Maison Carrée itself must have made an elegant axial temple for the forum, and it is often restored with porticoes in back and on both sides that would define the extent of the open area of the forum; however, archaeological evidence for this does not yet prove the hypothesis, and the more recent assertion that, at least behind the temple, there rose a colonnaded public edifice seems more likely to be correct.[93] Excavations carried out in the 1990s have contributed to a fuller understanding of the topographical evolution of the Nemausan forum. A location for the city's curia across from the Maison Carrée sanctuary is now likely, with the public open square of the forum extending between.[94] The usual suggestion is that this forum layout should date from the Augustan period, although renovation or reworking of it in both the Hadrianic/Antonine age and, though less likely, in the Severan or later periods should not be ruled out as possibilities until the entire chronology of urban development in Roman Nemausus can be better known.

Recent excavations at Fréjus (Forum Iulii), in l'espace Mangin, have not only refined our knowledge of the street plan inside the walls of the port town, but have also convincingly located its forum along the south side of the *cardo*, the town's main north–south street (see Fig. 13). The open area that became a regularized forum appears to have existed by 43 BCE if not earlier. Once veterans of Octavian's victorious Actian army were settled at Forum Iulii shortly after 31 BCE the forum must have been developed further. Restoration and expansion probably occurred during the Flavian period, when the town reached its greatest extent and received Imperial benefactions. This largesse may have been due in some part to the eminence of the town's most distinguished citizen, Gn. Julius Agricola. Publication of these important excavations has yet to be completed, but already the secure placement of the forum has greatly advanced our knowledge of Forum Iulii.[95]

At Narbo Martius (Narbonne), both forum and Capitolium have left little more than traces of archaeological evidence, and even that has been mostly covered

over. Inscriptions and reliefs recovered during the nineteenth century have permitted at least a chronological reconstruction of these monuments in what was, until the middle of the second century CE, the administrative capital of the province. This evidence indicates initial construction of the forum during the Augustan period; two inscriptions, *CIL* XII.4333 and 4335, were both placed there before 10 BCE. A total reconstruction of the city center in the second century CE can now be convincingly dated, though still on very fragmentary evidence, to Hadrian (reigned 117–138 CE), but the devastating fire that ravaged Narbonne in the middle of the same century (before 145 CE) mandated a total reconstruction, at great expense, of all the monuments of the city center (*CIL* XII.4342). Given the chronological precision possible in reconstructing the development of the forum of Narbo, it is particularly regrettable that no remains are visible, and excavation has been insufficient to permit architectural reconstruction.[96]

Most impressive of all the fora in Gallia Narbonensis must have been that which covered the center of Vienne by the end of the first (or possibly the beginning of the second) century CE. Reconstruction of this enormous complex has been made possible through detailed study of city archives combined with archaeological and geological research. Evidence indicates an immense forum, 280 meters long, surrounded by porticoes (Fig. 75). The forum was built between and connected two sacred areas: the preserved temple, often attributed to Augustus and Livia, on the west (see Fig. 56), and a large colonnaded enclosure on the east, properly called a *porticus triplex*, which may have been an *augusteum,* a shrine of the Imperial cult (Fig. 76). In the center of the *porticux triplex* was an altar; the building's decorative program included masks of Jupiter Ammon and Medusa and shields that recall those of the colonnades of the Forum of Augustus in Rome. The structure is currently attributed to Tiberius, but solely on speculative evidence. A noticeable omission from the Imperial expansion of Vienne's forum is a basilica. Insertion of the open forum proper between the two cult areas and completion of its decorative program is credited to Domitian (ruled 81–96 CE), and certainly could not have been accomplished earlier than that, although completion in the early second century under Trajan or even Hadrian would be equally consonant with the rest of the urban history of Vienne under the Empire. The sheer scale of this gigantic forum attests firmly the wealth and importance achieved by the city throughout the first century CE and beyond, a status that is confirmed in the ancient writers.[97]

COMMERCIAL ARCHITECTURE

The Macellum (Provisions Market)

Typically, the *macellum*, the fresh foodstuffs market, would be located directly adjacent, or in very close proximity, to a Roman town's forum. Over the centuries,

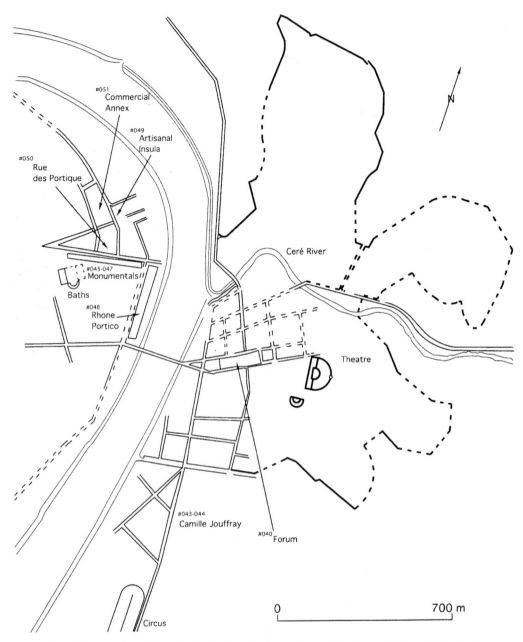

75 Vienne, plan of the city indicating likely position of the forum (Frakes 2009: fig. 7,
 drawn by E. Lamy; reproduced by permission of the author).

Rome had several different *macella* that are known to us primarily from literary
texts and from the fragments of the Severan Marble Plan. A number of *macella*
have survived outside Rome, including monumental examples at Leptis Magna
in Libya and at Puteoli (Pozzuoli) in Campania, as well as one at Pompeii that

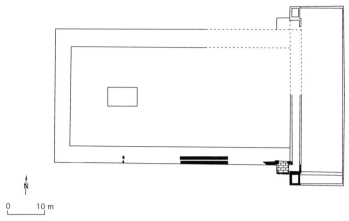

76 Vienne, hypothetical plan of the forum, altar, and porticus (Frakes 2009: cat. #040, drawn by E. Lamy; reproduced by permission of the author).

opened directly onto the city's forum; throughout the Roman world, some eighty examples of macella have been located, but relatively few are known in detail. All these *macella,* of whatever size, share certain architectural characteristics: they are enclosed in a wall with a single, frontal, entryway opening onto a main street or onto the forum; water is available to the *macellum,* often from a branch aqueduct, and was brought into a central fountain or basin (sometimes enclosed in a *tholos*), in which (apparently) the fresh provisions were washed before they were turned over to the buyer; and the walls are surrounded by a series of shops (*tabernae*) which were presumably rented by individual merchants.

In northernmost Gallia Narbonensis, a *macellum* has been tentatively identified by excavations at Genava (Geneva). Traces of a square building about 14 meters on each side were found, with some evidence for porticoes and *tabernae* surrounding its exterior, at the southwest corner of the ancient forum. Since nothing is known of the interior appointments of this building, its identification as a market is based solely on its shape and location. It seems to date from the second half of the third century CE. *Macella* are known by inscription or literary reference at Baeterrae (Béziers), Lucus Augusti (Luc-en-Diois), Monêtier-Allemont, and Narbo (Narbonne); one at Nemausus (Nîmes) was built by a *duumvir* (mayor) sometime during the high Empire and is mentioned as late as the fifth century CE by Sidonius Apollinaris (*Carm.* 23.42). It may be hypothesized that the *macellum* at Nîmes, given the city's size and importance in the high and late Empire, might have been a monumental version similar to those at Puteoli and Leptis, but that is pure speculation. So far, archaeological evidence for Narbonese *macella* has either not come to light at all, or is so meager (e.g., Geneva) that it is impossible to be sure the remains are those of a provisions market at all.[98]

Shops (*Tabernae*) and Workshops (*Fabricae, Officinae*)

One of the most important elements in the life of any Roman town was the innumerable local shops (*tabernae*) that lined residential streets. Here the quotidian life of the great mass of residents of the Roman Empire, citizens and subjects alike, must have been lived. The residences of all but the well-off were seldom large enough, or sophisticated enough, to support the requirements of daily living. *Tabernae* could be used for all manner of trade and custom. They were the venue of trade in goods and luxuries; many sold prepared food and drink, many also cooked food which had been prepared by a customer at home. Ostia, where so many examples have been excavated and restored, demonstrates the variety that *tabernae* could take. A typical *taberna* might be nothing more than a square or rectangular space opening directly onto a street via (often) a folding door (to save space inside), with benches or shelves on which goods could be displayed and watched over. Many *tabernae* had lofts installed above the vending area, for storage and, fairly regularly, as a makeshift living area for those who worked in or even those who owned the business. But *tabernae* came in as many sizes, shapes, and floor plans as the Roman imagination could invent; in other words, they show an unending series of minor variations and adaptations. An example of the flexibility of *tabernae* can be seen in the *thermopolium* now restored on the Via di Diana at Ostia. It started as a simple one-room drink and food shop selling onto the street from a counter, with very little, if any, seating available to customers. Over time the business must have done well, for it expanded into a second large room behind, as well as a space – possibly originally intended as a second separate *taberna* – immediately adjacent into which more display counters and seating were added, and an oven built at the rear. Hence a small supply store appears to have grown into a bar-restaurant of some size, and presumably an important convenience to residents of the immediate neighborhood. The presence of a large oven in which customers could bake their own food must have been a boon to many families, as well as profitable for the owner of the *thermopolium*.[99]

Roman workshops and production units (*fabricae* or *officinae*) exhibit an even greater variety in size and shape. Potters' workshops tended to be gathered in the same areas and in substantial groups; often a section of the suburban parts of a Roman town would be popularly called the "potters' quarter." Such agglomerations needed access to the raw materials used in production, and to relatively easy transport for their goods. If, as with pottery, the production process involved baking, there had to be space for ovens and kilns as well as for the fuel to run them to be delivered and stored. Hence the concentration of workshops and artisans' establishments in suburban quarters where many separate production units worked cheek-by-jowl to one another is not surprising. In terms of architecture, there is no rule for *officinae;* they took on or adapted to the space and appointments required for their businesses.[100]

The Shops of Vaison-la-Romaine (Vasio)

Examples of streets lined with retail shops occur throughout Roman Provence. Several of the most vivid are the residential streets so far excavated at ancient Vasio (Vaison-la-Romaine; see Fig. 18). Little architectural decoration remains for these, but their ground plans alone clearly reveal their nature, since they are small square or rectangular spaces directly accessible to and from the street. The *tabernae* of Vaison-la-Romaine usually adjoin larger houses or other buildings. This suggests that, as we know was true elsewhere in the Roman world, *tabernae* tended to be rented to the shopkeepers by those who owned the larger buildings into which they were inserted, providing rental income to the landlords as well as retail income to the proprietors. At Vaison, two *tabernae*-lined streets are visible: the "Rue de Colonnes" (see Fig. 68) which flanks the House of the Dauphin, and the aptly named "Rue des Boutiques" (Fig. 77), a street composed of gentle steps. Shops on the Rue de Colonnes seem to have been small and simple, mostly single rooms, while those on the Rue des Boutiques had more space and were provided with thresholds and folding doors. A variation on this sort of "street of shops" can be seen, also at Vasio, in the interesting complex called "Terrain Thès." Lines of shops opening on the streets are interspersed with entrances to what were clearly, based on the presence of production facilities, artisans' workshops. These larger shops and workshops were entered over a grooved threshold next to which there might be a counter, some have lateral access doors on their sides, and most show evidence of a piped-in water supply. The interior walls tend to be stuccoed or whitewashed. One *officina* contained an olive press and two large storage jars (*dolia*), in another the weights used for weavers' looms and some bone needles were found. The suggestion of an artisans' retail market complete with areas for production that did not need the larger and more dangerous industrial facilities required by potters can be readily reconstructed here.

Shops and Workshops at St.-Romain-en-Gal (Roman Vienna)

The residential sector of Vienne expanded across the Rhône River at an early stage in the city's development, certainly by the Julio-Claudian period. What grew up on the west bank, separated from the monumental city center, provides a fascinating study in the suburban development and appearance of a successful Roman city. In a number of areas of the street grid, shops opened onto covered porticoes that lined the streets. These were often grouped on parallel streets so that the backs of shops abutted on the backs of the shops in the next street. Identification of these structures as shops seems likely due both to their modest size and from the occasional finds of storage amphorae. In the northern part of St.-Roman-en-Gal, a remarkable ensemble of *tabernae, officinae,* and *fabricae*

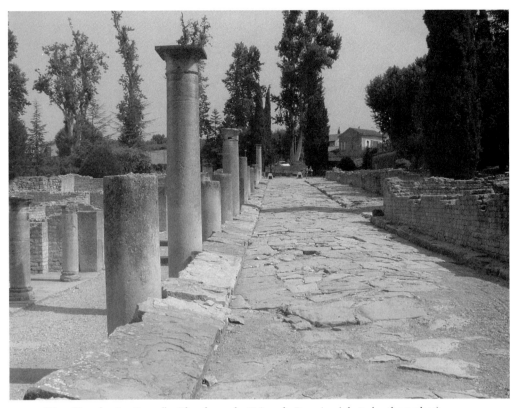

77 "Rue des Boutiques" with colonnade, Vaison-la-Romaine (photo by the author).

has been brought to light: a group of three complexes that gives a remarkable visual impression of industrial and commercial activity in Roman Provence, indeed in any area of production and sale anywhere in the Roman world. The northernmost part of the complex consisted of a triangular-shaped building (Fig. 78). The upper sector of this was subdivided into nine square or trapezoidal rooms, some containing storage amphorae set into the floors. Perhaps these rooms served as storage space for the various businesses in the complex. To the south the next facility was a large fullery (*fullonica*), a business for cleaning and dyeing all sorts of articles of clothing and household use. The fullery measures 25 × 15 meters and was constructed around a central open-air courtyard. It took up the entire middle section of the complex. The courtyard provided open space for drying and also space for four large waterproofed basins or tubs set into the floor which were used for cleaning and dyeing fabric. South of the fullery there was a second long open space lined on either side with *tabernae*, some of which had water piped in. Those on the south side opened onto the exterior street as well as onto the interior hallway. This one triangular building, then, provided the site for a major industrial establishment, a sequence of retail shops, and storage rooms essential to both.[101]

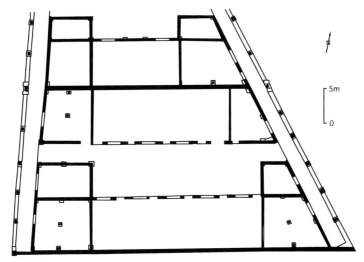

78 Vienne, plan of the artisanal *insula* and street at St.-Romain-en-Gal (Frakes 2009: cat.
 #049, drawn by E. Lamy; reproduced by permission of the author).

Granaries and Warehouses (*Horrea*)

The Horreum *at St.-Romain-en-Gal*

In the same quarter of St.-Romain-en-Gal, just beyond the triangular building
(mentioned above) stood another substantial multiuse structure. Overall it mea-
sured about 40 × 23 meters Layout and construction indicates that it was built
as a warehouse (*horreum*), probably for grain storage (Fig. 79). The plan indi-
cates a central gallery, two stories high, running almost the length of the build-
ing. The central gallery seems to have been unroofed; onto this space opened
two levels of rectangular storerooms, the upper level of which was roofed. In a
remarkable example of engineering refinement, the floor of the entire complex
was protected from damp by being raised on a layer of empty amphorae set into
the top soil. This promoted air circulation and helped to prevent spoilage of the
cereals stored within. Initial construction of the complex is dated to the second
half of the first century CE. Some evidence suggests that it was completely over-
hauled at a later time and converted to another purpose. Access to the build-
ing was modified and monumentalized by adding an elaborate entryway in the
north and south walls. The entries led into a transverse hallway lined with pil-
lars. The storage rooms seem to have been converted into shops; additional stor-
age, production, or perhaps living space was created by the addition of a loft
or mezzanine space accessible by wooden stairways in each of the storerooms.
A new row of *tabernae* was also built along the exterior of the south wall of
the *horreum*, facing the street, but with no direct access into the *horreum*. The
entryway to every *taberna* except one was divided in half by the pillars that had
supported a second floor within each storage room when the building was in use

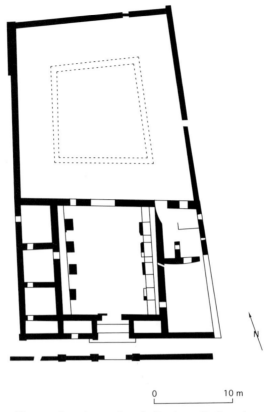

79 Vienne, plan of *horreum*/warehouse, Rue du Portique, St.-Romain-en-Gal (Frakes 2009:
 cat. #050, drawn by E. Lamy; reproduced by permission of the author).

as a *horreum*; these were apparently retained so that each shop could have a mez-
zanine or loft above it, accessed by a wooden staircase. On the south side, more
shops were attached to the complex but had no access to its interior; their doors
opened onto the street outside. The purpose of this renovation of the *horreum*
is still under discussion; it is possible that the changes represent no more than
a refurbishment of the granary, but it has been suggested that, in its final con-
figuration, the complex could have functioned as a trading emporium or bazaar,
almost a sort of shopping mall. However, the evidence remains ambiguous.[102]

The Horrea *at Massalia in Roman Times*

Throughout the Roman world, warehouses (*horrea*) were most commonly located
near docks and port facilities. They tend to share a plan similar to that of the
structures described above at St.-Romain-en-Gal, one that was easily accessi-
ble and made maximum use of available space. Due to the perishable nature
of many of the commodities which would be stored in the *horrea*, engineering
refinements to prevent, or at least limit, the intrusion of moisture were regularly
employed. Little has survived from either Greek or Roman Massalia, but we do

have some remains of *horrea* that were situated approximately 15 meters from the Roman quay or docks (see Fig. 5). What remains are primarily lower elements of the *horrea,* in particular one area filled with thirty-three huge *dolia* which were used to store wine, oil, or grain. Another warehouse whose ground plan has been recovered was a hypostyle hall, more than 20 × 24 meters in total coverage, with pillars at regular intervals in rows throughout. In it were found fragments of *dolia* with stamps that date them (and it) to the second and third centuries CE. These *horrea* opened toward the port and, like those at St.-Romain-en-Gal, were raised above ground level to promote air circulation. They also sat over an extensive drainage system of baked tile, sometimes with empty amphorae inserted between the drain courses to promote drying. The substructural walls of the warehouses were double thickness, again lined with baked tile in a further attempt to keep out moisture. The remaining walls are of *opus testaceum*: brick-faced masonry standing on stone foundations. Offices and meeting rooms were included in them, and were elaborately decorated in polychrome marble revetment (*opus sectile*) or in stucco painted red and blue, and with mosaic floors. Massalia's warehouse district was connected directly to the city center by a colonnaded street whose portico was decorated with statues. This complex of *horrea* is usually dated to an urban and commercial renovation project carried out under Nero (ruled 54–68 CE), but specific archaeological evidence for its date has not so far come to light. Extremely fragmentary elements of *horrea* are also known in Provence at Fréjus on the so-called eastern "Plate-Forme," which was actually the foundation for storage areas serving the port there (see Fig. 13), and at Arles near the river docks at Trinquetaille (see Fig. 12), which are presumably in the same location they were in Roman times.

Cryptoporticus

Underground three- or four-sided porticoes survive throughout the Roman world. Examples such as those on the Palatine hill in Rome (ostensibly of Neronian date) and several different ones known at Hadrian's villa near Tivoli appear to have been intended for use as covered walkways constructed underground to keep them as cool as possible during the hot months. Their function as a shaded alternative to heat of the sun would explain their occurrence in city centers; however, some evidence implies an economic function for these structures in an urban setting. Some *cryptoporticus* seem to have been used as public stores and grain warehouses (perhaps for grain distribution to the military as well as the *annona*, the distribution of grain to the public), and the fact that – in Provence especially – these underground galleries were carefully built to isolate and protect them from moisture, as well as from unauthorized entry, can be interpreted as evidence of a purpose beyond a practical refuge from the sun. No conclusive proof is available, but what is clear is that the *cryptoporticus*

in Provence were important and common elements in the architecture of major Roman urban centers.

The Cryptoporticus *at Narbonne (Narbo)*

Thanks to their continued use and reuse, the *cryptoporticus* of Roman Narbo (see Fig. 11) are the only significant ancient Roman structures in the city. These *cryptoporticus* were located to the west of the line of the *via Domitia,* which constituted the *cardo* of Roman Narbo Martius, and just south of the forum. They consisted of four galleries intersecting at right angles to form a subterranean rectangle measuring 50.85 × 37.70 meters; sections of two of the underground passages can be reconstructed, providing a plan that clearly suggests the extent and layout of the whole (Fig. 80). They are covered in barrel vaults, through which light was admitted by twenty-six small windows. The walkway is 3 meters below the ancient ground level, almost 5 meters below the modern. At the northwest corner, a secondary gallery contained six more light sources; there may have been an equivalent on the southeast corner, but if so it has not survived. The ancient access points to the *cryptoporticus* have not been discovered. The presence of *opus incertum* and *opus reticulatum* wall facings, coins, stamped clay lamps from Arezzo and from La Graufesenque, and stamped Italic amphora all indicate an original construction date toward the end of the first century BCE. This would be consistent with the period of early development enjoyed by Narbo when it was made administrative capital of the province under Augustus. The *cryptoporticus* remained in use throughout the Imperial period. Their layout and the apparent trouble taken to protect the interior from damp suggest at least an original function as a vast storehouse. Much later in antiquity, Sidonius Apollinaris (*Carm.* 23.40–3) refers to it with the word *horrea,* so either that function or, at least, a memory of such a function for the *cryptoporticus* at Narbo would seem to have survived.[103]

The Cryptoporticus *at Arles (Arelate)*

The *cryptoporticus* at Arles ran beneath the great portico that enclosed the Augustan forum (see Fig. 74). Its galleries lie 5.8 meters below the modern ground level and are 4.5 meters in height, spreading to 8.55 meters in width. They form an eastward opening "U" of 88.76 × 58.83 meters. The galleries are subdivided by arcuated entablatures springing from pilasters along the longitudinal axis, twenty in each of the long galleries, and twelve lining the short one. The west gallery opens out, on the axis point, into a rectangular exedra. These galleries were originally paved in stone, most of which has disappeared, and were lit and ventilated by curved windows that open in the arc of the barrel vaults that cover the passages. The windows were most likely covered by grills. The means of access was in the north gallery. In later times this *cryptoporticus* was used to store furniture, and a chapel dedicated to St. Lucien was also

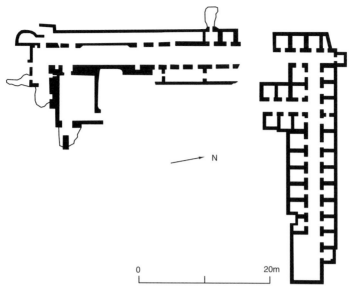

80 Narbonne, plan of *cryptoporticus* and *horreum*/warehouse (Frakes 2009: cat. #017, drawn by D. Skau; reproduced by permission of the author).

installed there, but other information on its *nachleben* is random and scattered until the passages were reopened in the twentieth century and studied systematically. Their construction and orientation corresponds to the rules laid out by Vitruvius, which was that they should be oriented along the *decumanus* of the city. They were carefully engineered for drainage. The walls were covered in a thick coating of mortar composed of chalk and charcoal. It remains a matter of debate whether this *cryptoporticus,* whose architectural decoration was rather more elaborate and elegant than that at Narbonne, had any sort of economic function, or whether it was reserved solely for pleasant subterranean strolls. Construction of both forum and *cryptoporticus* in the Augustan period is supported by the evidence of inscriptions and a portrait bust of Octavian found in situ in the underground galleries.

Ports and Port Installations

Narbonne (Narbo) and Arles (Arelate)

Roman port construction is usually a subject for consideration in terms of trade and economics rather than architecture. However, Gallia Narbonensis offers a number of outstanding natural harbors, all of which were put to use by the Romans. The finest of all must have been the harbor at Massalia, which is still one of the busiest ports in the Mediterranean. The majority of our information for the port in antiquity comes from textual sources, so our understanding of the construction and architecture of the port and its facilities is minimal. The

same is true at Nice (ancient Nicaea): like Massalia it was used in ancient times, and has remained in constant use ever since. As a result, little of its ancient plan or development can be determined. Our historical sources also tell us a good deal about the Roman port at Narbonne (Narbo). It is described as a river port that was separated from the seacoast by a series of moles. Canals were dug to guide traffic through lagoons that meandered inland. This is perhaps similar to the system that exists today in the area around Les-Saintes-Maries-de-la-Mer. But beyond this geographical outline, what we know of the port of ancient Narbonne is random. Strabo (4.1.6), writing in the early first century CE, calls it the port of all Narbonensis. The importance of the port lasted until at least the mid-second century CE when a devastating fire struck. At that time Arles seems to have succeeded Narbonne as the principal port of Provence. Unfortunately, archaeological evidence for the port at Arles is meager.[104] The scattered sources indicate that it had much the same arrangement as that of Narbonne, with a river port far enough inland that it could be protected from coastal storms, but with relatively easy access and close enough to the Mediterranean to make landing, offloading, and onloading of merchandise, and even transportation of shipment from seagoing to river boat, feasible, even profitable.

The Roman Port at Fréjus (Forum Iulii)

Only at Forum Iulii (Fréjus) is there sufficient archaeological material in situ to permit some sort of reconstruction of the facilities associated with a major Romano-Provençal port. The town's position on the coast and the coast road made it important to Caesar in 49 BCE and its name connecting it to the "Iulii" is first used in a letter of 43 (Cicero, *Ad Fam*.10.15.3). After the battle of Actium in 31, important elements of Octavian's victorious navy were stationed here, which instantly made it an important port (Tacitus, *Ann*. 4.5; Pliny, *HN* 3.35). Its military role remained notable throughout the first century CE (Tacitus, *Hist*. 2.14; *CIL* XII.5733). The harbor of Fréjus was built in a large lagoon covering approximately 20 hectares and slightly inland from the coast, thus providing a protected place for landing and docking (see Fig. 13). It was linked with the sea by a canal, the sides of which can still be seen in places. Remains of the canal indicate that it ranged in width from 50 to 80 meters and could thus accommodate substantially large vessels. The entire area of the actual harbor is now dry and farmed. Agricultural activity has brought to light structures and substructures on three sides of the harbor (Fig. 81); only its northern edge remains untraced. The south end is still defined by a quay and wall approximately 500 meters long. On the east end of the harbor were two semicircular exedras, one now filled in, upon which stands the so-called Lanterne d'Auguste. The "lanterne" is a hexagonal tower about 10 meters high; its upper section was restored in 1828 but its lower section and base are Roman, though possibly from a late

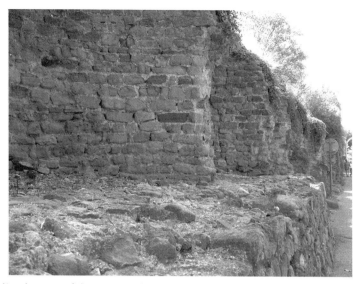

81 Fréjus (Forum Iulii), remains of dock facilities on west flank of "Butte St.-Antoine" (photo by the author).

period (Fig. 82). A similar "lanterne" stood on the opposite side of the canal, providing a clear signal to navigators of the entrance to the port. The terraces of the area now called the Plate-Forme are raised on vaulted arcades on the southwest and southeast which allowed access to large barrel-vaulted rooms and below them tripartite cisterns (the sort of appointments essential to naval installations, similar to the battered remains of the Imperial port facilities at Cape Misenum at the edge of the Bay of Naples, with its immense water-holding tank popularly called the Piscina Mirabile). Atop the terraces there are confusing remains of living quarters, baths, a peristyle courtyard, and other elements that might represent the living quarters and command offices of the fleet when it was in port at Fréjus, though none of this can be regarded as proven by the jumble of remains left there and only minimally explored or explained. Shipyards may have been located to the southwest of the Plate-Forme extending all the way to the Butte St.-Antoine bastion, where traces of docking facilities can be seen. Nonetheless, the overall picture of the port's plan and facilities is now fairly clear, and quite convincing.[105]

ARCHITECTURE FOR ENTERTAINMENT AND LEISURE

Theaters and *Odeums*

The forms of Roman theaters, just like the forms of Roman drama, were heavily indebted to Greek models. Many Romans were familiar with the Greek theaters in cities of the Western Mediterranean, notably those in Sicily and

82 Fréjus, "La Lanterne d'Auguste" Roman lighthouse (photo by the author: JCA).

Magna Graecia, long before they began building their own versions. As the
Romans gradually conquered the Eastern Mediterranean during the second
and first centuries BCE, they increased their familiarity with Greek theaters
and drama. The culmination of this contact is attested by Plutarch (*Pompey*
42.4): he specifically states that Pompey's immense theater in the Campus
Martius – the first Roman theater ever executed in stone (completed between
55 and 52 BCE) so intended as a permanent structure within the city of Rome
itself – was inspired by Pompey's visit to the Greek theater at Mytilene, on
the island of Lesbos.

Though obviously derivative, the Roman theater is a distinct building type
from a Greek theater. We know that in early centuries when plays were to be
presented at Rome itself, temporary wooden theaters were set up. These tem-
porary structures must have played a part in determining the eventual form
the Roman stone theater would take. So must the changed character of perfor-
mances in Rome, in which the role of the chorus was first reduced, then all but
eliminated, thus rendering the circular Greek *orchestra* unnecessary. Romans
enclosed the stage (*pulpitum,* sometimes *scena*) and its backdrop (*scenae frons*)
within the same architectural unit that contained the seating area (*cavea*) and

the vaulted exit passageway (*aditus maximus*) that provided the major means of access to the seating. A final important, and apparent, distinction between the construction of Roman theaters and Greek ones is that, due to extensive use of vaulting and cement construction, Roman theaters could be built on flat ground, whereas the curve of the *cavea* of a Greek theater was generally built into a natural hill or rise that had been excavated out to receive it; the result is, of course, that Roman theaters could be built in any part of an urban area where there was sufficient space. Their locations were determined as much by ease of access for spectators as by geography.[106] Outside the city of Rome, Roman-styled theaters had been built in stone for at least a century before Pompey's in the Campus Martius, as is revealed by the partially preserved examples at Naples, at Herculaneum, and especially at Saepinum. Once the theater of Pompey, and probably its immediate successor, the theater of Marcellus, were completed in Rome, they provided a compelling and dominating model for subsequent theater construction throughout the Roman world just as the design, decoration, and use of the Corinthian order in the Temple of Mars Ultor appears to have normalized and controlled the layout and design of Roman temples. A variation of the standard theater model did develop in the Gallic provinces, the so-called Gallo-Roman theater type, but it seems to have had no impact in Gallia Narbonensis.[107]

The cities and towns of Roman Provence contain remains of at least fifteen theaters, of which the best preserved and best documented is at Orange. Others that are still clearly visible include the theaters at Arles, Vaison-la-Romaine, and Vienne. The remainder are fragmentary. Fragmentary theaters can be hypothetically restored once even a small section has been excavated by comparison to others in Provence, as has been done with the modest remains of the Roman theater at Aix-en-Provence.[108] More difficult to analyze are theaters that are almost entirely restored, that is, laid over an ancient base but intended for more modern usage, such as the theater at Fréjus; indeed restoration and modern use have also affected and continue to affect the four better-preserved theaters just listed.[109] Since these theaters are so much alike in plan, let us begin with the clearest example, that at Orange, which we will then compare to those at Vienne, Vaison, and Arles.

The Theater at Orange (Arausio)

The theater at Orange (Fig. 83), together with the theater at Aspendos in southern Turkey, are the two most complete Roman theaters available for study. They provide a remarkably full picture of theater architecture in the Roman Empire. The theater at Orange does preserve some elements of Greek theater design: although the outer sides of the *cavea* are built on an elaborate system of radial vaults, the central part rests against the slope of the hill, atop which the Capitolium of Arausio or some other major sanctuary presumably sat. The

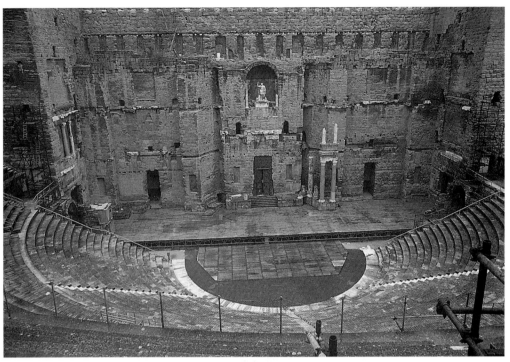

83 Orange, *cavea*, orchestra, and *scenae frons* of Roman theater (photo by the author).

connection of the *cavea* with the *scenae frons* by means of vaulted *aditi maximi* also demanded that the *orchestra* be reduced, in this case to a semicircle 29.9 meters in diameter (Fig. 84). Four shallow steps rise above the orchestra; magistrates and other influential members of the audience would sit in this prime area on removable chairs. The diameter of the *cavea* at Orange is 103.69 meters, not quite as large as that at Vienne, but still visually impressive. The lower seating area (*ima cavea*) contains twenty rows of seating divided into four sections or wedges (*cunei*), the middle (*media cavea*) contains eight rows of seating, and the top section (*summa cavea*) has three. No evidence remains of a covered walkway (Fig. 85) above the seating area (*porticus in summa cavea*) but since so much of the highest elevation of the theater is restored, the possibility should not be ruled out; however, the evidence of such an arrangement at the theater at Vaison does provide a clear comparative example. The forty-three corbels that have been restored in the upper two sections of the *postscaenium* wall behind the stage may suggest that awnings (*velae*) were used in this theater; however, only six corbels at each end of the highest row show the holes that would have allowed ropes to be put through them for actual use, so this restoration must remain speculative pending further evidence.

The low wall that fronts the stage (*proscaenicum*) and marks the edge of the orchestra is 1.35 meters high and 0.91 meters wide; it was decorated with four rectangular niches alternating with three curved ones articulated by small

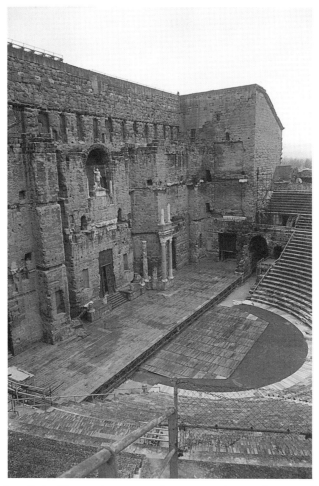

84 View of vaulted *aditus maximus* connecting *cavea* and stage, theater at Orange (photo by the author).

columns. Each niche could hold a small statue. The stage (*pulpitum*) itself is wider, 61.1 meters, than it is deep, between 7 and 9.5 meters, depending on the protrusions from the wall behind it, but is in fact deeper than many other Roman theater stages. The most striking feature of this theater, as was probably true of any Roman theater, was the *scenae frons*, the towering backdrop building behind the stage. At Orange (Fig. 86) it rises to the same height as the top of the *summa cavea* (almost 29 meters), although the upper zone is largely restored. The elegant façade of the *scenae frons* consisted of a central door (*regia*) set into a semicircular niche, which was in turn surrounded on both sides by a block of masonry that projected forward toward the *cavea*; above the *regia* was a large niche (3.35 meters high), framed in the same manner as the *regia*, which held an Imperial statue. Two more doors opened from the *scenae frons* on either side of the *regia*, halfway between it and the edge of the stage. Both had a similar

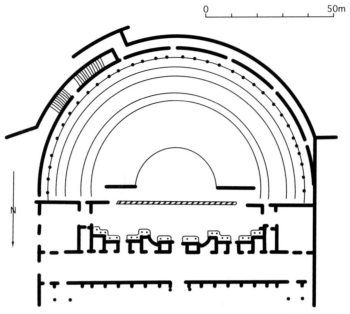

85 Plan of theater at Orange, including hypothetical walkway at the top of the *cavea* (Frakes 2009: cat. # 060–1, drawn by E. Lamy; reproduced by permission of author).

door above it flanking the statue niche above the *regia*. The entire *scenae frons* was decorated on each side with three stories of Corinthian columns and in the center, two stories, a feature sometimes labeled a *columnatio* (Fig. 87). The restoration provides a strong sense of the decoration as well as the impressive height of the scene building.[110]

Despite our considerable level of understanding about the theater at Orange, some doubts and questions remain. Its date of construction is ambiguous, and while the plan and most of its essential elements are most likely Augustan, when exactly it was built during his long reign is not clear. Its diameter is almost a duplicate of that of the theater at Arles, which is certainly Augustan, though such a similarity of dimension in no way proves the date; however, the Corinthian capitals of the *columnatio* have been dated to Hadrian, as well as to Augustus. The statue of Augustus in the niche above the *regia* (Fig. 88) is a pastiche; the head now attached had no original connection with the torso and provides no indication of the statue's, much less the building's, date. Like so many other major buildings in Romano-Provençal cities, the theater was almost certainly restored in the second century CE, perhaps by Hadrian. Another problem associated with the theater and its dating is the question of what stood to the west of it (Fig. 89). A semicircular cut, 74 meters in diameter, was made into the north side of the same hill into which the theater's *cavea* is inserted. Other walls extended north from the cut for some distance. The original purpose of these walls is unclear, but eventually they

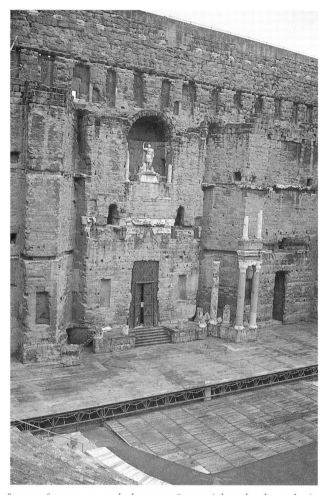

86 View of *scenae frons* as restored, theater at Orange (photo by the author).

were used as porticoes. The entire structure has been described as a *circus* or a *gymnasium*; however, this proposal is unsatisfying for why would either of those types of buildings have been placed immediately next to a theater? A more probable solution is that the semicircle indicates the placement and notably smaller size of a first – presumably Augustan – theater in the city. This putative "Augustan" theater must then have been replaced and partially subsumed by the larger one that survives, probably in the Hadrianic reworking. The most recent proposal is the hypothesis that a small temple, similar to that at Vernégues, stood in the hemicycle in the age of Augustus, and was flanked by a fountain. Absolute proof of any of these hypotheses has not yet come to light. The later topography of this area to the west of the theater is demonstrated by findings from excavations carried out in the 1920s and again in the 1950s. They uncovered a platform and some vestiges of a substantial temple (see Figs. 56 and 57) built in the second century CE, perhaps at the

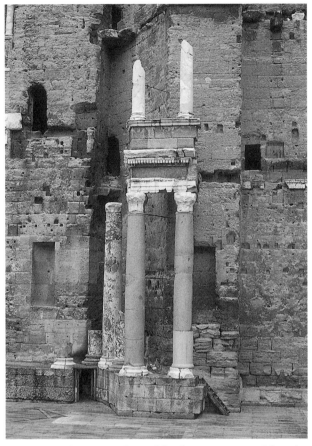

87 *Columnatio* as restored on *scenae frons* of the theater at Orange (photo by the author).

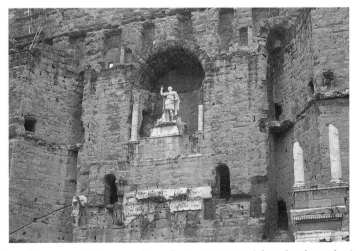

88 Statue of Augustus (?) in *scenae frons*, theater at Orange (photo by the author).

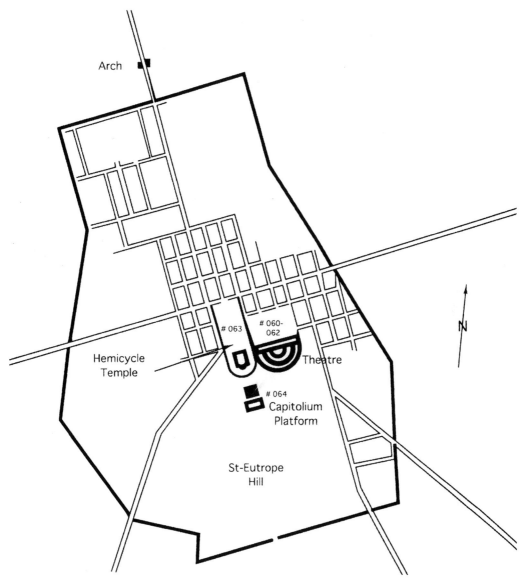

Arch

#063

#060-062

Hemicycle
Temple

Theatre

#064
Capitolium
Platform

St-Eutrope
Hill

N

89 Hypothetical plan of Roman Orange, showing theater and adjacent hemicycle to north of St.-Eutrope hill (Frakes 2009: fig. 3, drawn by E. Lamy; reproduced by permission of author).

time of the renovation of the theater. The vaults in the substructures are reminiscent of those beneath Hadrian's temple to Venus and Roma at Rome and presumably served this temple at Orange in the same manner.[111] This second century CE temple presumably replaced either the smaller Augustan theater or an Augustan temple previously set into the hemicycle excavated from the St.-Eutrope hill's north face.

The Theater at Arles (Arelate)

Securely dated to the age of Augustus, the partially preserved theater at Arles (Fig. 90) was built against a low slope above which the *cavea* was carried on nineteen radial vaults. The access system beneath the seating involved four vaulted entrance tunnels (*vomitoria*) connecting to an annular passageway. The *media* and *summa cavea* above were supported on another twenty-seven radial vaults, with a variety of staircases provided to reach different levels. When complete, Arles' theater rivaled the one at Orange in size; the total diameter of the exterior's curved profile is only 1 meter less (102 vs. 103 meters). All that survives intact are the substructures of the *cavea,* the first five rows of seats, the footings of the *scenae frons,* and a number of fragments of columns and entablature; the elegant remains of colored marbles suggest a sumptuous program of decoration that must have been impressive (Fig. 91). A late Augustan date is generally agreed upon, except by Heilmeyer who dates the architectural fragments from the *scenae frons* to the 40s or 30s BCE.[112] Given the size of this theater, and the likely elegance of its decorative scheme even in its severely damaged condition, it is to be regretted that more has not survived.

The Theater at Vaison-la-Romaine (Vasio)

Vaison was never a large urban area and its theater (Fig. 92) was predictably smaller than those at Orange and Arles: the *cavea* measures 96 meters in diameter, the *orchestra* diameter 29.85 meters (Fig. 93). Sear estimates its seating capacity to have been between 5,100 and 6,300 (compared with 5,850–7,300 at Orange and 5,800–7,250 at Arles). Nonetheless, for the size of Vaison, at least what can be estimated of it during the Imperial era, the theater is larger than might be expected. Perhaps the most interesting feature of the heavily restored theater is its position. The *cavea* is entirely supported by a hill, "La Colline de Puymin" (see Fig. 18), which was excavated to accommodate it, presumably to save the extra labor and expense inherent in supporting the *cavea* on extensive free-standing vaults. Thus one would expect entrance to the *cavea* to have been possible only through the *aditi maximi* on either side of the *orchestra;* however, the seating area could also be reached from the back of the *cavea,* by means of a tunnel excavated through the hill to the top of the seating area, an arrangement which (presumably) made the climb to the theater somewhat easier for the spectators. This theater also provides clear evidence of the system, called a *porticus in summa cavea*, for providing covered shelter for spectators at the top of the *cavea* (Fig. 94). The *scenae frons* is too badly destroyed to be restored with any accuracy (Fig. 95); however, the discovery of portrait statues of Claudius, Domitian, Hadrian, and his wife Sabina intentionally buried in shallow pits within the building suggests a reconstruction with large niches that would permit such statues to

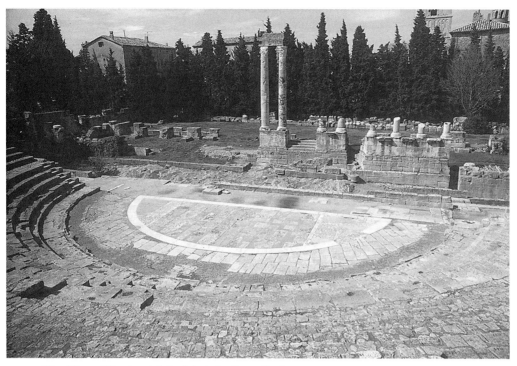

90 View of theater at Arles (photo by the author).

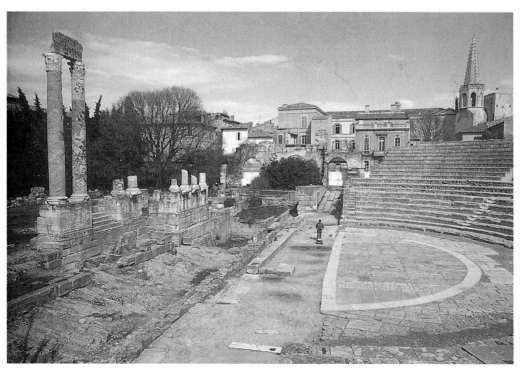

91 Orchestra and stage of theater at Arles, as restored (photo by the author).

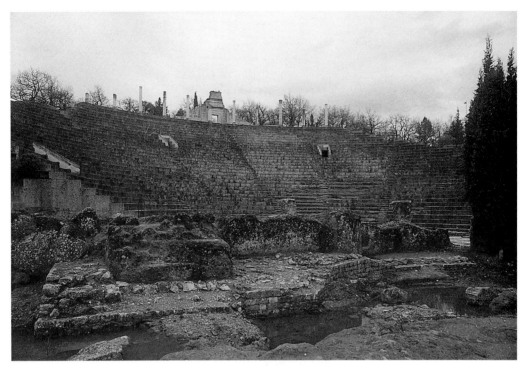

92 View of the theater at Vaison-la-Romaine (photo by the author).

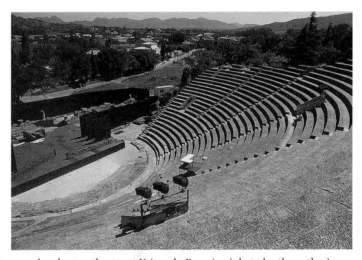

93 *Cavea* and orchestra, theater at Vaison-la-Romaine (photo by the author).

be displayed, similar to the *scenae frons* in the theater at Orange. Because so
little stratigraphic detail was recorded at the time it was excavated, the dat-
ing of the Vaison theater must remain speculative. It may have been begun
during the reign of Tiberius (14–37 CE) or possibly not until the reign of
Claudius (42–54 CE), hence the presence of his statue, though other schol-
ars regard that as evidence of a first reworking of the theater. There were

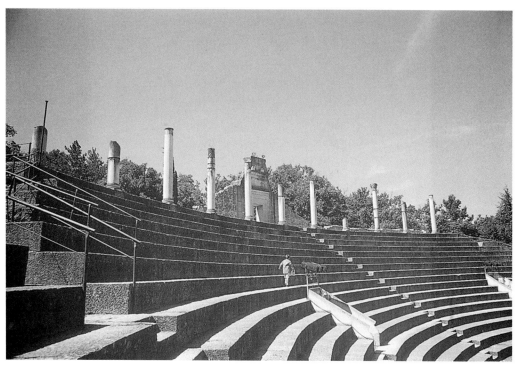

94 *Porticus in summa cavea* as restored, theater at Vaison-la-Romaine (photo by the author).

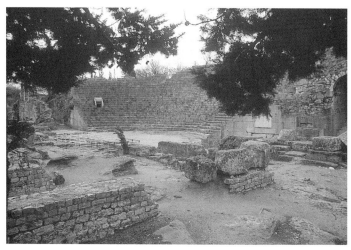

95 View of fragmentary scene building, theater at Vaison-la-Romaine (photo by the author).

probably restorations or revisions under Domitian, and a (possibly substantial) rebuilding under Hadrian. These are reasonable hypotheses based on the Imperial portraits recovered from the theater, but the state of the available evidence does not allow for any certainty.[113]

The Theater at Vienne (Vienna)

Roman Vienna (see Fig. 14) was more politically important and wealthier than Roman Arausio (Orange) and the remains of the theater, though substantially restored, are almost as impressive as those at Orange, and are even larger (Fig. 96). For example, the diameter of the *cavea* at Vienne is 130.4 meters, compared with Orange's which is 103.63 meters; the *orchestra* at Vienne is 34.76 meters in diameter, compared with 29.9 meters at Orange; and Sear estimates Vienne's seating capacity (Fig. 97) at an immense 8,300–10,400 (Orange is estimated to have held 5,850–7,300 spectators). Like the theater at Vaison, the *cavea* at Vienne had little substructural vaulting; it is supported primarily by the hillside against which it stands. The diameter of the *orchestra* (34.76 meters) again demonstrates the extraordinary size of this theater (Fig. 98). Relatively little is known about the decorative scheme of the *scenae frons,* since almost nothing of the original has been preserved. We do know that two sets of four lions confronting one another stood at the top of the central niche of the *proscaenium* (where they could have obstructed the view of some patrons); satyrs' heads, sleeping dogs, three bulls, and a stallion have also been recovered from the decoration. Archival records tell us that two statues of Silenus were given to Catherine de'Medici in the sixteenth century, but these have disappeared; various other animal sculptures are reported, and apparently all this animal iconography was crowned by an attic representation of Orpheus charming the animals with his music. The theater has undergone extensive reconstruction, the ancient parts that remain substantially intact are the *cavea,* although most of the seating is new, the *orchestra*, the *proscaenium,* and tiny parts of the *scenae frons.* The dating of the theater is as disputed as the dating of almost every other Roman monument in Vienne: a foundation in the Augustan era is generally agreed upon; restoration, probably extensive, in the second century CE also seems certain, but whether under Trajan, Hadrian, Antoninus Pius, or even later is a matter for speculation. The theater was excavated in 1908 and extensively restored, then opened to the public and used for performances beginning in 1938.[114]

The Odeum at Vienne

The *odeum* as a building type derives from a small roofed theater built by Pericles in the agora at Athens during the fifth century BCE. It was a lecture or recital hall, which could be used for any smaller form of presentation, and presumably served an audience more sophisticated than those attending the theater or the amphitheater. An *odeum* could be roofed or unroofed. In roofed *odea* such as the example at Pompeii, the curved *cavea* was enclosed inside a square building, and staircases were introduced between the back corners of the building and the curve of the seating. The roof was then suspended over the whole. A roofed

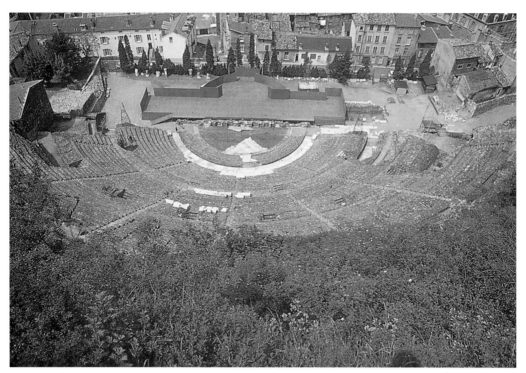

96 View of the theater at Roman Vienne, from the *summa cavea* (photo by the author).

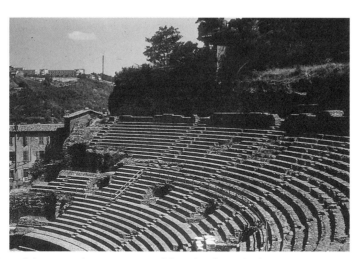

97 View of the *cavea,* theater at Vienne (photo by the author).

odeum was also called a *theatrum tectum* (roofed theater), and they were often (as at both Corinth and Pompeii) located adjacent to or near a true theater, suggesting that they were thought of in Roman times as part of an "entertainment complex" for (mostly) nonsporting diversions.[115] An unroofed *odeum*, such as the example at Corinth, was a smaller theater left open to the sky. Domitian is

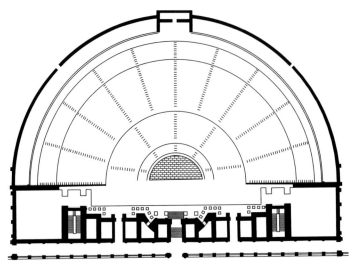

98 Plan of the theater at Vienne (Frakes 2009: cat. # 041–2, drawn by E. Lamy; reproduced by permission of the author).

credited with building the only known *odeum* in the city of Rome, near his race course in the Campus Martius. No archaeological traces of the hall have ever been found.

The only known example of an *odeum* in Provence was found at Vienne (see Fig. 14, where it is labeled "Odeon"). Sadly, it is so fragmentary that we cannot be certain whether it was roofed or unroofed. The size of the *cavea* would argue against the presence of a roof; however, the location of stairs at the seating area could argue in favor of one. The remains are too fragmentary to provide a clear answer. The fragments of architectural decoration are impressive: notably including carved column bases, column capitals with sculpted heads, and fragments of veneer in marbles imported from Greece, Asia Minor, and Africa. The identification of the building is fairly certain, due to an inscription found in the building that labeled it an *odeu[m]*, although the ground plan is also quite clear. The decorative material and imported marbles have led to a very unusual general agreement that the building must date from the second century CE. It stands on the foundations of a building of Julio-Claudian date, but whether that was an earlier *odeum* or something entirely different cannot be determined.[116]

Amphitheaters

The amphitheater as a monumental building form developed relatively late in the history of Roman architecture. Vitruvius barely mentions them; instead, he emphasizes the use of fora as venues for gladiatorial shows, the need to provide sufficient open space for them and the need to provide adequate vantage points for spectators (Vitruvius, *De arch.* 5.1.1–2). This reflects the common practice

of his day, a practice that began with the introduction of gladiatorial games in Rome in 264 BCE and persisted until the opening of the Flavian amphitheater in about 80 CE. A strong case can be made that the amphitheater was developed from the temporary wooden structures that were erected for such shows in the Roman forum.[117] Permanent amphitheaters built in stone had appeared in Campania, at Pompeii, by 80 BCE and in Etruria, at Sutri, by the middle of the first century; it is often asserted that the history of the form in Campania goes back to the second century BCE, with perhaps the amphitheaters at Cumae, Capua, and Puteoli (Pozzuoli) originating in this era, but there is as yet no convincing archaeological evidence for this retrojection of the type beyond the early first century BCE.[118] The first permanent amphitheater in the city of Rome was built in 29 BCE by Statilius Taurus, at the behest of Octavian. Construction of the Flavian amphitheater at Rome, beginning in the 70s CE with refinements continuing into the 80s, marked a significant advance in the design of such buildings. The system of elaborate masonry and concrete vaults that held both radiating and concentric ramps, staircases, and corridors, which had already been used in theaters, was applied to the amphitheater. That development must have increased the speed of filling and emptying the *cavea* with spectators, as well as increasing the general safety of audiences. This arrangement also made the practical use of these massive buildings possible. The Flavian amphitheater at Rome became the model for the Imperial amphitheater type, and its influence can be seen throughout the western Empire (relatively few amphitheaters were built in the east), including in the two major examples in Narbonese Gaul.[119]

The Amphitheaters at Arles and at Nîmes

These two remarkably similar amphitheaters share a number of elements in plan, in construction, and in decoration. The similarity of the two has convinced most observers that they are, in essence, contemporary. Certainly, in size they are very close: the amphitheater at Arles (see Fig. 12) measures 136 × 107 meters on its axes, while that at Nîmes (see Fig. 15) measures 130 × 101 meters, and when the Arles amphitheater still retained its uppermost story, it was also probably just slightly taller than the one at Nîmes, which has most of its attic story intact. Both employ a system of radial and concentric ramps that is clearly modeled on that of the Colosseum; interestingly, however, neither possesses the elaborate series of substructures beneath the *arena* itself, nor the trapdoors, lifts, and pulleys that permitted elaborate stage settings to be lifted directly into the arena and provided for surprise entries and exits. Brick stamps in place in the Colosseum strongly suggest that those substructures were added during the reign of Domitian, if not slightly later; this may help to assign a date to the amphitheaters at Arles and Nîmes. The exteriors of the two amphitheaters employ two superimposed arcades of sixty arches each, both of which are framed in Doric pilasters on the bottom level (Arles, Fig. 99; Nîmes, Fig. 100).

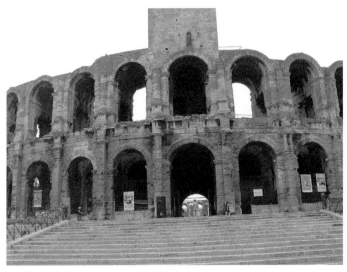

99 Roman amphitheater at Arles, view of exterior (photo by the author).

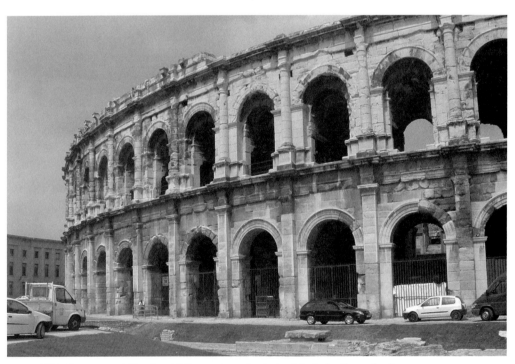

100 Roman amphitheater at Nîmes, view of exterior (photo by the author).

At Nîmes the second story arcade's arches are framed in engaged Tuscan half-columns (Fig. 101)[120]; at Arles the order of the second story is Corinthian (Fig. 102). The half-columns on the second stories of both amphitheaters stand on rectangular pilasters topped by a projecting cornice from which the shaft of the engaged column rises. This architectural arrangement does not occur before the

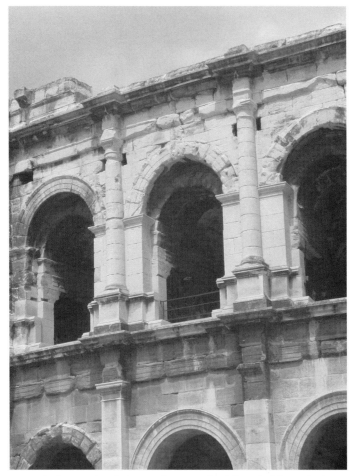

101 Nîmes, amphitheater, detail of second-story order (photo by the author).

reign of Domitian (81–96 CE). An example of it can still be seen in the preserved
fragment of colonnade that survives from the Forum Transitorium in Rome, still
in situ on the Via dei Fori Imperiali. Its use in the decorative scheme of both
amphitheaters provides a reasonable *terminus post quem* for their construction:
neither is likely to be any earlier than the last two decades of the first century
CE, and probably not before the end of that period (ca. 90 CE or later). This
would appear to be overall the most satisfactory date that can be assigned to
the amphitheater at Arles and is not much disputed; the variations in technical
details of vaulting and the slightly more elaborate external carving suggest a
slightly later date for the one at Nîmes, either the very last years of the first cen-
tury, or possibly the early years of Trajan's reign (ca. 100 CE).[121]

There are two other small distinctions in appearance between the exteriors of
the two amphitheaters, but neither carries any particular implications for dat-
ing. At Nîmes, on the second story façade an unusual horseshoe-shaped element

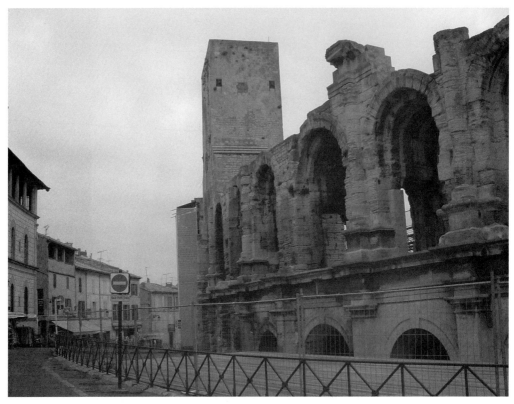

102 Arles, amphitheater, detail of external orders (photo by the author).

can be seen between the transverse vaults and the frontal arches; this does not appear at Arles, and suggests there were some difficulties in reconciling the exterior with the complex system of vaulting inside at Nîmes. Also, at Nîmes, heads of bulls were carved above the entrance vaults on the first story (Fig. 103), presumably as decoration or perhaps to aid in identifying the particular entranceway a spectator was to use. The use of a bull's head as a symbol for Nîmes seems unusual. Bulls' head protomes also appear on the porte d'Auguste, but ever since veterans of Octavian's Egyptian campaign were settled in Nîmes after 30 BCE, the crocodile had been the city's animal symbol. Two identical inscriptions found in the substructures of the amphitheater at Nîmes give us the name of the architect or the engineer responsible for those substructures if not for the entire building (*CIL* XII.3315):

T. CRISPIVS REBVRRVS FECIT
T. Crispius Reburrus made (this)

Sadly, no other record of Crispius Reburrus has survived.[122]

The internal structures at Nîmes (Fig. 104) and at Arles are essentially the same. The arena floors of both cover a large cross-shaped trench, presumably for

103 Nîmes, amphitheater, carved bulls' heads over entranceways (photo by the author).

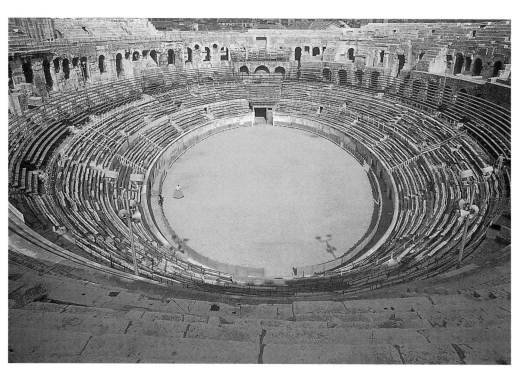

104 Interior *cavea* and *arena* as restored, amphitheater at Nîmes (photo by the author).

use during shows as well as for cleaning and drainage. Two concentric corridors, covered by barrel vaults, circle the buildings beneath the *cavea*; the outer corridor is connected to the slightly lower inner corridor by sloping ramps; staircases run from the inner corridor to the *vomitoria* that admitted spectators to the seats of the *ima cavea*. At the second story, the surrounding corridor is roofed with flat lintels and three staircases begin from it, one leading down to a barrel-vaulted mezzanine (also accessible from below by stairs) which allows access to the *vomitoria* of the second tier of seats (the *media cavea*), the second leading to *vomitoria* in the third tier (*summa cavea*), and the third leading off from the second up to a small gallery that circled the building at the attic level and permitted entry to the fourth small tier of least desirable seats. The entire system is elaborate, carefully planned, and clearly derived from that of the Flavian amphitheater; the execution of it at both Arles and Nîmes is sophisticated.[123] These late first/early second-century CE amphitheaters show that in the execution of the most refined forms of engineering, as well as in the ability to encompass them in well-built architectural casings, the builders of Gallia Narbonensis were close to the equals of those working contemporaneously in Rome and Italy. While the localizing elements on these amphitheaters, as was true also of the theaters in the province, are few and far between, and not at all as readily visually identifiable as the distinctive forms of carving and motifs applied to temples, arches, porticoes, and other such religious and official monuments, nonetheless – particularly in the bulls' head protomes and the unusual inner vaulting profiles of the second-story arcade on the amphitheater at Nîmes – there are subtle variations that do not recur elsewhere and subtly but clearly join the amphitheaters to the distinctive decorative tradition of Roman architecture in Provence.

The Amphitheater at Fréjus

This amphitheater has long remained a puzzle due in large part to severe flood damage inflicted on it in December 1959, caused by the collapse of the Malpasset dam on the Reyran River.[124] The building seems to reveal a mixture of elements typical of early amphitheaters scrambled together with elements from post-Flavian examples. Compounding the difficulties associated with this site is its restoration after the flooding as a modern entertainment complex: much of what is left of the Roman construction was covered over. The eastern side of the *cavea* is partially excavated into the side of a hill and the first rows of seats are cut directly into the rock. The upper seating areas and the entire western side rise on vaulting executed in *opus vittatum* (Fig. 105). The *arena* itself is at ground level, and beneath the arena appears a very deep cruciform ditch. At almost 2 meters deep, this trench is much deeper than those normally associated with amphitheaters. An attempt to explain this anomaly is that, as at the amphitheater at Mérida (Roman Augusta Emerita) in Spain, this extra-deep

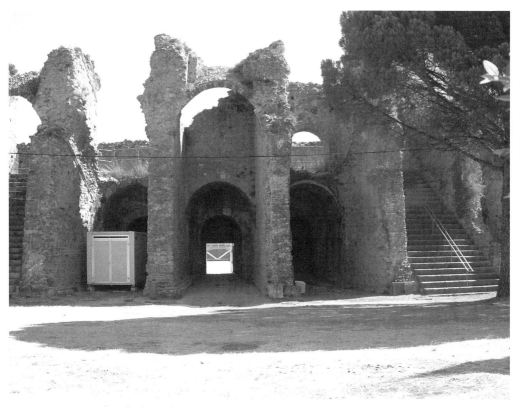

105 View of vaults beneath *cavea,* amphitheater at Fréjus (photo by the author).

ditch could be filled with water so that miniature naval battles could be staged; the presence of an aqueduct branch nearby is cited as corroboration. But no actual evidence supports such a reconstruction. Little of the external façade of the amphitheater can now be restored; however, it is possible to see that the lower story was faced in ashlar masonry (Fig. 106) and decorated with pilasters that did not rise from bases. The amphitheater is situated very close to, but outside, the city walls in this western sector of Fréjus, as was the theater (see Fig. 13). This placement must raise doubts about the effectiveness of the city walls as fortifications against a landward military threat if an easily overrun amphitheater was built adjacent to but outside them; any threat to the town must have been regarded as unlikely at best. This arrangement suggested to Golvin that the remnant of the amphitheater at Fréjus might represent a second building of the amphitheater; that an earlier, smaller one inside the walls would have served the naval city when protecting the fleet was a significant concern, one which ceased to be a consideration once the coast of southern France was secure. Golvin's reconstruction, however, has not been confirmed by the most recent archaeological investigations of the building, carried out during 2006 and 2007.

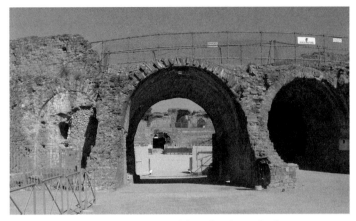

106 Entryway vault, amphitheater at Fréjus (photo by the author).

Dating this amphitheater is a matter of dispute: some elements in it would seem to make it fit most easily into the range of Julio-Claudian amphitheaters that includes those at Paestum and Alba Fucens in Italy, but its placement outside but immediately adjacent to the city walls, and the relatively extensive use of vaulting beneath the *cavea*, suggests a later date, probably not before the first half of the second century CE. The problem was deemed insoluble until the most recent excavations permitted a clear demonstration, in which the architectural and stratigraphic evidence could be independently confirmed by ceramic chronologies established for the site and the building, that the extant amphitheater was built entirely in the first half of the second century CE, during the reign of Trajan or Hadrian or both.[125]

Circuses and *Stadia*: Arles and Vienne

Evidence for racing venues – *stadia* or circuses – is sparse in Narbonese Gaul. At Arles an obelisk from the spina of the city's circus served as a reminder of its location until 1675 when it was moved to the area of the Place de la République, where it remains (Fig. 107). Various elements of Roman Arles' circus (see Fig. 12) were uncovered in 1831 when the Arles-Bouc canal was dug, and occasional investigations have continued in the area since: three sections of its seating have come to light; parts of the eastern exterior wall were rediscovered in 1970–1971, and several substructural bays beneath the seating were excavated in 1974. These finds indicate that the circus was oriented southwest to northeast, with its *carceres* (starting gates) at the northeast. A fragmentary Flavian inscription (*CIL* XII.670) suggests that some kind of circus existed in the same location during the first century CE, but it could have been an earlier, wooden structure; the excavations in the 1970s and 1980s indicate that the later stone-built circus

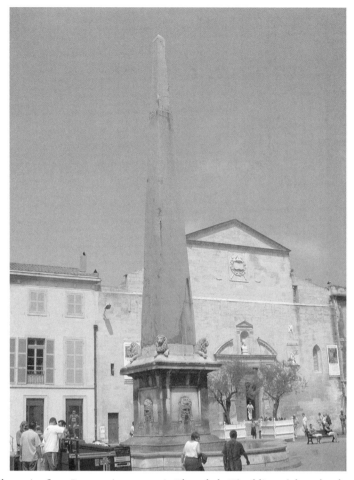

107 Arles, *spina* from Roman circus, now in Place de la République (photo by the author).

was constructed in the second century. It remained in use into at least the fifth century CE: Sidonius Apollinaris (*Ep.* I.11.10) tells of *ludi circenses* being staged therein when he visited the city in 461.[126]

Vienne also had a circus, located just outside the city walls to the south (see Fig. 14). A pyramid-shaped obelisk (called "l'aiguille" = the needle, or sometimes "La Pyramide") that must originally have stood on its spina is still visible (Fig. 108). Excavations in the nineteenth century proved that the "needle" came from the circus, and first revealed some seating on the west side. Excavations between 1903 and 1907 brought to light the remainder of the complex and provided its overall dimensions: 455.2 meters long and 118.4 meters across. Dating this circus has provoked some controversy; the "needle" is generally agreed to be a late antique creation, and the circus as we know it probably also dates from the fourth century CE. To date, the evidence uncovered is not sufficient

108 Vienne, circus obelisk called "L'aiguille" or "La Pyramide" (photo by the author).

to justify the hypothesis advanced by some scholars that it replaced an earlier circus on the same site, however logical that may seem.

A single mosaic from Vienne, and a random remark in a letter of the younger Pliny (IV.22) indicate that Vienne also had a *stadium*. If Pliny knew of it, then it was clearly in use by the later first century CE, but we cannot establish a secure location for it. Beyond this slight evidence, *stadia* are otherwise unattested in Provence.[127]

Libraries: Nîmes

The first "public" library at Rome was established in 39 BCE by Asinius Pollio. It was followed by libraries endowed by Octavia in the Porticus Metelli near the theater of Marcellus and by Augustus in his temple to Apollo on the Palatine. Libraries (*bibliothecae*) appear in many cities throughout the Empire and at a wide variety of dates. However, evidence for ancient libraries in Provence is minimal and ambiguous at best: the only candidate in Narbonese Gaul is the

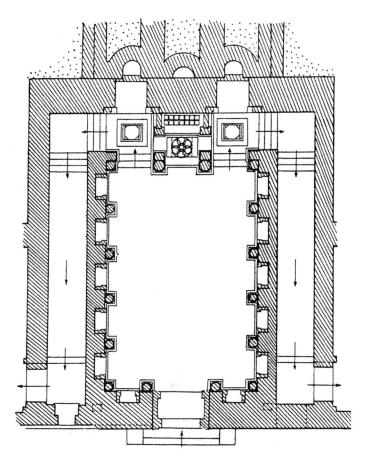

109 Architectural plan of probable *bibliotheca* (library) at Nîmes (after Gros 1996: fig. 427, p. 371).

quadrangular vaulted building connected with the great *Augusteum* (see below) at Nîmes. This building (Fig. 109) was erroneously identified as a temple to Diana, although its architectural form in no way suggests a temple, and the association with Diana is unfounded. The building is 14.52 meters long and 9.55 meters wide; its rear wall is broken out into a substantial axial exedra surrounded on either side by two small spaces accessible by a stairway (Fig. 110). Decoration throughout was executed with elegance and beauty, including the carved soffits and numerous other finely detailed elements. The lateral walls of the quadrangle are decorated with small attached columns standing on pedestals; each column is topped with a composite capital, all of which supports an Ionic entablature. The walls also have rectangular niches which could have held wooden inserts for the storage of scrolls (Fig. 111). Although of relatively modest size, the general plan of the building, together with the presence of tall niches in the walls, recalls the elegant and well-preserved Library of Celsus at Ephesus in Asia Minor, or the library built by Hadrian at Athens; indeed, the engaged columns

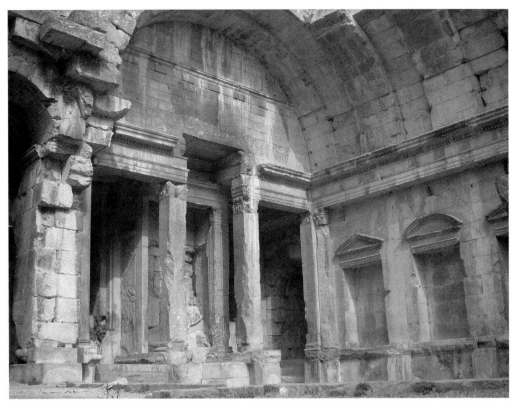

110 Rear wall of *bibliotheca,* with niches, staircase, and barrel-vaulted roof, Nîmes (photo by the author).

framing alternating triangular and segmental pediments which decorate the barrel-vaulted room's interior walls most closely resemble those of the so-called Temple of Bacchus at Baalbek in Lebanon, which is Antonine in date. From these comparanda alone, a second century CE date, the Hadrianic or Antonine era, would not seem unlikely for this monument, and would accord well with its design, but it has also been argued that both the order and the decoration would suit the Augustan period, and that the building had a religious function connected with the water shrine to *Nemausus* and the *Augusteum*, to which it is adjacent. Both explanations of its function are possible and they need not be mutually exclusive; it could perhaps have served both religious and library functions at the same time, or in succession. The disagreement over dating may reflect a change in its function, or simply the long history of the great sanctuary of which it formed a part, since it was begun under Augustus, extensively reworked under Hadrian or his successor, and continued as a shrine, and perhaps a library, until late antiquity. Whatever date is preferred, the identification of the so-called Temple of Diana as a *bibliotheca* is architecturally convincing, even if it served dual purposes.[128]

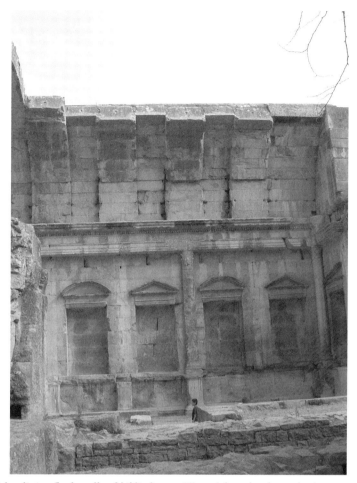

111 Niches lining flank walls of *bibliotheca* at Nîmes (photo by the author).

HYDRAULIC ARCHITECTURE: BATHS, WATER SANCTUARIES, AQUEDUCTS, AND WATER MILLS

Roman *Thermae* and *Balineae* (Public and Private Baths)

Roman architecture reveals a penchant for creating buildings that could serve multiple purposes within the same walls, and none was ever more successful than the bath buildings, both public and private, that were one of the most typical features of Roman cities and towns. Like so many other building types, the Romans adopted the bath buildings – as well as the earliest word used in Latin for them: *balineae* – from Greeks. Before the end of the first century BCE the Romans had so completely revised, adapted, redefined, and reinvented the architecture of bathing complexes that a new word was applied to them. This new word was first used when M. Agrippa built his public baths in the

Campus Martius (between 26 and 19 BCE) and, in their dedication, referred to them as the *thermae Agrippae*. Both words continued in use, *thermae* referring to official, public bathing establishments of large size, *balineae* to smaller, often private or semiprivate, baths (Pliny, *HN* 36.121 and 189). The architectural heritage of bath buildings in the Roman world begins with the Hellenistic period baths that were built in the major cities of Sicily (including Megara Hyblaea, Gela, and Syracuse) where the hypocaust system (*hypocausterium*) so essential to all Roman baths was first attempted. The next phase in their development may still be seen in the Stabian Baths at Pompeii. Here the plan reveals a number of features that would become standard elements of thermal architecture: the undressing room (*apodyterium*), warm room (*tepidarium*), hot room (*caldarium*), cold plunge room (*frigidarium*), and occasionally such features as a sweat room (*sudatorium* or *laconicum*). The Stabian Baths also featured separate areas for men and women, and the placement of the furnace room (*praefurnium*) between the hot and warm rooms, where it could provide the most efficient heating. Here the hypocaust system is clearly in use: the floors of all heated rooms are raised on low brick pilasters (*suspensurae*) so that warm air could circulate underneath thus heating the relatively thin flooring (*balneae pensiles*). For rooms where extra heating was necessary, such as the *caldarium* and *sudatorium,* clay tubes were run up the walls from the hypocaust and into the ceilings, even into domes and vaults, so that the entire surroundings of such rooms could be heated. Variations of this remarkable system of central heating appear in every bathing facility throughout the Roman world. It represents one of the signal successes of the Roman genius for engineering. The architectural plan of *balineae* was always adaptable to the space and topography available to it; *thermae,* the gigantic public bath buildings of Imperial times, were also variable in plan, but less so, becoming fairly standardized by the time Trajan built his huge bath complex on top of the Oppian wing of Nero's infamous Golden House. The design of the *thermae Traiani* became the model for later baths, not only in Rome (the Baths of Caracalla, and of Diocletian) but throughout the Empire.[129]

The Row-type Baths at Glanum, Vaison, and Fréjus

A bath complex (Fig. 112) was added to the residential district of Glanum when the area was rebuilt in the third quarter of the first century BCE. The plan of the baths (see Fig. 6) is remarkably similar to the final phase of the Stabian Baths at Pompeii, a comparandum that is also chronologically acceptable. The Glanum baths reveal the usual sequence of dressing room, warm room, and hot room laid out in a row on one end of the complex, ranged beside an open exercise ground (*palaestra*) next to which was a swimming pool (*natatio*). The furnace is especially well preserved, revealing both the channels for the circulation of heated air, and the *suspensurae* that carried the raised floor. The hot room was

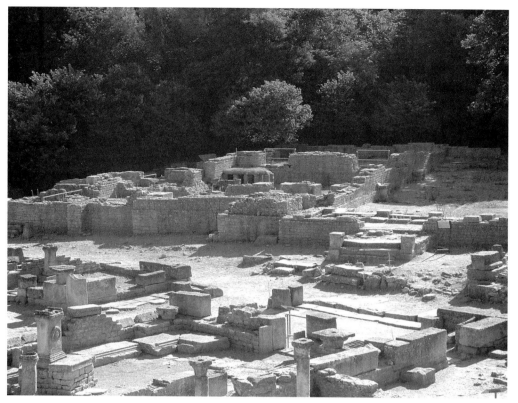

112 Glanum, remains of Roman row-type baths (photo by the author).

originally apsidal, with the curved end impinging on the *palaestra*. In a renovation dated by Gros to the last years of the reign of Augustus, but to the Flavian era by Nielsen, the apse was removed and replaced by a flat wall, thus enlarging the space available to the exercise yard. Little remains of the superstructure, though barrel-vaults over the three aligned rooms are usually restored by analogy to the Stabian Baths. The walls of the porticus surrounding the pool were decorated with half-columns.

Similar in design to the baths at Glanum, but of uncertain date, is the complex at Vaison-la-romaine called the North Baths. Again, the design is based on the idea of arranging the rooms requiring heat in a single line. These baths had to be fitted into an extremely small plot of land, so the row layout was perhaps the only one possible. One element common to linear baths in Campania appears to have disappeared completely in Provence: no row-type bath in Gallia Narbonensis possesses the small round room that is often restored as a sweat room when it appears in older examples, or as a cold room in later variations where it is not connected into the hypocaust system at all. At Glanum there would not have been space to add such a room to the plan, but that was not necessarily true at Forum Iulii; nonetheless it was included in none of these and

so constitutes a local architectural variation in the layout of row-type baths in Roman Provence.

At Forum Iulii (Fréjus), just the foundations of yet another row-type bath building have been found atop La Plate-Forme. Although nothing remains but foundations, the use of *opus incertum* suggests an initial construction during the second half of the first century BCE. Renovations and reconstruction seem to have occurred over the years, but the basic row plan seems to have been retained. At some point the *frigidarium* was given a shallow pool in its center, and a round *sudatorium* was also added; however, the confused stratigraphy of the site makes dating these additions impossible, if indeed they were additions and not parts of the original design. Here again, the relatively modest spaces into which these early Narbonese baths were inserted may explain the lack of these features.[130]

The Baths of the Port ("La Porte Dorée") at Fréjus

A second, more fully understood, bath has been identified at Fréjus. The archway standing to the west of the port area was for centuries assumed to be the monumental fornix of the city's south gate (Fig. 113). Excavation and investigation in the last century demonstrated that the archway is, in fact, the sole remaining vestige of a substantial bath complex. The arch itself indicates the height and suggests the overall dimensions of the *frigidarium*. In 1988 emergency excavations conducted in advance of a street realignment and the construction of an underground parking garage brought to light enough traces of the rest of these *thermae* to permit dating and a reasonably reliable reconstruction. The complex was built into a rocky rise of land leading up from the port area. All remains described use of a form of *opus mixtum,* identified by the excavators as *opus mixtum vittatum*, this masonry style interspersed brick with stone courses. The substructures still visible at the Porte Dorée arch were presumably used as service corridors and passageways. The excavated remains, though now mostly hidden beneath the street and parking garage, included a bathing or swimming pool *(natatio)* measuring about 27 × 13.5 meters, and 1.25 meters deep. The pool was revetted in marble of which a few fragmentary plaques and several bronze clamps were discovered in situ. The lower section of a white marble statue was found on the floor of the pool. Presumably, this came from one of the niches set into the west wall of the *natatio*, which strongly suggests that the wall decoration took the form of a *nymphaeum* that poured its water into the pool, a decorative scheme known from other Imperial baths. A hot room, or rooms, opened off the *natatio* to the south on the other side of the archway. Beyond were noted traces of the furnace that heated the complex *(praefurnium)* followed by a long service corridor and a staircase.

The excavators dated the complex to the second half of the second century CE based on comparisons with other bath buildings of similar type, the use

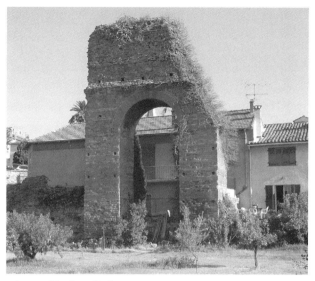

113 Extant archway of baths called La Porte Dorée at Fréjus (photo by the author).

of the *opus mixtum vittatum*, and the elaborate hydraulic system devised for
the evacuation of water from the *natatio* into the neighboring area which was
defined by a mole established to keep the seawater at bay, and which came in
the late first century CE to be the site of a public fountain house and garden.
The bath complex stood immediately adjacent to the fountain house and, when
built, was connected to and integrated with the preexisting *nymphaeum;* in add-
ition, both of them bordered on the mole that defined the port and separated
it from the town. The fountain house revealed some indications of having been
reworked when it was adapted into the plan of the baths; it may subsequently
have been incorporated into them altogether.[131]

The Severan Baths at Cemenelum (Cimiez)

Excavations at Cemenelum (Cimiez) in Roman *Alpes Maritimae* (see Fig. 2 for
location) have revealed a set of three *thermae*, all datable to the third century
CE, all laid out in the design Nielsen called the "axial row type." The three
complexes are labeled East, North, and West Baths. The north complex is very
large, almost monumental in scale, with a total size including the *palaestra* and
outer walls of 2,880 square meters, and the bathing rooms alone covering 710
square meters. The size reflects perhaps the influence of the contemporary Baths
of Caracalla in Rome. The west wall of the *frigidarium* in the North Bath is
preserved up to the initial springing of its vault; the plan featured double hot
rooms (one on either side of the central axis), and a *laconicum* added into an
extension of the warm room. Like the walls of La Porte Dorée at Frejus, the
extant walls are of *opus vittatum*, a masonry facing common in many periods in

Provence, though generally attributed to the third and fourth centuries CE in Italy. In the Middle Ages the high walls of the *frigidarium* of the North Baths were mistakenly thought to have been a temple to Apollo, and they are still so labeled in guidebooks from time to time. Little evidence for the decoration of any of these baths at Cemenelum has survived, since they were often despoiled for building materials in later centuries. The East and West Baths, smaller versions of the North Baths, also employ *opus vittatum* facing in their masonry, and stand nearby; what prompted the contemporary construction of three such baths in such proximity has yet to be satisfactorily explained.[132]

While baths were being constructed at a surprising pace at Cimiez in the third century CE, in many other cities of the Empire they were being closed or abandoned. It was at this period that the long-established north baths at Vaison were shut down, and replaced with other buildings; the baths at Glanum were also closed. The Cimiez baths continued in use for a generation or two longer, but seem to have ceased to function by approximately the last decade or so of the fourth century.[133]

The Constantinian Baths at Arles (Arelate)

The threat to the Rhine and Danube borders of the Empire in the fourth century CE, which caused the Imperial desertion of Trier (*Augusta Treverorum*), worked to the civic advantage of Arles. The combination of an important Episcopal seat with the relocation of the Imperial mint and Imperial administration to the city caused a wave of prosperity and architectural embellishment. This may be sufficient to explain the construction of the new bath complex (see Fig. 12 for location), which is known as the *thermae Constantinianae*. The layout of these baths is slightly unusual. They are a variation of what Nielsen calls the "half-axial ring type," which means they did not extend nearly as far along their axis as did huge Imperial *thermae*, but were still at least partially axially symmetrical. At Arles, the cold rooms and, perhaps, the warm rooms were symmetrical, but the rest of the plan was not: there was a *sudatorium* on the west side of the main axis, but answering it on the east was the furnace room. The walls that survive stand close to the river; they include an impressive apse (Fig. 114) that opened from the north wall of the *caldarium*. The apse had three vaulted windows and was roofed by a half-cupola (Fig. 115); the walls are faced in *opus vittatum* like those of the north baths at Cimiez and the Porte Dorée at Fréjus. Parts of the hypocaust system have been reconstructed from the original materials: the *suspensurae* are unusually tall (Fig. 116), resulting in floors raised as much as a meter above the foundation levels. The entire building, even taking into account the restrictions on size that seem to have been accommodated in its layout, would have constituted a remarkable benefaction to any city in the early fourth century CE, and Constantine's sojourn at Arles ca. 314 CE seems a reasonable peg upon which to hang their inception and funding. While the attribution

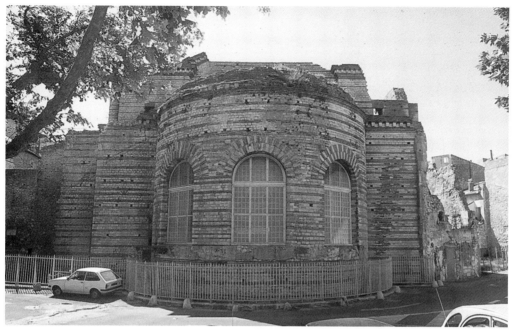

114 *Caldarium* apse from the exterior, Constantinian baths at Arles (photo by the author).

to Constantine makes sense within the history of Roman Arles, the date cannot be regarded as absolutely proven: Nielsen points out, quite rightly, that the presence of lead pipes in the water system of the building would normally be taken to establish a rather earlier date. If, however, the Constantinian dating is sound, these baths also imply that the aqueduct system at Arles was still in good working order at a time when other cities in Narbonese Gaul, and elsewhere in the western Empire, were finding it hard to maintain the traditional excellence of Roman hydraulic engineering.[134]

Water Sanctuaries and Monumental Fountains

It is easy, when walking through ruins of Roman antiquity, to forget what a large role water, especially water moving in channels or fountains, played in the architecture and design of those places. The poet Propertius (*Elegies* II.32.15), writing during the age of Augustus, summons up the water-graced image of the ancient Roman city at its best, when he evokes the city resounding to:

Et sonitus lymphis tot crepitantibus orbe, cum subito Triton ore refundit aquam.

The sound of the water which splashes all round its basin when suddenly Triton pours forth water from his mouth.

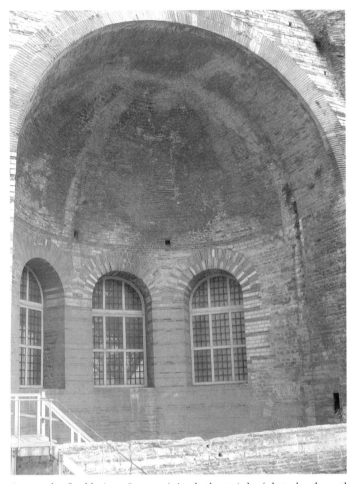

115 Interior cupola of *caldarium*, Constantinian baths at Arles (photo by the author).

The poet envisions the Roman city as a place of playing fountains, elegant water-works with statuary around them, and beautifully decorated sanctuaries to the water deities. This image is confirmed by Marcus Agrippa who, during the reign of Augustus, erected or at least paid for 500 fountains decorated with 300 stat-ues in bronze or marble and 400 marble columns at Rome (Pliny, *HN* 36.121). While there were, without doubt, many hundreds of fountains and waterworks spread all over the Roman cities of Narbonese Gaul, just as there were at Rome, these tend to be the kind of monuments that are easily despoiled, providing decorative material for centuries of later gardens, palaces, homes, public parks, and museums. Only a small number of such remarkable water monuments can be studied or understood now; water sanctuaries and fountains seem to be espe-cially ephemeral. However, a few important water sanctuaries have been exten-sively investigated in "provincia nostra," and they will provide at least some

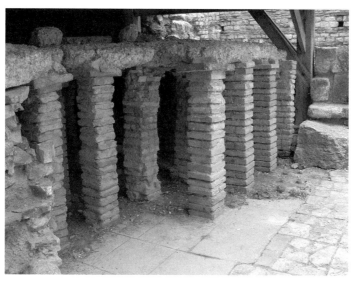

116 *Suspensurae* of hypocaust, in situ, Constantinian baths at Arles (photo by the author).

sense of the enormous importance placed on water in the architecture and plan-
ning that was invested in them.

The Water Sanctuaries at Glanum

Long before the town and its shrines were Romanized in the late second and first
centuries CE, water played a role in the native sanctuary at Glanum. The pre-
Roman hydraulic engineering employed here must be counted as some of the
earliest examples known. The sanctuary to Glans herself (see Fig. 6 for location)
consisted of an enclosed and venerated water source, which was approached
by a paved corridor, then a covered staircase which led down to a spring. In
Roman times, and perhaps well before, the spring was covered by a stone arch
that rose on engaged pilasters set against walls of carefully cut and fitted ashlar
masonry (Fig. 117); this structure may date as far back as the second century
BCE. The original date of the sanctuary's construction is obscured by the recon-
struction carried out around the water sanctuary when Glanum was Romanized
under Augustus, and by the construction by Agrippa of the temple to Valetudo
immediately next to the spring (Fig. 118). The monumentalization of the spring
within its ashlar vaulting recalls fountains built in Hellenistic cities in Asia
Minor, and although the architecture is mostly functional, with minimal deco-
ration, the very plainness gives it elegance. To the northeast of the sanctuary
was a large well set in a *dromos*; the opening was 3 meters in diameter and 10
meters deep; it was accessible through a corridor that turned at a right angle in
a manner remarkably similar to the approach to the sanctuary itself. It appears

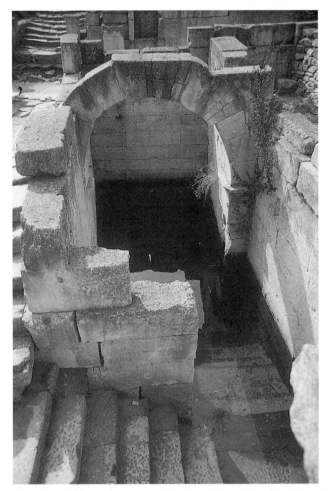

117 Glanum, barrel-vaulted water sanctuary, shrine to Glans (photo by the author).

to form part of the same sanctuary; the excavational stratigraphy dates it to the second century BCE.

In the center of Glanum, in front of the twin temples, was a public fountain (Fig. 119), a good deal smaller than the structures around the water sanctuary not far to the north. The fountain was semicircular with a rectangular basin projecting from its front to catch the water; it stood between the twin temples in their porticus and the reworked forum of the Roman town. Its date seems to be contemporary with both the twin temples and the renovated forum, approximately the last decade BCE. The fountain was 5.75 meters wide, large enough to have been decorated with statues and reliefs, fragments of which were found in the vicinity. The architectural effect must have been of an aedicula with a niche set into it, a type seen occasionally in other parts of the Roman world.[135]

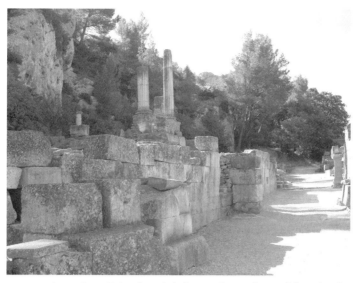

118 Reconstructed temple to *Valetudo* and shrine to Glans, Glanum (photo by the author).

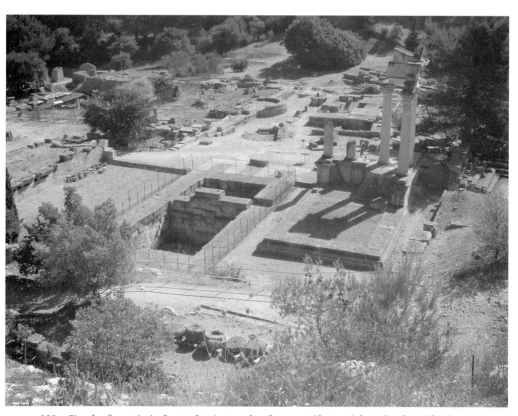

119 Circular fountain in front of twin temples, forum at Glanum (photo by the author).

The Water Sanctuary at Nîmes: The Augusteum

Like the water sanctuary at Glanum, the city of Nîmes also had a sacred spring, venerated from a very early date, dedicated to Nemausus and, again like the sanctuary at Glanum, monumentalized by the Romans during the reign of Augustus (for location see Fig. 15). Unlike the shrine at Glanum, the native shrine at Nemausus was also transformed into a shrine to Augustus. In 25 BCE, in an apparent attempt to associate the *princeps* with the traditional deity of the spring, dedications to Augustus (*CIL* XII.3148 and 3149) were set up in two exedras beside the water basin that formed the shrine to Nemausus. Over the next decades the area was gradually monumentalized. The arrangement probably focused on an altar which was dedicated toward the end of Augustus' reign. No trace of the altar remains, but it might be imagined as something like the *Ara Pacis Augustae* in Rome and would have carried a full inscription to the official Imperial cult of Rome and Augustus, following the model set in 12 BCE with the dedication of the Altar of the Three Gauls at Lugdunum (Lyon). Thus the native water sanctuary became an *Augusteum* (Fig. 120). The heart of the sanctuary consisted of a rectangular platform surrounded by porticoes in the Doric order whose columns were partially submerged in water flowing from the spring. The wall upon which they stood was designed in alternating rectangular and semicircular exedras. Entrance to the complex must have been through the center of the southern portico, which may have been monumentalized into a sort of *propylaea*, or columned entryway, although Naumann suggested a temple in this position. The great altar stood in the center of the platform, which was surrounded by water and accessible by small bridges, and encircled by an elegantly decorated *nymphaeum* whose water was supplied from the spring. The water was then channeled out of the sanctuary southward toward the city center. The purpose and dates of some other poorly preserved structures in the vicinity of the sanctuary are unclear: north of the altar and nymphaeum directly in front of the spring is a squared foundation; to the west of the squared foundation are two exedrae with the remains of stairways. To the west of the complex stood the barrel-vaulted chamber whose architectural form suggests a library *(bibliotheca)*. It may also have been a cult building, though it was certainly not a temple to Diana despite the popular name. Its rear wall may have held an Imperial statue, although no such statue nor any inscription has been found; the only evidence for a statue is the presence of a distyle niche. The eighteenth century Jardin de la Fontaine incorporates decorative carving and some suggestions of the original plan of the *Augusteum* (Fig. 121), and may provide a visual hint, though no more, of the appearance of the Roman Imperial complex. During construction of the Jardin de la Fontaine, in the mid-1740s, traces of a theater's *cavea* immediately to the northeast of the sanctuary were reported. The theater was probably addorsed to the sanctuary's porticus, which would have provided a covered

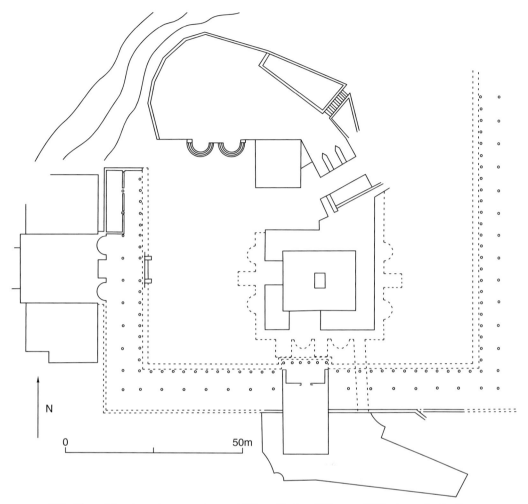

N

0 50m

120 Plan of the *Augusteum* sanctuary at Nîmes (Frakes 2009: cat. #035, drawn by D. Skau; reproduced by permission of the author).

walkway and display space similar to the *Porticus Pompeianae* that stood behind Pompey's theater in Rome, or the so-called Piazzale delle Corporazioni that still stands attached to the theater at Ostia. Unfortunately, no remains of Nîmes' Roman theater can now be seen, although there is no particular reason to doubt the early reports of its discovery. A connection between a porticoed sanctuary and a theater makes architectural sense, and may also be implied by inscription (e.g., *CIL* XII.3232). On the south, east, and west sides the vaulted chamber was surrounded by a three-sided portico (*porticus triplex*) in two naves. An abundance of inscriptions, some bilingual (Greek as well as Latin), support the identification of the complex as an *Augusteum*, a sanctuary to the cult of the Imperial family, here joined – by topography as well as by intent – with the native cult of the water deity *Nemausus*. And water remained the single most important

121 Floral decorative relief in the Jardin de la Fontaine, Nîmes (photo by the author).

visual (and probably aural) element in the planning and engineering of this mul-
tipurpose sanctuary: the flow of water from the spring was carefully routed and
channeled to enhance the elegance of the architecture, as well as to connect the
Imperial sanctuary with the never-forgotten native cult.[136]

Beyond the porticoed sanctuary that enclosed the spring, and its immediate
appendages such as the possible *bibliotheca,* the *Augusteum* also incorporated
or intentionally corresponded visually with other elements of the overall plan
of Nemausus (Fig. 122). To the south, it is possible that there was some sort of
intentional "sight line" established between the *Augusteum* and the forum of
Nîmes and/or the Maison Carrée temple, but this remains entirely speculative.
What has been convincingly demonstrated is that the design of the sanctuary
took into account, and corresponded visually to, the reworked "Tour Magne" of
the city's circuit walls. The immense tower stood on its great height due north
of the *Augusteum;* through the addition of a new wall and staircase, it was con-
nected to the sanctuary below, and thus became a sort of beacon that would
announce the presence of the sanctuary from afar.[137]

The dating of this sanctuary has been a matter of debate, and is likely to
remain so. Naumann asserted that the plan and much of the decoration origi-
nated under Hadrian, and was substantially reworked under Septimius Severus.
Inscriptional evidence from the sanctuary records dedications in the reigns of
both Trajan and Hadrian; some of the remaining architectural and decorative
elements also accord well with a Hadrianic date. More recently, the surviving
architectural sculpture of the *nymphaeum* and *porticus* have been redated to the
last two decades of the first century BCE, in the mid-Augustan period, which

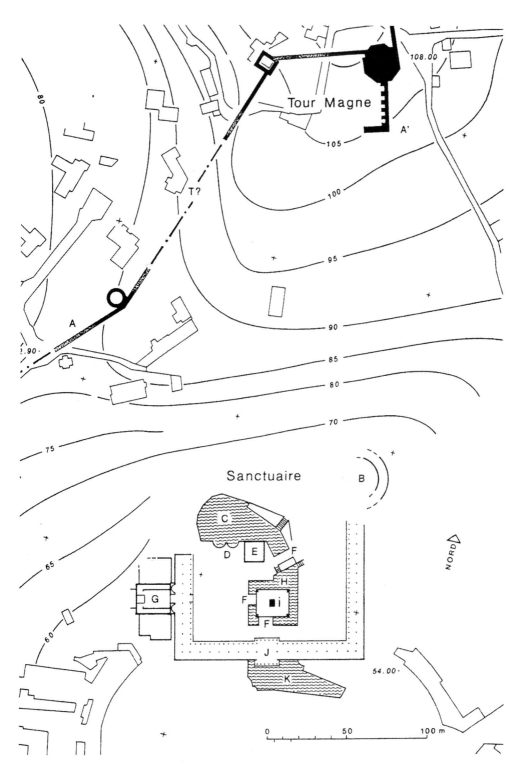

122 Plan showing relationship of *Augusteum* to other Roman monuments at Nîmes (after
 Gros 1996: fig. 498, p. 440).

permits the construction of the sanctuary to be dated between the first Augustan dedications in 25 BCE and the end of that century or earlier, which also accords well with the renovation and expansion of the Tour Magne. The date of the so-called *bibliotheca* on the west side of the sanctuary is also disputed: Hesberg concluded that the bibliotheca and the Temple of Apollo in the Circus Flaminius in Rome were contemporary based on a comparison of remains. Gans expanded on Hesberg's work and concluded that the vaulted building dated to the Augustan era. But other elements in that same building appear to be a good deal later: the best comparanda for its decorative system combined with the stone barrel vault are Antonine. Not all scholars have accepted the redating to Augustus, with Thomas making a particularly strong case for an Antonine date.[138] Gans himself dated the *porticus triplex* that enclosed the *bibliotheca* to the Flavian period, based on its plan and the surviving cornice of the south building. It, too, could be second century CE. A balanced assessment would seem to suggest that the conversion of the native water sanctuary into an *Augusteum* was indeed undertaken in the time of Augustus, and that a certain amount of Augustan architectural features and decoration have survived there. But there was clearly much subsequent intervention in the huge complex, and a substantial restoration and redecoration under Hadrian or Antoninus should not be ruled out, especially given the concentration of second century CE inscriptions discovered in the Jardin de la Fontaine (e.g., *CIL* XII.3183, 3232; *CIG* II.6785–6788; *IG* XIV.2495–2497), which attest to "patronage and honors accorded by the first emperors of the second century." The *Augusteum,* then, demonstrates continuity in a variety of ways: religious continuity between local and Imperial cult, continuity of planning throughout a Roman city, and architectural continuity from Augustus to Antoninus Pius and perhaps beyond.[139] Careful engineering and manipulation of running water was always the essence of the architectural design in the sanctuary, and that did not change over the centuries.

Aqueducts and City Water Systems

Sextus Julius Frontinus, who served as curator of aqueducts (*curator aquarum*) at Rome in 97 CE, wrote in awe of the Roman accomplishment in hydraulic engineering (*Aq.* 16):

> Tot aquarum tam multis necessaries molibus pyramidas videlicet otiosas
> Compares aut cetera inertia sed fama celebrate opera Graecorum.

> For instance, compare so many essential structures (transporting) so much water to the idle pyramids or the widely celebrated but otherwise useless works of the Greeks.

Rome's aqueducts were an unparalleled engineering accomplishment. They also contributed fundamentally to the Roman way of life as it developed and spread

across much of the known world of its time; and they have inspired the imagination of many people ever since, especially the long arcuated stretches that still seem to march across the Campagna east of Rome, heading for the city by curving routes which served to slow down the flow of water and make it manageable. In practical terms, that image is a delusion. The overwhelming majority of Roman aqueducts whose courses are known to us ran on arches for less than 10 percent of their total length; indeed having to raise an aqueduct on an arcade was an expensive and difficult undertaking which Roman planners and engineers avoided in any way they could. Constructing a water course a meter or so below ground was cheaper, easier, more reliable, and ultimately simpler to clean and repair, and it did not cost nearly as much to dig a trench as it did to build an arcade. The bridges and viaducts that were needed to carry water supplies across valleys were thought of as necessities to be regretted, not architectural glories to be admired and encouraged. The very first aqueduct that served Rome, the Aqua Appia, ran entirely underground, and was considered a signal success, in part for that reason. So, when we consider aqueducts for their architecture, we are doing something that those who built and worked with them would probably have considered absurd. Nonetheless, the elegance of those arcaded stretches cannot be denied. All the cities of Narbonese Gaul were served by aqueducts: Vienne, at its height, seems to have had as many as eleven of them in use, but only a few featured extensive arcading, and only those will be discussed.

The aqueduct of Fréjus

Roman Fréjus was served by a remarkable aqueduct, the entire course of which, approximately 40 kilometers, can still be traced today. In typical fashion, the aqueduct did not run in a straight line, but meandered both on account of geographical interruptions and in order to maintain a horizontal level that would not permit the water to flow too rapidly: in fact, its starting point near the source of the river Siagnole is slightly less than 30 kilometers due north of Fréjus. The first stretch of the aqueduct ran along the side of a deep gorge. This section must have fallen off the slope or collapsed, because it was rerouted through a man-made cut in the rock to the west of the gorge, at a place called Roche Taillée or Roquetaillade. From there it ran south, carried under the river Biançon in an underground channel, then along the east bank of the Reyran River. At that point, in the valley of the Reyran, the aqueduct was raised on arcades whenever it had to cross any of the river's numerous tributaries. A number of the arcades can still be seen (Fig. 123), at the Avellan, at Bouteillière, and especially over the Gargalon. The aqueduct came right up to the city wall and, thereafter, the water channel was actually carried along the top of the walls until it poured into a distribution tank (*castellum divisiorum*) just west of the Porte de l'Agachon on the northwest side of the city. The preserved piers of the aqueduct (Fig. 124)

123 Aqueduct crossing modern road, near Fréjus (photo by the author).

124 Aqueduct piers near the Roman walls of Fréjus (photo by the author).

where it approaches the city (near the Porte de Rome) show how apprehensive its architects were about the height at which the water was to be carried: each pier is heavily reinforced with sloping buttresses on two sides, apparently to make certain it would not collapse or be easily destroyed.[140] The only date that can be suggested for this elaborate aqueduct is well after the construction of the city's walls, since its *specus* (water channel) is quite clearly an addition *ex post facto*, but that could mean, realistically, any time from the later first century CE onward.

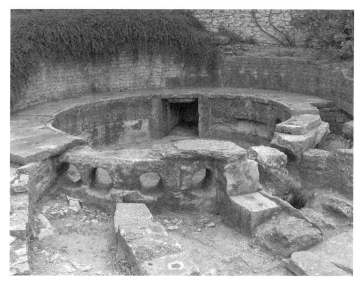

125 *Castellum divisorium* (distribution tank) of aqueduct at Nîmes (photo by the author).

The Aqueduct of Nîmes and the Pont du Gard

The distance between the village of Uzés and the city of Nîmes is only about 20 kilometers, but the aqueduct that brought water from the Ure River, near Uzés, to Nîmes covers the distance in almost 50 kilometers. A dedication to the aqueduct's source was set up near the *nymphaeum* of the great water sanctuary in Uzés (*CIL* XII.3076) by the source's caretakers (*cultures Urae fontis*), which emphasized the importance placed on the water supply by its users at Nîmes. The line of the aqueduct can be followed for much of its route; one large bridge and several small bridges survive and underground stretches can still be traced. The *castellum divisorium* of the aqueduct at Nîmes has been identified at a location approximately equidistant between the Porte d'Auguste and the *Augusteum*. The aqueduct line terminated in a round, shallow, open tank, about 6 meters across. The water then flowed out from the *castellum divisorium* through thirteen large lead pipes, ten set into the south side of the tank, three at the bottom of the tank (Fig. 125). The *castellum* was also decorated by a paved walkway with a bronze balustrade and enclosed in a small but elegant building that would have made it look like a shrine, not an inappropriate presentation for the water of nymphs. Even traces of fresco were reported on the lower parts of walls, showing aquatic scenes and dolphins. In antiquity it must have been something of a local attraction. In modern times a portion of the Uzés–Nîmes aqueduct is perhaps the most famous of all Roman aqueducts and one of the most famous structures left from classical antiquity: the renowned Pont du Gard. (Fig. 126). As the line crosses the deep and wide valley of the Gardon River, a bridge

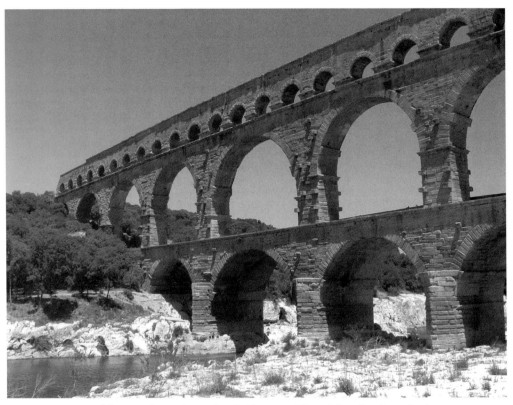

126 View of the Pont du Gard aqueduct bridge, near Nîmes (photo by the author).

was constructed to carry the channel across the void. An image of it is featured in almost every Latin textbook, every general survey of Roman culture, in many art and architecture surveys, and in most travel guides for France and Europe.

The Pont du Gard also provides an argument for dating the aqueduct. Although it is popularly attributed to Marcus Agrippa and assumed, like so many other Roman monuments in Provence, to have originated in the age of Augustus, there is no actual proof to support this assumption. Agrippa did work on the aqueducts at Rome and did make some gifts or contributions to Nîmes (*CIL* XII.3153 and 3154) but no text or inscription attributes to him any responsibility for the Nemausan aqueduct. Inscriptions from the aqueduct (CIL XII.2980) mention one man's name – Veranius – in the context of architectural instructions, but he is otherwise unattested. Both in terms of engineering and architecture, the likelihood is small that a structure such as the Pont du Gard could have been undertaken in Augustan times. Construction of such an extensive aqueduct in Gallia Narbonensis seems far more likely at the end of the first or in the first part of the second centuries CE during the period of Nemausus' rise to greatest size and importance when it succeeded Narbo as capital city of "provincia nostra."[141]

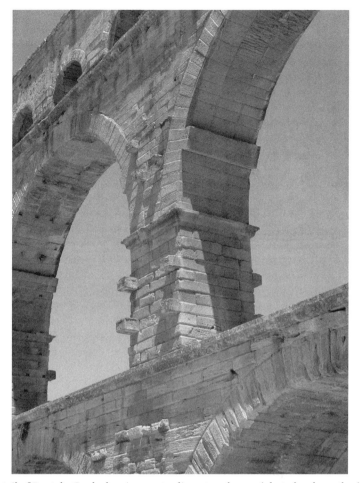

127 Detail of Pont du Gard, showing protruding stone bosses (photo by the author).

The magnificence of the Pont du Gard might seem paradoxical, at least in consideration of its aesthetics. Like many other aqueduct bridges, this one crossed a remote valley some distance from the nearest important road, and the river itself often flowed too swiftly to act as a primary means of communication. The question must then arise: who saw it? In fact, the Pont du Gard is anything but a refined example of Roman architecture. Much of its stone is no more than roughly cut, and unfinished stones protrude all over the monument (Fig. 127), which presumably served as permanent supports for wooden scaffolding during the original construction and were retained so that the scaffolding could be easily put back up when repairs were needed (an occurrence Frontinus assures us was all too frequent, at least on the arcaded stretches of the aqueducts at Rome). Nonetheless, despite the lack of any overt attempt at architectural refinement, the Pont du Gard is elegant and beautiful, a true paradox. This is due in

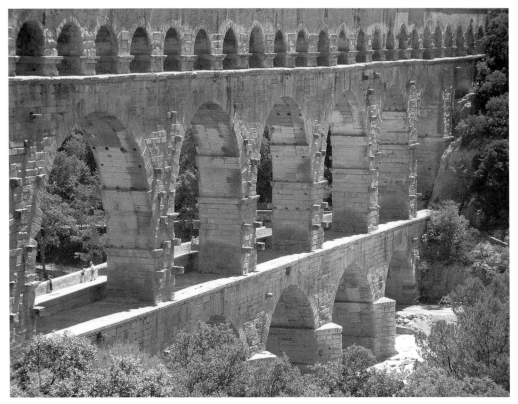

128 Superimposed vaults of the Pont du Gard (photo by the author).

large part to the fundamental design of Roman bridges, which simply alternated piers and arches in a series and then stacked one row on top of another (Fig. 128). It must have been difficult for a Roman engineer to build an ugly bridge given such a system of harmoniously proportioned elements he had to use. A related possibility is that more Romans saw the Pont du Gard, and other great aqueduct bridges, than their locations might suggest. After all, aqueduct systems were points of civic pride in the Roman world so some attention at least may have been paid to the visual impression their revealed arcades, especially bridges, would make. Another subtle aesthetic point that needs to be considered in regard to the Pont du Gard is that it was built across difficult terrain, and some irregularities had to be allowed into the design, and then concealed. For instance, the central arch in the lowest register is significantly bigger than the others in the same row. In order to allow the tops of all the arches to reach the same height, the central one had to descend a good deal further, which required the creation of two asymmetrical piers, curved on one side, straight on the other; and the same compromise had to be employed on the second row so that it would match what was below (Fig. 129). The small arches of the top row are carefully disposed so that they seem to respond arithmetically to the large

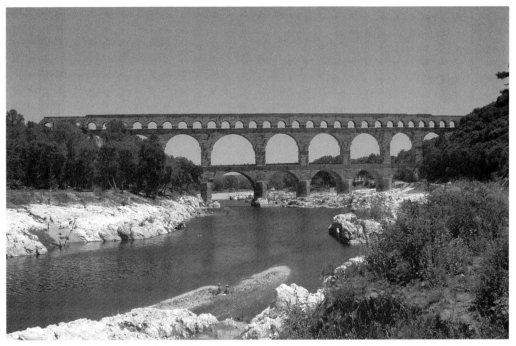

129 Central section of Pont du Gard, showing variant-sized vault spans (photo by the author).

ones beneath, but in fact there are four small arches over the larger central span while there are three over each of the others. These variations are disguised, to some degree, by making the piers between some arches thicker and so visually heavier than others. Overall, the Pont du Gard reveals tremendous care and planning, even if its surface has been left relatively roughly finished, and is the kind of engineering that truly makes itself a form of architecture.[142]

The Aqueduct of Arles, and the Water Mill at Barbégal

The aqueduct of Arles was fed by two sources located in the mountain chain called Les Alpilles. The two aqueducts converged just north of the two parallel aqueduct bridges that cross the vallon des Arcs; from there the two aqueducts split again: the western one carried its water to the city of Arles, while the eastern supplied the mill at Barbégal. The route of the western aqueduct, though mostly underground, can be traced: it entered Arles under a gate in the walls and fed a *castellum divisorium* that distributed the water throughout the city (see Fig. 12). The underground course of the aqueduct detours around the city's amphitheater. This suggests that the aqueduct, if not the entire water supply system, was installed after the building of the amphitheater, which is convincingly dated ca. 90 CE or a little later. An earlier water supply system is probable,

but no evidence for it has been identified. Of course, a pre-existing water system could have been altered when the amphitheater was built, but a date after 90 CE or even into the early second century CE receives unexpected confirmation from recent excavations in the vicinity of Barbégal.

A fascinating aspect of the aqueduct at Arles is the discovery of the most complete set of remains of a water-driven flour mill from Roman antiquity. The site is located 4 kilometers south of the town of Fontvieille and 7 kilometers west of Arles itself, at the entrance to the valley of Les Baux, on a steep southern slope of a limestone outcropping known as the Rochers de la Pène. It was excavated between 1937 and 1939 under the direction of François Benoit, whose description of the remains (Figs. 130 and 131) was summarized by Philippe Leveau:[143]

> The building, 61 × 20 m., was divided into two symmetrical parts each comprised of a series of rooms, separated by a monumental stairway. The water for the mill was provided by an aqueduct which cut through the limestone at the top of the ridge. The water from the aqueduct was channeled into two descending and stepped mill-races constructed against the interior face of the east and west walls of the building. Within the mill-races there were spaces for 16 wheels. The rooms between the races and the stairway housed the grinding mills turned by wheels. The entire complex was enclosed by a wall.

The external appearance of the mill when it was fully operational must have been striking, with all sixteen wheels turning and water pouring out at the bottom with enough force to move the water away from the mill itself and drain the surrounding land. Environmental investigation undertaken by Leveau has demonstrated that, contrary to Benoit's reconstruction of a lake and docks at its foot, the water used to turn the mill wheels flowed at a sufficiently high velocity to drain away from the bottom of the ridge, rather than pooling in the low areas at the base of the slope. This means that the land around the mill could be reclaimed for agricultural purposes, and probably produced the grain that was ground into flour by the mill. The environmental research undertaken by Leveau implies that the grain supplied to the mill, rather than being shipped to the mill from elsewhere, was grown nearby, perhaps as part of an agricultural development plan. This would, as Leveau points out, place Arles among those Roman *coloniae* that – courtesy of settlements of Roman veterans or their descendants who had available the funds and possessed or had access to the knowledge by which wet, marshy, low-lying land could be reclaimed – ended up managing an entire agricultural landscape. It would appear that the Roman Imperial system of settlement and of administration provided Arles, as it did other cities, with the security and technology it needed to organize so extensive a project, and to make it work.[144]

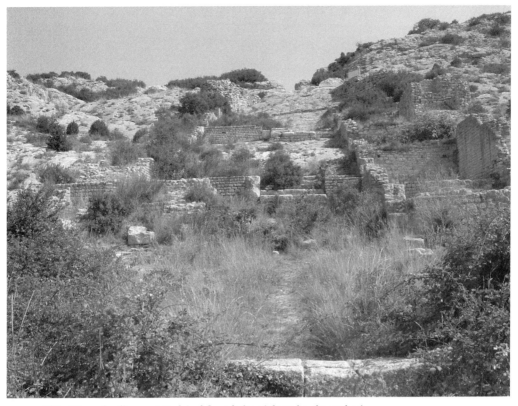

130 View of mill race at Barbégal from below (photo by the author).

Leveau's explorations have also significantly redefined the dating and chro-
nology of the mill at Barbégal. The mill was powered by one of the two aqueduct
lines running from Les Alpilles to Arles. Leveau found a coin of the emperor
Trajan embedded in the aqueduct's cement lining. The coin showed little wear
so was presumably lost soon after minting, sometime between 103 and 111 CE.
This alone would provide reasonable evidence for a *terminus post quem,* a date
after which the aqueduct began supplying water to the mill. Excavation in the
drainage ditch just beyond the mill provided confirmation of this date: coins of
the second and third centuries CE and shards of 2nd century CE pottery were
found. The date when the mill went out of use, or its use was altered, cannot be
absolutely proved, but a *terminus ante quem* was suggested by the discovery of
four inhumation burials near the site, which could be roughly dated (by pottery
shards) to the late third or early fourth century, and which would have been
impossible while the mill was in regular or even frequent use. Overall, then,
Benoit's dating of the Barbégal mill strictly and solely to late antiquity and his
connection of it to the period of Constantine's sojourn at Arles must be aban-
doned. Leveau's chronology would establish the water mill early in the second

131 View of mill race at Barbégal from above (photo by the author).

century CE at the time of the greatest expansion in the economy of Arles since
the age of Augustus. This may also offer support to the hypothesis that the water
system in Arles itself was either a creation of the same period or, more likely, a
reworking mandated by the construction of the city's amphitheater only shortly
before.

DOMESTIC ARCHITECTURE

The Domus: Atrium and Peristyle

The interplay of the several cultures that contributed to Roman architecture in
Provence are nowhere better revealed than in the houses that have been exca-
vated in residential quarters of the towns and cities. Formerly, the question of
Romano-Provençal domestic architecture was considered in terms of the two
primary house plans that appear to have been in use throughout the Roman
period in southern Gaul: the Greek *peristyle* plan and the Roman *atrium* plan.
The peristyle house is known to us from Hellenistic Greece, especially Delos,
and was probably introduced to Provence through the mediation of Massalia.

The atrium plan was common in Roman Italy and is known today from examples excavated at Pompeii and Herculaneum and also from the description provided by Vitruvius (*De arch*. VI.3–4). But such a rigid distinction would ignore a great deal of the evidence that points to a fluid and adaptable practice of domestic architecture and construction. In the private domestic sphere, Romanization seems to have melded together habits and traditions from Greek and Italic repertoires to produce a remarkable variety of forms. Instead of devising lists of Greek versus Roman plan dwellings, we will proceed by individual site – *oppidum*, town, city – to look at the variety of examples, their possible chronologies, and what they can tell us about the housing preferences of the people who built them.[145]

Houses in the Native Oppida of Provence

Because of a long cycle of warfare, destruction, and reconstruction during the pre-Roman era, the majority of examples of housing in the native hill-fort towns comes from later periods of habitation. These native towns came into contact with Massalia as early as the fourth century BCE, and what was probably a domestic architecture of huts and cabins was brought into contact with more elaborate house plans in use in the port city. Given the regional economic dominance of the Greek port/colony, it would be reasonable to expect a slow but steady increase in the occurrence of the peristyle house plan, or at least elements of it, from approximately the fourth to the second centuries, followed by the appearance of the Italic atrium design; however, this has not proven to be the case. In fact, current evidence indicates that elements of both types start to appear in new or rebuilt domestic buildings in the *oppida* almost contemporaneously. The current state of evidence seems to indicate that the most attractive feature of peristyle or atrium houses over native style domestic architecture was the ability to include a cistern for collection and storage of fresh water. Since hill-fort towns tended to be located in elevated, commanding locations and were often poorly supplied with springs, the ability to gather and store rainwater would have been a distinct advantage. To incorporate such a system into the house plan must have seemed a stroke of genius. A number of examples have been excavated, including two that stood adjacent to one another, built at the very start of the first century BCE at Ensérune. One was a substantial free-standing atrium style *domus* with a second story and series of rooms which could easily accommodate the needs of a wealthy family (Fig. 132). The layout of the other house, located to the south of the atrium-style domus but very poorly preserved, may have employed a Hellenistic variant of the peristyle plan sometimes called "à pastas," possessing a sort of embryonic porticus within the house that covered the cistern. Other *oppida* reveal similar mixings of Hellenistic and Italic traditions of house design in the course of their rebuildings from the fourth to

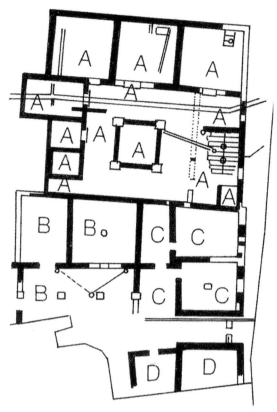

132 Ensérune, ground plans of adjacent houses (after Gros 2001: fig. 142, p. 144).

the first centuries BCE; house plans at St.-Blaise, at Lattes, and at Entremont all
reveal influences from both. After the Roman military conquest ca. 125 BCE,
the *oppida* that survived continued, in terms of their domestic buildings, with
an eclectic mix of types and styles, though often there is little evidence for the
very late periods.[146]

The site of Olbia, modern Hyères in the Var, presents an interesting variation.
It was founded by Massalia ca. 340 BCE as a fortified settlement in opposition
to native Celtic *oppida*, specifically to protect Massalia from incursions by the
Saluvii (Strabo, *Geog.* IV.1.5). The town was laid out on a standard grid plan in
which the residential sector comprised six blocks of 11 × 5.5 meters each, in
which small cube-shaped houses appear to have been built. A house built in
one of these squares much later, ca. 40 BCE, again shows the introduction of the
Hellenistic variant plan "à pastas" which could be fitted into a fairly constricted
space, but the designation of the plan here may not be correct, since there is no
evidence of the small columned or pilastered portico that ought to characterize
it. What actually seems to have happened here is a reworking of the "à pastas"
plan insofar as was possible on a very small building site where the strictures

imposed on its size caused its architect to dispense with the interior portico alto-
gether, thus producing a type of house that proved well suited for tight spaces
and for those who could not afford something larger; this composite type of
habitation became an important possibility for urban housing. Here Hellenistic
tradition has been made entirely subservient to the space available, and perhaps
to economic necessity.[147]

Domestic Architecture at Glanum

Glanum's long and varied history of occupation has made it one of the rich-
est archaeological sites in Provence. First a native sanctuary town, then deeply
influenced if not totally dominated by Massalia during the second century BCE,
it was extensively Romanized in the time of Augustus, then laid waste and aban-
doned ca. 270 CE. As at Pompeii and Ostia, abandonment allows us more fully to
understand the growth and development of the city in antiquity, including its
extraordinary assemblage of residences from both the Greek and Roman peri-
ods. Before the end of the second century, during the height of Massalian influ-
ence, the northwest sector of Glanum (see Fig. 6) must have been surveyed and
divided into parcels intended for domestic building. This metrological division
of residential areas happened before the Romans took any interest in Glanum,
and employed units of measure unique to the region, insofar as can be dis-
cerned. The central residential quarter of the town seems to have been regular-
ized in much the same manner in the first half of the first century BCE. While the
surveying and land division seems to have relied on local methods, the house
types constructed in these newly surveyed areas do not seem to draw upon
any particular native (Saluvian) tradition. The ground plan of the residential
quarters (Fig. 133) reveals that Hellenistic traditions were widely used: House
V is a good example of the "à pastas" plan with a vestigial portico of just three
free-standing supports with the few rooms of the small house placed in a line
behind it; House VI (House of the Anta Capitals) is a true peristyle house with
a central pool surrounded by a colonnade (Fig. 134); and House XI possesses a
small courtyard covered with an *impluvium* lined on two of its sides by groups
of small rooms.[148]

Houses VII and VIII are more complicated, the relationship between the two
structures not yet completely clear. House VII's plan (Fig. 133) with its cen-
tral three-sided colonnade should constitute another *domus* "à pastas," though
larger than others discussed so far, but it appears in its earliest phase to have
been built as a partial peristyle that was attached to, and formed the rear section
of, House VIII (the House of Atys). If Houses VII and VIII were both originally
part of the same house it would have had a total size of nearly 800 square meters.
However, doubt persists. House VII may not have been a house at all; if the
"mansion" existed at all, House VIII had been separated from it by the second
half of the first century BCE. A narrow entryway was opened to the street from

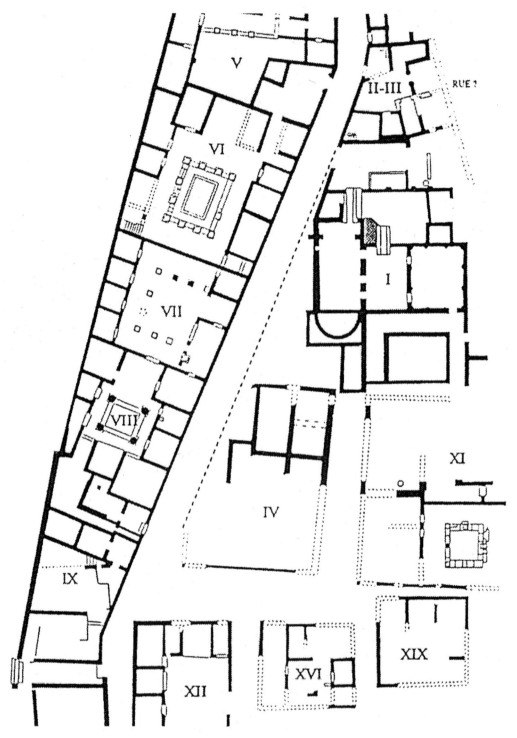

133 Plan of central residential quarter at Glanum (after Gros 2001: fig. 146, p. 146).

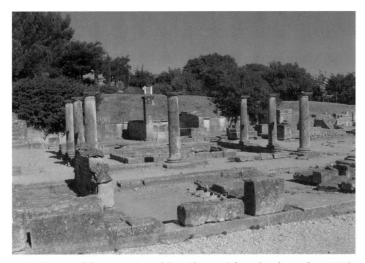

134 House VI (House of the Anta Capitals) at Glanum (photo by the author: JCA).

the three-sided colonnade, small rooms were added along the back and slightly larger ones at the front and south sides, all facing inward, and this has led to speculation that it might have been converted into a somewhat unusual *macellum* (Fig. 135). If that is in fact what happened, then the architectural effect on House VIII was a significant revision of its plan from a grand atrium–peristyle mansion worthy of Region VI at Pompeii to that of a true atrium of the Vitruvian type. In the change from mansion to atrium, the room on axis to the north of the *impluvium* was redesigned to become a sort of *tablinum*, and the two rooms on either side of it were converted for use as bedrooms (*cubicula*).[149] A later (final?) alteration was made to House VIII, probably in the first century CE, when the huge plinths that mark the corners of the *impluvium* were added.

House VI (House of the Anta Capitals) confirms that the domestic construction undertaken after the replanning of Glanum in the second century BCE was heavily influenced by the Hellenistic tradition. The peristyle covered a large cistern, and traces of a staircase imply that it must have had a second story. The portico of the peristyle court is larger on the north side – where it provided a special architectural emphasis to the largest room of the house – than on the south. This arrangement resembles the "*oikos*" as described in Vitruvius and as known from excavations in Greece. The *oikos* functioned as a sort of parlor, as it were, in the Greek house plan. The peristyle itself comes close to Vitruvius' definition of the *Rhodian* peristyle, but the columns that face the *oikos* are not taller, just broader, than the others; however, they were more elaborately decorated with fluting and Corinthian capitals, which respond visually to the beautifully carved Corinthian pilasters of the "antae" themselves. The house corresponds in plan to examples known from Delos, as well as to one excavated at Ampurias in Spain. The style and elaboration of the decorative carving give a sense of the

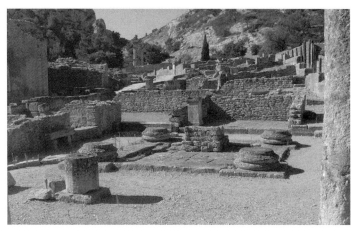

135 View of Houses VII and VIII (House of Atys) at Glanum (photo by the author).

preference of a wealthy citizen of Glanum, presumably someone imbued with a taste for the Hellenistic style of décor, perhaps through the contemporary connection between his town and Massalia. House VI remained inhabited, although with some alterations to its ground plan, until Glanum was abandoned.[150]

House XII (House of Cornelius Sulla) takes its name from a floor mosaic in its *tablinum*: the name "Cornelius Sulla" appears in the mosaic and is assumed to label the owner of the property. Obviously, the name suggests the famous Roman dictator who died in 78 BCE, but there is no evidence of a direct connection. The house was built during Glanum's second period of residential construction, the first half of the first century BCE, and is a remarkable variation on other house plans in use at Glanum during this period. Its design consists of two wings of rooms without a colonnade, resulting in an exterior plan that created an almost perfect square. Its total area covered 255 square meters and it seems to have had a second story, as indicated by the thickness of the lower story walls. This unusual layout again shows the inventiveness of house designers and builders at Glanum, and seems to imply a desire on the part of the owner for a large open court at the front of his house that would provide a suitable forecourt to the elegantly decorated *tablinum* behind (Fig. 136). In fact, the plan is neither specifically Italic nor Greek, though it draws from both traditions; it is closer to the elaborations on the simple squared house plans seen at hill-fort *oppida* at Ensérune and Olbia. Clearly, these builders and their patrons were not bound by local traditions or the tenets of imported style; rather, they built what they thought would work best for them, regardless of tradition.[151]

The Augustan House at Narbo (Narbonne)

Although little preclassical or classical architecture has survived at Narbonne, one remarkable large *domus* has been excavated. This was a substantial house,

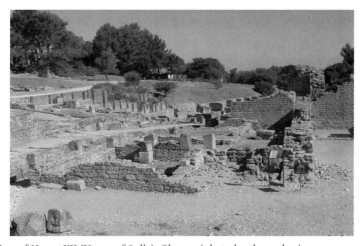

136 View of House XII (House of Sulla), Glanum (photo by the author).

built probably between 40 and 20 BCE, and laid out on a rectangular plan that covered 975 square meters (Fig. 137). It appears to have been a typical atrium plan with *fauces* on axis and a *tablinum* behind, with a dining room (*triclinium*) next to it. The western half of the house has been excavated fully. It was laid out as a peristyle surrounding a garden (*viridarium*); the north portico gave access to a large central room which was mostly open to the peristyle court; its entrance was flanked by two columns which must have signaled its presumptive importance as the *oecus,* the principal room of the house. The columns of the portico were taller than the others, thus allowing it to fulfill Vitruvius' requirements (*De arch.* VI.7.3) for a Rhodian peristyle that emphasized the most important rooms, like an *oikos* in the Hellenistic house plan. The plan is superficially reminiscent of the House of the Menander at Pompeii, but the excavations at the Narbonne *domus* indicate that it did not result from the union of two originally separate houses, but was planned as a true atrium-peristyle house and is one of the first and most successful examples of the combination of Hellenistic and Italic planning elements into a harmonious whole, a characteristic seen repeatedly in Gallia Narbonensis. Modifications were introduced to the *domus* during the course of the first century CE, including a reduction in size of the large *oecus* by the addition of two rooms that flanked it on either side. These additions were thought by the excavators to have been *cubicula.* The main rooms of the complex were frescoed in a style similar to the Fourth Pompeiian fresco style, including representations of a Genius and a Victory with a bust of Apollo crowned in laurel. This *domus* at Narbonne is an example of the elegance and refinement that was coming into private architecture in Provence during the Augustan period, together with the unification of Greek and Italic traditions in planning.[152]

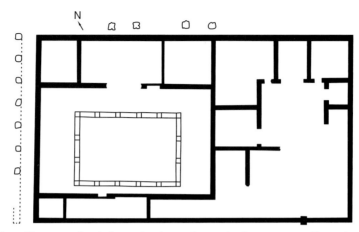

137 Plan of house at Clos de la Lombarde, Narbonne (Frakes 2009: cat. #018, drawn by D. Skau; reproduced by permission of the author).

Domestic architecture at Vasio (Vaison-la-Romaine)

Much of Roman Vasio is still unexcavated, lying, as it does, beneath the modern town of Vaison-la-Romaine. What has been examined reveals, for a relatively small town, a surprising number of large Roman houses (see Fig. 18). The House of the Dauphin is perhaps the most famous of these. Due to the site's complexity and the imprecise standards of excavation and documentation applied during the initial excavation, aspects of the house's development are difficult to determine. The earliest level, dated to 40–30 BCE, is roughly the same as that of the *domus* at Narbonne. Like House XII (The House of Cornelius Sulla) at Glanum (see above), the outline of The House of the Dauphin also formed a nearly square shape which covered an area of 35.52 square meters, with an irregular area appended to it (Fig. 138). Goudineau suggests that this area was a walled but unroofed garden (*hortus*); Gros suggests that it could have been a roofed gallery. The main block of the house is clearly a variation on the internal peristyle courtyard, a layout that suggests a rural villa intended as a farm rather than an urban mansion. It featured a small bathing complex, so it was to some extent self-contained, again more like a rural rather than a city dwelling. The masonry in the earliest phase of the House of the Dauphin is a very irregular *opus incertum,* and the stages of rapid improvement that the *domus* enjoyed are clearly reflected in the constant improvement and refinement in masonry style revealed in the surviving walls. The section of Vasio in which this house was located underwent a significant urban improvement during the Flavian era, when the street beyond it was paved, stepped, and colonnaded, becoming the "Rue des Colonnes" and surely an upscale residential area. The house, too, underwent a substantial renovation which was carried out with masonry in the

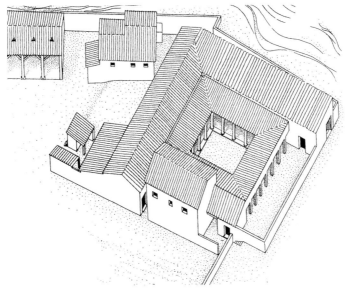

138 Vaison, House of the Dauphin, reconstruction of Augustan period – Phase 1 (after Gros
 2001: fig. 145, p. 145).

local variation of "opus reticulatum." The house owner apparently acquired the
irregular triangular stretch of land between the original façade of the rectangu-
lar *domus* and the street and added covered porticoes along the periphery while
enlarging the house to the east, beyond the peristyle, and installed a pool or
basin for water surrounded by small exedras and rooms; the rudimentary bath-
ing area was transformed into a small *balinea*, and a large parcel of land to the
south was added to the complex to serve as a garden. But the owner, or succes-
sive owners, did not stop there. Not long afterward, at the very end of the first
or the beginning of the second century CE, within the triangular space facing
onto the street from the original house, he or she had built a tetrastyle atrium
that was accessible to the street by a low stairway, thus turning what had been
a large peristyle villa into a gigantic atrium–peristyle urban villa/mansion (Fig.
139). The expansion and embellishment of the House of the Dauphin indicates
the prosperity that must have been enjoyed by successful entrepreneurs, politi-
cians, and businessmen in the relatively peaceful and settled province; the suc-
cessive owners enlarged and revised the original rustic-style villa into an urban
mansion (Fig. 140) that recalls the expansions, renovations, and redecorations
attributed to the "nouveaux riches" of Pompeii and Herculaneum before the
eruption of Vesuvius.[153]

Next door to the House of the Dauphin stood the House of the Silver Bust.
This house (Fig. 141), which takes its name from a find there, was entered from
the "Rue des Boutiques" through a paved *vestibulum* into an initial peristyle

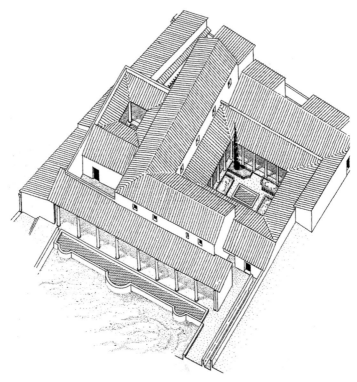

139 Vaison, House of the Dauphin, reconstruction of second century CE – Phase 3 (after
Gros 2001: fig. 163, p. 158).

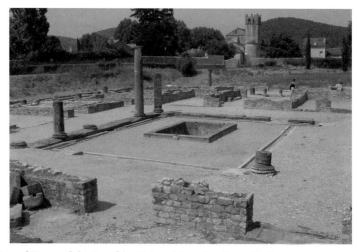

140 View of House of the Dauphin, Vaison (photo by the author).

from which a room opened to the left onto a quadriporticus; here again the
columns of the side of the peristyle nearest the quadriporticus were larger than
their colleagues, making it fit the definition of a Rhodian peristyle, which was
clearly considered the height of elegant refinement in such rooms. At some

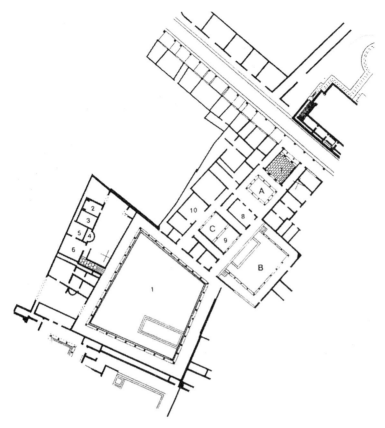

141 Vaison, Plan of the House of the Silver Bust (after Gros 2001: fig. 165, p. 161).

point, the bathing complex immediately to the west of the House of the Silver
Bust was united with this house, presumably purchased by the homeowner. By
adding an entire bathing complex, which contained a fully colonnaded *palaes-
tra* as well as the bath itself, the size of the property more than doubled (Fig.
142). The baths were probably originally open to the public; the proprietor of
the House of the Silver Bust in fact did not annex them solely for his family's
use; he installed a *collegium* there, making it the seat of a professional and social
association of which he was undoubtedly the patron. Throughout, the House of
the Silver Bust appears to have been richly decorated, though almost nothing
survives on the site other than evidence for some elegant marble *opus sectile*
flooring just off the quadriporticus. The date is, again, probably a progression
from the late first to the early second century CE for the enlargements, annexa-
tions, and rebuilding.[154]

Two further urban mansions, more properly urban villas, at Vasio appear
to have been built at exactly the same period: the House of the Messii and the
erroneously named *Praetorium* (see Fig. 18). Both opened onto the street that led
through the residential areas up the hill to the theater, a location which Hales

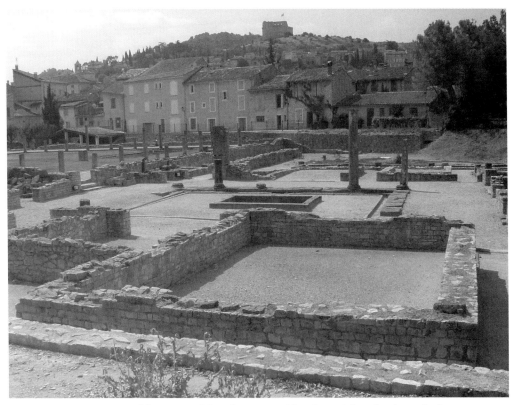

142 Vaison, view of the House of the Silver Bust with palestra (photo by the author).

described as "high profile." Inscriptions of the Messii family occur frequently in the excavated areas of Vasio; whether they actually inhabited the particular mansion (Fig. 143) to which their name has become attached cannot be definitively established. The house had two principal entryways from the same street, which might suggest that one led into the private areas of the house and the other into the public rooms. However, a succession of purchases and annexations of adjacent properties so confused the floor plan of the expanding house that, each time it became larger, access to any particular section of it must have become increasingly problematic. Here expansion produced, ultimately, a mansion lacking any clear main axis. The huge peristyle garden toward the rear of the property seems to have actually served as a *hortus,* planted in trees and topiary hedges, possibly with vines and vegetables. However, the entire complex had no true atrium, no impluvium, and no cistern: water for the bathing complexes and latrines must have been supplied from an aqueduct. Closer to the theater stood the house known as the Praetorium. So little of it has survived that it is difficult to say much about it other than that it, too, had annexed adjacent properties and expanded to an immense size.

Further to the east, truly on the outskirts of Vasio, the Villa of the Peacock, named from an elegant polychrome mosaic discovered there (Fig. 144), was built

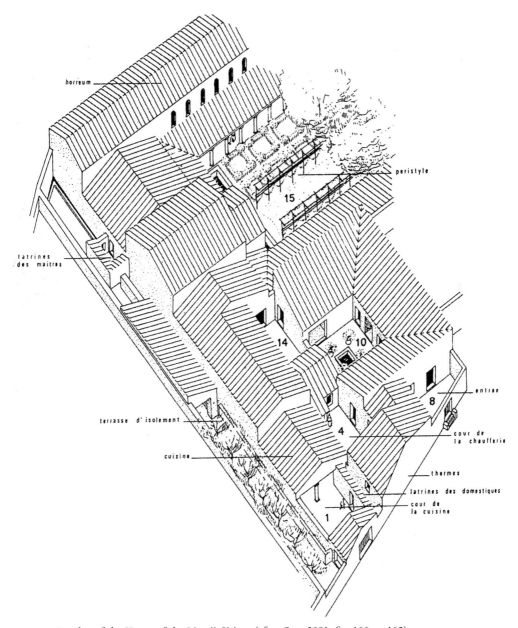

143 Plan of the House of the Messii, Vaison (after Gros 2001: fig. 166, p. 162).

probably toward the end of the first century CE. The plan of this villa, located on the edge of the city, is a contrast to the complex and confusing layouts of the House of the Dauphin, the House of the Silver Bust, and the House of the Messii. At the Villa of the Peacock, a much more rigorous control was exercised over the plan of the house, because it was designed and built all as a single entity, not added to over time. Although it shares many elements with the city mansions

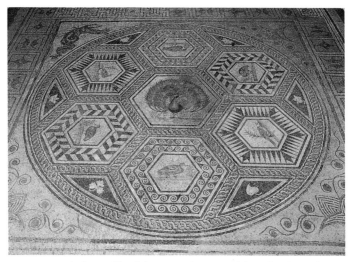

144 Eponymous mosaic from Villa of the Peacock, Vaison (photo by the author).

just described, it looks completely different. Its floor plan is almost symmetrical: its central axis, which runs straight through the middle of the house, is closed by a stepped fountain with a niche that overlooks the central courtyard. The beautiful peacock mosaic was only one of a number of high-quality mosaics found in this villa. Unlike most of the other surviving examples of early and middle Imperial elite housing in Gallia Narbonensis, the Villa of the Peacock is a rare example of the classic Roman suburban villa.[155]

The House of the Ocean Gods at Vienna (St.-Romain-en-Gal/Vienne)

The entire area of St.-Roman-en-Gal, the residential quarter of Roman Vienna (modern Vienne) that grew up on the west bank of the Rhône across from the Roman city center, gives a vivid impression of the architectural surroundings of Roman quotidian life, much as do the residential and commercial sectors of Ostia. Many of the residential buildings here went through a variety of phases and transformations, and much can be learned from a close look at four primary phases of the best-known and most comprehensively discussed, the House of the Ocean Gods. The first level of the house is the least understood; its stratigraphy and pottery shards would suggest a foundation between 30 and 20 BCE. By comparison with its later size, this was a relatively modest *domus,* but it already had a peristyle garden with a basin or pool for water. About the only other evidence for this early phase is the use of baked brick as masonry which was then covered in thick layers of paint. The house was expanded around 60 CE. Entrance at this period was on the east side of the house, into a huge *vestibulum* lined with pilasters around a central pool. The peristyle garden was also enlarged at this time and given a bigger pool. Around 100 CE the already large *domus* was expanded once more and became almost a mansion.

Entrance was now from the south, through a porch with three steps. This was followed by a *vestibulum* (12.7 × 9.4 m) with a floor mosaic of four heads of the god Ocean, with attributes, that gave its name to the house. A round fountain stood in the center of the vestibule. The *vestibulum* was also flanked by six rooms of varying size. Some of these rooms opened out onto the streets and were presumably rented out as *tabernae*. Proceeding north along the main axis of the new addition to the mansion, the next room was a second peristyle garden. This new garden was smaller than the original at the far north end of the axis. The columns of the new peristyle stood on the edge of a rectangular pool; the pool was revetted in marble plaques and could be entered by a stair, and a second small U-shaped basin stood at the north end of the room which probably served as a water fountain, as implied by the lead pipes with bronze ramsheads that were found in it. Beyond this peristyle, the axis of the house continued to the north and included a bathing complex with a full hypocaust system. The bathing area opened onto the huge second peristyle (32 × 20 meters) which contained two pavilions and another fountain. The central axis of this second peristyle does not conform with that of the rest of the complex, suggesting an addition taken from adjacent property (Fig. 145). It is possible that, in this expanded form, the House of the Ocean Gods came to play the same role at Vienne as the House of the Silver Bust appears to have played at Vaison: there is a good possibility that these huge accessions were not devoted purely to private, familial space, but that a professional and social *collegia* was installed here. At a later time, after 170 CE, the house was apparently divided up into smaller properties, most likely apartments or condominiums. One of these is now called the House of Five Mosaics due to its high-quality floor decorations. The House of the Five Mosaics, with its three-sided colonnade in the center, is reminiscent of the much reworked House of Fortuna annonaria at Ostia.[156]

Further Roman Houses at Vienne (Vienna)

Even as the House of the Ocean Gods was being transformed from a mansion into a multidwelling *insula,* large houses with a variety of floor plans continued to be built through the second and into the third centuries CE at St.-Romain-en-Gal. Some, such as the House of Sucellus with its ridiculously long *peristyle* (so long, in fact, that it appears never to have been completed) were clearly intended as show places (Fig. 146); others, such as the House of Columns (Fig. 147), show a tendency also seen across the river in the House of the Atrium (below) to revisit the older *atrium*–peristyle layout. There seems to have been a tension, in second century CE *domus* design, between this instinct to revert to the older, axial, style of house with its long tradition, and to continue experimenting with what could be done by enlarging, elongating, or reduplicating the garden element, usually still with its peristyle.

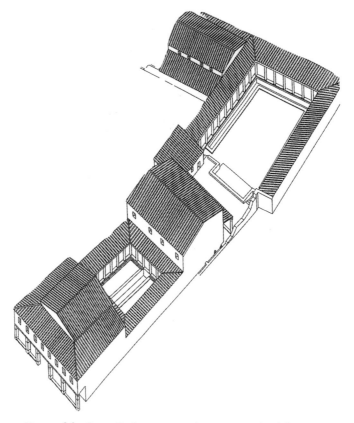

145 Vienne, House of the Ocean Gods, axonometric reconstruction (after Gros 2001: fig. 170, p. 163).

Across the Rhône from St.-Romain-en-Gal in the heart of Vienna (see Fig. 14), a remarkable group of true atrium–peristyle houses were built during the last quarter of the second century CE. The best example is called the House of the Atrium (Fig. 148). True to its name, the house has a plan that returns the atrium to its typical first century location, on axis with the peristyle court. In this house the private areas appear to have been centered entirely on the peristyle, which had two stories and was surrounded with *cubicula*. The House of the Atrium, in fact, seems to be an architectural revival of the true Italic style of large houses, calling to mind the examples from Pompeii and Herculaneum. Refinements of the second century were integrated into the earlier plan: the house had remarkable hydraulic engineering with latrines and a complete linear bath sequence with heating provided by its own hypocaust.[157]

City Houses at Orange and Aix-en-Provence

The houses discussed so far, at Glanum, Narbonne, Vaison-la-Romaine, and Vienne, have ranged from medium-sized dwellings to very large mansions. They were built in smallish towns, such as Glanum and Vaison, where property owners could

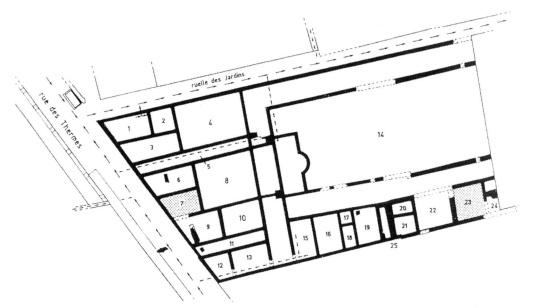

146 Plan of House of Sucellus, St.-Romain-en-Gal, Vienne (after Gros 2001: fig. 203, p. 189).

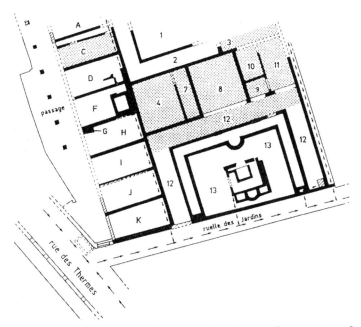

147 Plan of the House of Columns, St.-Romain-en-Gal, Vienne (after Gros 2001: fig. 204, p. 190).

readily buy up neighboring properties, or in residential areas, such as in Narbonne and Vienne, outside the city centers where there was less competition for space, so essentially the same kind of expansion was possible and did indeed happen. As the techniques of urban archaeology have progressed in the last fifty years, it has

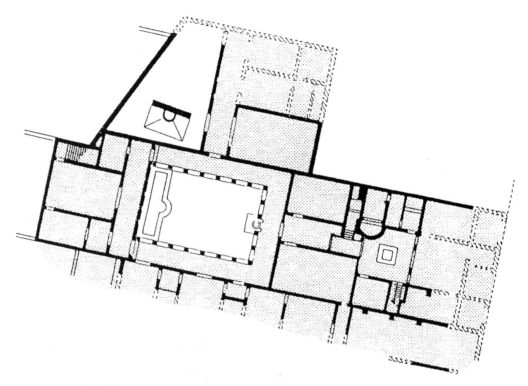

148 Plan of the House of the Atrium, Vienne (after Gros 2001: fig. 202, p. 189).

become possible to deduce the ground plans, some features, and even some of the decoration of houses that were part of ancient inner cities and still are today, often hidden below cellars and basements of still-occupied places. Examples of this progress can be seen at Orange where the plans of two substantial houses, "House A" and "House B" have been restored (Fig. 149). Both houses were quite large: A covered an area of 885 square meters while B covered 900. Both are designed around a central colonnaded courtyard of square or rectangular plan. B had a pool in its courtyard on axis with the triclinium at the other end. All these Imperial period houses feature hypocaust systems for heating and running water for latrines and kitchens.[158] They suggest urban domestic comfort and good planning, notable for making maximum usage of the space available to their architects and designers.

At Aix-en-Provence (Aquae Sextiae), remains of Imperial period houses have recently been found, many of which were located in the northern quarter of the Roman city. Taken together these houses give a valuable idea of the development of the private *domus;* these (a bit more imaginatively named than the examples at Orange) include the House of the Large Peristyle in the Jardin de Grassi, the House in the Enclos Reynaud, and that in Enclos Milhaud, as well as the House of Rue des Magnans which yielded a magnificent mosaic floor. A tendency can be seen in these houses to separate the public reception rooms and office spaces

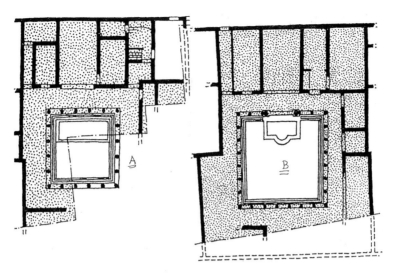

149 Plan of Houses A (left) and B (right) at Orange (after Gros 2001: fig. 198, p. 186).

from the central courts, quadriporticus, and gardens of the private sections of the domicile. The result is, often, to make the internal routes through the house difficult to determine, at least based on what remains. While these substantial homes cannot be characterized as "standardized," they do show a strong tendency to use similar solutions to the problem of public versus private domestic space. To accomplish this they manipulate the peristyle courtyard plan, reducing or eliminating the colonnade and eliminating the atrium. This concern for protecting the private parts of the *domus* is not usually seen in Republican or early Imperial house plans, and certainly not in Italy, not often in Provence either until the second century CE and afterward. It suggests a new consciousness arising among the elite citizens of the province by the second century CE, and may point the way to later developments.[159]

Looking back at this survey of the development of the private *domus* in Gallia Narbonensis through the Roman period, an interesting point of speculation is why the peristyle plan ultimately seems to have dominated, to the detriment of the atrium and, despite attempts at revival seen in second century Vienna, of the atrium–peristyle plans? Even in the inner city *domus* now coming to light, it is remarkable how often variations on the peristyle courtyard are found at the heart of the house, the center of family life and functions. Could the peristyle's continuing popularity be ascribed to its long-time association with villas, large country houses that suggested leisure – *otium* – as well as wealth and refinement to Roman and Romano-Provençal sensibilities? The emotional desire to bring *rus in urbe* is well attested in all areas of domestic building in the Roman world; perhaps the peristyle *domus* simply fulfilled that ideal better, and more adaptably, than the other possibilities.

Rural Housing: Villas and Farms

The Villa at Chiragan

Surprisingly little evidence for country villas and farms has been found to date in Gallia Narbonensis. The reason for this state of affairs is perhaps attributable to the archaeological focus on the towns and cities. The best known, though still poorly published, example of a Roman villa in "provincia nostra" – though admittedly on the westernmost border – is at Chiragan (Haute-Garonne), which in antiquity stood along the Roman road from Toulouse to Dax; it is one of the largest villas to have been excavated in France. This villa was occupied from at least the age of Augustus to the fourth century CE, and was renovated approximately every century. The original Augustan phase was centered on a large peristyle house that included a small *balinea* and, presumably, the usual outbuildings of a farm, though none of that early date have been securely identified. Around 100 CE the villa was enlarged by the addition of a substantial *hortus* with *cryptoporticus* which led to a small hexagonal building on the edge of the river Garonne. A second, longer, *cryptoporticus* extended from the *domus* toward the east, terminating at a row of small buildings, perhaps dwellings for farm workers. The baths were enlarged and much more lavishly decorated. Apparently substantial financial success came to the owner(s) of the villa sometime in the second half of the second century CE. By 200 CE at the latest the villa was again renovated and upgraded. Some have speculated that the proprietor by this period was an Imperial official since an entire gallery of Imperial portraits from Augustus to Septimius Severus was found in a fifth century CE rubbish pit, but this could merely indicate a wealthy individual with a taste for portraiture or patriotic fervor. An entire new section of the property was added southeast of the baths, a new wing that featured an apsidal dining room (*triclinium*), an atrium, another enclosed garden (*viridarium*) with an exedra, and another small dwelling. By the fourth century CE, the aspect of a luxurious country estate receded, and the villa seems to have returned to its original function as a working farm. Four new sets of buildings were added, including stalls for oxen, eleven weaving workshops, barns and sheds opening on a newly defined farmyard to the east, and an extended series of residences that appear to have been designed to house working families and their animals. It is estimated that, in this last phase, the villa operating at full capacity would have required some 350 workers to function. The villa appears to have been destroyed by the Vandals in or around 408 CE, and was abandoned. Its plan is remarkably similar to that of the much better-known Roman villa at Montmaurin, outside Provence.[160]

The Farms near Barbégal (la Merindole)

Field surveys and excavations in the Vallée des Baux near Barbégal and its Imperial-era water mill were carried out in cooperation with Leveau's reinvestigation of the

mill itself. The evidence recovered by this broader survey supports the evidence found at the mill site: that the land around Barbégal, far from being made marshy by stagnant mill water run-off, was drained and then farmed during the period the mill was in use. During Benoit's excavations in the late 1930s the existence of an "industrial center" was noted 400 meters east of the mill. Beginning in 1992, the new excavations have demonstrated that the "industrial center" was, in fact, a Roman farming villa (La Mérindole) featuring a large *domus* and undoubtedly involved in growing grain to supply the mill. The villa's remains consist only of fragmentary stone foundations and footings for walls indicate a rectangular structure, 10.4 × 6.5 meters, divided into two rooms. Pottery shards and two coins associated with the building suggest a chronology beginning in the late second or early third century CE, and extending to the middle of the fifth century. This time span would overlap with the most likely working life of the mill. A cemetery with eighteen graves was located adjacent to the villa. The stratigraphy, and the reuse of some of the mill's grinding stones, indicates that the cemetery was in use only after the buildings of La Mérindole ceased to function as a farm. Despite the fragmentary nature of the material found, this villa strongly supports the evidence from Barbégal itself that the entire area was involved in the cultivation of the grain that supplied the mill during its active life. Though circumstantial, the excavators assert that the evidence is sufficient to suggest that the mill was "a private endeavor built and maintained by a *societas* of estate holders in the Vallée des Baux" rather than an investment made by the city of Arles or the Imperial authorities. The idea is intriguing; more evidence will be needed to confirm it.[161]

Although relatively few rural villas and farms have so far been excavated in Provence, we should assume they were as common there as elsewhere in the Roman world. The soil of Provence is rich enough to support a wide variety of agricultural endeavors, and evidence such as that from the Vallée des Baux excavations supports a reconstruction of a largely agricultural countryside throughout most of Gallia Narbonensis. While seemingly successful and wealthy villas such as the one at Chiragan must always have been relatively few, working farm villas that needed a ready supply of workers and a ready market for their produce were undoubtedly the norm here as in so much of the rest of the Roman world. Their design and their architecture would have tended to be functional and adapted to the specific uses and products that supported their existence. A substantial portion of the population of the Roman world probably lived the entirety of their lives in just such rural environments.

FUNERARY ARCHITECTURE

Cemeteries and Burial Monuments

Romans respected and remembered their dead, and to that end created a variety of monuments to preserve the memory of their ancestors. In general the wealth

and prestige of the deceased would dictate the type and scale of funeral monument. The variety of commemorative monuments began with the modest *cippus*, an inscribed grave marker, moved to more elaborate relief sculptures and altars, both with appropriate inscriptions and frequently with commemorative portraits. For the elite, free-standing mausolea or cenotaphs provided sculptural and inscriptional reminders of a person's family and accomplishments. One of the most renowned, but also most complicated and controversial, of such funerary monuments is the monument of the Iulii at Glanum (St.-Rémy-de-Provence) which will be a major focus of this investigation. Finally, at Rome, Augustus and Hadrian created multigenerational memorial mausolea in which they, their families, and their successors could repose and be remembered. The elite could imitate these Imperial monuments on a somewhat smaller scale, as seen in the tomb of Caecilia Metella on the Via Appia, or the pyramid tomb of G. Cestius in Augustan times. The large multigenerational family tomb, such as the Tomb of the Scipios, had long been a respectable type for Roman elites. Imperial developments were part of a consistent yet innovative tradition of funerary architecture. The less rich or famous Romans shared this tradition of reverence for their dead and their ancestors and also wished to commemorate them. Since the dead were traditionally not supposed to be buried inside the *pomerium* of a city or town (emperors excepted, of course), from earliest times cemeteries were established along the roads that led into the place where the dead had lived. Hence the Via Appia and the Via Latina on the southeast side of Rome came to be lined on both sides with mile upon mile of tombs, inscribed altars, family *mausolea*, cenotaphs, reliefs, and every imaginable sort of *monumentum*. This was equally true all over the Roman world, and is readily seen in Gallia Narbonensis.

A number of necropoleis are attested to around many of the major cities of the province. Perhaps most famous is the burial ground just outside the walls of Arles, called Les Alyscamps. (see Fig. 12 for location).[162] The area was so greatly altered in the medieval era that it is impossible to say little more than that it was laid out along the Via Domitia leading into Arles, and has been the source of an extraordinary collection of ornately carved third-century and later sarcophagi, both pagan and Christian. Les Alyscamps was the final resting place for the remains of Arles' most renowned Christian martyr, Genesius (St.-Genet), who was decapitated during the reign of Diocletian in the residential quarter (on the west bank of the Rhône) called Trinquetaille and finally buried in the Alyscamps necropolis; the remains of Arles' first bishop, St Trophimus, may also have been placed there. A paleo-Christian church, St.-Honorat-des-Alyscamps, was built next to the necropolis; fragments of the church may still be seen. Arles had a second substantial necropolis near the circus (see Fig. 12 for location): remains of a *mausoleum*, probably from the fourth century CE, have been identified there. The structure seems to have been a large rotunda, approximately 42.5 × 38.0 meters, in the tradition of the mausolea of Augustus and Hadrian at Rome.

Unfortunately the site was destroyed in the nineteenth century. Inscriptions and fragments of architectural decoration and relief sculpture provide evidence of similar "cities of the dead" lining the roads at Nîmes (where the evidence consists primarily of small inscribed funerary *cippi* of middle- and lower-class residents, rather than the larger monuments of the wealthy) and Narbonne (remarkable fragments of architectural decoration from altars and tombs).[163] The evidence at Narbonne, especially, indicates, beginning in the second half of the first century BCE, a special popularity for funeral monuments designed in the shape of square or rectangular altars and decorated with Doric friezes in which the metopes are filled with flowers or leaves or bulls' heads (*bucrania*) in a style derived directly from similar commemorative altars that had become popular in Rome a century or so earlier. These Doric altars were also often given friezes that showed weaponry, which has led them sometimes to be identified as burials of Roman veterans settled in the *colonia* at Narbonne after 45 BCE, but this cannot be supported since the style remained popular well into the Julio-Claudian period and appears on altar monuments which bear inscriptions recalling people from all sectors of the population, not just resettled veteran soldiers. Gros has suggested that what this material from Narbonne most probably indicates is a long tradition of commemorating the dead of the province by monuments that recalled, through their decorative scheme, the benefits brought by the Caesarean and Augustan Romanizations; certainly its continuing popularity is well attested here, as it was in Roman Spain.[164]

The Aedicular Tomb or Monument on a Podium

To commemorate, and often actually to contain the remains of, the best Roman families, a particularly elegant form of monument gained special popularity during the course of the first century BCE and retained its importance thereafter. Such monuments consist of at least two architectural elements, one atop the other: a high podium or base, and an *aedicula* often in the form of a round *tholos* or, less often, a prostyle niche, either of which could be employed to display representations of the dead. These aedicular monuments occur in every part of the Roman world. A good testimony to their popularity is provided at Pompeii, where twenty-five of them appear among the 100 or so monumental tombs so far studied there. This tomb type was well-known by the early years of Augustus' reign; Vitruvius (*De arch.* II 8.3) describes them as monuments that were all too often despoiled for their architectural or sculptural elements, then left to destruction by the elements. These monuments have always presented a difficulty in nomenclature to architectural historians: some call them "tower tombs," others "pyramidal spire tombs," yet others use the cumbersome but exact "tombs derived from the Mausoleum plan," and so on. Simply "mausoleum" or "tower tomb" is misleading, especially when they are not places of burial but commemorative monuments (in which case, as at Glanum, for instance, the term

"cenotaph" may be applied), but overall "aedicular" may be the most accepting adjective of all for them. However they are labeled, they are ubiquitous in the Roman world.[165]

The mausoleum or cenotaph of the Iulii at Glanum

One of the most widely known and apparently most complete aedicular monuments is also one of the most frequently disputed and difficult to understand in all Roman Provence. It stands on the edge of ancient Glanum (St.-Rémy-de-Provence); it and the town's single fornix arch (see Fig. 9) share the popular name Les Antiques. This monument is usually called either the mausoleum or the cenotaph of the Iulii. It is not at all typical of the aedicular monument on a podium as described above, but is both more elaborate and more complex (Fig. 150). It is also not a tomb, but appears to have been conceived as a commemorative marker of some sort, hence calling it a "cenotaph" seems appropriate. The inscription, located on the second level of the architrave's north face, contains some odd spelling (or misspelling). The dedication was incised into the stone but apparently never then filled with bronze (Fig. 151), since there is no trace of clamp holes (*CIL* XII.1012):

SEX.L.M.IVLIEI.C.F.PARENTIBVS.SVEIS

Many expansions of the abbreviations have been suggested over the centuries in order to make sense of the inscription. The one now most generally accepted is:

Sex(tus) L(ucius) M(arcus) Juliei C(aii) f(ilii) parentibus sueis

Sextus, Lucius [and] Marcus Iulii sons of Caius [dedicate this] to their parents

The oddities are not huge but they are puzzling. The spelling of the *nomen* "Iulii" (IVLIEI) contains an intrusive E and that intrusion is repeated in the spelling of the reflexive pronominal adjective "suis" (SVEIS). The presence of that diphthong in Romano-Provençal Latin or Latin-derived family names is otherwise known, for example on an inscription that names the potter "Celtus" of Lezoux (in the genitive case) (CELTEI), and it does occur in the locative form of "hic, haec, hoc" (HEIC) on funerary inscriptions, as well as in the inscription on the bridge arches at St.-Chamas (*CIL* XII.647). It is usually explained as an orthographical phenomenon that disappeared in Rome late in the first century BCE but remained in use in Gallia Narbonensis somewhat later, at least into the first half of the first century CE, if not into the second. This seems a reasonable explanation of the spelling, though the comparanda are very few. The last two words – parentibus sueis – would seem to be the dedication in the dative case "to their parents" and one assumes it would refer to the parents, the father and mother, of the three sons of Gaius (Sextus, Lucius, and Marcus) who are making

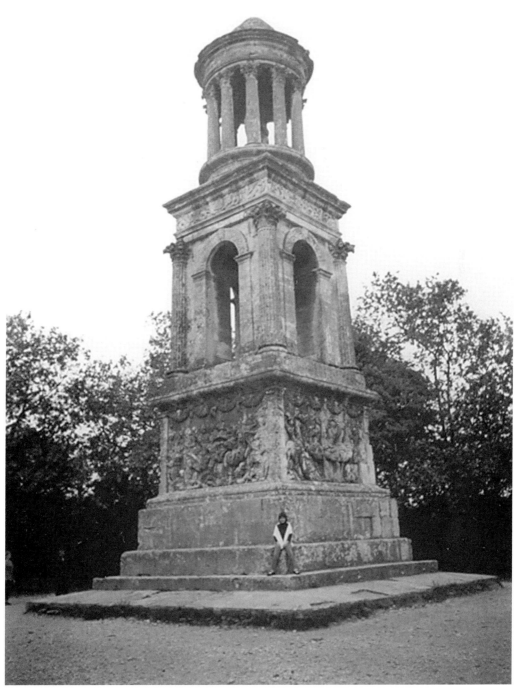

150 Cenotaph of the Iulii at St.-Rémy-de-Provence (photo by the author).

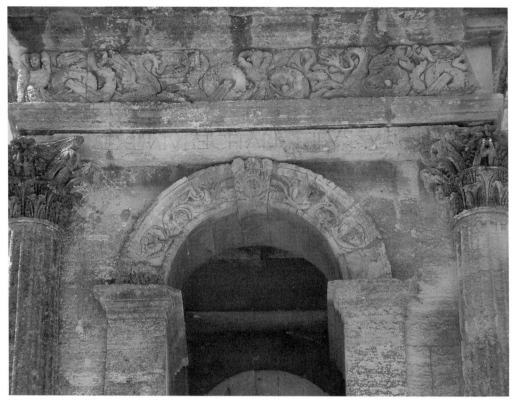

151 Inscription on the Iulii monument, in situ (photo by the author).

the gift. However, the poorly preserved statues in the third level of the monu-
ment (the columned rotunda) are both males clad in the toga (Fig. 152). Attempts
to explain this paradox by suggesting that "parentes" is being used in the sense
of "ancestors in the male line" and thus refers to the father and the grandfather
of the three sons do not carry much conviction, since the very few parallels
can be found only in Latin poetry (e.g., Vergil, *Aen.* III.180) and in reference
to mythic ancestors, not in inscriptions. The contradiction between inscription
and statuary on the monument remains puzzling. A recent proposal suggests
that the cenotaph was put up in honor of a citizen of Glanum who had served as
an officer in the army of Julius Caesar with sufficient distinction to be granted
Roman citizenship by the commander and to have taken Caesar's gentilician
name of "Julius" for his family. Gros goes on to suggest that the dedication of
such a monument in their family hero's memory would have been in 29 BCE,
when the local aristocrats of Gallia Narbonensis swore their loyalty to Augustus.
This interpretation again requires the assumption that "parentes" refers to this
man as grandfather of the first three names and father of their father Gaius,
with no reference to their mother. While appealing, this interpretation cannot
be regarded as proven or susceptible of proof. More recently, Roth Congès has

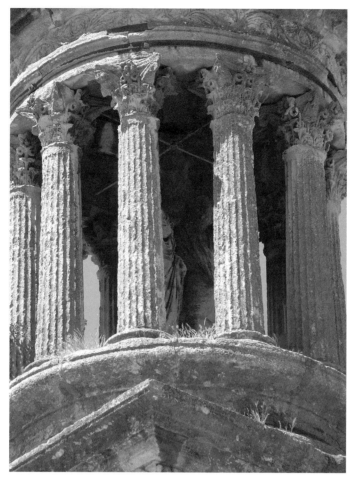

152 Third-level columned rotunda of Iulii cenotaph, with statues in situ (photo by the author).

renewed the argument for dating it to the triumviral period (40s–30s BCE), but there remains nothing that can prove either dating or any other. Indeed the monument will fit just as well, or as poorly, into the late first or early second century CE tradition of architectural sculpture in Provence. So frustrating are the difficulties that the inscription has occasionally been dismissed as a fake.[166] It might be wiser to regard 29 BCE as a *terminus post quem*, a date after which the cenotaph may have been built.

The architecture of the cenotaph can best be described from the bottom up, divided into three major units. (1) The lowest unit stands on a plinth 5.78 meters long on each side and 1.06 meters tall, which in turn carries a socle 5.21 meters long and 2.18 meters high. Atop this, and separated from it by a low base with a molding (0.40 meters high), stands a frieze course that consists of four sculpted relief panels (one on each side of the monument) with Corinthian composite

pilasters and capitals at each end; these frieze panels stand 2.18 meters high including the floral swags that run along the top of each one. A cornice (0.45 meters tall) then projects above. (2) The middle unit starts from a second plinth (0.49 meters high) upon which rises a quadrifrontal arch with each archivolt set within a post and lintel frame supported by engaged Corinthian columns at each corner, the whole element from column bases to capital tops rising 4.09 meters. The heavily carved archivolts appear on each of the four sides of the cenotaph, rising at their apex to exactly the same height as the tops of the Corinthian capitals on the corners. An architrave 0.43 meters high surmounts the quadrifrons, then an elaborate garlanded frieze course (0.49 meters) is topped by an equally elaborate cornice (also 0.49 meters). The north face of the architrave carries the inscription discussed earlier. (3) The upper unit of the monument rises on a base with torus–scotia–torus molding profile 0.99 meters tall. Above this a circular *tholos* of ten Corinthian columns (3.01 meters high from bottom of bases to tops of capitals) supports an entablature composed of three-fasciaed architrave, frieze course carved in garlands, and projecting cornice, which together add another 1.01 meters to the height. The pyramidal cupola roof springs from the cornice and rises to a truncated apex a final 1.93 meters high.[167]

Two elements of the architectural design are especially striking: the sizeable frieze course in Unit 1 with what appear to be battle reliefs, and the introduction of the quadrifrontal arch in Unit 2. The controversial battle friezes may be described one by one, with note always being kept that there is substantial disagreement among art historians as to what scenes they portray.

North panel (Fig. 153): a cavalry battle. Five soldiers fight one another; sixth and seventh soldiers lie dead or wounded at the bottom of the panel, and a fallen horse is next to one. The fallen warrior and horse are about to be trampled. One warrior wears a double-horned helmet. There is no good evidence on which to identify this as any specific battle, and there is no iconography or attributes that would suggest a mythological scene.[168]

West panel (Fig. 154): an infantry battle. Thirteen men are engaged in hand-to-hand fighting. Two lie at the bottom, wounded or dead; three are in defensive pose with shields raised to deflect attacks; the remainder are attacking or getting prepared to do so. Mythological interpretations attempt to explain the scene as either the battle between Greeks and Trojans over the body of Patroclus or an evocation of the death of Achilles, but there is little iconographical justification for these ideas.[169]

East panel (Fig. 155): battle with a wild boar. At least twelve infantrymen and cavalrymen still in uniform appear to encounter a large boar, carved on the bottom right of the panel and turned frontally toward the viewer. One horseman appears about to stab the boar with a spear. The layout of the scene is confusing to the eye; the left half of the panel appears almost divorced from the right. A popular mythological identification is, of course, the Calydonian boar hunt,

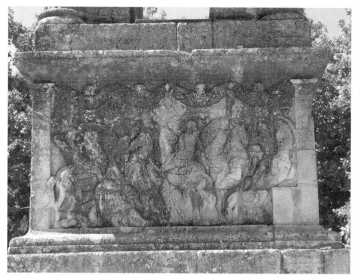

153 Iulii cenotaph, north frieze panel (photo by the author).

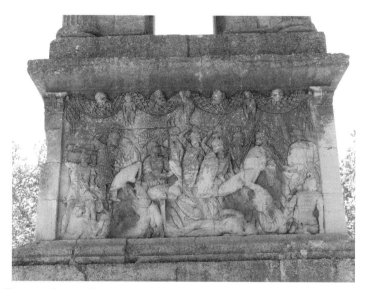

154 Iulii cenotaph, west frieze panel (photo by the author).

but since no female figure is present, it would have to be that myth without
Atalanta participating, which seems unlikely at best. Other suggestions have
put the Calydonian boar hunt on the right, the death of Adonis in the center,
and the massacre of the Niobids on the left, a suggestion which makes no icono-
graphical sense at all. It should be noted that boar hunt scenes were frequently
used on funerary memorials to emphasize the valor of the deceased, without
mythological associations required.[170]

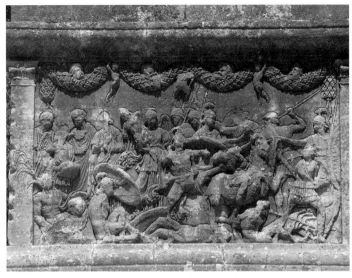

155 Iulii cenotaph, east frieze panel (photo by the author).

South panel (Fig. 156): Victory in battle. Two easily recognizable winged Victories appear here; one reads from a scroll, the other places her hand on the shoulder of the soldier in the center of the panel who dominates the composition. Three soldiers are being overwhelmed by their attackers, as the central soldier watches their deed. This seems the clearest military evocation among these relief panels: the warrior in the center has won, and the Victories commend him and tell the tale. Those who insist on a mythological reading attempt to call this an Amazonomachy, although reading any of the carved figures as female requires an effort of imagination.[171] What these four panels, taken together, recall most strongly is the relief style of sarcophagi. This arouses immediate concern about dating the monument, an issue that could profit from further consideration. The technique by which the figures are outlined, and the manner in which some of them violate the borders of the panels by overstepping the boundaries, are not unknown in Romano-Provençal art, but it is difficult to assign a date to it. The technique, also seen but less emphasized on the battle reliefs of the second attic on the arch at Orange, is otherwise common primarily in the relief carving of sarcophagi in the second and third centuries CE. It is somewhat surprising to see it on the cenotaph at Glanum, if the date of 30–20 BCE most often suggested is accepted. It is characteristic of the difficulties that abound with this monument that the most popular epigraphic date assigned is disconsonant with the relief carving on its frieze panels.[172] Kleiner has argued that the genesis of these relief scenes may be due to the artists who carved them not having been aware of any ethnic affiliation or tradition, whether Greek mythological or later Roman, to the works of art they were carving; he suggests that they would have been

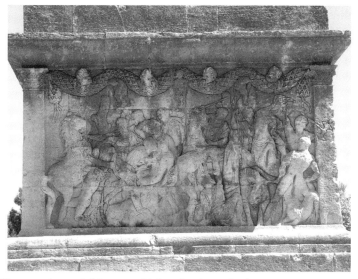

156 Iulii cenotaph, south frieze panel (photo by the author).

working from available models that were altered or reworked as desired by the artist(s) and/or their patron(s). There can be no doubt that the overall presentation of the monument is meant to assert a very Roman identity – the battered statues in the tholos wear the Roman toga, so those who made them must have wanted them to look and to be seen as Roman, and they stand beneath a Latin inscription, though admittedly one that does not make its message at all clear – but while these are excellent points, they do not clear up the severe difficulties of chronology that the monument presents. Uses of it as a comparandum for other arguments of chronology cannot and should not be accepted.[173]

Equally remarkable in the design of the cenotaph at Glanum is the introduction of Unit 2: the quadrifrontal arch in its middle. The arch's surface is elaborately carved, both in the Corinthian capitals of the columns that flank it and in the reliefs on the curves of the archivolts themselves. Each archivolt is graced with twining garlands running along its curve; at the apex (where the keystone of a voussoir arch would occur) is placed the head of a Medusa surrounded by outstretched wings. Furthermore, above the archivolts and columns – in the frieze course of the entablature – pairs of griffins and tritons appear on the east, west, and south sides, and the tritons hold medallions of some sort; on the north side the medallion is missing although the triton is there lifting a club over his head, and sea monsters appear in place of the griffins. The carving, even though badly weathered after centuries of exposure, is extremely elegant and was clearly executed by an artist or artists of some skill. These reliefs are not in conflict with any specific date ever suggested for the cenotaph, since they are elements that can appear in almost any context with the Corinthian order. What

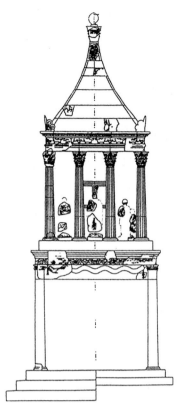

157 Reconstruction of cenotaph/mausoleum at Beaucaire (after Gros 2001: fig. 489, p. 414).

is unique is the presence of the *quadrifrons* in the design of the monument. This is unparalleled and surprising. It causes the Glanum cenotaph to look and be a good deal taller than most comparanda. Like the battle relief panels, this is intriguing and unexpected. It adds an extra element of architectural symbolism that should contribute to the meaning of the cenotaph. Gros offers the powerful interpretative suggestion that the *quadrifrons* might be included to suggest the transition that the dead hero commemorated by the battle panels has made at his death, "un niveau de transition entre les exploits de la vie terrestre et l'heroïsation du sommet" ("a platform of transition between the exploits of earthly life and heroization at the climax"). While somewhat hyperbolic, this interpretation does make sense of the architect's decision to introduce this otherwise unprecedented four-sided arch into the composition of the monument. It is a remarkably inventive conception in design. It is also completely achronological, since there are no datable comparanda.[174] In sum, the mausoleum or cenotaph at Glanum remains a frustrating puzzle of a monument, an uncomfortable fit within the architectural and sculptural history of Narbonese Gaul whether analyzed as late Republican, Augustan, or mid-Imperial. Its place in

the chronology of Roman funerary monuments continues to be debated, with no agreement in sight. It is possible that the reconstruction of the monument in the early nineteenth century was overly fanciful and has hopelessly compromised what can now be known about its ancient form and decoration. Certainly, severe doubts about the monument as we know it must be admitted.

Other Aedicular Funerary Structures in Provence

Monuments of the same general type as the Glanum cenotaph are attested in many parts of Gallia Narbonensis, but all must be reconstructed from fragments, so will ultimately remain hypothetical. A group of sixty-four fragments of such a monument were recovered from the Rhône riverbed near Beaucaire and were sufficient to permit a hypothetical reconstruction (Fig. 157) based on comparison with the Glanum cenotaph, and excavation of a necropolis at the site of Fourche-Vieille at Orange has revealed fragments of a large tower monument from which a figured frieze remains. Both can be reconstructed as somewhat smaller versions of the Iulii cenotaph at Glanum, but without the insertion of the *quadri-frons* into the design. Smaller fragments, insufficient to permit reconstruction, have been found at Vernégues, St.-Julien-les-Martigues, Alleins, and Avignon. Clearly, these were frequent and popular monuments in the province; it is to be regretted that only the one anomalous example at Glanum has survived.[175]

@@ @@ @@ @@

FOUR

A BRIEF CONCLUSION

This survey of the historical and architectural topography of the best-pre-
served and best-documented cities and towns of Provence leading up to and
then through the Roman Imperial period (which began, effectively, in 125 BCE
and lasted into the fourth century CE), and then of the remains of specific
forms of architecture and building therein, reveals overall the remarkable con-
sistency of development and the extraordinary effectiveness on both public
and private architecture of the long-term Romanization of Gallia Narbonensis
in antiquity. There is no real dispute that most if not all these urban areas were
founded or refounded, but certainly were established, in the second half of the
first century BCE, sometimes by Julius Caesar in the wake of both his Gallic
campaigns of the 50s and his siege of Massilia in 49, more often by Octavian
(in the triumviral period) who became Augustus in 27 BCE, who visited the
area certainly in 16–15 BCE and probably at other times, too. These foundation
visits often appear to have provided for defensive wall circuits to be planned
and constructed (e.g., at Arles, Fréjus, Vienne, Nîmes) and a gridded street pat-
tern to be laid out inside the walls. Due to continuing expansion and rebuild-
ing, as well as reconstruction demanded by heavy use of some buildings, it is
often hard to determine how many documented monuments within these cities
and towns were begun in this first Roman period, but it is probably safe to
assume that the primary areas such as the forum, a number of important reli-
gious sanctuaries (especially those facing onto the fora) with their temples were
begun then. Theaters, where they exist in these towns, are often thought also
to have been constructed in the late first century BCE (the best documented
being that at Arles for this period), although this is far from certain when the
evidence is scrutinized more closely (e.g., at Vienne, Fréjus, Nîmes, Orange, or
Vaison). Where towns were built for a specific purpose, such as Fréjus (Forum

Iulii) to serve as a port for Augustus' navy, the facilities required to fulfill that purpose were constructed first, and the habitation areas accommodated subsequently. The frequent assignment of land around these new towns to veterans of Augustus' armies provided both protection and, perhaps more important, strong influence in favor of Romanization if that were needed in what had been, after all, native territory not long before.

What is striking after the late first century BCE in all these Narbonese settlements – even the sanctuary town of Glanum – is how consistently the architectural and urban Romanization of each one proceeded. While the sequence of new dedications and of rebuilding of older monuments is specific to each site, as demonstrated above, an overall pattern can be discerned for the entire province. Each site seems to show only slow development until the last decades of the first century CE (with the possible exception of Vienne, where the visit of the emperor Claudius to Lyon in the 40s CE may have caused a spurt of dedications). There is often evidence of expansion in the Flavian period (from the 70s CE to the end of the first century), particularly with the addition of amphitheaters modeled on the Flavian one in Rome (which was dedicated in 80 CE) at Arles and Nîmes. Even a small town lacking colonial status, such as Vaison, received a gridded street plan, a basilica, and other Romanizing elements at the end of this century. With the accession of Trajan to the purple in 98 CE, the true flowering of Roman Provence arrived. The fact that Trajan was married to a lady of a Provençal, specifically Nemausan, family should lead us to expect a surge in Imperial patronage and benefactions to the cities and towns of Gallia Narbonensis, just as it did for the cities and towns of Trajan's native Hispania, and this is clearly what occurred. Just about every site in Provence reveals expansion, both new monuments and extensive restoration and repair of older ones, during the second century CE. Predictably enough, Nîmes, since it was probably Plotina's birthplace and was certainly the ancestral seat of the family of Antoninus Pius, seems to have been the most thoroughly patronized and glorified at this time, but as we have seen, Narbo was extensively restored after its devastating fire in 145, theaters and temples were reworked or added at Vienne, Arles, and Orange, and an amphitheater was built at Fréjus. It is in this same period that the elaborate mansions of wealthy aristocrats seem to have been built at Vaison, and the *scenae frons* of its theater was given a collection of heroizing Imperial portrait statues. Nîmes very probably replaced Narbo as the administrative capital of the province by the middle of the second century CE (if not earlier) and was glorified by the addition of a still unlocated basilica (or some other sort of building) in commemoration of Plotina, the expansion and elaboration of its forum and temple complex as well as of the magnificent *Augusteum* which had been created to Romanize the traditional water sanctuary of the local divinity, not to mention the creation of the magnificent bridge over the Gardon River along the course of the city's main aqueduct line. Looking at

these towns and cities in the second century CE, then, we can see in them the same urge toward monumentality that was being exercised by Imperial patronage in the reworking of great Greek cities of Asia Minor and in the new Imperial foundations in North Africa. In short, the cities and towns of Narbonese Gaul become excellent examples in the European provinces of the Empire of true Antonine monumentalization.

This prosperous and grandiose period of architectural glory for Roman Provence seems to come to an end, perhaps rather slowly, beginning with the Severan dynasty in the first decades of the third century CE. While there are significant hints or possibilities of Severan building and restoration at Nîmes and at Orange, the evidence is both contradictory and complex; absolute certainty is hard to find. The remainder of the third century CE was clearly as confused and foreboding a period in Gallia Narbonensis as it was in most of the Roman Empire, with central authority hopelessly compromised and the threat of external invasion ever present. Indeed, for much of Roman Provence this situation does not appear to have changed very much in the first half, at least, of the fourth century CE. As the Roman Empire was rapidly Christianized, internal authority seems to have increased but external pressure and the threat of invasion continued and became if anything more dire. Of the great Romano-Provençal cities, only Arles reveals new construction and clear evidence of restoration and reconstruction in the time of Constantine, undoubtedly due to the leading role its Christian community assumed with the holding of the great Council there in 314 CE, and on into the fifth century – when it became the seat of the Prefect of All Gaul – Arles thrived. This is not true of the other great cities of the province; though a number (Vienne, Nîmes, Vaison) did send bishops or priests to the Council of 314 and show other evidence of strong Christian communities in place, none enjoyed the sort of architectural renaissance that the patronage given by Constantine and Constantius II provided for Arles. Only Arles, at the last, continued the tradition of monumentality and architectural glory that so much of Narbonese Gaul had enjoyed during the late first and through the second centuries CE, a period that marked the apogee of Roman architecture and urbanism in Provence.

NOTES

1 Historical Overview: Roman Provence "Provincia Nostra"

1 The translations of Caesar, Pliny, and Tacitus are mine. The majority of general treatments of the Romanization of Provence (and of Gaul in general) have favored the "Roma-centric" viewpoint (in accord with Tacitus and Pliny): e.g., Clébert, 1970; Lerat, 1977; Drinkwater, 1983; and King, 1990. Hatt 1970 first expressed some reservations. Rivet 1988 is primarily "Roma-centric" but far more detailed and perceives nuances in the influence and resilience of local customs and practices in Gallia Narbonensis, as does Drinkwater 1990. Woolf 1998: 67–76 provides a perceptive discussion of Tacitus' passage in relation to what we know of provincial developments, in particular in Gaul. For two contrasting but fascinating interpretations of "Romanization" and what it implies, see Reece 1990 and Millett 1990.

2 This expansion in viewpoint has come about slowly. The work of Leveau (e.g., 1993, 1996, and 2005–6), of Woolf (e.g., 1992, 1995, 1996, especially 1998, and 2001), and of Hitchner (e.g., 1999) has been central to this shift in our perception of Romanization in Gaul and particularly in Provence. For an overview of Leveau's essential contributions, see Woolf 2008.

3 The rich remains of Roman architecture in Provence have enjoyed many detailed studies of individual buildings or monuments, but relatively little genuine synthesis, attempts by Février (1964 and 1973), Chevallier (1975 and 1982) and Le Prioux and Champol (1997) notwithstanding. The best broad treatments have appeared within Pierre Gros' comprehensive history of Roman architecture (Gros 1996 and 2001) and within a general study of architecture and urbanism in Gaul (Bedon et al. 1988). The most recent survey of the archaeology of the province (Gros 2008) provides a good introduction to current French scholarly analysis of Romano-Provençal archaeology and architecture, but omits almost all non-French contributions, to the book's detriment (see the review by Downing 2010 for detailed analysis and criticism).

4 Ebel 1976: 1; Rivet 1988: 3–9 provides greater geographical detail. On traditional products of Provence, both agricultural and natural, see Hodge 1998: 51–9.

5 The ancient sources are surprisingly unanimous: Timaeus (in Ps.-Scymnus 211–240) dates the foundation at exactly 120 years before the battle of Salamis in 480–479

BCE, Livy 5.34 places it in the reign of Tarquinius Priscus at Rome (so between 616 and 579 BCE), and Solinus gives the 45th Olympiad (600–596 BCE). This foundation date is accepted by almost all scholars (e.g., Rivet, 1988: 9–11; Hodge 1998: 64–7; Hermary et al. 1999: 37–9).

6 Clavel-Léveque 1977: 9; Ebel 1976: 5–11; King 1990: 11.

7 A superb summary of what is known archaeologically of Greek Massalia is given by Gantès 1992. See also Hodge 1998: 75–88.

8 The evidence for Etruscan and Punic contact is collected by Clébert 1970: I. 147–53, which also provides a summary of the evidence for the foundation, extent, and wealth of Massalia (I.157–67); see also Hodge 1998: 116–24. On the foundation legend, see Pralon 1992; for a series of studies of the Massiliote economy, see Bats et al. 1992: 163–261.

9 Soricelli 1995: 13–26; Hodge 1998: 138–51; Clébert 1970: I.168–87, especially 178–9 on the Étang, and 180–3 on Sainte-Blaise; on Entremont, see Treziny 1992 and Hodge 1998: 194–202; on both *oppida,* see Gros 2008: 13. The evidence for Massaliote influence along the coastline is collected by Bats 1992, who is followed by Hodge 1998: 170–93; further discussion is provided by Freyberger 1999: 38–60. On the walls and tower at Nîmes, see Varène 1987 and 1992. A good summary of the evidence is given by Dyson 1985: 129–34.

10 Rivet 1988: 198–200 and Hodge 1998: 151–8 summarize the historical and archaeological evidence succinctly. For more detailed discussion of the architectural influences revealed at Glanum, see Roth-Congès 1992a and Gros 1992; more recently, Heyn 2006.

11 The essential ancient source is Polybius, who was contemporary with these events. For modern discussions, see Clébert 1970: II, 27–30; Ebel 1976: 55–63; Rivet 1988: 32–35; and Heyn 2006: 179–81.

12 Ancient sources are fragmentary, so the story has to be pieced together from, e.g., Appian, *Civil Wars* 1.34; Livy, *Per.* 60 and 61; Diodorus Siculus 34.23; Strabo 4.1.5 and 4.6.3; and Florus 1.37 (3.2). This is done brilliantly by Rivet 1988: 39–40; see further Soricelli 1995: 27–34 and Freyberger 1999: 74–80. On the importance of the foundation of Aquae Sextiae, see Clébert 1970: II, 36, reemphasized by Gros 2008: 21–2. On Entremont and its identification as the Saluvian capital: Benoit, 1968, also King 1990: 36–7. For an interesting discussion of Greek influence on planning and fortifications at Entremont, see Treziny 1992.

13 Suetonius *Nero* 2 would send Ahenobarbus to Provence during his consular year, but all other sources imply that the campaign took place the following year (in 121 BCE): Livy, *Per.* 61, Orosius 5.13.2, Florus 1.37 (3.2), and Strabo 4.2.3. See further discussion in Soricelli 1995: 34–42.

14 See Badian 1966: 903–4; Ebel 1976: 75–82; and Rivet 1988: 42–4 for summaries of the evidence. The date of the foundation of Narbo is provided by Velleius Paterculus 1.14.5; see Dyson 1985: 159–60 for discussion. On the milestones see Duval 1968 and König 1970; on the via Domitia in general, see Clément and Peyre 1998.

15 Dyson 1985: 161–2; also Rivet 1988: 44–6. The horrified reaction in Rome is described twice by Plutarch, *Lucullus* 27.7 and *Camillus* 19.7.

16 Clébert 1970: II, 41–4; Ebel 1976: 88; Rivet 1988: 46–8; Dyson 1985: 161–2; Soricelli 1995: 43–62 (the most complete discussion by far); Freyberger 1999: 80–8; and Heyn 2006: 181. For a floridly dramatic treatment of Marius' campaigns in Provence and their survival in legend, see Cook 1905: 32–49.

17 Cicero's speech survives only in fragments, but there is enough to permit important conclusions. A good introduction to the speech and what it tells us is provided by Boulanger, 1929: 3–16; an even better commentary is Clemente 1974: 95–162. See

also Rivet 1988: 57–60, who usefully classifies the kinds of evidence the speech provides; Ebel 1976: 96–102 for a concise summary; Hackl 1988; and Soricelli 1995: 85–91.

18 The best ancient narratives of this episode are those by Sallust, *Cat.* 40–5, and Plutarch, *Cicero* 28.

19 Including Forum Iulii for Legio VIII, and Aquae Sextiae for Legio XII. Indeed, the name "Forum Iulii" may very well have recalled, to its founders, the vital role the port had played on behalf of Caesar. The name first appears in a letter of Cicero (*Ad Fam.* 10.15.3) that can be dated to 43 BCE; for discussion of the possibility that the town's name came from the earlier connection with Caesar, see Rivet 1988: 65. On dating its foundation, see Gascou 1982.

20 Clébert 1970: II, 48–52. See Pliny, *NH* 3.34 on the subsequent status of Massilia; Strabo 4.1.9 on the distribution of formerly Massiliote towns. Also Dyson 1985: 173.

21 The single most important ancient sources for what happened in Provence between 46 and 43 are Cicero's letters to and from Munatius Plancus (Cicero, *Ad Fam.* 10: 9, 11, 15–19, 21, 23, and 34). For summations of the evidence for this series of colonial foundations, see Clébert 1970: II, 58–63; Février 1973; Rivet 1988: 74–8; and Freyberger 1999: 121–37.

22 An elegant portrait bust once thought to represent the young Octavian was found in the cryptoporticus at Arles, and remains in the Musée Lapidaire there: see Bromwich 1996: 149 and plate 18. However, recent analysis offers a far more likely identification of the subject as Octavian's nephew, Marcellus (Gros 2008: 42).

23 Strabo 4.11, substantiated by *CIL* XII.5510 (an Augustan milestone from near Vienne, though dating to 3 CE). Whatever it was Agrippa contributed to the city of Nîmes, it was probably not the Maison Carrée temple (the inclusion of his name on the dedicatory inscription is now mostly rejected: see Anderson 2001: 69–70, though cf. Balty 1960: 150–77); whether it might have been the aqueduct that much later passed over the Pont du Gard cannot be established nor documented (see Rivet 1988: 167, and *CIL* XII.3153 and 3154: fragmentary Nemausan inscriptions that mention Agrippa) but it certainly cannot have been the Gardon River bridge itself (Chevallier 1975: 748) which could not have been built before the reign of Trajan.

24 Augustus, *RG* 12.2; Cassius Dio 54.25.1; *CIL* XII.3151 (dedicatory inscription from the "Porte d'Auguste" at Nîmes) and *ILGN* 263 (wall inscription from Vienne). On the roadworks: Strabo 4.1.3, and Ammianus Marcellinus 15.10.3.

25 Formigé 1949 remains the basic source on this monument. See also Clébert 1970: II, 66–8.

26 Maison Carrée inscription: *CIL* XII.3156; Amy and Gros 1979: 177–94; Anderson 2001: 68–72. The suggestion that the Glanum cenotaph might have commemorated Gaius and Lucius Caesar has not been generally accepted (e.g., Gros 1986a: 67; Rivet 1988: 79, 200).

27 Bromwich 1996: 232; Rosso 2006, no. 187 (pp. 413–16).

28 An excellent summary is provided by Rivet 1988: 89–91, which I follow here.

29 On the Orange cadastral inscriptions, the best overall source remains Piganiol 1962; important further information can be found in Salviat 1986, Fiches 1996, and especially Assénat 2006: 35–52. Aside from the passages in Suetonius, the failure of Domitian's vineyard policy receives confirmation from the occurrence of wine jar stamps from Baeterrae (Béziers) at Monte Testaccio in Rome: *CIL* XV.4542–3.

30 Bromwich 1996: 232–3 and pl. 34 (statue of Domitian); Rosso 2006, nos. 189–90 (pp. 416–21).

31 For the consuls, see Rivet 1988: 85; on Gallic aristocrats in Rome at this time, see Ricci 1992. The ancient testimonia for the province's prosperity include Pomponius

Mela 2.5.75; Pliny, *HN* 17.85 (wheat), 14.18, 26, 27, 43, and 68 (wine), 9.29–32 (fish) and 31.94–7 (fish sauce); and 8.91 (wool); Columella 12.23 (wine); Martial 10.36 and 13.107 (wines), also 12.32 (cheese); and Strabo 4.1.8 (oysters and fish).

32 Origin of the aqueduct at Arles and the water mill at Barbégal under Trajan is established by Leveau 1996, and confirmed in Leveau and Thernet 2005. For a possible Trajanic phase to the arch at Orange, see Küpper-Böhm 1996: 92–104. For Plotina, Hadrian, and Nîmes, see *HA Hadrian* 12; also Cassius Dio 69.10.3. This evidence is reviewed and accepted by Raepsaet-Charlier 1987: 631; Boatwright 1991: 515 and 2000: 137; Anderson 2001: 75–6; and Fraser 2006: 41.

33 *CIL* XII.1122; Cassius Dio 69.10.2. Fraser 2006: 41–2, 47–50, 54, 58, 61–2 provide a comprehensive survey of what can be attributed to Hadrian in Gallia Narbonensis. Note also Thomas 2007: 50. For the statues from Vaison, see Bromwich 1996: 232–3 and pl. 35; also Rosso 2006, nos. 191–2 (pp. 421–5).

34 Antoninus' name, before his adoption by Hadrian, was taken from that of his Nemausan grandfather: T. Aurelius Fulvius Boionus Arrius Antoninus (*CIL* VIII.8239). *CIL* XII.4342 records Antoninus' benefactions to Narbo after the conflagration; Grenier, in his preface to Pflaum 1978: xi–xii makes a strong case for the shift of the provincial capital. For the milestones, see *CIL* XII.5573–83 (they can be dated to 144–145 CE). This evidence is accepted by Thomas 2007: 50.

35 At least according to the often maligned evidence of the *Historia Augusta (HA Caracalla* 5.1).

36 Aurelius: *CIL* XII.2391, 2392. Severus and Clodius Albinus: Cassius Dio 76.6–7 and Herodian 3.7.2–6; King 1990: 172–4 provides an excellent summary of the period. On a possible Severan dating for the arch at Orange: Mingazzini 1968, and Anderson 1987 (cf. Kleiner 1991 and Gros 2008: 50), with the further suggestion that the removed inscription on the north face could reflect the coming of Caracalla to the area in 211 or 212. Honors voted to Caracalla are recorded in *CIL* XII.1851 and 4347. The most important ancient source for the *constitutio Antoniniana* is Cassius Dio 78.9.5.

37 This lacuna-filled period is treated as well as is possible by Rivet 1988: 92–3; a more general summary of the period may be found in King 1990: 172–81; most recently, but quite brief, is Gros 2008: 137–40. For the evidence from Vaison and Glanum: Clébert 1970: II, 74–5.

38 The "provinces" that contained what had been Gallia Narbonensis were: *Provincia Viennensi,* which contained – among other towns – Vienne, Valence, Vaison, Orange, Carpentras, Cavaillon, Avignon, Arles, and Marseille (i.e., the cities along the Rhône); *Provincia Narbonensi Prima,* which contained Narbonne, Toulouse, Béziers, Nîmes, Lodève, and Uzés (i.e., the cities westward from the Rhône valley as far as Toulouse); and *Provincia Narbonensi Secunda,* which incorporated Aix, Apt, Riez, Fréjus, Gap, Sisteron, and Antibes (i.e., the cities east of the Rhône valley and estuary toward the Var). See Clébert 1970: II, 76; Rivet 1988: 97–100; and King 1990: 182.

39 Rivet 1988: 103–6; especially good on Constantinian Arles and the fourth century is Clébert 1970: II, 77–9; essential now is Heijmans 2004.

40 Primary sources for this confusing period include Jerome, *Ep.* 123.15; Zosimus 6.3; Orosius 7.40–3; Sidonius, *Carm.* II, V, VII, and XIII, and his *Ep.* 6.12 and 7.1. Rivet 1988: 106–8 provides a masterful summary.

41 Küpper-Böhm 1996, *passim.* Useful surveys of the history and remains of postclassical Provence include Cook 1905: II, 182–413; and more recently: Agulhon and Coulet 1987; Février 1989; Colonna d'Istria 2000; and Garrett 2006.

2 The Cities, Suburbs, and Towns of Roman Provence

1 Important general studies of urbanism in Roman architecture include Ward-Perkins 1974: 22–36; Gros and Torelli 1988; Owens 1991: 94–163; and Anderson 1997: 181–336. Recent books that deal with the urbanization of Roman Provence include Bédon 2001; Goodman 2007: 79–231; and Gros 2008: 31–103.

2 See the street plans for Roman cities and towns in Provence collected by Bedon 2001, as well as those in applicable volumes of the *Carte archéologique de la Gaule*: e.g., vols. 4 (Berard and Barruel 1997), 6 (Dellong et al. 2003), 7 (Mocci and Nin 2006), 30/1 (Fiches and Veyrac 1996), 30/2 (Provost 1999), 34/2 (Lugand and Bermond 2003), and 13/5 (Rothé and Heijmans 2008) et al.

3 See especially Leveau 1993 and 1994, and most recently Goodman 2007.

4 Leveau 2005–6 is particularly important on the suburban development of ancient Vienne.

5 On the history and development of Roman concrete, see Anderson 1997: 145–7, and, much more complete, Lancaster 2005: 3–12 and 51–65. Essential to understanding the creativity made possible in Roman architecture by the development of concrete is Lancaster's suggestive concluding chapter called "Innovations in Context": Lancaster 2005: 166–81, even though her focus is exclusively on concrete construction in Rome and central Italy.

6 Good overviews of this cultural development are provided by Cleere 2001: 6–7 and Gros 2008: 7–10. On the use of the word *oppidum,* see N. Purcell's entry in the third edition of the *Oxford Classical Dictionary,* ed. S. Hornblower and A. Spawforth (Oxford: Oxford University Press, 1999): 1069.

7 Brief descriptions and some aerial photographs of these are provided by Cleere 2001: 126 (Entremont), 88 (Ensérune), 156 (Saint-Blaise), 125 (Constantine), 39 (Murcens), 78 (Nages), and 165 (Taradeau).

8 Cleere 2001 summarizes the evidence for Greek Agde (p. 60), Antibes (p. 61), Hyères (p. 134), Nice (p. 146), and Arles (p. 111) as well as providing a quick overview of both native and Greek evidence from Glanum (pp. 158–9). Another excellent summation of the evidence for all the Greek settlements, and what evidence there is for their interaction with native towns (especially Glanum), is given by Gros 2008: 10–14.

9 For a convincing and nuanced overview of the evidence for the early town plans of these renowned colonies in Sicily and South Italy, see Owens 1991: 30–50 and Greco and Torelli 1983: 160–212.

10 Bedon 2001: 215–17; Hodge 1998: 75–9, and esp. figs. 51 and 52. On the development of harbor and walls, see Benoit 1972 and Hesnard 1995.

11 On these identifications and the fragmentary evidence for them, see Clavel-Lévêque 1977: 107–8, whose opinions are generally accepted by Hodge 1998: 78–9 and by Bedon 2001: 215–17.

12 Hodge 1998: 78 and notes 35 and 36 (p. 248), see also note 11 (p. 245); Bedon 2001: 216.

13 The still controversial tale of Hippodamus of Miletus is complicated and self-contradictory to a degree. Aristotle (*Pol.* 2.5 and 7.10.4) attributed to him the invention of the division of cities and the laying out of Athens' port city Piraeus, which ought to place his working life in the mid-fifth century BCE (Hippodamus' responsibility for Piraeus is also mentioned by Xenophon, *Hel.* 2/4/11). He is also connected with the foundation of Thurii in southern Italy in 443 BCE (Diodorus Siculus 12.10.6–7) and with the laying out of the town of Rhodes at a much later date ca. 408 BCE (Strabo,

Geog. 9.1.15 and 14.2.9), which would seem an incredible working lifetime. On Hippodamus' dates, the sources for him, and how his "diaeresis" of land and population for newly founded towns may have worked, see Burns 1976; Greco and Torelli 1983: 233–50; Owens 1991: 51–73; and Gorman 1995.

14 Hodge 1998: 78; Bedon 2001: 216–17. On the south Italian and Sicilian comparanda see Ward-Perkins 1974: 23–4 (especially on Megara Hyblaea); Greco and Torelli 1983: 160–6 (Megara Hyblaea), 177–8 (Tarentum), 199–204 (Metapontum) and 208–12 (Posidonia); and Owens 1991: 30–50.

15 Ephesian Artemis was much worshipped at Massalia's parent city of Phocaea, in particular as a guiding spirit behind Phocaean immigration and colonization; Massalia dedicated a treasury at Delphi to demonstrate her honoring of Apollo: Hodge 1998: 79–80 and note 41 (p. 249).

16 Clavel-Lévêque 1977: 187–9, followed by Hodge 1998: 79–80. On Caesar's siege of Massalia see Rivet 1988: 65–6 (who is especially clear), and the ancient sources Caesar *BC* 1.34–6 and 56–8, 2.1–16; Lucan, *Phars.* 3.300–74; Vell. Pat. 2.50; and Dio 41.19. On the career of Vitruvius and the possibility of his participation at Massalia, see Anderson 1997: 39–44; Vitruvius' detailed description of the siege and the city (10.16.11–12) could well be that of an eyewitness (Anderson 1997: 42; contra Hodge 1998: 79).

17 Bedon 2001: 216.

18 Adapted from Gantès 1992, who is followed by Hodge 1998: 88 and Cleere 2001: 136–41.

19 Bedon 2001: 216–18 provides the best, and almost the only, discussion of the topography and architecture of Roman Massilia. Bromwich 1996: 169–70 attempts an overview that is understandably sketchy.

20 For the gridded street plan and a rapid description of the remains: Bromwich 1996: 267–70 and Cleere 2001: 134–5; also Hodge 1998: 174–7.

21 Rivet 1988: 3–19, 219–25, 239–42; Hodge 1998: 170–93.

22 Bedon 2001: 79; Rivet 1988: 190; Hodge 1998: 160.

23 Rivet 1988: 265–71; Hodge 1998: 143–8 (Saint Blaise), 150–1 (Lattes), 158–60 (Agde), 161 (Avignon and Cavaillon).

24 Admittedly an unusual neuter place-name in Greek (though the Latinized neuter form – "Glanum" – follows the usual Roman rule) but one attested by both *cippus* and coin inscriptions. Brenot 1989: 75; Roth-Congès 1992a: 353; Hodge 1998: 151.

25 This is argued most strongly, and persuasively, by Heyn 2006: esp. 179–80. See also Salviat 1990: 12–18 on the pre-Roman evidence found on the site, also Arcelin 1992: esp. 307.

26 Hodge 1998: 153; cf. Heyn 2006: 182–3.

27 See Livy (21.19–21) for a vivid description of Roman soldiers moving through southern Gaul seeking allies against Hannibal in the last years of the third century BCE.

28 Heyn 2006: 181–3, following Roth-Congès 1985: 204–6 and 1992a: 356; also Bromwich 1996: 202–4 and Cleere 2001: 158–9 for useful summaries of site chronology. For a clear description of the archaeological evidence, see Bedon 2001: 290. On the entablature carving and its identification as Tuscan, see Wilson Jones 2000: 110. For discussion of the chronological connections with Italian temples, and the implications thereof, see Gros 1990: 101 and 1992: 374; Roth-Congès 1992a: 356; and Torelli 1995: esp. 179–80.

29 On the problem of the defense walls in the "Hellenistic" rebuilding of Glanon, see Roth-Congès 1992a, and a response to her paper by Treziny 1992: 472–3, who points out that the tiny bit of pre-Roman wall known at Glanon could not possibly have

played any sort of defensive role. This objection is accepted by Hodge 1998: 153. On possible further extension of that early wall, see Agusta-Boularot et al. 2004: 29, followed by Heyn 2006: 183.

30 Prytaneum: Giacobbi-Lequément et al. 1989: 20; Roth-Congès 1997: esp. 177–280, who makes the strongest argument for the identification in a reply to Gros, who prefers to see the complex as a Hercules sanctuary and market; Gros 1995: esp. 329, somewhat tepidly supported by Hodge 1998: 274 and Heyn 2006: 184 (who rightly points out the problems in Roth-Congès' use of the Greek terms *bouleuterion* and *prytaneum* for these buildings). The "Romanness" of the building seems undeniable, however it is identified.

31 Heyn 2006: 187–8, following Gros 1990: 103, who in turn follows Rolland 1958: 54.

32 This is very convincingly argued by Heyn 2006: 189–91. Contra: Hodge 1998: 157 who asserts that only Greeks could have been responsible for some of the structures built in Glanum at this time. He follows Kleiner 1973: 381 who argues that Glanum had been established either by Massalia or by other Greek colonists during the second century, which its Hellenic-type buildings of the time demonstrated.

33 On the wall painting of the house of Sulla and on the mosaic inscription, see Gros 1992: 273, who is followed by Heyn 2006: 192–3. Rolland 1977 wanted to date the mausoleum/cenotaph of the Julii as early as 20 BCE; Gros 1979 countered with arguments for 10–20 CE, which were accepted by Kleiner 1980 and many others; however, there is little absolute evidence for either dating other than the generally agreed reflorescence of Glanum in the Augustan period, and disturbing elements in the sculpture, architecture, and inscription of the Julii monument remain unresolved and, perhaps, inexplicable within so early a chronology.

34 For native compromises at Glanum, see Roth-Congès 1985: esp. 193, followed by Heyn 2006: 192–3. On the similar amalgamation of constructional and design elements in the last phase of Entremont, see Treziny 1992; Bromwich 1996: 130–4; and Hodge 1998: 197–202.

35 Bedon 2001: 290–2; Bromwich 1996: 205, 207; Cleere 2001: 159 for descriptions of the remains. Rivet 1988: 198–200 documents and discusses the inscriptions, as well as portraits found in the excavations that may represent Octavia and Julia, sister and daughter of Augustus, respectively. For those identifications and for the most comprehensive treatment of all finds from the sanctuary area, see Picard 1963 and 1964.

36 Bedon 2001: 290–1; Bromwich 1996: 207; Cleere 2001: 159.

37 On the monumental area in Roman times, see Bedon 2001: 290–1, Bromwich 1996: 210–12; and Cleere 2001: 159–62, noting that these three summaries of the evidence disagree with one another on many points. The most important study of the "twin" temples is Gros 1981a, revised in Gros 1996: 155–6, but the anomalies remain.

38 Rolland 1977 remains the essential study of the arch at Glanum. See Gros 1979 for the more recent suggestion of dating, refined but in essence followed by Küpper-Böhm 1996: 77–85, who reasserts the comparison to the arch at Orange as well as attempting to establish dating parallels with fragments of the "Arc admirable" from Arles, and the fragmentary arches at Carpentras and Cavaillon. For the location of "Les Antiques" at the road intersection, see Bromwich 1996: 216–19; Cleere 2001: 162; and Bedon 2001: 292.

39 Rivet 1988: 46–7 and 212.

40 On the scattered ancient remains of Aquae Sextiae, see Bedon 2001: 53–5 (town plan: 53); also Ambard 1984. For an excellent overall summary, see Amy 1976: 77–8.

41 Guild et al. 1980: 115–64. See also Bérard et al. 1994.

42 Gros 2008: 61–3, following Mocci and Nin 2006: 235–68. So recent is this discovery that no mention of the Roman theater at Aix appears in Bedon 2001 or in Sear 2006.

43 Bedon 2001: 54–5.

44 Gayraud and Solier in Stilwell 1976: 607; Rivet 1988: 130–1.

45 Gayraud 1975: 834–8 traces these developments most convincingly; cf. Rivet 1988: 130–4.

46 Gayraud and Solier 1976: 607.

47 Gayraud 1981: 281–90; see also Rivet 1988: 134.

48 Gayraud 1981: 274–8.

49 The name "Theline" is sometimes connected with the modern designation for that district, Trinquetaille, though finds of Greek pottery and pre-Roman foundations on both sides of the river suggest that the linguistic identification, while appealing, has little basis in fact. For the historical evidence, see Caesar, *BC* 1.36 and 2.5; for "Theline" see Avienus, *Ora Maritima,* lines 689–91; the name of the *colonia* is confirmed by Mela 2. 5. 75 and the elder Pliny, NH 3. 36. Rivet 1988: 190 and Amy 1976: 88 provide good summaries of the early evidence. On finds of pre-Roman materials: see excavation notices in *Gallia* 8 (1950) 122; 12 (1954) 430; 18 (1960) 303–5; and 35 (1977) 515; this evidence is now conveniently collected in Rothé and Heijmans 2008: 96–114.

50 Bedon 2001: 53; a good summary is given by Amy 1976: 87. See also Goodman 2007: 85–6, 102–3, 125–6, 147–9, and 162–4; Rothé and Heijmans 2008: 162–7.

51 Amy 1973 is the single most important treatment of this monument. See also Rivet 1988: 193–4, who follows Grenier 1958: 291–308, 321–322; and Gros 2008: 44–5 and 48–50.

52 Küpper-Böhm 1996: 14–24 (on the Arc du Rhône, following Gladiss 1972), 63–75 (on the Arc admirable and Arc de Constantin), and 146–51 (on an Antonine arch at Arles). See also Fornasier 1994 and 2003: 23–52 and 174–84.

53 Reconstruction and dating proposed by Grenier 1958: 297–300; accepted by Amy 1976: 87 and by Rivet 1988: 193–194.

54 Gros 1987: 357–63 and Gros 2008: 48–50 and fig. 32. See also Sintés 1990.

55 For the difficulties with the Tiberian dating, see Gros 1987: 359 (note 72, an attempt to dismiss Verzar's analysis); Rivet 1988: 193. The resemblance in plan of the *forum adiectum* at Arles to the design of the Basilica Ulpia in the north end of Trajan's forum becomes evident by comparing Gros 1987: fig. 18 (p. 359) with any standard plan of the Imperial fora's northern end, e.g., Ward-Perkins 1981: fig. 6; Anderson 1984: pl. 1; or Wilson Jones 2000: fig. 1.1. See further Heijmans and Sintes 1994: 147–8 and Rothé and Heijmans 2008: 366–71 on the meager archaeological evidence in situ.

56 Rivet 1988: 194–5; Amy 1976: 87; Gros 2008: 45–8.

57 The new aqueduct was, of course, that which served the water mills at Barbégal (see Leveau 1996) and continued in use through the fourth century CE.

58 The essential source on late antique Arles is Heijmans 2004. On specific monuments, see Bedon 2001: 55; Rivet 1988: 193–5.

59 For summaries of this historical evidence, see Bedon 2001: 167–8; Rivet 1988: 226–7, and Goudineau 1976b: 335.

60 Overall survey of the ancient monuments of Forum Iulii: Bedon 2001: 167–71 with a town plan (p. 169) and recent evidence for the forum; for the port, see Goudineau and Brentchaloff 2009; for the theater, see Béraud et al. 1998: 35–8; for the amphitheater, see Pasqualini et al. 2010.

61 For recent research: De Madron 1999 and Gébara and Michel 2002.

62 Rivet 1988: 232–3 is particularly good on late antique and early Christian Forum Iulii.

63 I here follow Pelletier 1982: 34–40 and 73–80, as do Rivet 1988: 305–6 and Bedon 2001: 324–7. See Leglay 1976: 978 for a very different reading of the scattered evidence. The other important ancient sources on early Vienna are Cassius Dio 46.50, and Suetonius, *Div. Iul.* 76.3. Claudius' speech is partially preserved as *CIL* 12.1668 (which includes the reference to Vienna) and summarized by Tacitus, *Ann.* 11.23.

64 Anderson 2001: esp. 71–4; Grenier 1958: 393–7; Pelletier 1982: 446–53.

65 On the theater, see Sear 2006: 252–3. Pelletier 1982: 211–16 summarizes the many possible dating suggestions. On the *odeum* and its history, see Pelletier 1982: 217–21 and Rivet 1988: 309.

66 On the rest of the "official" monuments of Vienne, the best source remains Pelletier 1982: 150–5 (baths), 221–3 (circus), 432–8 (Cybele theater and temple), who is followed by Rivet 1988: 309–10. See also Bedon 2001: 325–6; and, on the area south of the city walls, Goodman 2007: 11, 148–9. Another excellent summary is provided by Leglay 1976: 978–9. It should be noted how well this architectural history and characterization of Imperial Vienna corresponds to the vision of the monumental Roman Imperial city described by Thomas 2007: esp. 107–60.

67 Pelletier 1982: 122–7, 170–84, 193–6 on these expansions and elaborations to Vienne. Much more detailed research is now available in Leveau 2005–6 and Leveau and Rémy 2005–6, some of which is well summarized in Goodman 2007: 101–3, 125–8, 147–9, and 162–4.

68 Good summaries of this material may be consulted in Bedon 2001: 327–31; Leglay 1976: 978–9; and Rivet 1988: 309–10; more detailed is Pelletier 1982: 225–376. Also excellent is Goodman 2007: 101–3, 115–17, and 125–8. For a detailed study of the evolution of one sector of St.-Romain-en-Gal, see Prisset et al. 1994.

69 Rivet 1988: 162; Gros 1976: 616; Bedon 2001: 237–41. On the coins, see Kray 1955 and Veyrac 1998.

70 Gros 1996: 47–50. On the walls, see Varène 1992; on the Porte d'Auguste, see Célié et al. 1994: 393–6.

71 On the forum and its relationship to the temple, see Célié and Monteil 2009, and Frakes 2009: 46–9. On the temple, important studies include Balty 1960; Amy and Gros 1979; and Gros 1996: 157–9. Wilson Jones 2000: 66–8 discusses the design influence exerted by Augustus' forum. For the Hadrianic dating hypothesis: Anderson 2001, accepted by Thomas 2007: 50.

72 Célié and Monteil 2009; also Gros 2009. The connection to the Hadrianic building attested in the Historia Augusta is attractive, but not susceptible to independent proof: see Grenier 1958: 149–50 and Rivet 1988: 164–5.

73 Gros 1983: 162–72 restores the fragmentary inscription from this part of the portico, which reads "…NAE…," as a reference to [PLOTI]NAE, thus reinforcing a Hadrianic or Antonine dating. This is accepted by Frakes 2009: 180 but has otherwise been generally ignored.

74 Gros 1984 and 1996: 440–1; Varène 1987; Fiches and Veyrac 1996: 241–68, and Veyrac 2006: 47–100 are the most comprehensive discussions of the remains. The dating debate continues; for various arguments see Naumann 1937 (who thought the entire complex Hadrianic rebuilt under Septimius Severus); Hesberg 1981–2 and Gans 1990 (who argue for much more extensive Augustan remains throughout). Most recently, see Veyrac 2006 (who admits the inconclusive nature of much of the debate) and Thomas 2007: 50 (who argues for an Antonine date). Frakes 2009: no. 0135, pp. 179–83 admits that the dating is "difficult."

75 Golvin 1988: 184; Wilson Jones 2000: 13; Fraser 2006: 55.

76 The dating of both the aqueduct and the Gardon river bridge is discussed by Février 1973: 26; Chevallier 1975: 748 and 1982: 61; Rivet 1988: 165–7; Hauck 1989; and Veyrac 2006: 127–36.

77 On Antoninus' origin: *CIL* 8.8239. On Plotina's probable Nemausan birth: Dio 68.10.13. Further on Plotina, see Raepsaet-Charlier 1987: 631 and Boatwright 1991: 515; also Anderson 2001: 76–7. Grenier in the preface to Pflaum 1978: xi–xii makes a very strong case for the shift of the Narbonese capital to Nemausus.

78 See Fraser 2006: 41–2, 47–50, 54, 58, 61–2 for Hadrianic benefactions to Narbonese cities. What happened in second-century CE Nîmes corresponds very well to the provisions laid out by Thomas 2007: esp. 127–49 (discussing only Roman cities in Asia Minor) for the relationship that came to exist between important cities and the emperor during the Antonine age.

79 Rivet 1988: 163; also Gros 1976: 616.

80 Goudineau 1976a: 83; Rivet 1988: 272; Bedon 2001: 242–5. A Vespasianic inscription found near Place de la République in 1951 proves that it was the second Gallic Legion that was settled here: see Piganiol 1962: 79–89.

81 These anomalies of construction sequence in the city walls are pointed out by Rivet 1988: 273–4. For a variety of possible plans of the city, see, e.g., Grenier 1958: 175; Amy et al. 1962: pl. 1; Chevallier 1982: pl. XVI.I; Rivet 1988: 274 (fig. 37); and Bedon 2001: 243.

82 Here again, as I have already suggested for Imperial period Nîmes, the sort of visually overwhelming monumentality that came to characterize Antonine reworkings of great cities of Roman Africa and Asia Minor, as pointed out by Thomas 2007: esp. 107–49, comes to mind (again see Janon et al. 2009).

83 Bellet 1991; Rivet 1988: 273–4; Bedon 2001: 242–4; Gros 2008: 48–50. On the theater and temple complex, see Janon et al. 2009; on dating the arch, see also Anderson 1987.

84 Mingazzini 1968; Anderson 1987. Even Küpper-Böhm 1996: 100–4 finds it essential to hypothesize a Trajanic phase for the arch, though she tries to retain a much earlier origin for it.

85 Piganiol 1962 remains the essential, original study of these cadasters, and his publication is a monument to inspired scholarship. Rivet 1988: 274–5 provides an excellent summary of the evidence. See also Salviat 1977: Poupet 1993; Assénat 1994–95; and Fiches 1996. On the process of centuriation and how Roman surveyors functioned, see Dilke 1971 and Campbell 2000.

86 Rivet 1988: 272; Goudineau 1976a: 84.

87 Goudineau 1976c: 955–6; Rivet 1988: 286–7 and 296. The Vocontii's status is attested by both Strabo (4.6.4) and Pliny (*NH* 3.37), see also Goudineau 1979: 251–64 for a full discussion of the dating evidence. Syme 1958: 611–24 makes a strong case for assigning the historian Tacitus to Vasio.

88 The best discussion of all these difficulties is Goudineau 1979: esp. 251–64. He provides a useful summary in Goudineau 1976c: 956, and updates it in Goudineau et al. 1999.

89 Rosso 2006: nos. 187–92 (pp. 413–25).

90 Bedon 2001: 313–16 (map of the site: 315); Rivet 1988: 288–89; Goudineau 1976c: 956; Goudineau et al. 1999.

91 Bedon 2001: 314–16; Goudineau 1976c: 957.

92 Goudineau 1976c: 957; Rivet 1988: 288.

3 Roman Architectural Forms in Provence

1 Augustus' forum was completed and dedicated in 2 BCE. Wilson Jones 2000: 135–56 makes the case for the Augustan codification of Corinthian most strongly; see also Gros 2001: 475–8 and Stamper 2005: 130–50 who are clearly convinced.

2 See Heilmeyer 1970 on the difficulties of being certain how to date Corinthian capitals, information applied directly to Roman Provence by Mingazzini: 1971–2. Similar difficulties were noted by Kleiner 1973: 385–6 dealing specifically with Provençal Corinthian capitals. Wilson Jones 2000: 135–46 gives a brilliant exposition of the development from Hellenistic capitals in Italy (beginning in the second century BCE) to and beyond the standardization under Augustus. Gros 2001: 478–503 surveys Imperial Corinthian capitals in Italy and the provinces.

3 Though the sands available in southern France did not provide the truly extraordinary bonding power achieved in Italy through the use of dark volcanic sand called *puteolanum,* since it was first identified near Puteoli on the Bay of Naples, in mortar and cement, as described by Vitruvius, *De arch.* 2.6.

4 See Bedon's essay "Nature et origine des materiaux utilizés pour les villes" in Bedon et al. 1988: I, 45–76, from which it is necessary to extract the information that relates specifically to Provence: especially important is his treatment of both Hellenistic and Roman period stone quarries in Provence (pp. 67–70, focusing particularly on the known quarry sites near Glanum and Nîmes). Unquestionably the finest general presentation of Roman construction techniques and materials ever written is Adam 1984. Most of the nonarchaeological evidence we have for the subject is provided by Vitruvius, who composed his ten books *De Architectura* in the first decade(s) of Augustus' reign (Anderson 1997: 3–15 and 39–44).

5 Gros 2001: 479–82 for an excellent survey; also Wilson Jones 2000: 140–2 and 145–7. See also Roth-Congès 1983a for a comprehensive treatment of the development of varying acanthus leaves all over Narbonese Gaul. Beyond the buildings listed, such distinctly Provençal decorative vegetation is known on fragments from a mausoleum at Allens, and from several examples at Arles coming from the Rhône arch, the temple on the Forum, and the theater.

6 See the many illustrations provided by Roth-Congès 1983a, a few of which are reproduced in Gros 2001: 480–1, figs. 582–5.

7 Cf. Gros 2001: 480–1, figs. 586 and 587. The possibility that any of these examples might have been carved after the Augustan period, but still conformed to the standard required for Imperial architecture, is not considered by Gros. For differing assessments of individual monuments already mentioned here, see Mingazzini 1957, 1968, and 1971–2; also Anderson 1987 and 2001.

8 Wilson Jones 2000: 145–7 shows the evidence for local variation within overall conservative patterns of Corinthian capital design very clearly, noting "How appropriate, after all, was the Vitruvian term *genus,* standing as it does for a family of individuals rather than an order" (147).

9 Hatt 1970: 128–9; Rivet 1988: 16–17 and 20–26; Bedon, "Les enceintes urbaines," in Bedon et al. 1988: 77–80; King 1990: 20–1; and Hodge 1998: 197–202 (on Entremont) and 202–4 (on Ensérune).

10 Bedon, "Les enceintes urbaines," in Bedon et al. 1988: 80; King 1990: 19–20.

11 The text of Trogus is preserved by Justin, *Historiae Philippicae ex Trogo Pompeio,* 43.3.16–4.6, quoted in Rivet 1988: 10–11. On these *oppida* and their remains, see the excellent treatment in Hodge 1998: 194–208; also Cleere 2001: 90 (on Ensérune especially).

12 On the meager remains of Massalia, see Clébert 1970: II, 125–30; King 1990: 12–13; Hodge 1998: 79–88 (especially good on the Bourse site); and Hermary et al. 1999: 41–51, 71–85. Hatt 1970: 129–33 gives a good overview of the spread of these elements in native towns; King 1990: 19–22 and Hodge 1998: 194–208 provide archaeological summaries (especially good on Entremont).

13 Varène 1992 is the essential study. See also Bedon, "Les enceintes romaines," in Bedon et al. 1988: 85–7 and Gros 1996: 47–50, who follows Varène.

14 The difficulties encountered throughout the twentieth century by a number of scholars in attempting to reconstruct the history and the line of the Roman walls of Arles provide an instructive *caveat;* see Rivet 1988: 191–3. To this day there is much uncertainty (e.g., Stambaugh 1988: 278; Bromwich 1996: 141–2).

15 Février 1977: 71–80; for more recent excavations see Béraud et al. 1998: 22–9.

16 Célié et al. 1994: 393–6; Gros 1996: 47–8. Rivet 1988: 163 points out that the other preserved gate, the porte de France, cannot be dated thus, and that the plural *portas* probably refers only to the four passageways of the porte d'Auguste. On the porte de France, see Varène 2002.

17 See Varène 1992, esp. 146–75 on the towers; Gros 1996: 48–50; Rivet 1988: 163; Bromwich 1996: 98–100.

18 Chevallier 1982: 11. On the *tropaeum Traiani* at Adamklissi, see Florescu 1961 and Sampetru 1984.

19 The original and still the most important study of the monument is Formigé 1949 (Jules Formigé, together with the American Edward Tuck, was responsible for much of the restoration). See also Chevallier 1982: 9–12 (repeated more or less word for word in Bedon et al. 1988: 174–8); Bromwich 1996: 270–275; Cleere 2001: 166–8; Knell 2004: 86–8.

20 Clébert 1970: II, 66–9; Rivet 1988: 335–6.

21 The two at St. Chamas are duplicates of each other, but stand independently at either end of a bridge; the so-called *quadrifrons* at Cavaillon is in fact a combination of two originally separate but similar arches.

22 For an admirable attempt to make sense of the fragmentary arches of Arles, see Küpper-Böhm 1996: 14–24 (arc du Rhône), 63–76 (arcus admirabilis and arc de la porte de l'Aure), 146–52 (Antonine arch). The arc du Rhône is brilliantly treated by Gladiss: 1972, who makes a convincing case for her reconstruction and dating of it. The others remain difficult and disputed.

23 Again the most comprehensive, if sometimes radical, treatment is Küpper-Böhm 1996: 110–12 (Apt), 113–20 (Toulouse), 136–44 (Die), and 159–74 (fragments from various cities).

24 The bridge span itself appears to be almost entirely from the seventeenth century CE, as is the wheel-rutted pavement across it. The arches at either end were repaired numerous times (e.g., only one of the four lions – that on the right-hand side of the eastern arch – could be original, the others are certainly later copies), and the western arch was all but destroyed during World War II when first a German tank and then an American truck ran into it, causing a total collapse, after which the arch had to be reassembled (Bromwich 1996: 200).

25 Küpper-Böhm 1996: 7–9 assigns them to the middle of Augustus' reign; Lugli 1966 argued for the last years of Augustus or even the early years of the reign of Tiberius; Bromwich 1996: 201 suggests 20–10 BC and Kleiner 1998: 611 appears to accept that earlier Augustan dating, as does Gros 2008: 90, 117; Rivet 1988: 205 does not address the issue at all.

26 King 1990: 116, asserts that bridge and arches were built "following the instructions in the will of L. Donnius Flavos, probably in the second century AD." In short, the dating is quite rightly disputed.

27 There is no evidence or reason to connect the arch with the period of the Flavian dynasty in Rome, 69–96 CE.

28 Lugli 1966: esp. 1047–54; Küpper-Böhm 1996: 5–13; Bromwich 1996: 200–1.

29 Like most of the Narbonese arches, the arch dedicated by the Sergii at Pola is commonly assumed to be Augustan. Mingazzini 1957: 203–4, however, argues strongly for a Severan date.

30 The essential study of the arch at Glanum is Rolland 1977, from which all measurements are taken. See especially the superb line drawings of almost every element of the arch, which were prepared by J. Bruchet.

31 The decade 10–20 CE is proposed by Gros 1979, 1981b, and 1996: 68, and is now accepted by both Küpper-Böhm 1996: 79–80 and Kleiner 1998: 611. However, it should be remembered that this date is established in part by comparison with the arch at Orange, which cannot be dated epigraphically in any acceptable fashion, a fact which must in turn cast all Augustan or Tiberian datings for Provençal arches (and indeed other Roman monuments in Provence) into some doubt (see Anderson 1987). For a detailed description of the Via Domitia: Clément and Peyre 1998.

32 For a brutally negative evaluation of Courtet's arguments, see Turcan 1984: 809, who likewise rejects Mingazzini 1957: 205, who offers a number of comparanda to support his assertion that the reliefs on the Carpentras arch "non possono essere anteriori alla Colonna Antonina." A number of the stylistic and technical characteristics cited by Mingazzini accord well with characteristics of late Antonine and Severan sculpture discussed by Picard 1961; Turcan's dismissal of these arguments seems overly harsh.

33 Turcan 1984; see also Chevallier, "La fonction politique I," in Bedon et al. 1988: 178–80. Gros 1979 first proposed a date in the first decade of the first century CE, and this has been accepted by Küpper-Böhm 1996: 37–8 and Kleiner 1998: 611. But Gros 1996: 68 revised his dating to attribute the arch directly to Tiberius and to the 20s CE. Chronological surety remains elusive, and the stylistic comparanda offered by Mingazzini 1957: 205 remain attractive, as does the possibility of an Antonine or even Severan date for the reliefs (Anderson 1987).

34 For a detailed recent study of these reliefs, see Lamuà Estañol 2009.

35 Küpper-Böhm 1996: 42–62, esp. 42–6 for dating to the early first century CE. See also Gros 1996: 68–9, and Chevallier, "La fonction politique I," in Bedon et al. 1988: 178, who mentions the much later dating suggestions.

36 Walter 1984: 863. See Brilliant 1967: 109 for an example of such attached Victories on a coin of 104–111 CE minted in Rome.

37 The new dating is proposed and argued by Küpper-Böhm 1996: 133–5. It has been accepted by Gros 1996: 76, but Kleiner 1998: 611 expresses reservations. The unusual decorative scheme applied to the arch argues in favor of a high Imperial dating (Küpper-Böhm 1996: 129–33), and it should be compared with the fragmentary remains of the arch at Die, also now dated to the second century CE, and perhaps with the arch (La Porte Noire) at Besançon (Roman Vesontio), which is probably from the reign of Marcus Aurelius or Commodus (Walter 1984; Gros 1996: 76).

38 This is convincingly asserted by Walter 1984: 863, who suggests comparison with a long-lost arch in Rome datable to 104–111 CE (from numismatic evidence), the

Trajanic arch at Ancona (both of which seem to have sported bronze Victories clamped to the spandrels), as well as with well-known examples with Victories sculpted in stone including Trajan's arch at Benevento, and the later second century Porte Noire at Besançon (Roman Vesontio).

39 Anderson 1987: 171–5; see also Mingazzini 1957: 196–8 and Chevallier 1975: 748. *Contra* Gros 1979: 58–60, 1996: 66; and Kleiner 1991: 205 (who agrees, however, that the occurrence of the arcuated lintel at Orange is "unexpected").

40 Gros 1996: 58 remarks "*l'arc de Cosa … n'évoque pas une structure monumentale autonome: il s'agit seulement d'une large baie entourée de deux passages latéraux dans un panneau qui assurait la liaison entre les bâtiments adjacents.*" I.e., it is no better a precedent for free-standing triple fornix arches than the single fornix arch flanked with post-and-lintel display bays that held the Capitoline fasti in the Roman Forum during the time of Augustus.

41 Kleiner 1991: 205 (on the arches attributed to Germanicus); Gros 1996: 57–8 (on Cosa) and 65–6 (assigning Medinaceli to the mid-Augustan period without corroborating evidence of any kind). Collins 1998: 183 more persuasively dates the arch at Medinaceli to the reign of Septimius Severus on stylistic grounds and lack of legible inscription. The chronological difficulties shared by the arches at Medinaceli and at Orange are striking.

42 Gros 1996: 78–9 on the arches at Leptis and Timgad, and 89–92 on those at Gerasa and Palmyra; Brilliant 1967 is the comprehensive study of the Severan arch in the Roman Forum. See Chatelain 1908: 68–70 and Anderson 1987: 160–1 on datings proposed for the Orange arch prior to attempted reconstructions of its inscription.

43 Anderson 1987: 162–9. This point has now been accepted by Kleiner 1991: 204: "I congratulate Anderson on demolishing a myth of modern scholarship." Strangely, however, Küpper-Böhm 1996: 90–2 returns to the Amy-Piganiol text, pushes its date even earlier into the reign of Tiberius (before the battle with Sacrovir!), and ignores the other epigraphic anomalies. Gros 1996: 66 ignores the issue, dating the Orange arch solely by comparison with the arch at Glanum, which he assumes to be Tiberian because it is so like the arch at Orange (!); see also Gros 1979.

44 Kleiner 1991. Gros 2008: 50 attempts to reassert the "Tiberian" nature of the spolia carvings, to little effect (cf., the review by Downing 2010). Küpper-Böhm 1996: 90–2 and 99–103 makes the confusion worse by hypothesizing a foundation for the arch a decade before the revolt of Sacrovir, but then is forced to attribute the second attic and its reliefs to the reign of Trajan (cf., Kleiner 1998: 611–12).

45 No physical evidence for the addition of this Tiberian attic is mentioned, which seems odd.

46 Mingazzini 1968, and Anderson 1987: 185–9, with further arguments for a later dating of the rest of the sculpture on this arch (see also pp. 176–85).

47 Anderson 1987: 189–92; see also Mingazzini 1957: 193–201 and Mingazzini 1968. The debate continues (see King 1990: 76; Kleiner 1991 and 1998; Küpper-Böhm 1996: 100–3; Anderson 2001: 68; Gros 2008: 50).

48 Most strongly asserted by Gros 1979, 1996, and 2008. Gros' analysis has been accepted by most scholars until very recently, e.g., Turcan 1984; Küpper-Böhm 1996; and others, but it remains a disconcerting fact that the only independent evidence ever cited to justify the assignment of the entire series of arches to the very late first century BCE and early first century CE is the entirely hypothetical text of *CIL* XII.1230, which means that all are dated by reference to the undatable arch at Orange. Kleiner 1985: 47 acknowledges that the decoration of the arch is unlike normal Julio-Claudian sculpture, but then says that the Orange arch "is, however,

securely dated on epigraphical grounds to c. AD 20–26," a point he subsequently and graciously retracted (Kleiner 1991: 204).

49 Vitruvius' Book 4 is the essential ancient source. See Gros 1996: 122–6 and Stamper 2005: 33–48.

50 The hellenization of Roman Republican architecture has been studied extensively by Gros (e.g., 1973, 1992, 1996: 127–30). He is widely acknowledged, e.g., by Stamper 2005: 49–67 and Thomas 2007: 5–6.

51 Gros 1981a and 1996: 155–6; Roth-Congès 1983a.

52 Frakes 2009: #027, pp. 158–61.

53 Salviat 1990: 36–7; Gros 1981a.

54 Chevallier, "La fonction réligieuse," in Bedon et al. 1988: 140; Salviat 2000: 30–1; Rivet 1988: 198–200.

55 History of the site: Rivet 1988: 215; Bromwich 1996: 238–9; Gros 1996: 156; Cleere 2001: 176–7; Gros 2008: 92–4. Two essential recent studies are Agusta-Boularot et al. 2005–6: esp. 201–3 and 221–3; and the excellent synthesis of older evidence and newer exploration: Agusta-Boularot et al. 2009a, which must be regarded as definitive until a full monograph may appear.

56 For architectural and topographical comparanda, see Agusta-Boularot et al. 2009: esp. 131–40, noting especially figs. 9 and 10. It is intriguing that much of the evidence cited to determine the nature and function of the sanctuary is Julio-Claudian or later (Augusta-Boularot et al. 2009: esp. 147–50). This ought to suggest an early to middle Imperial development and integration of the sanctuary, as well as possible reworking of the temple itself.

57 On the widely dispersed evidence for habitation of Vernégues in Roman times, see Fournier and Gazenbeek 1999; also Chapon et al. 2004. On conversion of the temple into a Christian chapel, and its relationship to (and reuse of) the pagan remains, see Agusta-Boularot et al. 2009a: 138–46.

58 Bellet 1991: 42; Goudineau 1976: 83–4 provides an interesting discussion; Rivet 1988: 273.

59 Janon et al. 2009 is now the essential study of the grand temple. See also Bellet 1991: 43–4; Gros and Torelli 1988: 279–80; Picard 1958.

60 Balty 1960: 9–62.

61 Kraay 1955: 75–87; Veyrac 1998.

62 Wilson Jones 2000: 66–8.

63 Gros 1996: 157–9 draws extended symbolic meaning from the acanthus frieze, which he believes would evoke the virtues of a Golden Age and the fecundity of renewed nature, all of which was guaranteed by the *pax Augusta* established by the Princeps. This seems something of an overstatement (see also Gros 2009).

64 Recent examples of this Augusto-centric view of the Maison Carrée include Ulrich 1994: 209–10; Gros 1996: 157–9; Knell 2004: 88–9; Ramage and Ramage 2005: 106; Kleiner 2007: 97–8; and especially Christol and Darde 2009.

65 Harstone 1995; see also Wilson Jones 2000: 66: "There is the further possibility that the project [i.e., the Maison Carrée] was conceived on a modular basis...."

66 Anderson 2001: 72–4, following Harstone 1995. For Hyginus, see Thulin (ed.), *Corpus Agrimensorum Romanorum* (Leipzig, 1913): 86 (P112v) and Dilke 1971: 73 and 82. For ground plans, see Amy and Gros 1979: II 32 and Wilson Jones 2000: 67. Balty 1960: 141–4 identifies the quarry at Lens as the source of the Maison Carrée's stone; for a comprehensive study of that quarry, see Bessac 1996. On preshaping and transport of marble architectural elements, see Ward-Perkins, "Materials, Quarries and Transportation" and "The Roman System in Operation," in Dodge and Ward-Perkins 1992: 13–22 and 23–30.

67 The idea that Gaius and/or Lucius visited Nîmes around this time, and that the temple was dedicated in their honor, seems unlikely even on the surface, and such a visit is no more specifically attested in our sources than is the often assumed visit there by Augustus in 16–15 BCE; such a visit is possible but not provable, and seems a flimsy justification for restoring either the original or an alteration to the dedicatory inscription of the temple.

68 Anderson 2001: 68–70 on the inscription, 74–5 on the stratigraphy. Amy and Gros 1979: I 177–95 on the inscriptional text, cf. Balty 1960: 150–77, who revised and accepted Espérandieu's Agrippan version. On the excavations, see Amy 1971 for the initial report; Amy and Gros 1979: I, 197–200 for a little more information; and Célié 1993 for the compressed chronology.

69 Anderson 2001: 76–7; see also Thomas 2007: 50. On Plotina, see Raepsaet-Charlier 1987: 631 and Boatwright 1991: 515. That Antoninus' grandfather was from Nîmes is shown by *CIL* VIII.8239. On deceptions perpetuated in Roman building inscriptions, see Thomas and Witschel 1992 and Fagan 1996.

70 Gros 1996: 159–60; Anderson 2001: 70–1; Rivet 1988: 305–9.

71 Only a drawing of the clamp holes was included, contrary to the practice adopted for the Orange arch and Maison Carrée inscriptions

72 Rémy 2004–5: vol. 5.1, no. 34 (pp. 104–6).

73 Rivet 1988: 309–10; Gros 1996: 160; Anderson 2001: 71.

74 This is suggested by Frakes 2009: 3

75 MacDonald 1982: 5

76 Frakes 2009: 20–2 provides a clear and interesting discussion of these points.

77 This becomes abundantly clear in the examples given by MacDonald 1982: 32–73 (on "connective architecture") and by Thomas 2007 in his wide-ranging selection of examples from Asia Minor, especially.

78 Frakes 2009: #028–32, pp. 161–74 (Glanum), and #026, pp. 156–58 (Entremont). All dates are those given by Frakes.

79 Frakes 2009: #019–20, pp. 142–6. On the Forum portico's remains, see Guild et al. 1980.

80 Frakes 2009: #021–25, pp. 146–56. Gros 1987: 339–63 and in Rothé and Heijmans 2008: 152–5 argues for a Tiberian date for the apsidal forum, but some doubt is implied in Heijmans 1999. On all these Arelatan fora, see Heijmans and Sintès 1994: 141–50.

81 Frakes 2009: #015–18, pp. 135–41.

82 Frakes 2009: #060–64, pp. 221–30.

83 Rosso 2006: no. 184 (pp. 409–12) for the probable Tiberius portrait, and no. 187 (pp. 413–16) for the heroic Claudius statue, both discovered in the theater, the former in 1858–9, and the latter in 1912–13.

84 Rosso 2006: no. 189 (pp. 416–19) and no. 190 (pp. 419–21) on the cuiassed statue that was found together with the portrait head of Domitian, which are joined in the museum at Vaison, a connection that Rosso sidesteps though admitting the proportions, breakage lines, etc. all support attributing the head to the body (p. 417); and no. 191 (pp. 421–3) on the Hadrian and no. 192 (pp. 423–5) on the Sabina statues, which occasion her no doubt whatsoever.

85 Frakes 2009: #065–68, pp. 231–8. Frakes appears to be following outdated information in #065 (the theater cavea's portico), especially Grenier 1958: 218–21.

86 Frakes 2009: #041–51, pp. 193–208, for catalog of the individual colonnades known from Vienne. On pp. 68–73, Frakes attempts to connect the porticoes of Vienne to its industry in ceramics.

87 Frakes 2009: pp. 46–9 provides an elegant description of the colonnaded Forum; see also #036, pp. 183–6; and for the Augusteum portico: #035, pp. 179–83. See also

Fiches and Veyrac 1996: 278–96 (Forum) and 241–68 (Augusteum). Important studies not included in Frakes include Ulrich 1994: 208–10; Anderson 2001; and Célié and Monteil 2009.

88 Roth-Congès 1992a; see also her earlier discussion of the pre-Roman town (Roth-Congès 1985), which anticipates a number of these conclusions. Heyn 2006: 183–9 follows and refines Roth-Congès.

89 Salviat 1990: 40–3; Roth-Congès 1992a: 355–61. On the terminological dispute, cf. Gros 1995: 328–9 and Roth-Congès 1997: 179–84; see further Hodge 1998: 274 and Heyn 2006: 184–6.

90 Salviat 1999: 39–40 provides the clearest description. See Balty 1962 on identification of the curia. For the doubtful dating of the Forum's Imperial reconstruction to the Flavians, see Chevallier, "La fonction politique et administrative II," in Bedon et al. 1988: 214–15.

91 On the Imperial Fora at Rome, see Anderson 1984; also Gros 1996: 216–20, and 220–9 on their influence on Roman cities outside Italy, and Wilson Jones 2000: esp. 21–3.

92 The most extensive treatment of the battered evidence from the forum at Arles is Gros 1987, who proposes radical rethinking of the dating and implications of the remains (in particular hypothesizing the *forum adiectum* and assigning it to Tiberius), sometimes following suggestions made by Gladiss 1972; see also Gros 2008: 40–50, esp. figs. 26 and 32, and 2009: esp. 113; the dating to Tiberius is open to question. For the more traditional view, see Grenier 1958: 291–308 and 321–2, who is followed by Rivet 1988: 193–4, and Bromwich 1996: 144–6. Perhaps most satisfactory of all is to accept Gros' suggestion of a *forum adiectum*, but to observe that its architectural form and placement both suggest Imperial forum architecture much more likely to date from the time of Trajan or later than that of Tiberius.

93 The evidence, such as it is, is neatly summarized in Darde and LaSalle 1993: 24–5. See also Célié et al. 1994: 389–91. On the likelihood of a public building behind the Maison Carrée and the archaeological evidence for it, see Célié and Monteil 2009: 164–5.

94 Célié and Monteil 2009: 162–4 on the topographical evolution of the forum area, and 165–6 on the Maison Carrée's relationship to it, as well as on the hypothetical chronology; assignment of this entire urban project to Augustus was previously asserted by Balty 1960: 120–9, and repeated by Ulrich 1994: 209–10, without considering the possibility of later contributions or reworkings.

95 Pasqualini et al. 2005–6.

96 By far the most important study of Narbonne is Gayraud 1981, in which the evidence for the forum is presented at 258–72. See also Gayraud 1975: 839–41 (Augustan forum) and 851–3 (later forum and fire).

97 Roth-Congès and André 1989 with reconstruction; this is followed by Gros 1996: 223. Praise for Vienne – as *urbs opulentissima* – can be found in Pomponius Mela (2.4.75), Martial (7.88: *pulchra Vienna*), and Plutarch (*Quaestiones Conviviales* 5.3.1), where it appears to have gained something of a reputation as a "party town."

98 The comprehensive and invaluable study of *macella* throughout the Roman world is De Ruyt 1983: 47 (Baeterrae), 73–5 (Genava), 106 (Lucus Augusti), 109 (Monetier), 114 (Narbo); see also Gros 1996: 450–66, esp. fig. 516 (comparative plans of *macella*), and Chevallier, "La fonction économique," in Bedon et al. 1988: 330–1, on the market at Nîmes.

99 This system continued to exist in Italy into the first part of the twentieth century CE: apartments were still often built without facilities for cooking, since those facilities would be available at the local bar or bakery. See Anderson 1997: 326–36 for a fuller treatment of *tabernae* and their importance to Roman daily life.

100 Chevallier, "La fonction économique," in Bedon et al. 1988: 331–3 provides an over-view of artisans' quarters.

101 Chevallier, "La fonction économique," in Bedon et al. 1988: 336; Goodman 2007: 114–15.

102 Chevallier, "La fonction économique," in Bedon et al. 1988: 336–7. Both Goodman 2007: 115–17 and Gros 1996: 472–3 analyze its original function as a *horreum* for grain storage, but do not treat the identification of its second phase as a shopping gallery, which is appealing but difficult to prove.

103 Solier 1973; Gayraud 1975: 841; Rivet 1987: 134; Chevallier, "La fonction économique," in Bedon et al. 1988: 321–3.

104 Gayraud 1975: 843–8; Chevallier, "La fonction économique," in Bedon et al. 1988: 313–16.

105 Essential now is Goudineau and Brentchaloff 2009, which is magisterial in its treat-ment of the evidence. See also Béraud et al. 1998: 52–62; Février 1977: 80–5, 113–14; Rivet 1988: 229.

106 An excellent overview is provided by Crema 1959: 75–89 and Gros 1996: 274–80. For greater detail, see Sear 2006: 1–10 (on the constituent parts of a theater), 24–37 (on theater design, relying primarily on Vitruvius, Book 5).

107 Gros 1996: 281–90 on the tradition and on early theaters in Roman Italy, and 294–8 on the Gallo-Roman theater and its lack of importance in Provence, where only one Gallo-Roman type theater has been discovered, at Albe (Alba Helviorum), and even it was converted into a typical Roman monument after its first building period: Sear 2006: 244 and Gros 1996: 296. Theaters were consistently located in the city center in Narbonese Gaul, not on the periphery (Goodman 2007: 140).

108 See the recent plans and photographs in Gros 2008: 61–3.

109 Sear 2006: 245–53 for a catalog of them all. On the theater at Aix, see Mocci and Nin 2006: 235–68; on the minimal remains at Fréjus, see Béraud et al. 1998: 35–8.

110 Sear 2006: 245–7.

111 Much of this evidence is summarized in Rivet 1988: 273 and acknowledged by Sear 2006: 245–7. The possibility of a Hadrianic date for the surviving theater is ignored by Gros 1996: 299. On the complex just west of the theater, see Janon et al. 2009.

112 Sear 2006: 247–8.

113 Sear 2006: 250–2. Further on the Imperial portrait statues, see Goudineau et al. 1999; also, and most important, Rosso 2006: nos. 187 (pp. 413–16), 189–90 (416–21), and 191–2 (421–5).

114 Sear 2006: 252–3. On later restoration and reworking, see Rivet 1988: 309.

115 Gros 1996: 308–16.

116 Sear 2006: 253; Rivet 1988: 309.

117 The debate over the earliest forms of the temporary amphitheater can be pursued in Welch 2007: 30–71 (who hypothesizes and argues strongly for the oval-shaped wooden structures) and in Golvin 1988: 15–23.

118 Welch 2007: 72–101; Golvin 1988: 24–5; Gros 1996: 320.

119 Welch 2007: 128–62; Gros 1996: 328–33.

120 Tuscan because they stand on bases, hence not Doric as often suggested. At Arles the order of the second story is Corinthian.

121 Goodman 2007: 143 provides a comprehensive list of amphitheaters in Narbonese Gaul. Golvin 1988: 184 summarizes the various arguments and asserts the slight-ly later date for Nîmes convincingly; the idea that its date might be early Trajanic was first proposed by Lugli 1964–5 and accepted by Ward-Perkins 1970: 233; it is now also accepted by Fraser 2006: 55; Fincker 1994; Gros 1996: 336–7 (again Gros 2008: 83–5); and Wilson Jones 2000: 13. Some prefer to make the two amphitheaters

Domitianic and contemporary with one another, ca. 90 CE; there seems no question that that date is correct for Arles, and Nîmes surely cannot be more than ten years later, so there is little significant conflict among any of these datings.

122 Wilson Jones 2000: 13 on the vaulting profile, which he assumes was "a mistake." See Étienne 1966: 990–2 and figs. 4 and 5 on the bulls' heads and the inscriptions. The Reburrus inscriptions are thoroughly treated by Donderer 1996: 217–19 (no. A 111). See also Fincker 1994: 201–3 and Veyrac 2006: 275–316 on the evidence for extraordinary hydraulic engineering within the Nemausan amphitheater.

123 Golvin 1988: 188–90; Gros 1996: fig. 393.

124 The most important study is Pasqualini et al. 2010, which must supersede all previous ones, and which – on the basis of ceramic chronologies as well as architectural and stratigraphic analysis – asserts a construction date for the Fréjus amphitheater in the first decades of the second century CE, thus rendering it a Trajanic or Hadrianic monument.

125 Golvin 1988: 162–3 and Gros 1996: 327 support a Julio-Claudian date for the remains, perhaps with subsequent reworking, accepted by Béraud et al. 1998: 38–41. Grenier 1958: 734–41 argued for a Hadrianic or later date; he was followed by Février 1977: 28 and by Rivet 1987: 228–9; this later dating has now been demonstrated to be correct by Pasqualini et al. 2010: esp. 158–60.

126 On the circus at Arles: Humphrey 1986: 390–8; Goodman 2007: 148; Grenier 1958: 983–7; Rivet 1988: 195.

127 Humphrey 1986: 401–7; Grenier 1958: 989–92; Pelletier 1982: 221–2; Bedon, "La fonction sociale," in Bedon et al.: 1988: 261–4; Goodman 2007: 148.

128 Roth-Congès 1994: 402; Gros 1996: 370–1 and 441; Bedon, "La fonction sociale," in Bedon et al. 1988: 269–70. Gans 1990: 93–125 suggests the Augustan date for the decorative scheme, but the use of the stone vault to cover the room does not agree with his suggestion; the far more satisfactory comparison to Baalbek and an Antonine date for the building are urged strongly by Thomas 2007: 50 and note 199 (p. 289).

129 Syntheses of the architectural history of Roman baths are provided by Nielsen 1990 and Yegül 1992. These are distilled by Gros 1996: 388–401. Also important are the three articles by Delaine (1989, 1992, 1993) as well as her study of the Baths of Caracalla (1997). The exhaustive catalog by Bouet 2003 is essential for baths in Narbonese Gaul.

130 Bouet 2003: II 107–13 (Fréjus), 236–9 (Glanum), 325–8 (Vaison); Nielsen 1990: I 66, II nos. 99 (Fréjus), 100 (Glanum), 101 (Vaison); Gros 1996: 396; Bedon, "L'eau dans les villes," in Bedon et al. 1988: 290–1; Goodman 2007: 125–8.

131 Béraud et al. 1991; Béraud et al. 1998: 46–51; Bouet 2003: II 101–3.

132 The essential publication is Benoit 1977: 55–94. See also Nielsen 1990: II nos. 68–70. Gros 1996: 406–7.

133 Benoit 1977: 40–4 and 153–62; Bedon, "L'eau dans les villes," in Bedon et al. 1988: 296.

134 Bouet 2003: II, 41–4; Grenier 1960: 256–61; Nielsen 1990: I, 70, II, no. 97.

135 Roth-Congès 1994; Gros 1996: 435.

136 The identification of the water sanctuary as an *Augusteum* was first advanced by Gros 1984, whose description I follow here (see also Gros 1996: 440–1) and has been generally accepted. The complex was first studied in detail by Naumann 1937; subsequent important treatments (in addition to Gros' essential work) include Hesberg 1981–2, Roth-Congès 1983b; Gans 1990; Bourgeois 1992: 175–217; Roth-Congès 1994: 402; Veyrac and Pène 1994–5; and Veyrac 2006: 47–100. Debate over the fragmentary remains of the entryway is surveyed by Gros 1983.

137 Varène 1987 makes a strong case for an intentional connection between the "Tour Magne" and the *Augusteum,* an idea first suggested by Gros 1984: 133.

138 Thomas 2007: 50 and note 199 (p. 289).

139 The following studies contribute specifically to the ongoing discussion of dating in the complex: Naumann 1937; Hesberg 1981; Gros 1983 and 1984; Roth-Congès 1983b and 1994; Gans 1990; Thomas 2007: 50. Reconstruction and redecoration over time would seem the best explanation for the inconsistencies.

140 The classic description of the Fréjus aqueduct is that of Donnadieu 1928: 175–82; for updated information (followed here) see De Madron 1999 and Gébara and Michel 2002. Further descriptions, maps, and photographs can be found in Février 1977: 8–9 and 118–24; Rivet 1988: 230 and pls. 45–47; Bromwich 1996: 264–7; Béraud et al. 1998: 62–8; Gros 2008: 78–9, fig. 62a, b.

141 Veyrac 2006: 127–36; Rivet 1988: 165–7; Bedon, "L'eau dans les villes," in Bedon et al. 1988: 283–4. On dating, see Février 1973: 26; Chevallier 1975: 748; Chevallier 1982: 61; Hauck 1989; Hodge 1995: 139. Knell 2004: 89–91 appears to be unaware of the difficulties with assigning an Agrippan/Augustan date. On the *castellum,* see Hauck and Novack 1988; Hodge 1995: 146–7; and especially Veyrac 2006: 161–94. On the Veranius inscription, see Donderer 1996: 302–3 (no. C 14).

142 Hodge 1995: 139–40 is especially good on the aesthetics that inform the Pont du Gard. See also Paillet 2005.

143 Leveau 1996: 138. See also Fleming 1983 and Hodge 1990. On the water system within Arles, see Rivet 1988: 196.

144 I follow Leveau 1996. Since that article appeared, see Leveau et al. 2000 and Leveau and Thernot 2005 for ongoing research at Barbégal.

145 McKay 1975: 159–64 attempted to classify houses in Glanum, Vaison, and Aix by category with little useful result. Hales 2003: 172–80 begins in the same way, but ends more profitably by discussing "the local nature of domestic architecture at Vasio." Chevallier, "La fonction residentielle," in Bedon et al. 1988: 338–62, pioneered the approach of discussing domestic architecture town by town, rather than type by type, with some success. Even better in applying the "local" approach to housing in Roman Provence is Gros 2001: 142–90.

146 Gallet de Santerre 1968; Gros 2001: 142–3; Chevallier, "La fonction residentielle," in Bedon et al. 1988: 339–41.

147 Bouiron 1996b; Chevallier, "La fonction residentielle," in Bedon et al. 1988: 343; Gros 2001: 144.

148 Roth-Congès 1985; Salviat 1990: 45–49; Bouiron 1996a; Gros 2001: 145–6.

149 Salviat 1990: 50–1; Gros 2001: 146.

150 Van de Voort 1992; Salviat 1990: 52–3; Gros 2001: 146, 147; Hales 2003: 175–6.

151 Salviat 1990: 45; Gros 2001: 146.

152 Sabrié and Sabrié 1987; Gros 2001: 150–2; Bouet 2003: II, 179–80.

153 The definitive study of the House of the Dauphin is Goudineau 1979. I follow his descriptions here, but in various conclusions I agree with Gros 2001: 156–9, and Hales 2003: 172–5.

154 Gros 2001: 159; Hales 2003: 177.

155 Hales 2003: 176–80; Gros 2001: 160–3.

156 The definitive publication about this complex is Desbat et al. 1994. For summaries, see Gros 2001: 162–3.

157 Brissaud et al. 1996; Gros 2001: 189–90.

158 Mignon 1996; Gros 2001: 186–7; Bouet 2003: II 189–92.

159 Guyon et al. 1996; Gros 2001: 188. On the Enclos Milhaud house: Bouet 2003: II 10–12.

160 The original excavation report is Joulin 1901; see also McKay 1975: 166–8 and Goodman 2007: 155. This villa can best be compared to the better-known example at Montmaurin, which is outside Gallia Narbonensis, but very similar in size, remains, and history (see Cleere 2001: 47–8, and Goodman 2007: 155–6).

161 Bellamy and Hitchner 1996.

162 A view of the cemetery was painted by Paul Gauguin (now in the Musée d'Orsay in Paris) in 1888, during the period when it was a popular "promenade" for citizens.

163 A good summary is provided by Goodman 2007: 150–3. On Arles: Rouquette and Sintès 1989: 82–4, 99, and Cleere 2001: 116–17 (also Cook 1905: 182–8 for a romantic description); see Euzennat and Hallier 1987 on the circus necropolis. On Nîmes: Sauron 1983; on Narbonne: Janon 1986 and Joulia 1988.

164 The essential study of this material is Joulia 1988; see also Gros 2001: 395.

165 Gros 2001: 399 on the terminological problems.

166 Rolland 1969: 65–9 on the history of restorations of the inscription. Gros 1986a offers the Caesarean hypothesis; Roth-Congès 2009 argues for the triumviral dating. Over a century ago, the inscription was denounced as a fake that had been added onto an already standing cenotaph, by Cook 1905: 53–6, who was determined to attribute the monument to the time of Marius, all evidence to the contrary notwithstanding (he simply ignored it). Doubts about the reliability of the extensive restoration of the monument ca. 1811 must be acknowledged, too (cf. Rolland 1969: 21–34).

167 All measurements are taken from Rolland 1969: pl. 7.

168 Woodruff 1977: 40; Picard 1964: 8; Chevallier, "L'environnement urbain," in Bedon et al. 1988: 380.

169 Woodruff 1977: 60; Picard 1964: 8; Chevallier, "L'environnement urbain," in Bedon et al. 1988: 380.

170 Kleiner 1980: 114–17; Woodruff 1977: 28;

171 Woodruff 1977: 93; Picard 1964: 15; Chevallier, "L'environnement urbain," in Bedon et al. 1988: 380.

172 Rolland 1969: 47–64 and pls. 39–48. The technical resemblance between these panels and Severan relief carving is emphasized by Picard 1961, who is followed by Brilliant 1967: 31–4 and Ridgway 1982: 102–3. For comparison to the Orange attic reliefs, see Anderson 1987: 186–9.

173 See Kleiner 1977: 675–88 and Kleiner 1980: esp. 110. The popular, but unprovable, hypothesis of a late first century BCE date for the monument has been accepted all too often as fact in the scholarly literature, most recently by Heyn 2006: 193–4.

174 Rolland 1969: 29–37; Gros 2001: 412.

175 On Beaucaire: Roth-Congès 1987; on Orange: Mignon 2000; cf. Gros 2001: 413–14.

BIBLIOGRAPHY

Abbreviations are those employed by the *American Journal of Archaeology,* as listed at http://www.ajaonline.org.

Adam, J.-P. 1984. *La construction romaine: matériaux et techniques.* Paris: ÉditionsPicard. Translated into English as *Roman Building: Materials and Techniques* by A. Mathews. Indianapolis: Indiana University Press, 1994.

Agulhon, M. and N. Coulet. 1987. *Histoire de la Provence.* Paris: Presses universitaires de France.

Agusta-Boularot, S., M. Christol, M. Gazenbeek, Y. Marcadal, V. Mathieu, A. Rapin, J.-L. Paillet, A. Roth-Congés, J. C. Sourisseau, and H. Tréziny. 2004. "Dix ans de fouilles et recherches à Glanum (Saint-Rémy-de-Provence): 1992–2002," *JRA* 17: 27–56.

Agusta-Boularot, S., G. Fabre, and A. Badie. 2005–6. "Les installations hydrauliques antiques de Château-Bas, à Vernégues," *RANarb* 38–9: 201–24.

Agusta-Boularot, S., A. Badie, and M.-L. Laharie. 2009a. "Le sanctuaire augustéen de Vernégues (Bouches-du-Rhône): Étude architecturale, antecedents et transformations," in Christol and Darde 2009: 131–58.

Agusta-Boularot, S., A. Badie, and M-L. Laharie. 2009b. "Ordre et chapiteaux du temple de Chateau-Bas à Vernégues," in Gaggadis-Robin et al., 2009: 71–86.

Aillagon, J.-J. (ed.). 2008. *Rome and the Barbarians: The Birth of a New World.* Milan: Skira.

Aillaud, L. 1923. *Chronique du vieux Nîmes.* Nîmes: Fabre éditeur.

Ambard, R., G. Bertucchi, and J. Gassend. 1972. "Fouilles d'urgence et découverte du decumanus à Aix-en-Provence," *RANarb* 5: 31–48.

Ambard, R. 1984. *Aix romaine: nouvelles observations sur la topographie d'Aquae Sextiae.* Aix-en-Provence: Association archéoloqique Entremont.

Amy, R. 1968. "Découverte d'une portion de voie romaine à Aix-en-Provence," *RANarb* 1: 251–6.

1971. "Circonscription de Languedoc-Rousillon: Nîmes," *Gallia* 29: 397.

1973. "Les cryptoportiques d'Arles," in Étienne 1973: 275–91.

1976. "Arles," in Stilwell 1976: 87.

Amy, R., P. Duval, J. Formigé, J.-J. Hatt, A. Piganiol, and G.-Ch. Picard. 1962. *L'Arc d'Orange*. 2 vols. Paris: *Gallia* Suppl., vol. 15 (Éditions du CNRS).

Amy, R., and P. Gros 1979. *La Maison Carrée de Nîmes*. 2 vols. Paris: *Gallia* Suppl., vol. 38 (Éditions du CNRS).

Anderson, J. 1984. *Historical Topography of the Imperial Fora at Rome*. Brussels: Collection Latomus, vol. 182.

1987. "The Date of the Arch at Orange," *BJb* 187: 159–92.

1997. *Roman Architecture and Society*. Baltimore and London: Johns Hopkins University Press.

2001. "Anachronism in the Roman Architecture of Gaul: The Date of the Maison Carrée at Nîmes," *JSAH* 60: 68–79.

Forthcoming "Architect and Patron," in C. Quenemoen and R. Ulrich (eds.), *A Companion to Roman Architecture* (Oxford: Blackwell Publishing).

Arcelin, P. 1975. "Les sépultures préromains de Saint-Rémy-de-Provence." *RANarb* 8: 67–135.

1992. "Société indigene et propositions culturelles massaliotes en basse Provence occidentale," in Bats et al. 1992: 305–36.

Arcelin, P., and A. Cayot. 1984. "Réflexions sur l'abandon de l'agglomération hellénistique de Saint-Blaise," *RANarb* 17: 53–70.

Assénat, M. 1994–5. "Le cadastre colonial d'Orange," *RANarb* 27–8: 43–56.

2006. *Cadastres et romanisation dans la cité antique de Nîmes*. Montpellier: *RANarb* Suppl., vol. 36.

Badian, E. 1966. "Notes on Provincia Gallia in the Late Republic," in Chevallier 1966: 901–18.

Balty, J. 1960. *Études sur la Maison Carrée de Nîmes*. Brussels: Collection Latomus, vol. 47.

1962. "Basilique et curie du forum de Glanum: note sur le centre monumental de la ville augustéenne," *Latomus* 21: 279–319.

1991. *Curia ordinis: recherches d'architecture et d'urbanisme antiques sur les curies provinciales du monde romain*. Brussels: Mémoires de la classe des beaux-arts, Académie des sciences, des lettres et des beaux-arts de Belgique, ser. 2, vol. 15, no. 2.

Barruol, G. 1963a. "Le monument funéraire de Villelongue d'Aude," *Cahiers ligures de Préhistoire et archéologie* 12: 88–102.

1963b. "Le pont romain de Ganagobie," *Gallia* 21: 314–24.

1968. "Essai sur la topographie d'Apta Julia," *RANarb* 1: 101–58.

Barruol, G., and J. Gascou. 1982. "Nouvelles inscriptions exhumés d'une enceinte du Bas-Empire à Nîmes," *RANarb* 15: 273–309.

Barruol, G., and R. Marichal. 1987. "Le forum de Ruscino," in Gasco 1987: 45–54.

Barton, I. (ed.). 1995. *Roman Public Buildings*, 2nd edition. Exeter: University of Exeter Press.

Bats, M. 1992. "Marseille, les colonies massaliètes et les relais indigènes dans le traffic le long du littoral méditerranéen gaulois (VI–I s. av. J.-C.)," in Bats et al. 1992: 263–78.

Bats, M., G. Bertucchi, G. Congès, and H. Treziny (eds.). 1992. *Marseille grecque et la Gaule*. Collection Études Massaliètes 3. Lattes: Éditions ADAM and Aix: Université de Provence (Service des publications).

Bazin, H. 1891. *Nîmes Gallo-Romain*. Nîmes: Imprimerie Henry Michel.

Beck, F., and H. Chew. 1989. *Quand les Gaulois étaient romains*. Paris: Gallimard, Réunion des Musées nationaux.

Bedon, R. 1984. *Les carrières et les carriers de la Gaule romaine*. Paris: Éditions Picard.

Bedon, R. (ed.). 1998. *Suburbia: Les Faubourgs en Gaule romaine et dans les regions voisines*. Limoges: Collection Caesarodunum, vol. 22.

Bedon, R. 2001. *Atlas des villes, bourgs, villages de France au passé romain*. Paris: Éditions Picard.

Bedon, R., R. Chevallier, and P. Pinon. 1988. *Architecture et urbanisme en Gaule romaine, vol 1: L'Architecture et la ville; vol. 2: l'urbanisme*. Paris: Éditions Errance.

Bellamy, P., and R. Hitchner. 1996. "The villas of the Vallé des Baux and the Barbegal Mill: excavations at La Mérindole villa and cemetery," *JRA* 9: 137–53.

Bellet, M.-E. 1991. *Guides archéologiques de la France: Orange antique*. Paris: Éditions imprimerie national.

Bellet, M.-E., C. Boccacino, P. Borgard, J. Bouillot, P. Bretagne, and A. Barbet. 1990. "Nouvelles observations sur l'habitat gallo-romain à Vaison-la-Romaine. La Vilasse Nord. Peintures. Colline de Puymin," *RANarb* 23: 71–116.

Benedict, H. 1942. "The Romans in southern Gaul," *AJP* 63: 38–50.

Benoit, F. 1954. "Recherches archéologiques dans la region d'Aix-en-Provence," *Gallia* 12: 285–300.

—— 1968. "Résultats historiques des fouilles d'Entremont (1946–1967)," *Gallia* 26: 1–31.

—— 1972. "L'évolution topographique de Marseille. Le port et l'enceinte à la lumière des fouilles," *Latomus* 31: 50–70.

—— 1977. *Cimiez, la ville antique: fouilles de Cemenelum I*. Paris: Éditions de Boccard.

Bérard, G., and G. Barruol (eds.). 1997. *Carte archéologique de la Gaule 4: Alpes-de-Haute-Provence*. Paris: Académie des inscriptions et belles-lettres FMSH.

Bérard, G., B. De Luca, C. Landuré, and A. Nicolaides. 1994. "Les maisons antiques de la rue Magnans à Aix-en-Provence," *Gallia* 51: 191–201.

Béraud, I., C. Gébara, and C. Landuré. 1991. "Les fouilles de la Porte d'Orée: transformations et avatars d'un secteur portuaire à Fréjus," *Gallia* 48: 165–228.

Béraud, I., C. Gébara, and L. Rivet. 1998. *Guides archéologiques de la France: Fréjus antique*. Paris: Éditions de l'imprimerie nationale.

Bessac, J.-Cl. 1996. *La pierre en Gaule narbonnaise et les carrières du Bois de Lens (Nîmes): histoire, archéologie, ethnographie et techniques*. Ann Arbor, Mich.: *JRA* Suppl., vol. 16.

Bessac, J.-Cl., and Vacca-Goutoulli, M. 2002. "La carrière romaine de L'Estel près du Pont du Gard," *Gallia* 59: 1–204.

Bessac, J.-Cl., M. Fincker, P. Garmy, and J. Pey. 1984. "Recherches sur les fondations de l'amphithéâtre de Nîmes," *RANarb* 17: 223–38.

Binninger, S. 2009. "Le décor figurative du Tropaeum Alpium: des fragments aux ateliers," in Gaggdis-Robin et al., 2009: 135–49.

Blagg, T. 1981. "Architectural patronage in the western provinces of the Roman Empire in the third century," in A. King and M. Henig (eds.), *The Roman West in the Third Century* (Oxford: BAR, IS109): 167–88.

Blagg, T., and M. Millett (eds.). 1990. *The Early Roman Empire in the West*. Oxford: Oxbow Books.

Boatwright, M. T. 1991. "The Imperial Women of the Second Century A.C.," *AJP* 112: 513–40.

—— 2000. *Hadrian and the Cities of the Roman Empire*. Princeton, N.J.: Princeton University Press.

Bogard, P. (ed.). 1996. *La maison urbaine d'époque romain: atlas des maisons de Gaule Narbonnaise*. 2 vols. Avignon: Conseil general de Vaucluse, Service d'archéologie.

Bouet, A. 1998a. "Complexes sportifs et centres monumentaux en occident romain: les exemples d'Orange et Vienne," *RA* n.s. 1: 33–105.

—— 1998b. "Un nouvel exemple de *campus* en Gaule Narbonnaise: Vaison-la-Romaine (Vaucluse)," *RANarb* 31: 103–18.

Bouet, A. 2003. *Les thermes privés et publics en Gaule Narbonnaise*. Rome: Collection de l'École Française de Rome, vol. 320.

Bouiron, M. 1996a. "Glanum, Bouches-du-Rhône," in Bogard 1996: 279–323.
 1996b. "Olbia-de-Provence," in Bogard 1996: 135–45.

Boulanger, A. 1929. *Cicéron: Discours*, vol. 7: *Pour M. Fonteius*. Association G. Budé. Paris: Éditions Les Belles Lettres.

Bourgeois, C. 1992. *Divona II: monuments et sanctuaires du culte gallo-romain de l'eau*. Paris: Éditions de Boccard.

Bradley, K. 2004. "On captives under the Principate," *Phoenix* 58: 298–318.

Brenot, Cl. 1989. "La 'drachme' de Glanum," *DossPar* 140: 71–80.

Brilliant, R. 1967. *The Arch of Septimius Severus in the Roman Forum*. Rome: Memoirs of the American Academy in Rome, vol. 29.

Brissaud, L., E. Delaval, A. Le Bot-Helly, and J.-L. Prisset. 1996. "Vienne," in Bogard 1996: 347–60.

Bromwich, J. 1996. *The Roman Remains of Southern France: A Guidebook*, 2nd edition. London: Routledge.

Brun, J.-P., and M. Borréani (eds.). 1999. *Carte archéologique de la Gaule 83/1–2: Var*. Paris: Académie des inscriptions et belles-lettres FMSH.

Burnand, Y. 1975. *Domitii Aquenses: une famille de chevaliers romains de la region d'Aix-en-Provence. Mausolée et domaine*. Paris: *RANarb* Suppl., vol. 5.
 1994. "Remarques sur quelques problèmes institutionnels du *pagus* et du *vicus* en Narbonnaise et dans les Trois Gaules," *Latomus* 53: 733–47.

Burns, A. 1976. "Hippodamus and the Planned City," *Historia* 25: 414–28.

Campbell, J. 2000. *The Writings of the Roman Land Surveyors*. London: JRS Monographs no. 9, Society for the Promotion of Roman Studies.

Célié, M. 1993. *Urbanisme et topographie du quartier de la Maison Carrée à Nîmes dans l'antiquité*. Aix-en-Provence: L'Université de Provence, mémoire de DEA, Histoire de l'art.

Célié, M., P. Garmy, and M. Monteil. 1994. "Enceintes et développement urbain: Nîmes antique des origines au Ier s. apr. J.-C.," *JRA* 7: 383–96.

Célié, M., and M. Monteil. 2009. "L'apport de l'archéologie preventive à la connaissance du Forum de Nîmes (Gard)," in Christol and Darde 2009: 159–68.

Chapon, P., J. Bussière, L. Delattre, M. Feugère, A. Richter, A. Roth-Congés, and I. Villemeur. 2004. "Les nécropoles de Vernègues (B.-du-Rh.). Deux ensembles funéraires du Haut-Empire," *RANarb* 37: 109–209.

Chatelain, L. 1908. *Les monuments romains d'Orange*. Paris: Librairie H. Champion.

Chevallier, R. (ed.). 1966. *Mélanges d'archéologie et d'histoire offerts à André Piganiol*. Paris: S.E.V.P.E.N.

Chevallier, R. 1975. "Gallia Narbonensis: bilan de 25 ans de recherches historiques et archéologiques," *ANRW* 2(3): 686–828.
 1976. *Roman Roads*. Translated by N. H. Fields. London: Batsford.
 1982. *Provincia: villes et monuments de la province romaine de Narbonnaise*. Paris: Éditions les Belles-Lettres.

Chouquer, G. 1993. "Répertoire topo-bibliographique des centuriations de Narbonnaise," *RANarb* 26: 87–98.

Chouquer, G., F. Favory, and A. Roth-Congés. 2001. *L'Arpentage Romain*. Paris: Éditions Errance.

Christol, M., and D. Darde (eds.). 2009. *L'Expression du pouvoir au début de l'empire:autour de la Maison Carrée à Nîmes*. Paris: Éditions Errance.

Christol, M., and M. Janon. 2000. "Le statut de Glanum à l'époque romaine," *RANarb* 33: 47–54.

Clavel-Lévêque, M. 1977. *Marseille grecque: la dynamique d'un impérialisme marchand.* Marseille: Éditions Lafitte.

Clavel-Lévêque, M., and P. Lévéque. 1982. "Impérialisme et sémiologie: l'espace urbain de Glanum," *MEFR* 94: 673–98.

Clébert, J.-P. 1970. *Provence antique,* vol. 1: *Des origines à la conquête romaine,* vol 2: *L'époque gallo-romaine.* Paris: Éditions Robert Laffont.

Cleere, H. 2001. *Oxford Archaeological Guides: Southern France.* Oxford: Oxford University Press.

Clément, P.-A., and A. Peyre. 1998. *La voie Domitienne: de la Via Domitia aux routes de l'an 2000,* 2nd edition. Montpellier: Presses du Languedoc.

Clemente, G. 1974. *I Romani nella Gallia meridionale.* Bologna: Patron Editore.

Collins, R. 1998. *Oxford Archaeological Guides: Spain.* Oxford: Oxford University Press.

Colonna d'Istria, R. 2000. *Histoire de la Provence.* Paris: France-Empire.

Cook, T. A. 1905. *Old Provence.* New York: C. Scribner's Sons. Reprint: Northampton, Mass.: Interlink Books, 2001.

Coutelas, A., and M. Heijmans. 2005–6. "Les mortiers de construction de la ville d'Arles au Haut Empire," *RANarb* 38–9: 403–10.

Crema, L. 1959. *L'architettura romana.* Enciclopedia classica III. 12. 1. Torino: Soc. Editrice Internazionale.

Darde, D., and V. Lasalle. 1993. *Guides archéologiques de la France: Nîmes Antique.* Paris: Éditions de l'imprimerie national.

De Filippo, R. 2001. "Tolosa: la ville et son forum," in J.-M. Pailler (ed.), *Tolosa: nouvelles recherches sur Toulouse et son territoire. CEFR* 281: 205–32.

Delaine, J. 1989. "Some suggestions on the transition from Greek to Roman baths in Hellenistic Italy," *MeditArch* 2: 111–15.

___ 1992. "New models, old modes: continuity and change in the design of public baths," in Schalles et al. 1992: 257–75.

___ 1993. "Roman baths and bathing," *JRA* 6: 348–58.

___ 1997. *The Baths of Caracalla.* Portsmouth, R.I.: *JRA* Suppl., vol. 25.

___ 2008. "Between concept and reality: case studies in the development of Roman cities in the Mediterranean," in J. Marcus and J. Sabloff (eds.), *The Ancient City: Perspectives on Urbanism in the Old and New World* (Santa Fe, N.M.: School for Advanced Research Press): 95–116.

Dellong, E., D. Moulis, and J. Farré (eds). 2003. *Carte archéologique de la Gaule 6: Narbonne et le narbonnais.* Paris: Académie des inscriptions et belles-lettres FMSH.

De Madron, R. 1999. *L'aqueduc romain de Mons à Fréjus.* Mane: L'Envol.

De Michèle, P. 2003. "Découvertes récentes sur le théatre antique d'Apt (Vaucluse)," *RANarb* 36: 199–229.

De Ruyt, C. 1983. *Macellum: marché alimentaire des Romains.* Louvain: Publications de l'Art et d'Archéologie de l'Université Catholique de Louvain, vol. 35.

Desbat, A., O. Leblanc, J. Prisset, H. Savay-Guerraz, and D. Tavernier. 1994. *La Maison des Dieux Océan à Saint-Romain-en-Gal.* Paris: *Gallia* Suppl., vol. 55.

Dilke O. 1971. *The Roman Land Surveyors: An Introduction to the Agrimensores.* Newton Abbot: David & Charles.

Dodge, H., and B. Ward-Perkins (eds.). 1992. *Marble in Antiquity: Collected Papers of J. B. Ward-Perkins.* London: Archaeological Monographs of the British School at Rome, vol. 6.

Donderer, M. 1996. *Die Architekten der späten römischen Republik und der Kaiserzeit: Epigraphische Zeugnisse.* Erlangen: Erlanger Forschungen Reihe A, Geisteswissenschaften Band 69.

Donnadieu, A. 1928. *La Pompéi de Provence: Fréjus*. Paris: H. Champion.

Downing, C. 2010. "Review of *La Gaule narbonnaise* by Pierre Gros (Paris 2008)," AJA Online Publications: Book Review, vol. 114.1.

Drinkwater, J. 1978. "The Rise and Fall of the Gallic Julii," *Latomus* 37: 817–50.

———. 1983. *Roman Gaul: The Three Provinces, 58 BC–AD 260*. Ithaca, N.Y.: Cornell University Press.

———. 1990. "For Better or Worse? Towards an Assessment of the Economic and Social Consquences of the Roman Conquest of Gaul," in Blagg and Millett 1990: 210–19.

Duncan-Jones, R. 1985. "Who paid for public buildings in Roman cities?" in F. Grew and Hobley (eds.), *Roman Urban Topography in Britain and the Western Empire* (London: Council for British Archaeology).

Durrell, L. 1990. *Caesar's Vast Ghost: Aspects of Provence*. London: Faber and Faber.

Duval, P.-M. 1968. "Le milliaire de Domitien et l'organisation de la Narbonnaise," *RANarb* 1: 3–6.

Dyson, S. 1985. *The Creation of the Roman Frontier*. Princeton, N. J.: Princeton University Press.

Ebel, C. 1976. *Transalpine Gaul: The Emergence of a Roman Province*. Leiden: E. J. Brill.

———. 1988. "Southern Gaul in the triumviral period: a critical stage of Romanization," *AJP* 109: 572–90.

Étienne, R. 1966. "La date de l'amphithéâtre de Nîmes," in Chevallier 1966: 985–1010.

Étienne, R. (ed.) 1973. *Les cryptoportiques dans l'architecture Romaine*. Rome: Collection de l'École française de Rome, vol. 14.

Euzennat, M. 1980. "Ancient Marseille in the light of recent excavations," *AJA* 84: 133–40.

Euzennat, M., and G. Hallier. 1987. "La nécropole du cirque," *Revue d'Arles* 1: 112–17.

Euzennat, M., and F. Salviat. 1969. *Les découvertes archéologiques de la bourse à Marseille*. Marseille: Éditions Lafitte.

Fabre, G., J-L. Fiches, and J.-L. Paillet (eds.). 1992. *L'aqueduc de Nîmes et le Pont du Gard: archéologie, géosystème et histoire*. Nîmes: Conseil general du Gard.

Fabre, G., J.-L. Fiches, and P. Leveau. 2005. "Recherches récentes sur les aqueducs romains de Gaule méditerranéenne," *Gallia* 62: 5–12.

Fagan, G. 1996. "The reliability of Roman rebuilding inscriptions," *PBSR* 64: 81–94.

Fauré-Brac, O. (ed.). 2006. *Carte archéologique de la Gaule 69/1: Rhône*. Paris: Académie des inscriptions et belles-lettres FMSH.

Ferris, I. 2000. *Enemies of Rome: Barbarians through Roman Eyes*. Stroud: Sutton.

Février, P.-A. 1964. *Le développement urbain en Provence*. Paris: BEFAR, vol. 202.

———. 1973. "The origins and growth of the cities of Southern Gaul," *JRS* 63: 1–28.

———. 1977. *Fréjus (Forum Iulii) et la basse vallée de l'Argens*, 2nd edition. Cuneo: Institut international d'études ligures.

———. 1989. *Provence des origines à l'an mil: histoire et archéologie*. Rennes: Éditions Ouest-France.

Fiches, J.-L. 1993. "Critères de datation et chronologie des limitations romaines en Narbonnaise," *RANarb* 26: 99–104.

———. 1996. "Les cadastres romaines en Gaule du Sud," *JRA* 9: 447–53.

Fiches, J.-L., and A. Veyrac (eds.). 1996. *Carte archéologique de la Gaule 30/1: Nîmes*. Paris: Académie des Inscriptions et Belles-Lettres FMSH.

Fincker, M. 1986. "Technique de construction romaine: la pince à crochet, un système original de mise en oeuvre des blocs de grand appareil," *RANarb* 19: 331–6.

———. 1994. "L'amphithéatre de Nîmes," *Pallas* 40: 186–207.

Fleming, S. 1983. "Gallic waterpower: the mills of Barbegal," *Archaeology* 36: 68–77.

Florescu, F.B. 1961. *Monumentul de la Adamclisi* 2nd edition. Bucharest: EARSR.

Formigé, J. 1949. *La Trophée des Alpes (La Turbie)*. Paris: *Gallia* Suppl., vol. 2 (Éditions du CNRS).

1964. "L'amphithéâtre d'Arles: description," *RA* 1964: 113–63.

1965. "L'amphithéâtre d'Arles: l'attribution des places," *RA* 1965: 1–46.

Fornasier, B. 1994. "Les arcs de triomphe d'Arles," *Histoire de l'art* 27: 19–29.

2003. *Les fragments architecturaux des arcs tromphaux en Gaule romaine*. Annales littéraires de l'Université de Franche-Comté, vol. 746 (série "Art et Archéologie," no. 46), Paris: Les Belles Lettres.

Fournier, P., and M. Gazenbeek. 1999. "L'agglomération antique de Chateau-Bas à Vernègues," *RANarb* 32: 179–96.

Frakes, J. F. D. 2009. *Framing Public Life: The Portico in Roman Gaul*. Vienna: Phoibos Verlag.

Forthcoming."The Forum Complex" In C. Quenemoen and R. Ulrich (eds.), *A Companion to Roman Architecture* (Oxford: Blackwell Publishing).

Fraser, T. 2006. *Hadrian as Builder and Benefactor in the Western Provinces*. BAR International Series 1484. Oxford: Archaeopress.

Freeman, P. 1993. "Romanisation and Roman material culture," *JRA* 6: 438–45.

Freyberger, B. 1999. *Südgallien im 1. Jahrhundert v. Chr. Phasen, Konsequenzen und Grenzen Römischer Eroberung (125–7/22 v. Chr.)*. Geographica Historica, Band 11. Stuttgart: Franz Steiner Verlag GMBH.

Gaggadis-Robin, V., A. Hermany, M. Reddé, and C. Sintes (eds.). 2009. *Les ateliers de sculpture régionaux: techniques, styles et iconographie*. Actes du Xe Colloque International sur l'art provincial romain (Arles et Aix-en-Provence, 21–3 Mai 2007). Arles: Musée départemental Arles Antique and Aix-en-Provence: Centre Camille Julliam (CNRS).

Gallet de Santerre, H. 1962. "Ensérune, an oppidum in Southern France," *Archaeology* 15: 163–71.

1968. "Fouilles dans le quartier ouest d'Ensérune," *RANarb* 1: 38–83.

Gans, U. 1990. "Der Quellbezirk von Nîmes: Zur Datierung und zum Stil seiner Bauten," *RM* 97: 93–125.

2003. "Zur Datierung und Aussage augusteischer Siegesdenkmäler im gallischen und iberischen Raum," in P. Noelke (ed.), *Romanisation und Resistenz (*Mainz: Verlag Philipp von Zabern): 149–58.

Gantès, L.-F. 1992. "La topographie de Marseille grecque," in Bats et al. 1992: 71–88.

Garrett, M. 2006. *Provence: A Cultural History*. Oxford and New York: Oxford University Press.

Gasco, C. (ed.). 1987. *Los Foros Romanos de la Provincias Occidentales*. Madrid: Ministerio de Cultura.

Gascou, J. 1982. "Quand la colonie de Fréjus fut-elle fondée?" *Latomus* 41: 132–45.

Gascou, J., and M. Janon (eds). 1985–1997. *Inscriptions Latines de Narbonnaise (I. L. N.)*. Paris: *Gallia* Suppl., vol. 44 (Éditions du CNRS): vols. 1 (Fréjus), 2 (Vienne), 3 (Aix-en-Provence), 4 (Apt).

Gayraud, M. 1975. "Narbonne aux trois premiers siècles après Jésus-Christ," *ANRW* 2(3): 829–59.

1981. Narbonne antique, des origines à la fin du IIIeme siècle. Paris: RANarb Suppl., vol. 8.

Gayraud, M., and Y. Solier. 1976. "Narbo Martius," in Stilwell 1976: 607.

Gazenbeek, M. 1998. "Prospections systématiques autour de Glanum (Bouches-du-Rhône): l'extension de l'agglomération," in Bedon. 1998: 83–104.

2000. "Interaction entre aqueduct et habitat rural: deux cas d'étude en France méditerranéenne: Nîmes et Arles," in Jansen. 2000: 225–30.

Gébara, C., and I. Béraud. 1990. "Les thermes du port à Fréjus," *RANarb* 23: 1–12.

Gébara, C., and J.-M. Michel. 2002. *L'aqueduc romain de Fréjus*. Paris: *RANarb* Suppl., vol. 33.

Gébara, C., and C. Morhange. 2010. *Fréjus (Forum Julii): le port antique/The Ancient Harbour*. Portsmouth, R.I.: *JRA* Suppl., vol. 77.

Genty, P., and J.-C. Roux. 1982. "Recherches sur l'urbanisme romain à Nîmes. Rempart, voie et habitat de la clinique Saint-Joseph," *RANarb* 15: 187–222.

Giacobbi-Lequément, M.-F. 1993. "Cinq inscriptions imperials de Glanum," *Latomus* 52: 281–93.

Giacobbi-Lequément, M.-F. 1994–95. "À propos de *Glanum, oppidum Latinum*," *RANarb* 27–28: 293–8.

Giacobbi-Lequément, M.-F., N. Lambert, and A. Roth-Congès. 1989. "Glanum: cité grecque et romaine de Provence: le centre monumental gallo-grec," *DossPar* 140: 16–23.

Gladiss, A. von. 1972. "Der 'Arc du Rhône' in Arles," *RM* 79: 17–87.

Golvin, J.-C. 1988. *L'amphithéâtre romain: essai sur la theorization de sa forme et ses fonctions*. 2 vols. Paris: De Boccard.

Goodman, P. 2007. *The Roman City and Its Periphery from Rome to Gaul*. London and New York: Routledge.

Gorman, V. 1995. "Aristotle's Hippodamos (Politics 2, 1267b22–30)," *Historia* 44: 385–95.

Goudineau, Ch. 1976a. "Arausio," in Stilwell 1976: 83–4.

　　1976b. "Glanum," in Stilwell 1976: 356.

　　1976c. "Vasio Vocontiorum," in Stilwell 1976: 955–7.

　　1979. *Les fouilles de la Maison au Dauphin à Vaison-la-Romaine*. Paris: *Gallia* Suppl., vol. 37 (Éditions du CNRS).

　　1983. "Marseilles, Rome and Gaul from the third to the first century BC," in P. Garnsey, K. Hopkins, and C. Whitaker (eds.), *Trade in the Ancient Economy* (Berkeley: University of California Press, 1983): 76–86.

Goudineau, Ch., Y. de Kisch, and J.-P. Adam. 1999. *Guides archéologiques de la France: Vaison-la-romaine*. Paris: Éditions de l'imprimerie national.

Goudineau, Ch., and D. Brentchaloff. 2009. *Le Camp de la Flotte d'Agrippa à Fréjus: les fouilles du quartier de Villeneuve*. Paris: Éditions Errance.

Greco, E., and M. Torelli. 1983. *Storia dell'urbanistica: il mondo greco*. Rome: Laterza.

Grenier, A. 1958. *Manuel d'archéologie gallo-romaine, III (Capitole – forum – temple – basilique – théâtres – amphithéâtres – cirques)*. Paris: Éditions A. Picard.

　　1960. *Manuel d'archéologie gallo romaine, IV (Aqueducs – thermes – villes d'eau – sanctuaires d'eau)*. Paris: Éditions A. Picard.

Gros, P. 1973. "Traditions hellénistiques d'Orient dans le décor architectonique des temples romains de Gaule Narbonnaise," *MemLinc* 158: 167–80.

　　1974. "Hellenisme et romanisation en Gaule Narbonnaise," in P. Zanker (ed.), *Hellenismus in Mittelitalien* (Göttingen: Vandenhoeck & Ruprecht): 300–14.

　　1976. "Nemausus," in Stilwell 1976: 616–17.

　　1979. "Pour une chronologie des arcs de triomphe de Gaule narbonnaise," *Gallia* 37: 55–83.

　　1981a. "Les temples géminés de Glanum," *RANarb* 14: 125–58.

　　1981b. "Note sur deux reliefs des "Antiques" de Glanum: le problème de la romanisation," *RANarb* 14: 159–72.

　　1983. "Le sanctuaire des eaux à Nîmes II. Le 'temple' du Sud," *RACentre* 22: 163–75.

　　1984. "L'Augusteum de Nîmes," *RANarb* 17: 123–34.

　　1986a. "Le mausolée des Julii et le statut de Glanum," *RA* 1986: 65–80.

　　1986b. "Une hypothèse sur l'arc d'Orange," *Gallia* 44: 198–201.

1987. "Un programme augustéen: le centre monumental de la colonie d'Arles," *JdI* 102: 339–63.

1989. "Les Antiques ou les limites de la romanisation," *DossPar* 140: 40–5.

1990. "Les siècles hellénistiques en Gaule transalpine: le problème des relais culturels et politiques," *Akten des XIII. Internazionalen Kongresses für Klassische Archäologie, Berlin, 1988* (Mainz: Verlag P. von Zabern, 1990): 101–11.

1991. "Nouveau paysage urbain et cultes dynastiques: remarques sur l'idéologie et de la ville augustéenne à partir des centres monumentaux d'Athènes, Thasos, Arles et Nîmes," in C. Goudineau and A. Rebourg (eds.), *Actes du colloque "Les villes augustéennes de Gaule" (Autun 1985)* (Autun 1991): 127–40.

1992. "Rome ou Marseille? Le problème de l'hellénisation de la Gaule trans-alpine aux deux derniers siècles de la République," in Bats et al. 1992: 369–79.

1995. "Hercule à Glanum: sanctuaires de transhumance et développement urbain," *Gallia* 52: 311–31.

1996. *L'architecture romaine*, vol. 1: *Les monuments publics.* Paris: Éditions Picard.

2001. *L'architecture romaine*, vol. 2: *Maisons, palais, villas et tombeaux.* Paris: Éditions Picard.

2008. La Gaule Narbonnaise: de la conquête romaine au IIIème siècle. Paris: Éditions Picard. German language edition: *Gallia Narbonensis: Eine römische Provinz in Südfrankreich* (Mainz: Verlag Philip von Zabern).

2009. "Les 'villes d'Auguste' en Narbonnaise: nouvelles recherches sur Arles et Nîmes," in Christol and Darde 2009: 111–17.

Gros, P., and M. Torelli. 1988. *Storia dell'urbanistica: il mondo romano.* Rome: Laterza.

Gros, P., and P. Varène. 1984. "Le forum et la basilique de Glanum: problèmes de chronologie et de restitution," *Gallia* 42: 21–52.

Guendon, J.-L., and P. Leveau. 2005. "Dépôts carbonatés et fonctionnement des aqueducs romains: le basin du vallon des Arcs sur l'aqueduc d'Arles," *Gallia* 62: 87–96.

Guild, R., J. Guyon, and L. Rivet. 1980. "Recherches archéologiques dans le clôtre de Saint-Saveur d'Aix-en-Provence," *RANarb* 13: 115–64.

Guyon, J., N. Nin, and L. Rivet. 1996. "Aix-en-Provence," in Bogard 1996: 9–64.

Guyon, J., N. Nin, L. Rivet, and S. Saulnier. 1998. *Atlas topographique des villes de Gaule méridionale*, vol. 1: *Aix-en-Provence.* Paris: *RANarb* Suppl., vol. 30.

Hackl, U. 1988. "Gründerung der Provinz Gallia Narbonensis im Spiegel von Ciceros Rede für Fonteius," *Historia* 37: 253–6.

Hales, S. 2003. *The Roman House and Social Identity.* Cambridge: Cambridge University Press.

Hannestad, N. 1988. *Roman Art and Imperial Policy.* Aarhus: Aarhus University Press.

Harfourche, R., and P. Poupet. 2000. "Un ouvrage hydraulique précoce dans son contexte rural de Narbonne (Colonia Narbo Martius): l'aqueduc du Traversan à Mailhac," in Jansen 2000: 135–44.

Harstone, J. 1995. "The design of the Maison Carrée at Nîmes (abstract)," *AJA* 99: 317.

Hatt, J.-J. 1970. *Celts and Gallo-Romans.* Geneva: Nagel.

Hauck, G. F. W. 1989. "The Roman aqueduct of Nîmes," *Scientific American* (March): 98–104.

Hauck, G. F. W., and R. Novack. 1988. "Water flow in the castellum at Nîmes," *AJA* 92: 163–72.

Heijmans, M. 1991. "Nouvelles recherches sur les cryptoportiques d'Arles et la topographie du centre de la colonie," *RANarb* 24: 161–200.

1999. "La topographie de la ville d'Arles durant l'Antiquité tardive," *JRA* 12: 142–67.

Heijmans, M. 2004. *Arles durant l'antiquité tardive*. Rome: Collection de l'école française de Rome, vol. 324.

Heijmans, M., and C. Sintès. 1994. "L'évolution de la topographie de l'Arles antique," *Gallia* 51: 135–70.

Heilmeyer, W. 1970. *Korinthische Normalkapitelle: Studien zur Geschichte der römischen Architekturdekoration*. Heidelberg: Ergänzungsheft 16 Römische Mitteilungen.

Hermary, A., A. Hesnard, and H. Tréziny. 1999. *Marseille grecque: la cité phocéenne*. Paris: Éditions Errance.

Hesberg, H. von. 1981–2. "Elemente der frühkaiserzeitlichen Aedikulaarchitecktur," *JÖAI* 53: 43–86.

Hesnard, A. 1995. "Les ports antiques de Marseille: Place Jules-Verne," *JRA* 8: 65–77.

Heyn, M. 2006. "Monumental development in Glanum: evidence of the early impact of Rome in Gallia Narbonensis," *JMA* 19: 177–98.

Hingley, R. 2005. *Globalizing Roman Culture: Unity, Diversity and Empire*. London and New York: Routledge.

Hitchner, R. 1999. "More Italy than Province? Archaeology, texts, and culture change in Roman Provence," *TAPA* 129: 375–9.

Hodge, A. T. 1990. "A Roman factory." *Scientific American* (November 1990): 106–11.

1992. *Roman Aqueducts and Water Supply*. London: Duckworth.

1995. "Aqueducts," in Barton 1995: 127–50.

1998. *Ancient Greek France*. Philadelphia: University of Pennsylvania Press.

Hölscher, T. 2005. "The Transformation of victory into power: from event to structure," in S. Dillon and K. Welch (eds.), *Representations of War in Ancient Rome* (Cambridge: Cambridge University Press).

Huard, R. 1982. *Histoire de Nîmes*. Aix-en-Provence: Edisud.

Humphrey, J. 1986. *Roman Circuses: Arenas for Chariot Racing*. London: B. T. Batsford.

Janon, M. 1986. Le décor architectonique de Narbonne: les rinceaux. Paris: *RANarb* Suppl., vol. 13.

Janon, M., X. Lafon, and J.-L. Paillet. 2009. "Nouveaux regards sur la zone du grande temple d'Orange," in Christol and Darde 2009: 119–29.

Jansen, G. (ed.). 2000. *Cura Aquarum in Sicilia*. Annual Papers on Classical Archaeology, Suppl., 6. Leiden: Stichting BABESCH.

Joulia, J.-Cl. 1988. *Les frises doriques de Narbonne*. Brussels: Collection Latomus, vol. 202.

Joulin, L. 1901. *Les établissements gallo-romains de la plaine de Martres-Tolosanes*. Paris: L'imprimerie nationale.

Kauffmann, A. 1983. "Cardo et place dallée à Aix-en-Provence," *RANarb* 16: 247–84.

King, A. 1990. *Roman Gaul and Germany*. Berkeley: University of California Press.

Kleiner, F. 1973. "Gallia Graeca, Gallia Romana and the introduction of classical sculpture in Gaul," *AJA* 77: 379–90.

1977. "Artists in the Roman world: an itinerant workshop in Augustan Gaul," *MEFR* 89: 661–86.

1980. "The Glanum cenotaph reliefs," *BJb* 180: 105–26.

1985. *The Arch of Nero*. Archaelogia, vol. 54. Rome: L'Erma di Bretschneider, 1985.

1991. "The study of Roman triumphal and honorary arches," *JRA* 4: 203–6.

1998. "The Roman arches of Gallia Narbonensis," *JRA* 11: 610–12.

2007. *A History of Roman Art*. Belmont, Calif.: Thomson/Wadsworth.

2009. "Gallia Narbonensis: the province that became Provence," *JRA* 22: 689–90.

Knell, H. 2004. *Bauprogramme römischer Kaiser*. Mainz: Verlag Philipp von Zabern.

Knight, J. 2001. *Roman France: An Archaeological Field Guide*. Stroud: Tempus.

Koeppel, G. 1982. "The grand pictorial tradition of Roman historical representation during the early empire," *ANRW* 2(12): 507–35.

König, I. 1970. *Die Meilensteine der Gallia Narbonensis: Studien zum Strassenwesen der Provinicia Narbonensis*. Itinera Romana, Beiträge zur Strassengschichte des Römischen Reiches, Band 3. Bern: Kümmerly & Frey Geographsicher Verlag.

Kraay, C. 1955. "The chronology of the coinage of Colonia Nemausus," *NC* 15: 75–87.

Küpper-Böhm, A. 1996. *Die römischen Bogenmonumente der Gallia Narbonensis in ihrem urbanen Context*. Kölner Studien zur Archäologie der römischen Provinzen, Band 3. Espelkamp: Verlag Marie Leidorf GmbH.

Lamuà-Estañol, M. 2009. "The reliefs of the Roman arch at Carpentras," in Gaggadis-Robin et al. 2009: 49–58.

Lancaster, L. 2005. *Concrete Vaulted Construction in Imperial Rome: Innovations in Context*. Cambridge: Cambridge University Press.

LaRoche, C., and H. Savay-Guerraz. 1984. *Guides archéologiques de la France: Saint-Romain-en-Gal, un quartier de Vienne antique sur la rive droite du Rhône*. Paris: Imprimerie Nationale.

Lassalle, V., and J. Peyron. 1972. "L'escalier de service de l'amphithéâtre de Nîmes," *RANarb* 5: 167–74.

Lavagne, H. 1992. "Le problème des Nymphées en Gaule," in R. Chevallier (ed.), *Les eaux thermals et les cultes d'eaux en Gaules* (Tours: Collection Caesarodunum), vol. 26: 217–25.

Leglay, M. 1976. "Vienna" in Stilwell 1976: 978–9.

Leon, Ch. 1971. *Die Bauornamentik des Trajansforums*. Vienna-Cologne-Graz: Böhlau.

Le Prioux, C., and H. Champollion. 1997. *La Provence antique*. Rennes: Éditions Ouest-France.

Lerat, L. 1977. *La Gaule romaine*. Paris: Librairie A. Colin.

Leveau, P. 1992. "L'aqueduc de Nîmes et les aqueduct antiques," in Fabre et al. 1992: 223–50.

———. 1993. "Agglomérations secondaires et territoires en Gaule Narbonnaise," *RANarb* 26: 277–99.

———. 1994. "La recherche sur les agglomerations secondaires en Gaule Narbonnaise," in J.-P. Petit, M. Mangin, and P. Brunella (eds.), *Les agglomerations secondaires* (Paris: Éditions Errance): 181–93.

———. 1996. "The Barbegal water mill and its environment: archaeology and the economic and social history of antiquity," *JRA* 9: 137–53.

———. 2004. "La cité romaine d'Arles et le Rhône: la romanisation d'un espace deltaïque," *AJA* 108: 349–76.

———. 2005–6. "Les agglomérations de la cité de Vienne, un dossier en devenir," *RANarb* 38–9: 157–69.

Leveau, P., and B. Rémy. 2005–6. "Vienne. Présentation du dossier: les elements d'une problématique," *RANarb* 38–39: 7–13.

Leveau, P., and R. Thernot. 2005. "Le pont de Barbégal au vallon des Arcs à Fontvieille: étude archéologique de la derivation de l'aqueduc d'Arles," *Gallia* 62: 97–105.

Leveau, P., K. Walsh, G. Bertucchi, H. Bruneton, J.-P. Bost, and B. Tremmel. 2000. "Le troisième siècle dans la Vallée des Baux: les fouilles de la patie basse et de l'émissaire oriental des moulins de Barbégal," *RANarb* 33: 387–401.

Lugand, M., and L. Bermond (eds.). 2001. *Carte archéologique de la Gaule 34/2: Agde et le Bassin de Thau*. Paris: Académie des incriptions et belles-lettres FMSH.

Lugli, G. 1964–5. "La datazione degli anfiteatri di Arles e di Nimes in Provenza," *RivIstArch* n.s. 13–14: 146–69.

Lugli, G. 1966. "Il Ponte Flavio presso Saint-Chamas in Provenza," in Chevallier 1966: 1047–61.

MacDonald, W. 1982. *The Architecture of the Roman Empire*, vol. 1: *An Introductory Study*, 2nd edition rev. New Haven, Conn.: Yale University Press.

 1986. *The Architecture of the Roman Empire*, vol, 2: *An Urban Appraisal*. New Haven, Conn.: Yale University Press.

Macmullen, R. 1959. "Roman imperial building in the provinces," *HSCP* 64 (1959): 207–35.

 2000. *Romanization in the Time of Augustus*. New Haven, Conn., and London: Yale University Press.

MacKendrick, P. 1971. *Roman France*. London: G. Bell and Sons.

Mattingly, D. 2004. "Being Roman: expressing identity in a provincial setting," *JRA* 17: 5–25.

Mattingly, H. 1972. "The numismatic evidence and the founding of Narbo Martius," *RANarb* 5: 1–20.

McKay, A. 1975. *Houses, Villas and Palaces in the Roman World*. London: Thames and Hudson.

Mérimée, P. 1835. *Note d'un voyage dans le Midi de la France 1835*. Réédition presenté par P.-M. Auzas. Paris: Hachette (1971).

Mierse, W. 1999. *Temples and Towns in Roman Iberia*. Berkeley: University of California Press.

Mignon, J.-M. 1996. "Approche morphologique et fonctionelle de la maison (Orange)," in Bogard 1996: 219–34.

 2000. "Orange: Fourches-Vieilles," in *Provence-Alpes-Côte d'Azur, Bilan scientifique 1999*. Paris: Service regional de l'archéologie: 184–8.

Millett, M. 1990. "Romanization: historical issues and archaeological interpretation," in Blagg and Millett 1990: 35–44.

Mingazzini, P. 1957. "Sulla datazione di alcuni monumenti comunemente assegnati ad età augustea," *ArchCl* 9: 193–205.

 1968. "La datazione dell'arco di Orange," *RM* 75: 163–7.

 1971–2. "La datazione della Maison Carrée de Nîmes," *RendPontAcc* 44: 141–50.

Mocci, F., and N. Nin (eds.). 2006. *Carte archéologique de la Gaule 7: Aix-en-Provence, Pays d'Aix, Val de Durance*. Paris: Académie des inscriptions et belles-lettres FMSH.

Mommsen, Th. 1968. *The Provinces of the Roman Empire: The European Provinces*. Translated by W. Dickson ; edited by T. R. S. Broughton. Chicago, Ill: University of Chicago Press.

Naumann, R. 1937. *Der Quellbezirk von Nimes*. Berlin: De Gruyter.

Nielsen, I. 1990. *Thermae and Balnea: The Architecture and Cultural History of Roman Public Baths*. 2 vols. Aarhus: Aarhus University Press.

Nin, N., and B. de Luca. 1987. "La voie aurélienne et ses abords à Aix-en-Provence," *RANarb* 20: 191–280.

Oliver, J. 1966. "North, south, east, west at Arausio and elsewhere," in Chevallier 1966: 1075–9.

Owens, E. 1991. *The City in the Greek and Roman World*. London and New York: Routledge.

Packer, J. 1997. *The Forum of Trajan in Rome: A Study of the Monuments*. 3 vols. Berkeley: University of California Press.

Pailler, J.-M. 1989. "Domitien, la 'loi des Narbonnais' et le culte imperial dans les provinces sénatoriales d'Occident," *RANarb* 22: 171–90.

Paillet, J.-L. 2005. "Réflexions sur la construction du Pont du Gard," *Gallia* 62: 49–68.

Pasqualini, M., P. Excoffon, J.-M. Michel, and E. Botte. 2005–6. "Fréjus, Forum Iulii: Fouilles de l'Espace Mangin," *RANarb* 38–9: 283–341.

Pasqualini, M., R. Thernot and H. Garcia. 2010. *L'Amphithéâtre de Fréjus: archéologie et architecture, relecture d'un monument.* Bordeaux: Ausonius Éditions, Mémoires 22.

Pelletier, A. 1982. *Vienne antique: de la conquète romaine aux invasions alamanniques.* Lyon: Imprimerie Bosc Frères.

Pelletier, A., H. Savay-Guerraz, A. Barbet, J. Lancha, and A. Canal. 1981. "Découvertes archéologiques récentes à Vienne," *MonPiot* 64: 17–140.

Pflaum, H.-G. 1978. *Les fastes de la province de Narbonnaise.* Paris: *Gallia* Suppl., vol. 30 (Éditions du CNRS).

Picard, G. 1957. *Les Trophées Romains.* Paris: Éditions de Boccard.

1958. "Sur le sanctuaire d'Orange (Arausio) dans le Vaucluse, adjacent au Théatre," *CRAI* 1958: 67–93.

1960. "L'arc de Carpentras," *CRAI* 1960: 13–15.

1961. "Problèmes de l'art sévérien," *Hommages à Marcel Renard* 3: 495–6. Brussels: Collection Latomus, vol. 103.

1963. "Glanum et les origines de l'art romano-provençal I: Architecture," *Gallia* 21: 111–24

1964. "Glanum et les origines de l'art romano-provençal II: Sculpture," *Gallia* 22: 8–22.

Piganiol, A. 1962. *Les documents cadastraux de la colonie romaine d'Orange.* Paris: *Gallia* Suppl., vol. 16 (Éditions du CNRS).

Poupet, P. 1993. "Convergence des recherches sur les cadastres, les parcellaires et les terroirs," *RANarb* 26: 11–18.

Pralon, D. 1992. "La légende de la fondation de Marseille," in Bats et al. 1992: 51–5.

Prisset, J.-L., L. Brissaud, and O. Leblanc. 1994. "Évolution urbaine à Saint-Romain-en-Gal: la rue du Commerce et la maison aux Cinq Mosaïques," *Gallia* 51: 1–134.

Provost, M. (ed.). 1999. *Carte archéologique de la Gaule 30/2: Le Gard.* Paris: Académie des Inscriptions et Belles-Lettres FMSH.

Raepsaet-Charlier, M. 1987. *La prosopographie des femmes de l'ordre sénatorial.* Louvain: Aedibus Peeters.

Raffard, D., M. Vinches, J.-P. Henry, P. Leveau, M. Goutouli, and R. Thernot. 2000. "The building of the Roman aqueducts: financial and technological problems: the case of the Arles aqueduct," in Jansen. 2000: 125–33.

Ramage, N., and A. Ramage. 2005. *Roman Art,* 4th edition. Englewood Cliffs, N.J.: Prentice-Hall.

Reece, R. 1990. "Romanization: a point of view," in Blagg and Millett 1990: 30–4.

Rémy, B. 2003. "Loyalisme politique et culte imperial dans la cité de Vienne au Haut Empire d'après les inscriptions," *RANarb* 36: 361–76.

Rémy, B. (ed.). 2004–5. *Inscriptions Latines de Narbonnaise (I. L. N.)* 5 (Vienne): fasc. 1 (2004), 2 (2004), 3 (2005). Paris: *Gallia* Suppl., vol. 44 (Éditions du CNRS)

Ricci, C. 1992. "Dalle Gallie a Roma: Testimonianze epigrafiche d'età imperiale di personaggi provenienti dal Narbonese e dalle tres Gallia," *RANarb* 25: 301–24.

Ridgway, B. 1982. "The Gauls in sculpture," *ArchNews* 11: 85–104.

Rivet, A. L. F. 1988. *Gallia Narbonensis.* London: B. T. Batsford.

Rivet, L. 1987. "Le Forum de Aquae Sextiae (Aix-en-Provence)," in Gasco 1987: 185–90.

Rivet, L., D. Brentchaloff, S. Roucole, and S. Saulnier. 2001. *Atlas topographique des villes de Gaule méridionale,* vol. 2: *Fréjus.* Paris: Éditions de Boccard (*RANarb* Suppl. 32).

Rolland, H. 1958. *Fouilles de Glanum, 1947–56*. Paris: *Gallia* Suppl., vol. 1 (Éditions de Boccard)

1969. *Le mausolée de Glanum*. Paris: *Gallia* Suppl., vol. 21 (Éditions du CNRS)

1977. *L'Arc de Glanum*. Paris: Gallia Supplement vol. 31 (Éditions du CNRS).

Roman, D. 1981. "Apollon, Auguste et Nîmes," *RANarb* 14: 207–14.

1987. "Aix-en-Provence et les débuts de la colonization de droit latin en Gaule du Sud," *RANarb* 20: 185–90.

Rosso, E. 2006. *L'Image de l'empereur en Gaule romaine: portraits et inscriptions*. Archéologie et histoire d'art, vol. 20. Paris: Éditions du Comité des Travaux Historiques et Scientifiques.

Roth-Congès, A. 1983a. "L'acanthe dans le décor architectonique protoaugustéen en Provence," *RANarb* 16: 103–34.

1983b. "Le sanctuaire des eaux à Nîmes I, le nymphée," *RACentre* 22: 131–49.

1985. "Glanum préromaine: recherche sur la métrologie et ses applications dans l'urbanisme et l'architecture," *RANarb* 18: 189–220.

1987a. "Fouilles et recherches recentes sur le Forum de Glanum," in Gasco 1987: 191–202.

1987b. "Le mausolée de l'île du Comte," *Ugernum. Beaucaire et le Beaucairois à l'époque romaine* 2: 47–128.

1992a. "Le centre monumental de Glanon ou les derniers feux de la civilization salyenne," in Bats1992: 351–67.

1992b. "Glanum, *oppidum Latinum* de Narbonnaise: à propos de cinq dédicaces impériales récemment découvertes," *RANarb* 25: 29–48.

1994. "Culte d'eau et deux guérisseurs en Gaule romaine," *JRA* 7: 397–407.

1997. "La fortune éphémère de Glanum: du religieux à l'économique," *Gallia* 54: 175–202.

2009. "Pour une datation triumvirale du mausolée des Iulii à Glanum," in Gaggadis-Robin et al. 2009: 59–70.

Roth-Congès, A., and P. Gros. 1985. "Le sanctuaire des eaux à Nîmes," in A. Pelletier (ed.), *La médecine en Gaule: illes d'eaux, sanctuaries des eaux* (Paris: Picard): 167–92.

Roth-Congès, A., and P. André. 1989. "Forums et etablissements publics: le forum de Vienne," in Ch. Goudineau and J. Guilaine (eds.), *De Lascaux au Grand Louvre, archéologie et histoire de la France* (Paris: Éditions Errance): 288–90.

Rothé, M.-P., and M. Heijmans (eds.). 2008. *Carte archéologique de la Gaule 13/5: Arles, Crau, Camargue*. Paris: Académie des Inscriptions et Belles-Lettres FMSH.

Rouquette, J.-M., and C. Sintès. 1989. *Guides archéologiques de la France: Arles antique*. Paris: Éditions de l'imprimerie nationale.

Sablayrolles, R. 1984. "Les *praefecti fabrum* de Narbonnaise," *RANarb* 17: 239–48.

Sabrié, M. and R. Sabrié 1985. "Décorations murales de Nîmes romain," *RANarb* 18: 289–318.

1987. *La maison à portiques du Clos de la Lombarde à Narbonne*. Paris: *RANarb* Suppl., vol. 16.

Salviat, F. 1977. "Orientation, extension et chronologie des plans cadastraux d'Orange," *RANarb* 10: 107–18.

1986. "Quinte Curce, les insulae Furianae, la fossa Augusta et la localization du cadastre C d'Orange," *RANarb* 19: 101–6.

1990. *Guides archéologiques de la France: Glanum, Saint-Rémy-de-Provence*. Paris: Éditions de l'Imprimerie National.

Salviat, F., and D. Terrer. 1984. "Portraits officiels sévériens en Narbonnaise," *RANarb* 17: 273–88.

Sampetru, M. 1984. *Tropaeum Traiani II. Monumentele Romane*. Bucharest: Institutul de Archeologie, Biblioteca de Archeologie, vol, 45.

Sauron, G. 1983. "Les cippes funéraires gallo-romaines à décor de rinceaux de Nîmes et sa region," *Gallia* 41: 59–109.

Schalles, H., H. von Hesberg, and P. Zanker (eds.). 1992. *Die Römische Stadt im 2. Jahrhundert n. Chr.* Cologne: Rheinland-Verlag GMBH.

Sear, F. 1983. *Roman Architecture*. Ithaca, N.Y.: Cornell University Press.

 1990. "Vitruvius and Roman theater design," *AJA* 94: 376–82.

 2006. *Roman Theatres: An Architectural Study*. Oxford: Oxford University Press.

Silberberg-Pierce, S. 1986. "The many faces of the Pax Augusta: images of war and peace in Gallia Narbonensis," *Art History* 9: 306–24.

Sintès, C. 1990. "L'évolution topographique de l'Arles antique du Haut-Empire à la lumière des fouilles récentes," *JRA* 5: 130–47.

Solier, Y. 1973. "Note sur les galleries souterraines de Narbonne," in Étienne 1973: 315–24.

Soricelli, G. 1995. *La Gallia Transalpina tra la Conquista e l'età Cesariana*. Como: Bibliotheca di Athenaeum, vol. 29.

Stambaugh, J. 1988. *The Ancient Roman City*. Baltimore and London: Johns Hopkins University Press.

Stamper, J. 2005. *The Architecture of Roman Temples: The Republic to the Middle Empire*. Cambridge: Cambridge University Press.

Stilwell, R. (ed.). 1976. *The Princeton Encyclopedia of Classical Sites*. Princeton, N.J.: Princeton University Press.

Syme, R. 1953. "Tacitus on Gaul," *Latomus* 12: 25–37.

 1958. *Tacitus*. 2 vols. Oxford: Oxford University Press.

Terrer, D. 1981. "Tibère à Fréjus," *RANarb* 14: 215–20.

Thollard, P. 1984. "Strabon, Lyon, Vienne et les Ségusiaves," *RANarb* 17: 115–22.

Thomas, E. 2007. *Monumentality and the Roman Empire: Architecture in the Antonine Age*. Oxford: Oxford University Press.

Thomas, E., and C. Witschel. 1992. "Constructing reconstruction: claim and reality of Roman rebuilding inscriptions from the Latin West," *PBSR* 60: 135–77.

Torelli, M. 1995. "Funerary monuments with Doric friezes," in H. Fracchi and M. Gualtieri (eds.), *Studies in the Romanization of Italy* (Edmonton: University of Alberta Press): 159–89.

Treziny, H. 1992. "Imitations, emprunt, détournements: sur quelques problèmes d'architecture et d'urbanisme en Gaule méridionale," in Bats et al. 1992: 337–49.

Turcan, R. 1984. "L'arc de Carpentras: problèmes de datation et d'histoire," in H. Walter (ed.). *Hommages à Lucien Lerat 2. Annales littéraires de L'Université de Besançon*, vol. 294 (Paris: Les Belles Lettres): 809–19.

Ulrich, R. 1994. *The Roman Orator and the Sacred Stage: The Roman Templum Rostratum*. Brussels: Collection Latomus, vol. 222.

Vacca-Goutoulli, N. 1994–95. "La taille de pierre sur l'aqueduc romain d'Arles au Vallon des Arcs à Fontvieille," *RANarb* 27–28: 165–74.

Van de Voort, J. F. 1992. "La maison des Antes de Glanum: analyse métrologique d'une maison à péristyle hellénistique," *RANarb* 24: 1–18.

Varène, P. 1987. "La tour magne et l'Augusteum de Nimes," *RA* 1987: 91–6.

 1992. *L'enceinte gallo-romaine de Nîmes: les murs et les tours*. Paris: *Gallia* Suppl., vol. 53 (Éditions du CNRS).

 2002. "La porte de France à Nîmes," *Gallia* 59: 205–31.

Varène, P., J. Bigot, and M. Frizot. 1982. "Note technique sur les vestiges architecturaux découverts à Nîmes à l'emplacement de la maison d'arrêt," *RANarb* 15: 319–24.

Veyrac, A. 1998. *Le symbolisme de l'as de Nîmes au crocodile*. Montagnac: Éditions Monique Mergoil.

2006. *Nîmes romaine et l'eau*. Paris: *Gallia*, Suppl., vol. 57 (Éditions du CNRS).

Veyrac, A., and J.-M. Pène. 1994–95. "L'augusteum de la fontaine de Nîmes: étude archéologique du basin de la source et de la canalization souterraine ouest," *RANarb* 27–28: 121–64.

Walter, H. 1984. "Les victoires de la 'Porte Noire' de Besançon," in H. Walter (ed.), *Hommages à Lucien Lerat 2: Annales littéraires de l'Université de Besançon*, vol. 294 (Paris: Les Belles Lettres): 863–9.

Ward-Perkins, J. 1970. "From republic to empire: reflections on the early provincial architecture of the Roman West," *JRS* 60: 1–19.

1974. *Cities of Ancient Greece and Italy: Planning in Classical Antiquity*. New York: George Braziller.

1981. *Roman Imperial Architecture*, 2nd edition. Harmondsworth: Penguin Books (Pelican History of Art).

Welch, K. 2007. *The Roman Amphitheatre, from Its Origins to the Colosseum*. Cambridge: Cambridge University Press.

Wenzler, C. 2002. *Architecture Gallo-Romaine*. Rennes: Éditions Ouest-France.

White, D. 1984. *Greek and Roman Technology*. London: Thames and Hudson.

Wilson, R. 1996. "Tot aquarum tam multis necessaries molibus ... Recent studies on aqueducts and water supply," *JRA* 9: 5–29.

1999. "Deliveries extra urbem: aqueducts and the countryside," *JRA* 12: 314–32.

Wilson Jones, M. 1989. "Designing the Roman Corinthian order," *JRA* 2: 35–69.

1991. "Designing the Roman Corinthian capital," *PBSR* 46: 89–150.

1993. "Designing amphitheatres," *RM* 100 (1993): 391–442.

2000. *Principles of Roman Architecture*. New Haven, Conn.: Yale University Press.

Woodruff, S. 1977. "The pictorial traditions of the battle scenes on the Monument of the Julii at *St. Rémy*." Ph.D. dissertation, University of North Carolina at Chapel Hill, 1977.

Woolf, G. 1992. "The unity and diversity of Romanisation," *JRA* 5: 349–52.

1995. "Beyond Romans and natives," *WorldArch* 28: 339–50.

1996. "Monumental writing and the expansion of Roman society in the early Empire," *JRS* 86: 22–39.

1998. *Becoming Roman: The Origins of Provincial Civilization in Gaul*. Cambridge: Cambridge University Press.

2000. "Urbanization and its discontents in early Roman Gaul," in E. Fentress (ed.), *Romanization and the City: Creation, Transformations, and Failures*. JRA Suppl., series no. 38 (Portsmouth, R.I.): 115–31.

2001. "The Roman cultural revolution in Gaul," in S. Keay, and N. Terrenato (eds.), *Italy and the West: Comparative Issues in Romanization* (Oxford: Oxbow Books): 173–86.

2008. "Celebrating Philippe Leveau in the landscape," *JRA* 21: 563–5.

Yegul, F. 1992. *Baths and Bathing in Classical Antiquity*. Cambridge: Cambridge University Press.

INDEX

abacus, 105, 113

acanthus leaves, 62, 94, 105, 113, 247n5, 251n63

Achilles, 228

acropolis, 24–5

Actian army, 134

Adamklissi (Rumania), 70, 248n18

aditus maximus, 149, 151

Adonis, 229

administrative centers, 4–5, 11, 13–16, 39, 53, 111, 122, 135, 144, 180, 198, 235

aedicula, 184, 223–4, 233

Aeduan tribe, 87

aerarium, 129

Africa, 30, 62, 162, 236, 246n82

Agay, 26

Agde, 22, 26, 27, 66, 241n8, 242n23

agora, 24, 33, 37, 129, 130, 132, 160

Agricola, Gn. Julius, 13, 26, 45, 117, 134

Agrippa, Marcus, 11–12, 32, 37, 45, 50, 52, 97, 109–10, 130, 175–6, 182–3, 194, 239n23, 252n68, 256n141

Ahenobarbus, Cn. Domitius, 7–8, 70, 238n13

Aigitna. *See* Cannes

L'Aiguille (obelisk, Vienne), 171–2

Aix-en-Provence, 7–9, 11, 21, 22, 37, 38, 66–7, 75, 118–21, 149, 216, 218, 238n12, 239n19, 240n38, 243n40

Aix-les-Bains, 73, 80

Akragas (Sicily), 23

Akrai (Sicily), 23

Alba Fucens (Italy), 170

Alba Helviorum, 254n107

Albinus, Clodius, 14, 91, 240n36

Alcantara (Spain), 73

Alexandria (Egypt), 70

Algeria, 85

Allobroges, 7, 9, 10, 47

Alonis, 26

Les Alpilles (mountains), 27–8, 97, 197, 199

Alpes Martimae, 13, 72, 80, 179

Alps, 3, 5, 8

altar
 Doric, 223
 inscribed, 31–2, 97
 Hercules, 30, 32, 97, 243n30
 Three Gauls, 186

amphitheaters, 254n117, 254n121
 Alba Fucens, 170
 Arles, 17, 43–6, 163–6, 197–8, 200, 235
 Capua, 163
 Cumae, 163
 Flavian (Colosseum, Rome), 44, 163, 168, 235
 Fréjus, 168–70, 244n60
 Nîmes, 17, 50, 52, 69, 163–8, 255n121
 Paestum, 170
 Puteoli, 163
 Vienne, 160

amphora, manufacturing and storage, 11, 25, 139–41, 144, 186

annex/annexation, 57, 125, 130, 211–12
Antibes, 5, 22, 26, 240n38, 241n8
Antipolis. *See* Antibes
Les Antiques (St.-Rémy-de-Provence), 17, 35–6, 77, 224, 243n38
Antonine itinerary, 24, 46
Antonine period, 42, 44, 53, 73, 244n52, 245n73, 246n77, 246n78, 246n82, 249n32, 249n33, 255n125
Antoninus, T. Aurelius Fulvius Boionus Arrius, 240n34
Antoninus Pius, 14, 26, 39, 42, 44, 46, 49, 53, 73, 78, 80, 91, 111, 114, 122–3, 128, 134, 160, 174, 190, 235–6, 248n, 252n69
Aosta (Italy), 73
Aouenion. *See* Avignon
apodyterium, 176
Apollinaris, Sidonius, 137, 144, 171
Appian, 8, 11, 72, 191, 222, 238n12
apse, 33, 43, 131–2, 177, 180–1
Apt, 11, 14, 73, 240n38, 248n23
Apta Iulia. *See* Apt
Aquae. *See* Aix-les-Bains
Aquae Sextiae. *See* Aix-en-Provence
aqueduct
 Aqua Appia, 191
 Arles/Arelate, 14, 44, 181, 197–9, 240n32, 240n38, 240n39
 Barbégal, 244n57, 256n144
 curator aquarum, 190
 Frejus, 36, 169, 191–2, 256n140
 Glanum, 99
 Nîmes, 52, 104, 193–4, 235, 239n23, 246n
 Pont du Gard, 53, 104, 193–4, 196–7, 239n23, 256n142
 underground, 191, 193, 197
 Uzés-Nimes, 193
 Vasio, 212
 Vienne, 137, 191
Aquitania, 15, 26, 57
Ara Pacis Augustae (Rome), 105, 186
Arausio. *See* Orange
arcades, 147, 163–4, 168, 191, 195–6
arch
 admirable (Arles), 41, 73, 243n38, 248n22
 Ancona, 79, 83, 250n38
 Aosta, 73

Arles, 41, 73, 75, 83, 85, 243n38, 244n52, 247n5, 248n22
Augustan, 76
Besançon, (La Porte Noir), 249n37, 250n38
Carpentras, 73, 75, 78–81, 83, 243n38, 249n32
Cavaillion, 73, 75–9, 82–3, 243n38, 248n12
commemorative, 36, 75–6
Constantine (Rome), 41–2, 244n52
Die, 249n37
fragmentary, 63, 75, 78, 83, 243n38, 248n22, 249n37
free standing, 35, 56, 73, 250n40
fornix, 35, 178
 single, 41, 73, 80, 224, 250n40
 triple, 56, 63, 73, 81, 83, 85, 89, 250n40
Gallienus (Rome), 73
Glanum, 36, 75–9, 81–3, 90, 243n38, 249n30, 250n43
Medinaceli (Spain), 85, 250n41
Orange, 16–17, 35–6, 56, 63, 73, 76, 78–9, 81–92, 107, 109, 115, 230, 240n32, 240n36, 243n38, 246n83, 249n31, 250n41, 250n42, 250n43, 250n48, 252n71, 257n172
Pola (Italy), 73, 76, 105, 114, 249n29
de la porte de l'Aure (Arles), 73, 248n22
la Porte Noir (Besançon), 249n37, 250n38
quadrifrontal, 79, 82, 122, 210, 228, 231–2, 248n21
du Rhône (Arles), 41, 73, 244n5, 247n5, 248n22
Sergi (Italy), 73, 249n29
of Severus (Rome), 78, 82, 85, 92, 240n36, 249n29, 250n42, 257n172
of Trajan (Benevento), 56, 79, 83, 85, 91, 250n38
triumphal, 36, 70, 73, 75, 81, 83, 90–2
architrave, three-fasciaed, 89, 228
archivolt, 75, 76, 78–9, 82, 228, 231
arcuation, 82, 250n39
Arelate. *See* Arles
arena, 163, 166–8
Arezzo, 144
aristocrats, 4, 13, 226, 235, 239n31

Arles, 5, 11–12, 15–17, 19, 22–3, 26–7, 37–8, 41–5, 47, 50, 52, 54, 57, 60, 63–4, 67, 73, 75, 83, 85, 118, 121–2, 132–4, 143–6, 149, 152, 156–7, 163–6, 168, 170–1, 180–3, 197–200, 221–2, 234–6, 239n22, 240n38, 241n8, 243n38, 244n55, 244n58, 247n5, 248n14, 253n92, 254n120, 255n121, 255n126, 256n143, 257n163

armature, 117, 122, 125

artisan studio, 49, 125, 135, 139, 141, 254n100

Asia Minor, 23, 72, 107, 130, 162, 173, 183, 236, 246n78, 246n82, 252n77

Aspendos (Asia Minor), 149

assembly hall, 30, 104, 130

asymmetry, 23, 196

Atalanta, 229

Athaulf, 16

Athenopolis. See St. Tropez

attic story, 90–1, 160, 163, 168, 230, 250n44, 250n45, 254n120

Augusta Emerita. See Merida (Spain)

Augusta Treverorum. See Trier (Germany)

Augustan age/era, 33, 38–9, 41, 44, 47, 49, 50, 52, 54, 56, 58, 63, 67, 73, 76, 79–80, 82, 85, 94, 100–1, 105–6, 110–11, 114, 116–17, 119, 121–3, 125, 128, 130, 132, 134–5, 144, 146, 152–6, 160, 174, 188, 190, 194, 206–7, 209, 220, 222–3, 239n23, 243n33, 245n74, 247n1, 247n7, 248n25, 249n29, 249n31, 250n40, 250n41, 255n128, 256n141, 258n

Augustan house(s), 58, 206–7, 209, 220

Augusteum (Nîmes), 52, 103, 128, 135, 173, 174, 186–90, 193, 235, 252n87, 253n87, 255n136, 256n137

Augustus, 7, 11–12, 17, 39, 43–5, 47, 49–53, 61–2, 64, 67–8, 70, 72, 75, 77, 88, 99, 104, 105, 107, 109–11, 113–15, 129–30, 132–3, 135, 144, 152, 154–6, 172, 174, 177, 181–3, 186, 190, 194, 200, 203, 220, 222–3, 226, 234–5, 239n23, 239n24, 243n35, 245n, 247n1, 247n2, 247n4, 248n25, 250n40, 251n64, 252n67, 253n96

Aurelian, 14, 91

Aurelius, Marcus, 14, 249n37

Austria, 8

Avellan, 191

Avennio. See Avignon

Avienus, 27, 244n49

Avignon, 7, 11, 14, 22, 27, 73, 240n38, 242n23

Avitus, L. Duvius, 57

axis, 35, 93, 96, 102–3, 130–1, 144, 179–80, 205, 207, 212, 214–16, 218

Baalbek (Lebanon), 174, 255n128

Baeterrae. See Béziers

balinea, 4, 175–6, 200, 209

balustrade, 193

barbarian incursions, 14, 78

bases, column, 28, 75, 79, 81, 94, 105, 162, 169, 228, 254n120

basilica (commercial), 59, 128

Basilica Ulpia (Rome), 43, 122, 244n55

basins 52, 140

baths, 255n129
　Arles, 180, 181
　of Caracalla (Rome), 176, 255n129
　of Diocletian (Rome), 176
　Forum Julii/ Frejus, 12, 54, 175, 178–9
　Gela (Sicily), 176, 179
　Glanum, 35, 37, 176–7, 179–80, 208
　Hellenistic period, 176
　Megara Hyblaea (Sicily), 176, 242n14
　la Porte Dorée (Fréjus), 147, 178–80
　Roman, 255n129
　Severan (Cimiez), 179–80
　Stabian (Pompeii), 176–7
　Syracuse (Sicily), 23, 176
　Vaison, 177–8
　Vienne, 245n66

Les Baux, 198, 220–1

Beaucaire, 8, 232–3, 257n175

Belgium, 106

Benevento (Italy), 250n38

Benoit, F., 198–9, 221, 238n12, 241n10, 255n

Besançon, 249–50, 273–4

Béziers, 11, 21, 54, 64, 73, 137, 239n29, 240n38

Biancon (river), 191

bibliotheca. See library

Bishop of Arles, 15, 222

Bishop of Nîmes, 54, 57, 236

Bishop of Vasio, 60

Bituitus, 7

Boduacus, 87

Bona Dea, 32

Borysthenes, 14

bouleuterion (Glanum), 30, 33, 37, 130, 143, 243n30

Bourg Saint-Saveur Cathedral (Aix-en-Provence), 38, 267

La Bourse (Marseille), 6, 25, 66, 248n12

Bouteillière, 191

Bracata, 3

brick, 25, 62, 67, 143, 176, 178, 214
 stamps, 143, 163, 239n29

bridge, 7, 52, 53, 58, 73–5, 104, 186, 191, 193–7, 224, 235, 239n23, 246n76, 248n21, 248n24, 249n26

Britain/Britannia, 4, 12–13, 15, 26, 45, 91–2

bronze, 79, 83, 88, 92, 109, 178, 182, 193, 215, 224, 250n38

Bronze Age, 50

Burrus, S. Afranius, 57

Caepio, Q. Servilius, 8, 34

Cabellio. See Cavaillon

cadastral inscriptions, 13, 56–7, 239n29, 246n

cadasters, 246n
 Orange, 13, 56, 125

Cahors, 21

caldarium, 176, 180–2

Calvinus, C. Sextius, 7, 37–8, 66

Campania (Italy), 32, 72, 136, 163, 177

Campanus, Lucius Pompeius, 80

Campus Martius (Rome), 148–9, 162, 176

canals, 41, 45, 146–7, 170

Cannae (Italy), 8

Cannes, 26

Canopus (at Hadrian's villa, Tivoli), 83

Cape Misenum (Campania), 45, 147

capitals
 composite, 173
 Corinthian, 61, 63, 247n2, 247n8
 Doric, 33, 65, 93, 130, 186, 254n120
 Ionic, 65, 93

Capitoline Triad, 98

Capitolium, 40, 56, 93, 101–3, 122, 134, 149, 250n

captives, 75, 78, 117

Capua (Italy), 163

Caracalla, 14, 46, 49, 92, 176, 179, 240n36

Carbo, Cn. Papirius, 8

Carcassone/Carcaso (Spain), 11

carcer/carceres, 129, 170

cardo maximus, 39, 41, 50, 58, 67, 78, 124, 144, 168

Carpentorate. See Carpentras

Carpentras, 11, 57, 73, 75, 78–81, 83, 240n38, 243n38, 249n32

Carrara (Italy), 63, 71

Carthaginians, 6

Cassis, 26

castellum divisorium (Nîmes), 191, 197, 256n141

castra plan, 39, 54–5

cathedral, 23, 25, 38, 52, 60, 119

Catherine de'Medici, 160

Catilina, Lucius Sergius, 10

Catugnatus, 10

Cavaillon, 11, 27, 73, 75–6, 78–9, 82–3, 240n38, 242n23, 243n38, 248n21

Cavares, 27, 54, 56

cavea, 38, 124, 148–52, 156, 158–63, 167–70, 186, 252n85

cella, 28, 70, 93, 102, 105, 113

Celtic tribes, 6, 20, 30, 66, 78, 202

Celtic-Ligurian culture, 6, 27–8, 32, 37, 66

Celto-Greek remains, 28, 247n9, 247n10

Celtus (potter), 224

Cemenelum. See Cimiez

cement, 62, 132, 149, 199, 247n3

cemeteries, 44, 55, 221–2, 257n162, 257n163
 les Alyscamps (Arles), 222

cenotaph, 17, 73, 257n166
 of the Julii (Glanum), 12, 35–7, 62, 76, 222, 224–33, 239, 243, 257, 268

Centre National pour les Recherches Scientifiques, 17

centuriation, 56, 57, 246n85

Chapelle de Saint-Césaire (Vernégues), 100, 251n55

Charsis. See Cassis

Château Bas, 97, 99. See also Vernégues

Chateau Roussillon. See Ruscino

Christian chapel, 99–101, 144, 251n55, 251n57

Christian church, 15, 46, 104, 222

Christian exorcist, 60

Christian martyr, 119, 222

Christian priest, 57, 75, 236
Christianized territory, 15, 44, 46, 50, 236, 245n62
Cicero, Marcus Tullius, 9–10, 32, 45, 146, 238n17, 239n19, 239n21
Cimbri, 8, 39, 47, 54
Cimiez, 72, 179–80
La Ciotat (Citharista), 26
cippus, 222–3, 242n24
circuit walls, 20, 22–3, 27, 47, 50, 52, 55, 64, 67–9, 188, 234
circus
 Arles 170–1, 222, 255n126, 257n163
 Flaminius (Rome), 190
 Nîmes, 53
 Orange, 102, 153
 Vienne, 49, 116, 172, 245n66
cisterns, 32, 147, 201, 205, 212
civitas, 19, 126
clamp holes, 51, 88–9, 92, 107, 109–10, 114–16, 178, 224, 250n38, 252n71
Claudius, 11–13, 26, 39, 47, 49, 58, 114–15, 124, 156, 158, 235, 245n63, 252n83
clerestory, 131
coffers, 85
coins, 28, 32, 49, 60, 75, 83, 144, 199, 221, 242n24, 245n69, 249n36, 249n38
collegium, 211, 215
colonia, 244n49
 Antonina, 249n32
 Augusta Nemausus Voltinia tribu, 50
 Firma Iulia Arausio Secundanorum, 54, 240
 Iulia Augusta Florentia Vienna, 47
 Iulia Hadriana, 14
 Julia Paterna Arelate Sexternum, 41
 Julia Paterna Narbo Martius, 39, 41
 Latina, 11, 37, 39, 47
 Octavanorum, 45
 Octavanorum Pacensis Classica Forum Iulii, 45
 Romana, 11, 47
 Valentia, 11, 57
colonnade, 4, 32, 42–3, 50, 59, 70, 83, 93, 96, 116–27, 129–35, 140, 143, 150, 165, 203, 205–6, 208, 211, 215, 218–19, 252n86, 252n87
columbarium, 80
Columella, 240n31

columnatio, 152, 154
columns
 attached, 75–6, 105, 173
 Doric, 33, 65, 93, 130, 186, 254n120
 engaged, 81, 113, 130, 164, 173, 228
 fluted, 75, 94, 205
 free standing, 105, 113, 130, 164
 half, 164, 177
 semi, 105, 164
 shafts, 76, 97, 107, 164
 spacing, 105
 Tuscan, 28, 164, 254n120
Comati tribe, 72
Commodus, 14, 249n37
concrete, 20, 163, 241n5
Constans, 16
Constantin (town), 21, 65, 241n7
Constantine (emperor), 15, 41, 44, 47, 134, 180–1, 199, 236
Constantine III, 15–16
Constantinian era, 41–2, 47, 180–3, 199, 236, 240n39
Constantius, 16
Constantius II, 44, 236
Constitutio Antoniniana, 14, 240n36
corbels, 150
Cori (Italy), 93
Corinth (Greece), 161
Corinthian order, 36, 50, 61, 63, 75, 89, 93–4, 96, 105–6, 113, 126, 149, 164, 231, 247n1, 254n120
Cornelia, 31
Cornelii family, 31
cornice blocks, 28, 73, 75, 82, 89, 96, 105, 164, 190, 228
Cosa (Italy), 85, 93, 250n40
Cote d'Azur, 26
Council at Arles, 44, 57, 60
Council of Riez, 60
Council of 15, 44, 57, 60, 180, 236, 314
Cour de l'Archévèché (Aix-en-Provence), 119, 121
courtyard, 30, 38, 42, 59, 140, 147, 203, 208, 214, 218–19
Crau (plain), 21
Croton (Italy), 23
cryptoporticus, 143, 220
 Arles, 41–4, 121, 132–3, 144, 239n22
 Chiragan, 220
 Narbo, 144, 155
cubiculum, 205, 207, 216

cult
 Cybele, 49, 245n63
 Imperial, 100, 114, 135, 186–8, 190
 Rome and Augustus, 75, 99, 114, 186
 severed heads, 33
Cumae (Campania), 163
cupola, 180, 182, 228
curia, 17, 33, 128–9, 131–2, 253n90
 Glanum, 131–2
 Nîmes, 134
 Rome, 41
Cyclops, 30

Dacia, 70
Dafenus/Daphnus, 60
damnatio memoriae, 13, 92
Dauphine, 5
Dax, 220
De architectura. *See* Vitruvius
Dea Augusta, 73
Deciates, 7
decoration
 Amazonomachy, 230
 battle scenes, 90, 91, 228, 230, 232
 Calydonian boar hunt, 228–9
 carving, 28, 61–4, 75, 78–81, 83,
 89–90, 92, 94, 96, 98, 105, 107,
 111, 113, 121, 165, 168, 186, 205,
 230–1, 242n28, 250n44
 low relief, 79, 89, 115, 249n32, 249n34,
 250n44
 portrait busts/statues, 13, 43, 80, 124,
 145, 156, 159, 220, 222, 235,
 239n22, 252n83, 252n84, 254n113
 shields, 47, 87–89, 135, 228
 vegetal, 62–3, 75, 78–9, 84, 94, 97,
 247n5, 251n63
 Victories, 79, 83, 230, 249n34, 250n38
decumanus maximus, 38, 41, 45, 50, 67,
 145
dedicatory inscriptions, 43, 49, 80, 85,
 89, 109, 115, 129, 239n, 252n67,
 252n68, 252n69
defensive walls, 20, 22–3, 25, 30, 44, 49,
 58, 64, 66–7, 70, 234, 243n29
Deified Augustus, 88, 115
Deified Caesar, 72
Deified Julius, 88
Delos, 30, 200, 205
Delphi, 242n15
Delphic Apollo, 25

diaeresis, 242n13
Die, 73, 248n23, 249n37
dies ater, 8
Dio, Cassius, 10–12, 72, 111, 239n24,
 240n32, 240n36, 245n63, 246n77,
 248n
Diocesis Viennensis, 15
Diocletian, 15, 176, 222
Diodorus, 6, 238n12, 241n13
Dionysus, 30
Diva Augusta, 115
Domitian, 13, 52, 58, 124, 135, 156, 159,
 161, 163, 165, 239n29, 239n30,
 252n48, 255n121
Domitius, L., 10
domus/house
 à pastas (Ensérune, Olbia), 201–3
 atrium-peristyle, 59, 117, 200–1, 203,
 205, 207–10, 212, 214–16, 218–20
 Augustan House (Narbo), 206
 Glanum, 203–6, 256n145
 Greek peristyle plan, 200, 210
 House A (Orange), 218–19
 House B (Orange), 218–19
 House of the Anta Capitals (Glanum),
 35, 203, 205
 House of the Atrium (Vienne), 59,
 215–16, 218
 House of Atys (Glanum), 35, 203, 206
 House at Clos de la Lombarde (Narbo),
 123, 207–8
 House of Columns (Vienne), 215, 217
 House of Cornelius Sulla (Glanum),
 31–2, 59, 206, 208, 215–16, 218,
 243n33
 House of the Dauphin (Vaison), 5,
 14, 38, 124, 139, 208–10, 213,
 256n153
 House of Five Mosaics (Vienne), 215
 House of Fortuna annonaria (Ostia), 215
 House of the Large Peristyle
 (Aix-en-Provence), 218
 House of the Menander (Pompeii), 207
 House of the Messii (Vaison), 211–13,
 255n145
 House of the Ocean Gods (Vienne),
 214–16
 House of rue des Magnans
 (Aix-en-Provence), 218, 256n145
 House of the Silver Bust (Vaison), 59,
 209, 211–16

House of Sucellus (Vienne), 215
House of Sulla (Glanum), 31–2, 206–8, 243n33
oikos, 205, 207
Olbia, 202, 206
Praetorium (Vaison), 211–12
Roman atrium, 200–1, 205, 219
Villa of the Peacock (Vaison), 212–14
drainage system, 143, 145, 168, 199
Drusian foot. *See* pes Drusianus
Durance (river), 57
duumvir, 137

ecclesiastical council, 15
Egypt, 50, 70, 107, 166
elephant, 8
elogia, 133
Enclos Milhaud (Aix-en-Provence), 218, 256n159
Enclos Reynaud (Aix-en-Provence), 218
Ensérune, 21, 64–5, 201–2, 206, 241n7, 247n9, 247n11
entablature
 arcuated, 73, 144
 Arles, 144, 156
 Corinthian, 23, 106, 228
 Glanum, 28, 94, 131
 Ionic, 173
 Maison Carrée, 50, 106–7, 109–10
 Orange, 89, 111
 St. Chamas, 70
 St.-Rémy-de-Provence, 228
 Tuscan, 28, 94, 242n28
 Vienne, 114–16
entertainment complex, 49, 161, 168
entranceway, 32, 67, 79, 93, 117–18, 130, 139, 147, 156, 166–7, 214–15
 columned, 186, 207
Entremont, 6–7, 21, 22, 27–8, 32, 37, 65–6, 119, 202, 238n9, 238n12, 241n7, 243n34, 247n9, 248n12, 252n78
epigraphic testimony, 41, 61, 92, 102, 115, 249n31, 250n43, 250n48, 251n48
Ephesian Artemis, 25, 242n15
Ephesus (Asia Minor), 173
Episcopal Palace (Carpentras), 178, 180
L'Espace Mangin (Fréjus), 134
L'Étang de Berre, 6, 21, 238n9
Etruria, 28, 93, 163
Etruscans, 6, 238n8

Etrusco-Italic style, 93–4, 105
Euric, 16
exedra, 133, 173, 209, 220
 rectangular, 144
 semicircular, 42–3, 146, 186

Fabius, C., 10
fabricae, 138–9
façade, 32, 105–6, 113–14, 117, 126, 129, 151, 163, 169, 209
fauces, 207
Faustinus, 57
fire, 14, 39, 51, 53, 122, 135, 146, 235, 253n96
Flaccus, M. Fulvius, 7
flanks, 43, 105, 113, 117, 139
Flavian era, 13, 26, 33, 37, 44–5, 58, 60, 68, 82, 119, 124, 128, 130, 134, 163, 168, 170, 177, 190, 208, 235, 249n27, 253n90
Flavius, C. Sappius, 57
Flavos, Lucius Donnius, 75, 249n26
Florus, 12, 238n12, 238n13
Foix, 5
Fonteius, M., 9, 32
Fontvieille, 198
forecourt, 43, 206
fornix, 35, 41, 56, 63, 73, 80–1, 83, 85, 89, 178, 224, 250n40
fortifications, 18, 20, 30, 64, 66, 238n9, 241n10, 245n66, 245n67, 246n81, 248n14
forum, 253n94, 253n96, 253n98
 adiectum (Arles), 43, 133, 244n55, 247n5, 252n80, 253n92
 apsidal, 43, 122, 130, 133, 252n80
 Boarium (Rome), 93
 colonnaded, 43, 50, 118, 122, 130, 135, 252n87
 Fréjus, 244n60
 Glanum, 118
 Imperial, 43, 132, 244n55, 253n90, 253n91
 Nemausus, 50–2, 126, 128, 134, 188, 235
 Roman, 250n40
 Transitorium (Rome), 165
 tripartite, 129
 Vienne, 132, 135–7, 234
Forum Iulii. *See* Fréjus
Fossa Marianae, 41

foundation, 6, 22, 38, 54–5, 62, 67, 70, 87, 98, 109–10, 121, 129, 130, 143, 162, 178, 180, 186, 214, 221, 239n21, 244n49

fountains, 103, 130, 137, 153, 179, 181–3, 214, 215

 Glanum, 35, 184–5

Fréjus, 11, 13, 19, 26, 38, 45–7, 67–8, 117, 132, 134, 143, 146–9, 176–9, 180, 191–2, 234–5, 239n19, 240n38, 244n60, 245n62, 254n109, 255n124, 255n130, 256n140, 268–70

fresco painting

 Second Pompeiian style, 32, 82–3

 Fourth Pompeiian style, 207

frieze, 30, 51–2, 70, 73, 75, 89, 92, 105, 107, 109–10, 114–15, 227–31, 233, 251n63

frigidarium, 176, 178–80

Frontinus, Sextus Julius, 190–1

Fullery (fullonica), 140

Fulvius, T. Aurelius, 14, 240n36

funerary functions, 35, 221–4, 229, 233

Gaeta (Italy), 72

Gaius Caesar, 12, 109–10, 224, 226, 239n26, 252n67

Galba, 12–13

gallery, 44, 96, 141, 143–5, 168, 208, 220, 234

Gallia Transalpina, 62

Gallic campaigns, 1, 10, 39, 47, 129, 234, 238n, 246n80

Gallic revolts, 8, 10, 12–13, 50, 250n43, 250n44

Gap, 240n35

gardens, 33, 117, 179, 182, 207–9, 212, 214–15, 219–20

Gardon (river), 52–3, 193, 235, 239n23, 246n76

Gargalon (river), 191

gates, 6, 10, 12, 38, 45, 64, 67–8, 70, 170

Gauguin, Paul, 257n162

Genava. See Geneva

Genesius, 222

Geneva (Switzerland), 1, 5, 137, 253n98

Gerasa (Jordan), 85, 250n42

Germanic tribes, 8–9

Germanicus, 85, 250n41

Germany, 15

Geta, 92

gladiators, 162–3

Glan(s), 28, 97, 184–5

Glanon. See Glanum

Glanum, 6, 12–13, 22, 27–30, 31–2, 36–7, 62–4, 66, 73, 75–9, 81–3, 90, 94–100, 113, 118–20, 129–32, 176–7, 180, 183–6, 203, 208, 216, 222–4, 226, 230–3, 235, 238n10, 239n26, 240n37, 241n8, 242n24, 242n29, 243n32, 243n34, 247n4, 249n30, 250n43, 252n78, 255n130, 256n145

Goths, 15–16, 44

La Graufesenque, 144

Greece, 5, 28, 65, 107, 112, 200, 205

Greek colonial foundations, 22–3, 26

Greek settlement, 21–2, 27, 41, 94, 241n8

grid plan, 18–19, 22, 24, 41, 43–4, 50, 58, 106, 122, 129, 139, 202, 234–5, 242n20

gymnasium, 153

Hadrian, 13–14, 39, 49, 51–3, 56, 68, 82–3, 85, 111, 114, 121–2, 124, 128, 133–5, 143, 152, 153, 155–6, 159, 160, 170, 173–4, 188, 190, 204n34, 222–3, 240n32, 240n33, 245n71, 245n72, 245n73, 245n74, 246n78, 252n84, 254n111, 255n124, 255n125

Hadrian's Villa (near Tivoli), 143

Hallstat culture, 20

Hannibal, 7–8, 242n27

harbors, 23, 25, 45, 145–6, 241n10

Haute-Garonne, 220

Hellenic architectural traditions, 6–7, 66, 118, 129, 243n29, 243n32, 247n2, 251n50

Hellenic incursion, 6

Hellenized Celtic hill forts, 6

Heloros (Sicily), 23

Helvetii, 1

hemicycle, 43, 102–3, 122, 153, 155

Heraclea Caccabaria, 26

Heraclea Monoikeia, 26

Heracles/Hercules, 30, 32, 97, 115, 243n30

Heracles Monoikos, 26

Herculaneum (Italy), 149, 201, 209, 216

hill-fort towns, 7, 21, 22, 27, 37, 64, 65, 201, 206

hilltop settlements, 21

Hippodamian town plan, 24–6

Hippodamus of Miletus, 24, 241n13

Hispania, 235

Historia Augusta, 14, 240n35, 245n72

Honorius, 16

horreum, 122, 141–2, 145, 254n102

hortus, 208, 212, 220

L'hotel de Laval (Arles), 42

house styles. *See also* domus
 Hellenistic 30, 37, 200–3, 205–7

hydraulic pump/system, 99, 175, 179, 181, 183, 190, 216, 255n122

Hyères, 22, 26, 202, 241n8

Hyginus, 106, 251

hypaethral assembly hall, 30

hypocausterium, 176

Imperial dates, 91, 156, 245n66, 246n82, 247n2, 247n7, 249n37, 251n56, 253n90

Imperial mint, 15, 180, 249n36

impluvium, 203, 205, 212

inscriptions
 cadastral, 13, 56, 57, 239n29, 246n85
 clamped, 51, 88–9, 92, 107, 109–10, 114–16, 178, 224, 250n42, 252n71
 counter-sunk, 88–9, 109–11, 115
 dating, 51, 56, 85, 92, 115, 250n48, 255n122, 257n166
 dedicatory, 43, 49, 85, 89, 109, 115, 129, 239n23, 239n24, 252n67, 252n68, 252n69
 entablature, 50, 73, 89, 107, 109–11, 114–16
 Greek, 30
 Imperial, 100, 114, 135, 187, 190
 Jupiter Tonans, 98–9
 Latin, 16, 30, 31, 88–9, 187, 224, 226, 231, 242n24, 245n73
 mausoleum, 222–4, 243n33
 mosaic, 243n33
 pagan, 44
 Reburrus, 166, 255n122
 triumphal, 70
 Vespasianic, 246n80

insula, 25, 125, 141, 215

interaxial width, 105

Iron Age, 20, 27–8, 64

Isère (river), 7, 57, 70

Italo-Roman model, 63

Italy, 3–5, 8–10, 12, 16, 23, 28, 32, 36, 62–4, 71–3, 92, 94, 114, 168, 170, 180, 201, 219, 241n5, 241n9, 241n13, 247n2, 247n3, 253n91, 254n107

Jardin de la Fontaine (Nîmes), 52, 186, 188, 190

Jardin de Grassi (Aix-en-Provence), 38, 218

Jefferson, Thomas, 104

Julio-Claudian era, 12, 39, 82, 90, 92, 101, 113, 114, 116, 121, 124, 138, 139, 162, 170, 223, 250n48, 251n56, 255n125

Julius Caesar, 5, 6, 9–11, 17, 21, 25, 27, 37, 39, 41, 43, 47, 50, 72, 132, 146, 223, 226, 235, 237n1, 239n242n244n49, 257n166

Juno, 98, 101

Jupiter, 98–9, 101, 135

Jura (mountains), 3

laconicum, 176, 179

Lakydon, 23

Languedoc, 5, 8, 259

lanterne d'Auguste (Fréjus), 45, 146–8

Latin language, 4, 16, 28, 30–1, 73, 88–9, 175, 187, 194, 224, 226, 231, 242n

Latin poetry, 226

Latium, 93

latrines, 212, 216, 218

Lattera. *See* Lattes

Lattes, 27, 202, 242n

Lebanon, 174

Legio II Gallica, 54

Lens (quarry), 107, 251n66

Leptis Magna (Libya), 85, 136–7, 250n42

Lesbos (Greece), 148

Lezoux, 224

library
 Athens, 173
 Celsus [Ephesus], 173
 Nîmes, 52, 128, 172–5, 186, 188, 190
 Rome, 172

Libya, 85, 136

Liège (Belgium), 106

Ligurian tribes, 7, 41, 72

lintels, 73, 168

Livia, 47, 114–15, 135
Livy, 6–10, 54, 238n5, 238n12, 238n13,
 242n
Locri (Italy), 23
Lodève (Montpellier), 11, 240n38
Louis XIV, 104
Luc-en-Diois. *See* Lucus Augusti
Lucius, brother of Gaius Caesar, 12,
 239n26, 252n67
Lucus Augusti, 137, 253n98
Lugdunum. *See* Lyon
Luteva. *See* Lodève
Lyon, 5, 12, 14, 44, 47, 54, 91, 114, 186,
 235

macellum, 30, 35, 128, 129, 135–7,
 253n98
Mainz (Germany), 85
Maison Carrée. *See* temple, Maison Carrée
Maison au Dauphin (Vaison). *See* domus,
 House of the Dauphin
La Maison d'Orphée (Vienne), 49, 116,
 160
Mallius, Cn., 8, 54
Malpasset (river dam), 168
marble, 41, 52, 62–3, 71, 107, 126, 136,
 156, 162, 178, 182, 211, 215,
 251n66
Marcellus, 41, 149, 172, 239n22
Marius, C., 9, 37, 39, 41, 238n16, 257n166
Mars Ultor, 51, 61, 62, 105, 149
Marseille, 5–6, 16, 22–4, 73, 239n20,
 240n38, 243n32, 248n12
Martial, 240n30, 253n97
masonry, 35, 58, 64, 71, 143, 151, 163,
 178–80, 208
 ashlar, 30, 67, 70, 76, 130, 169, 183
 brick, 143, 214
 quadratic, 66
Massalia. *See* Marseille
Massaliote Greek culture, 6, 26, 64, 238n7
Massilia. *See* Marseille
Massiliote wine trade, 6, 25
Mastrabala, 27
Mastromela, 27
Matres Glanicae, 32
mausoleum, 247n5
 Arles, 222
 of Augustus (Rome), 222–3
 of Caecilia Metella (Rome), 72, 222
 dynastic, 72–3

of G. Cestius (Rome), 222
 of Hadrian (Rome), 222
 Halicarnassus (Asia Minor), 72
 Julii (Glanum), 243n33
 multi-generational, 222
 of Plancus, L. Munatius (Rome), 45, 72,
 239n21, 239n24
 tomb of the Scipios (Rome), 222
 tower tombs, 223, 233
Maximus, Cn. Mallius, 8, 54
Maximus, Q. Fabius, 7, 70
Maximus, Valerius, 8
measurement
 Drusian foot. *See* pes Drusianus
 Roman foot, 69, 98, 106–7
medieval town, 38–9, 40, 85, 222
Medinaceli (Spain), 85, 250n41
Mediterranean Sea, 3, 5–6, 23–4, 62, 66,
 107, 145–8
Medusa, 135, 231
Megara Hyblaea (Sicily), 23, 25, 176, 242n
Mela, Pomponius, 13, 26, 57, 60, 239n31,
 244n49, 253n97
Mercury, 99
Merida (Spain), 168
merlons (Glanum), 33
Metapontum (Italy), 23, 25, 242n
Metella, Caecilia, 72, 222
metope, 70, 223
Meyne (river), 55
mezzanine, 141, 168
Midi-Pyrenees, 21
milestones, 14, 238n14, 239n23, 240n34
Miletus (Asia Minor), 23, 141
mill
 Barbégal, 197, 199, 200, 221, 240n32,
 244n57
 flour, 198
 race, 198
 water 14, 175, 197–9, 220–1
Minerva, 98, 101
moldings
 egg and dart, 105
 profiles, 82
 torus, 79, 228
 scotia, 79, 94, 228
moles, 45, 146
Molise (Italy), 28
Monaco, 26, 70
Monetier-Allemont, 137, 253n98
Mons, 46

Mont Cavalier (Nîmes), 50
Mont des Justices quarry, 71
Mont Pipet (Vienne), 49
Monte Testaccio (Rome), 239n31
Montpellier, 27
monumental area, 33, 35, 37, 56, 133, 139,
 243n37, 245n66
monumentalization, 28, 52, 141, 183, 186,
 236
mortar. *See* cement
mosaic, 30–1, 49, 143, 172, 206, 212,
 214–15, 218, 243n33
Murcens, 21, 241n7
Musée lapidaire (Arles), 239n22
Mytilene (Greece), 148

Nages-et-Solorgues, 21, 65, 241n7
Naples (Italy), 147, 149, 247n3
Narbo Martius. *See* Narbonne
Narbonese artistocracy, 14
Narbonese senators, 13
Narbonne, 8, 11, 26, 39–40, 67, 73, 111,
 118, 121–2, 132, 134, 137, 144–6,
 206–8, 216–17, 233, 235, 240n34,
 240n38, 246n77, 246n78, 249n29,
 253n96, 253n98, 257n163
Naro, 39
natatio, 176, 178–9
naves, 187
necropolis, 222
 Arles, 222
 circus (Nîmes), 257n163
 Fourche-Vieille, 233
Nemausus, 8, 11–14, 39–40, 51–4, 104–5,
 111, 121, 123, 126, 128, 134, 137,
 174, 186–8, 194, 246n77
Neolithic era, 20
Neptune, 99
Nero, 2, 8, 238n13
Nero, Ti. Claudius, 11–13, 25–6, 57, 143,
 176
Nero's Golden House (Rome), 176
Nice, 5, 22, 26, 72, 146, 241n8
niche, 80, 82, 150–1, 156, 160, 173–5,
 178, 184, 186, 214
 prostyle, 223
Nikaia. *See* Nice
Nîmes, 6, 8, 11–12, 15, 17, 19–20, 39,
 50–4, 57, 63–5, 68–70, 93, 99–100,
 103–4, 107, 110–11, 113, 115,
 123, 126–8, 132, 134, 137, 163–8,

172–5, 186–9, 193–4, 223, 234–6,
 238n9, 239, 240n32, 240n33,
 240n38, 246n78, 247n4, 252n67,
 252n69, 253n98, 254n121,
 255n121, 257n163
Noreia, 8
Noricum, 8
Notitia Galliarum, 15
nymphaeum, 32–3, 52, 128, 178–9, 186,
 188, 193

obelisk, 170–2
Octavian, 11, 41, 50, 54, 56–7, 60, 134,
 145–6, 163, 166, 234, 239n22
odeum (Vienne), 49, 147, 160–2, 245n65
oenoculture, 5
officinae, 138–9
oikos, 205, 207
Olbia, 22, 26, 66, 202, 206
olive oil production, 5–6, 139
Opimius, Q., 7
oppidum, 7, 21, 22, 28, 64–6, 201–2, 206,
 238n9, 241n6, 247n11
opus
 caementicium, 67, 131
 incertum, 144, 178, 208
 latericium, 62
 mixtum, 178, 179
 quadratum, 67, 75
 reticulatum, 144, 209
 sectile, 143, 211
 signinum, 30–1
 testaceum 62, 143
 vittatum, 58, 168, 178–80
Ora Maritima, 27, 244n49
Orange, 8, 11, 13, 14, 16–17, 19, 35–6,
 54–7, 60, 63, 67, 73, 76, 78–9,
 81–92, 100–3, 107, 109, 115, 121,
 123–4, 149–56, 158, 160, 216,
 218–19, 230, 233–6, 239n29,
 240n32, 240n38, 243n38, 246n83,
 249n31, 250n41, 252n71,
 257n175
orchestra, 148, 150, 156–8, 160
Orosius, 7, 8, 238n13, 240n40
Orpheus, 160
orthogonal street plans, 18–20, 22, 24–6,
 58, 129
Ostia (Italy), 12, 138, 187, 203, 214–15
Ostrogoths, 15
Otho, 13

Ouvèze (river), 58
Oxii tribe, 7

Paestum (Italy), 23, 25–6, 170
pagus, 21
painting, wall, 32, 243n33
palaestra, 212
 colonnaded, 211
Palais de la Bourse (Marseille), 6, 25, 66,
 248n12
Palatine Hill (Rome), 133, 143, 172
Palmyra (Syria), 85, 250n42
panels, relief, 7, 9, 77, 91, 227, 228, 230,
 232, 257n172
Pantheon (Rome), 111
parascenium, 63
Paterculus, Velleius, 10, 12
Patroclus, 22
patronage, aristocratic, 41, 44, 49, 51, 54,
 57, 60, 121, 190, 235–6
Paulinus, Valerius, 13
Pax Augusta, 251n63
Pax Romana, 78
pediment, 52, 82, 174
Pergantion, 26
peribolus, 42–3, 50, 133
Pericles, 160
peripteros sine postico, 111, 113
peristyle, 59, 105, 147
 columns, 28
 garden, 117, 212, 214–15
 house, 200–1, 203, 205, 207–10, 216,
 218–20
 rectangular, 118
 Rhodian, 205, 207, 210
pes Drusianus, 106–7
Peutinger Table, 46
Pharos (Alexandria, Egypt), 70
Phocaea (Greece), 6, 23, 242n
Piazzale delle Corporazioni (Ostia), 187
piers, 191–2, 196–7
pilasters, 73, 81–2, 113, 126, 144, 169,
 214
 brick, 176
 composite, 227
 Corinthian, 205, 228
 Doric, 163
 engaged, 183
 fluted, 73
 plain, 75
 rectangular, 164

pilgrimage site, 37
pipes, 181, 193, 215
Piraeus (Greece), 241n13
Piscina Mirabile (Campania), 147
Place Agricole (Fréjus), 67
Place du Forum (Arles), 122
Place des Herbes (Aix-en-Provence), 38
Place Jouffrey (Vienne), 125–6
Place Lenche (Marseille), 24
Place Magnin (Fréjus), 45
Place des Martyrs (Aix-en-Provence), 119
Place de la Poste (Vaison), 59
Place de la République (Orange), 56,
 170–1, 246n80
Place Triangulaire (Glanum), 129
Place Viaux (Marseilles), 25
Placidia, Gallia, 16
Plancus, L. Munatius, 45, 72, 239n21,
 239n24
La Plate-Forme (Fréjus), 68, 143, 147,
 178
plinth, 70, 79, 81, 94, 105, 205, 227–8
Pliny the Elder, 3, 13, 72, 237n1, 239n20,
 240n31, 244n9, 246n87
Plotina, Pompeia, 14, 52–3, 111, 134, 235,
 240n32, 245n73, 246n77, 252n69
plumbing, 35
Plutarch, 8–9, 13, 37, 148, 238n15,
 239n18, 253n97
podium, 93, 223–4
Pollio, Asinius, 172
Polybius, 6, 238n11
Pom(o)erium, 19, 35, 37, 41, 76, 78, 222
Pompeii (Italy), 136, 160–1, 163, 176, 201,
 203, 205, 207, 209, 216, 223
Pompeiian Fourth Style painting, 207
Pompeiian Second Style painting, 32,
 82–3
Pompeius. See Pompey the Great
Pompeius Trogus (Vasio), 57–8, 65,
 247n11
Pompey, Sextus, 54
Pompey the Great, 9, 57, 80
Pomponiana, 26
Pont Flavien, 73, 249n27
Pont du Gard, 52–3, 104, 193–7, 239n23,
 256n142
pool, 35, 52, 176–8, 198, 203, 209,
 214–15, 218
port facilities, 26, 66, 142, 147, 235
 Arles, 146

Fréjus, 26, 45, 146, 147, 235
Narbonne, 146
Porte d'Auguste (Nîmes), 50, 63, 68–9,
 166, 193, 239n24, 245n70, 248n16
Porte de France (Nîmes), 69, 248n16
Porte de Rome (Fréjus), 46
porticus (portico), 245n73, 252n78,
 252n79, 252n85, 252n86, 252n87
 addorsed, 129, 186
 lateral, 126, 130, 133
 Metelli (Rome), 172
 Pompeianae (Rome), 187
 of Pompey (Vaison), 58
 in summa cavea, 150, 159
 trapezoidal (Glanum), 30, 32, 118, 129
 triplex (Nîmes), 128, 135, 187, 190
 Warrior (Entremont), 30, 119
portraits, 13, 43, 80, 124, 145, 156, 159,
 220, 222, 235, 239n22, 243n35,
 252n82, 252n84, 254n113
Portus Aemines, 26
Poseidonia. See Paestum
Posidonius, 27
postscenae, 125, 150
potters' quarters, 25, 138–9
pottery evidence, 5–6, 27–8, 31, 138, 199,
 214, 221, 244n49
Pozzuoli. See Puteoli
praefurnium, 176, 178
Prefect of all Gaul, 44, 236
Priene (Asia Minor), 130
princeps, 11–12, 43, 186, 251n63
 Galliarum, 12
principate, 13–14, 32
Probus, 14
proconsul Narbonensis, 92
pronaos, 93
Propertius, 181
propylaea, 52, 186
protomes, 166, 168
provincia nostra, 1, 3, 5–6, 10, 12, 18, 61,
 70, 72, 182, 194, 220, 237n1
Provincia Narbonensis Prima and
 Secunda, 240n38
Provincia Viennensi, 15
provincial governor, 1, 9–10, 13, 16, 26,
 45
pyramid, 70, 190, 222–3, 228. See also La
 Pyramide
La Pyramide (Vienne), 171–2
prytaneum, 130, 243n30

pseudodipteral, 50, 105, 111
Ptolemy, 27
Pulcher, P. Codius, 10
pulpitum, 148, 151
Punic Wars, 7, 238n8
puteolanum, opus (volcanic sand), 247n3
Puteoli (Italy), 136–7, 163, 247n3
Le Puymin quarter (Vaison), 58, 156
Pyrenees (mountains), 5, 8, 20, 70
Pytheas, 27

quadrifrons, 79, 82, 228, 232, 248n21
quadriporticus, 122, 126, 210–11, 219
quarries, 62, 71, 107, 247n4, 251n66
quay, 25, 143, 146

ramps, 163, 168
Reburrus, Crispius, 166, 235
record office, 56, 102, 129
regia, 151
Reiorum, 11
reliefs, 70, 75–9, 81, 87, 89–91, 115, 135,
 184, 188, 222–3, 227–8, 230–2,
 249–50, 257n172
residential quarters, 19, 30, 35, 37, 49,
 110, 125, 138–9, 176, 200, 202–6,
 208, 211, 214, 217, 222
Restitutor Galliarum, 14
revolts, 8, 10, 12–13, 47, 250n43, 250n44
Reyran (river), 168, 191
Rhine (river), 15, 180
Rhodes (Greece), 12, 241n13
Rhône (river), 5–9, 12, 16, 19, 41, 49, 54,
 63, 70, 73, 80, 139, 214, 216, 222,
 233, 240n38
Riez, 11, 60, 240n38
roads, 8–9, 12, 14, 36, 38, 44, 54, 57,
 70, 78, 81, 94, 97, 146, 195, 220,
 222–33, 239n24, 243n38, 251n66
Rochers de la Pène, 198
Roma-centric, 12, 237n1, 251n64
Roman military, 13, 15–16, 37, 39, 54, 61,
 66, 73, 89, 106, 146, 202, 230
 Actian army, 134
 Eighth legion, 45, 50, 70, 107, 166,
 239n19
 fleet, 41, 45, 147, 169
 naval facilities, 45, 147
Roman provincial administration, 4, 5,
 11, 13–15
Roman Senate, 7–8, 10, 12, 72, 128, 131

Romanitas, 36–7

Romanization, 4–7, 9, 11, 12, 26, 30, 33, 35–7, 52, 61, 72, 91, 97, 117, 119, 132, 201, 223, 234–5, 237n2, 243n30

Rome, 1, 4–10, 14–15, 27, 39, 41, 43–7, 51, 53, 63, 67, 70, 72–3, 75–6, 82–3, 85, 93–4, 99, 102, 105, 111, 114, 122, 132–3, 135–6, 143, 148–9, 155, 162–3, 165, 168, 172, 176, 179, 182, 186–7, 190–2, 194–5, 212, 222–4, 235, 238n5, 238n15, 239n29, 240n, 241n2, 241n5, 244n55, 249n36, 249n38, 250n40, 253n87

Roquetailladet, 191

rotunda, 222, 226–7

Rue des Boutiques (Vaison), 59, 139–40, 209

Rue de la Caisserie (Marseille), 23

Rue Clos de Lombarde (Narbonne), 123, 208

Rue des Colonnes (Vaison), 124–5, 139, 208

Rufus, Gaius Attius, 75

Rumania, 70

Ruscino (Chateau Rousillon), 11

Sabina, 13–14, 58, 124, 156, 252n84

sacred precinct, 28, 33, 97

Sacrovir, Julius, 12, 87–9, 250n43

Saepinum (Italy), 149

St. Antoine, Butte (Fréjus), 147

St.-Blaise, 6, 21, 22, 27, 33, 66, 202, 238n9, 241n7, 242n

St. Chamas, 21, 73–5, 224, 248n21, 248n24

St. Charles Butte (Marseilles), 23

St.-Eutrope (Orange), 54–5, 101–2, 155

St. Genet, 222

Saint Honorate-des-Alyscamps, 222

St. Jerome, 15, 240n40

St. Laurent Butte (Marseilles), 23–5

St. Lucien (Arles), 144

Les-Saintes-Maries-de-la-Mer, 146

St.-Romain-en-Gal (Vienne), 49, 141–3, 245n68

St.-Rémy-de-Provence, 15–17, 22, 27–8, 35–6, 73, 76, 118, 222, 224–5

St. Tropez, 26

St. Trophimus, 222

Salamis, Battle of, 237n5

Sallust, 239n18

Saluvii tribe, 7, 37, 66, 202, 238n12

Salyens, 27, 31, 37, 129

sanctuary 22, 28, 30–3, 37, 51, 97–101, 132, 149, 174, 183, 186–90, 243n30, 243n35, 251n56
 city, 6, 36, 94, 203, 235
 Herculean, 30, 97, 243n30
 porticoed, 187–8
 water, 50, 52, 97, 99–100, 103, 184, 186, 188, 190, 235, 255n136

sarcophagi, 230
 battle, 90–1
 Christian, 222
 pagan, 44, 222

Sarus, 16

Savoie, 5

scaffolding, 195

scenae frons, 43

scrolls, 52, 85, 173

sculpture, 5, 30, 43, 52, 73, 78, 80–2, 85, 91–2, 100, 133, 160, 162, 188, 222–3, 227, 232, 243n33, 249n32, 250n38, 250n46, 250n48
 relief, 89, 91, 222–3

Second Triumvirate, 11, 45, 227, 257n166

Sedatus, 54

Selinus (Sicily), 23

Sertorius, 8, 9, 39

Severan dynasty/period, 14, 44, 78, 82, 85, 91–2, 134, 179, 236, 240n36, 249n29, 249n33, 250n41, 250n42, 257n172

Severan Marble Plan, 136

Severus, Septimius, 14, 56, 81, 85, 91, 128, 188, 220, 240n36, 245n74, 250n41

shields, 41, 87–9, 135, 228

shrine, 117, 183
 Hercules, 30, 32, 97, 243n30

Siagnole (river), 191

Sicily, 23, 62, 147, 176, 241n9, 242n

Sidonius Apollinarus, 137, 144, 171, 240n40

sieges, 6, 16, 25, 37, 41, 45, 66, 234, 242n

Silenus, 160

Sisteron (river), 240n38

Slovenia, 8

Smyrna (Asia Minor), 23

societas, 221

socle, 93, 227
soffits, 173
Solinus, 238n5
Spain, 8–9, 11, 15–16, 62, 70, 75, 85, 169, 205, 223
spandrel, 76, 79, 83, 250n38
Spanish campaigns, 9
specus, 192
spina, 170–1
spolia, 87, 89, 250n44
springs, sacred
 Les Alpilles, 97
 Chateau-Bas (Vernégues), 99
stadium, 24, 170, 172
staircases, 28, 32, 93, 98, 105, 142, 160, 163, 168, 174, 178, 183, 188, 205
statues, 240n33, 252n82, 252n84
 bronze, 79, 83, 182, 215, 250n38
 Augustus, 70, 152, 154
 Imperial, 151, 186, 235, 254n
 marble, 178
 triumphal, 90
Stephanos of Byzantium, 27
Stilicho, 15–16
stoa, 130
stone/stonework, 8, 14, 16, 25–6, 32, 58, 62–4, 66–7, 70–2, 82–3, 88, 98, 107, 109, 143–4, 148–9, 163, 170, 178, 183, 190, 195, 198, 221, 224, 231, 238n, 239n23, 240n34, 247n4, 250n38, 251n66, 255n128
Strabo, 7–8, 25, 37, 50, 146, 202, 238n12, 238n13, 239n20, 240n30, 241n13, 246n87
stratigraphical evidence, 17, 46, 57–8, 130, 158, 170, 255n124
street plan, 18–19, 22–5, 35, 38, 41, 43–4, 49, 55, 58, 66–7, 118, 119, 125–6, 129, 134, 137–9, 141, 143, 178, 208, 211–12, 215, 234–5, 241n2, 242n, 244n60, 246n81, 251n66. *See also* armature
 cardo, 39, 41, 50, 58, 67, 78, 124, 144, 168
 decumanus, 38, 41, 45, 50, 67, 145
suburbs, 18–20, 138–9, 214, 241n4
 commercial, 49
 residential, 19, 49
sudatorium, 176, 178, 180
Suetonius, 8, 11–13, 238n13, 239n29, 245n63

surveyors, 246n85
Sutri (Italy), 163
symbolism, 232, 251n63
symmetry, 42, 94, 180, 198, 214
syncretism, 30
Syracuse (Italy), 23, 176
Syria, 85

tabernae, 59, 137–41, 215, 253n99
tablinum, 205–7
tabularium publicum, 56
Tacitus, Cornelius, 4, 12–13, 26, 45, 57, 87–8, 116–17, 146, 237n1, 245n63, 246n87
Taradeau, 21, 241n7
Tarentum (Italy), 23, 25, 242n14
taurobolium, 57
Tauroentum, 26
Taurus, Statilius, 163
temenos, 79
temple, 4, 25, 28, 44, 51, 53, 79, 111, 117, 121, 129–30, 133, 149, 155, 168, 234–5, 242n, 247n5, 251n55, 251n56, 251n57
 Apollo, 172, 180, 190
 Arles, 247n5
 Augustus and Livia, *See* temple, Vienne
 Bacchus, 174
 Capitolium, 49, 56, 93, 101–3, 122, 134, 145
 Corinthian, 50, 93–4, 96–8, 105–6, 113–14
 Diana (Nîmes), 52, 128, 173–4, 186
 Etrusco-Italic, 93–4, 105
 Glanum, 94–5, 97–8, 183–5, 243n37
 Grand, 101–3, 251n59
 hexastyle, 50
 Italian, 56
 Maison Carrée (Nîmes), 12, 14, 17, 49–51, 58, 63, 93, 104–11, 115–16, 124, 126–8, 134, 188, 239n23, 239n26, 251n64, 251n65, 251n66, 252n67, 252n71, 253n93, 253n94
 Mars Ultor (Rome), 51, 61–2, 105, 149
 Orange, 56, 101, 102, 103, 123, 153, 155, 246n83
 Portunus (Rome), 93
 propylaion, 121
 prostyle/tetrastyle, 94, 98
 pseudodipteral, 50
 Rome and Augustus (Pola), 105, 114

temple (*cont.*)
single cella, 93, 102
Tuscan, 93–4, 102, 105
twin/Gemini, *See* temple, Glanum
Venus and Roma (Rome), 155
Vernégues, 63, 97–101, 113, 153, 251n55, 251n57
Vienne, 47, 63, 111–16, 135, 234–5, 245n63
La Tène culture, 20
tepidarium, 176
terracotta, 30
Terrain Thes, 139
Tetrarchs, 15
tetrapylon, 79
Teutones, 8, 37, 47, 54
theaters, 24, 26, 38, 40, 147–9, 151, 161, 168, 172, 186–7, 211–12, 234–5, 244n42, 245n65, 247n5, 252n83, 252n85, 254n113, 254n106, 254n107, 254n111
Arles, 17, 43–5, 63–4, 149, 152, 156–7, 168, 234–5, 247n5
Aspendos (Asia Minor), 149
Fréjus, 45–6, 244n60
Gallo-Roman, 149, 254n107
Greek, 147–9
Marcellus (Rome), 149, 172
Orange, 17, 56, 100–3, 123, 149–56, 158, 160, 234–5, 246n83
Pompey (Rome), 148–9, 187
stone, 26, 148–9, 163
theatrum tectum, 161
Vaison-la-Romaine, 13–14, 124–5, 149, 156, 158–9
Vienne, 123, 149–50, 160–2, 234, 245n65
wooden, 145, 163, 254n117
Theline (Arles), 22, 27, 41, 244n49
Theoderic, 16
thermopolium, 138
tholos, 137, 228, 231
Thurii (Italy), 241n13
Tiberius, 11–12, 43, 56, 58, 77–8, 87–9, 124, 133, 135, 158, 244n55, 248n25, 249n31, 250n43, 250n44, 250n45, 252n80, 252n83, 253n92
timber, 62
Timgad (Algeria), 85, 250n42
Tivoli (Italy), 83, 143
Tolosa. *See* Toulouse

topos, 5
torques, 30
Toulon, 26
Touloubre (river), 73
Toulouse, 5, 8, 11, 15–16, 73, 220, 240n38, 248n23
Tour Magne (Nîmes), 50, 64–5, 69–70, 188, 190, 256n137
towers, 6, 45, 64, 67, 69–70, 146, 151, 188, 223, 233, 238n9, 248n17
trading centers, 6, 27, 39, 66, 142
Trajan, 13–14, 39, 43–4, 49, 53, 56, 70, 75, 79, 83, 85, 91, 106, 111, 121–2, 132–3, 135, 160, 165, 170, 176, 188, 199, 235, 239n23, 240n32, 244n55, 246n84, 249n33, 249n38, 250n38, 250n44, 253n92, 254n121, 255n124
treasury, 30, 129, 242n15
trench, 166, 168, 191
tribunal, 131
Trier (Germany), 15, 180
Trinquetaille (Arles), 143, 222, 244n49
Trogus, Cn. Pompeius. *See* Pompeius Trogus
Trojans, 228
Tropaeum. *See* Trophée des Alpes
Tropaeum Traiani, 248n18. *See also* Adamklissi (Rumania)
Trophée des Alpes, 12, 70–2, 248n19. *See also* La Turbie
Tungri, 106
La Turbie, 70–2, 248n19. *See also* Trophée des Alpes
Turkey, 149
Tuscan order, 28, 43, 50, 70, 93, 94, 102–3, 105, 164, 242n, 254n120

Ugernum, 8
urban armature, 117, 122, 125
urban imperialism, 117
urban planning/urbanization, 6, 18–20, 23–5, 37, 118, 218, 237n3, 241n1
Uzés, 193, 240n38

Vaison-la-Romaine, 12–14, 19, 57–60, 123–5, 139–40, 149, 156, 158–9, 177, 208, 211–12, 216, 240n33, 240n37, 240n38, 246n87, 252n84, 255n130, 255n145
Valence, 11, 57, 240n38

Valens, Fabius, 13
Valentia. *See* Valence
Valetudo, 32–3, 63, 94, 97–8, 130, 183, 185
Vallée des Baux, 220–1
Vallon des Arcs, 197
Var (river), 20, 72, 202, 240n38
Vasio. *See* Vaison-la-Romaine
vault, 32, 75, 85, 130, 147–51, 155–6, 160, 163, 165–70, 174, 176, 179, 180, 183, 187, 190, 196–7, 255n128
 ashlar, 183
 barrel, 52, 144, 147, 168, 174, 177, 184, 186, 190
 concrete, 163
 entrance, 156, 166, 255n136
 free-standing, 156
 profiles, 168, 255n122
 quadrangular, 173
 radial, 149, 156, 163
 transverse, 166
Vena, Gaius Donnius, 75
Veranius, 194, 256n141
Vercingetorix, 10, 50
Vernégues, 63, 97–101, 103, 113, 153, 233, 251n55, 251n57
Vesontio. *See* Besançon
Vespasian, 13, 123–4, 156, 246n80
vestibulum, 209, 214–15
veterans, army, 10–11, 39, 45, 50, 54, 57, 104, 134, 166, 198, 223, 235
Via Appia (Italy), 72, 222
Via di Diana (Ostia), 138
Via Domitia, 8, 39, 50, 53, 77, 126, 144, 222, 238n14, 249n31
Via Heraclea, 8
Via Julia Augusta, 12
Via Latina (Italy), 222
viaducts, 191

Victor, 32, 60
Vienna. *See* Vienne
Vienne, 5, 11–15, 19, 47, 50, 52, 63, 67, 111–16, 123–6, 132, 135–7, 139, 141–2, 149–50, 160–2, 170–2, 191, 214–18, 234–6, 239n23, 239n24, 240n38, 241n4, 245n63, 245n65, 245n66, 245n67, 252n86, 253n97
Vieux Port (Marseille), 23
villas, 40, 49, 59–60, 83, 143, 203–4, 208, 209, 211–16, 220–1, 235
 Chiragan, 220–1
 La Merindole, 221
 Montmaurin, 220, 257n160
 Peacock (Vaison), 212–14, 219
La Villasse quarter (Vaison), 58–9
Vindalium, 7
Vindex, G. Iulius, 12
viridarium, 207, 220
Visigoths, 15–16, 44
Vitellius, 13
Vitruvius, 18–19, 25, 93–4, 105, 117, 128, 145, 162, 201, 205, 207, 223, 242n, 247n4, 247n8, 251n49, 254n106
Vocontii, 20, 72, 202, 246n87
volutes, 113
vomitoria, 156, 168
votive, 30–1

warehouses, 40, 49, 141–3, 145, 254n107
warships, 11
weaving, 220
wharfs/docks, 45, 49, 142–3, 198
windows, 131, 144, 180
Winged Victory, 76, 79, 83, 230
workshops, 49, 125, 138–9, 220

Zeno (Emperor), 16
Zosimus, 240n40